Masterpieces of Italian Drawing in the Robert Lehman Collection

The Metropolitan Museum of Art

Masterpieces of Italian Drawing in the Robert Lehman Collection

The Metropolitan Museum of Art

by George Szabo

Hudson Hills Press, New York

First American Edition

© by Silvana Editoriale - Milano
© 1983 by Hudson Hills Press, Inc.

Published in the United States by Hudson Hills Press, Inc.
Suite 301, 220 Fifth Avenue, New York, N. Y. 10001

Distributed in the United States by Viking Penguin Inc.
Distributed in the United Kingdom, Eire, Europe, Israel, the Middle East, and South Africa
by Phaidon Press Limited
Distributed in Australia, New Zealand, Papua New Guinea and Fiji
by The Craftsman's Press Pty. Limited

Editor and Publisher: Paul Anbinder
Copy-editor: Irene Gordon
Manufactured in Italy by Amilcare Pizzi S.p.A.

Library of Congress Cataloguing in Publication Data

Szabó, George.
 Masterpieces of Italian drawing in the Robert Lehman Collection,
the Metropolitan Museum of Art.

 Includes bibliographies and indexes.
 1. Drawing, Italian. 2. Lehman, Robert, 1892–1969—
Art collections. 3. Metropolitan Museum of Art (New York,
N.Y.) I. Metropolitan Museum of Art (New York, N.Y.)
II. Title.
NC255.S97 1983 741.945'074'01471 82–25849
ISBN 0–933920–35–0

Contents

List of Text Illustrations

25. Italian. Deruta, 16th century. *Majolica Plate: Hercules and Antaeus at Center with Border of Medallions, Flower Heads, and Scrolls.* c. 1500. Diameter: 43.2 cm. (1975.1.1033)

26. Italian. Deruta, 16th century. *Majolica Plate: Hercules Slaying Giants at Center against a Floral Background within a Yellow Scale Border and Rim Border of Conventional Foliate Design.* c. 1510. Diameter: 46.3 cm. (1975.1.1036)

27. Maestro Giorgio Andreoli. Gubbio, 16th century. *Majolica Plate: The Prodigal Son amid the Swine.* Initialed and dated 1525 on verso. Diameter: 28.6 cm. (1975.1.1105)

28. Giovanni Maria. Castel Durante, 16th century. *Majolica Bowl: Arms of Pope Julius II and Manzoli of Bologna Surrounded by Putti, Cornucopias, Satyrs, Dolphins, Birds, etc.* Dated 1508. Diameter: 32.4 cm. (1975.1.1015)

29. Italian. Castel Durante, 16th century. *Majolica Roundel: Triumph of Love.* c. 1510. Diameter: 21.9 cm. (1975.1.1025)

30. Venetian Master. 16th century. *Glass Bowl with Cold-Painted Representation of Apollo and the Nine Muses.* Diameter: 27.7 cm. (1975)

31. Il Riccio (Andrea Briosco). Venice, 1470–1532. *Kneeling Satyr.* Bronze, h. 24.8 cm. (1975)

32. Il Riccio (Andrea Briosco). Venice, 1470–1532. *Incense Burner with the Figure of a Faun.* Bronze, h. 51 cm. (1975)

33. Venetian Master. Beginning of 16th century. *Pilgrim Bottle.* Painted enamel on copper, h. 33 cm. (1975)

34. Venetian Master. Early 16th century. *Cassone with Carved Ornamental Decoration.* Wood, l. 64.7 cm. (1975)

35. Roman Master. c. 1550. *Cassone with Carved Figural Decoration and Arms.* Wood, l. 73.7 cm. (1975)

36. Italian Master, possibly working in France. c. 1550. *Chair with Carved Figures of Acrobats.* Wood, h. 105 cm. (1975)

37. Florentine Master. Second half of 16th century. *Picture Frame with Stenciled and Punched Decoration.* Wood, gesso, and gold leaf, 73 x 87 cm. (1975)

38. Milanese Master. Last quarter of 16th century. *Cup in Shape of a Marine Monster with the Infant Bacchus on Its Back.* Rock crystal with enameled gold mounts, h. 19 cm., l. 30.5 cm. (1975)

39. Venetian Master. Last quarter of 16th century. *Jewel in Shape of Venus Marina on a Dolphin.* Baroque pearl, gold enameled, and mounted precious stones, h. 7.5 cm. (1975)

40. Veronese Artist. Beginning of 15th century. *A Nobleman with His Horse and Dog.* Pen and ink on paper, 25.4 x 20.3 cm. Inscribed in lower center: Ripossate p[er] lafadiga che . . . ffato. (1975.1.401)

41. Venetian Artist. c. 1400. *Design for an Altarpiece with the Madonna della Misericordia.* Pen and ink with traces of wash on paper, 13.8 x 26.4 cm. (1975.1.256)

42. Piero della Francesca. Florence, 1416(?)–1492. *Man Seated on a Throne.* Pen and brown ink, with brown wash on prepared paper, 19 x 12 cm. Inscribed in upper left corner in 16th century: Raffaello da Urbino. In lower right corner: illegible inscription. (1975.1.397)

43. Ercole de' Roberti. Ferrara, c. 1456–1496. *Saint Sebastian.* Pen and brown ink on prepared paper, 30.2 x 21 cm. (1975.1.319)

44. Florentine Artist from the School of Sandro Botticelli. Last half of 16th century. *The Last Communion of Saint Jerome.* Pen and ink on paper, 15.9 x 19.7 cm. (1975.1.280)

45. Umbrian Artist. Second half of 15th century. *St. Francis(?)* Point of brush with brown and white paint on paper, 17.5 x 13.1 cm. Inscribed in the lower left corner: Gaddo Gaddi. (1975.1.396)

46. Bartolommeo Vivarini. Venice, Murano, c. 1432–c.1499. *Madonna and Child with Saint John.* Pen and ink and wash on paper, 20.3 x 14.6 cm. Verso of the old mat inscribed in an 18th-century hand: Di Andrea Mantegna CLXVIII. (1975.1.373)

47. Francesco Morone. Verona, 1471–1529. *Saint Paul.* Point of brush with white highlights on paper, 26.3 x 10.5 cm. Inscribed by a later hand along the lower right edge: Fran Moron. (1975.1.382)

48. Pietro Perugino (Pietro di Cristoforo di Vannucci). Città della Pieve, Rome, Perugia, Fontignano, c. 1450–1523. *Head of a Man*. Black chalk on paper, 22.5 x 15 cm. Partly reinforced in ink by a later hand. (1975.1.394)

49. Domenico Beccafumi. Siena, Pisa, Rome, 1486–1551. *Two Episodes from the Life of Esther(?)*. Pen and ink over black chalk on paper, 22 x 14.7 cm. The lower half numbered 2. (1975.1.272)

50. Domenico Beccafumi. Siena, Pisa, Rome, 1486–1551. *Three Studies*. Pen and ink over black chalk on paper, 22 x 14.7 cm. Verso of figure 49.

51. School of Pontormo (Jacopo Carucci). Florence, first half of 16th century. *Portrait of a Lady*. Silverpoint and red chalk on gray prepared paper, 17.2 x 13 cm. (1975.1.411)

52. Domenico Campagnola. Padua, Venice, 1500–1581. *Landscape with a Rock and Buildings*. Pen and brown ink on paper, 17.3 x 14.8 cm. (1975.1.290)

53. Venetian Artist. First quarter of 16th century. *Shepherd Sleeping or Resting under a Tree*. Pen and ink, traces of black chalk on paper, 25.3 x 20.2 cm. Partial watermark: tail and claws of an eagle. Inscribed at lower left in a sixteenth-century hand: zorzon. (1975.1.333)

54. Tintoretto (Jacopo Robusti). Venice, 1518–1594. *Figure of Christ for a Crucifixion*. Black chalk, heightened with white paint on blue paper, 32 x 16.7 cm. Verso of Tintoretto drawing, *Reclining Male Nude*. (1975.1.532)

55. Luca Giordano, Neapolitan, 1632–1705. *Angels*. Sepia, pen and wash on paper, 38.1 x 48.3 cm. (1975.1.332)

56. Luca Cambiaso. Monéglia, Genoa, Madrid, 1527–1585. *Venus and Cupid*. Pen and brown ink on paper, 30.5 x 21 cm. (1975.1.289)

57. Canaletto (Antonio Canal). Venice, London, 1697–1768. *Architectural Study*. Pen and ink on paper, 20 x 14 cm. Numbered, probably in an 18th-century hand, at upper right: 21. (1975.1.292)

58. Canaletto (Antonio Canal). Venice, London, 1697–1768. *View of the Rialto Bridge*. Pen and ink on paper, 14 x 20 cm. Verso of figure 57.

59. Gaetano Gandolfi. Matteo della Decima (near Bologna), Venice, Bologna, 1734–1802. *Studies of Classical Heads*. Pen and ink on paper, 28.6 x 20 cm. (1975.1.325)

60. Pier Leone Ghezzi. Rome, 1674–1755. *The Polish Count Onajchi*. Pen and ink on paper, 31.4 x 21.3 cm. Contemporary inscription on the verso: C.e Onajchi Polacco. (1975.1.327)

61. Pietro Antonio Novelli. Venice, 1729–1804. *Study of a Seated Slave*. Pen and ink with sepia wash and white highlights on brown paper. 46 x 31 cm. (1975.1.389)

62. Pietro Antonio Novelli. Venice, 1729–1804. *Study for the Sign of a Venetian Mirror Factory*. Pen and ink with sepia wash on paper, 22.5 x 15.5 cm. Inscribed within the drawing above: AL DOGE VENETO. Also inscribed below: A. C. F. Fabrica di Specchi, e d'ogni sorte di Lavori di Cristalli, e Perterri Di Antonio Codognato, e Figlio in Venezia. (1975.1.387)

63. Gian Paolo Panini. Piacenza, Rome, 1691–1765. *Ruins with a Statue*. Pen and brush with tinted washes in tondo form on paper, 26.2 x 18.4 cm. The faint inscription in lower right corner is illegible. Verso of Panini drawing, *Landscape with Statue and Ruins*. (1975.1.391)

64. Giovanni Antonio Pellegrini. Venice, 1675–1741. *Study for a Last Supper*. Pen and ink with sepia and bister washes on paper, 27.1 x 16.9 cm. (1975.1.392)

65. Giambattista Tiepolo. Venice, Madrid, 1696–1770. *Study of an Inkwell*. Pen and ink with gray wash over preliminary pencil drawing on paper, 45 x 29.5 cm. (1975.1.425)

66. Giambattista Tiepolo. Venice, Madrid, 1696–1770. *Study of a Standing Oriental Figure*. Pen and ink with sepia wash over pencil on paper, 22.8 x 14.2 cm. (1975.1.436)

67. Giambattista Tiepolo. Venice, Madrid, 1696–1770. *Study of a Preaching Monk*. Pen and ink with brown wash on paper, 27.3 x 19.3 cm. (1975.1.437)

68. Giambattista Tiepolo. Venice, Madrid, 1696–1770. *Zephyr and a Horse*. Pen and ink with gray wash over pencil, 31.5 x 20.1 cm. (1975.1.445)

69. Giambattista Tiepolo. Venice, Madrid, 1696—1770. *Caricature of a Seated Small Man.* Pen and ink with sepia wash over pencil on paper, 16.5 x 13.7 cm. (1975.1.455)

70. Giandomenico Tiepolo. Venice, 1727—1804. *Sheep and Goats.* Pen and ink with wash on paper, 19.3 x 29.2 cm. Signed on the rock in lower left corner: Dom°. Tiepolo f. Inscribed by a later at lower center: Tiepolo fecit. (1975.1.529)

71. Giandomenico Tiepolo. Venice, 1727—1804. *The Baptism of Christ.* Pen and ink with brown wash on paper, 26.3 x 17 cm. (1975.1.476)

72. Giandomenico Tiepolo. Venice, 1727—1804. *Rest on the Flight into Egypt.* Pen and brown ink with wash over black chalk on paper, 47 x 37.9 cm. (1975.1.474)

73. Giandomenico Tiepolo. Venice, 1727—1804. *The Betrothal of the Virgin.* Pen and ink with brown wash over black chalk on paper, 48.3 x 38.6 cm. Signed in pen and ink on column at right: Dom°. Tiepolo f. (1975.1.514)

74. Giandomenico Tiepolo. Venice, 1727—1804. *Saint Anthony and the Christ Child.* Pen and ink with wash on paper, 24.4 x 17.7 cm. Signed lower center: Dom°. Tiepolo f. Numbered in upper left corner in a nearly contemporary hand: 74(?). (1975.1.480)

75. Giandomenico Tiepolo. Venice, 1727—1804. *Punchinello Retrieves Dead Fowl from a Well.* Pen and brown ink with brown wash over black chalk on paper, 35 x 46.5 cm. Signed in lower right corner: Dom°. Tiepolo f. (1975.1.471)

76. Giandomenico Tiepolo. Venice, 1727—1804. *Punchinello's Indisposed Mistress.* Pen and ink with brown wash over black chalk on paper, 32.5 x 46.7 cm. Signed in lower left corner: Dom°. Tiepolo f. Numbered in upper left corner of margin: 15. (1975.1.470)

77. Giandomenico Tiepolo. Venice, 1727—1804. *The Burial of Punchinello.* Pen and brown ink with brown wash over black chalk on paper, 35.3 x 47.3 cm. Signed in lower left corner: Dom°. Tiepolo f. Numbered in upper left corner of margin: 103. (1975.1.473)

78. Giandomenico Tiepolo. Venice, 1727—1804. *Punchinellos Felling(?) a Tree.* Pen and brown ink with wash over black chalk on paper, 35.3 x 47.3 cm. Signed in lower left corner: Dom°. Tiepolo f. Numbered in upper left corner of margin: 40. (1975.1.468)

79. Giandomenico Tiepolo. Venice, 1727—1804. *Goddess.* Pen and ink with wash on paper, 24.2 x 12.8 cm. (1975.1.487)

80. Giandomenico Tiepolo. Venice, 1727—1804. *Hercules and Antaeus.* Pen and ink with wash over pencil on paper, 20 x 14 cm. Signed in lower right corner: Dom°. Tiepolo f. (1975.1.492)

81. Giandomenico Tiepolo. Venice, 1727—1804. *Angels and Cherubim.* Pen and ink with wash on paper, 16.5 x 23 cm. (1975.1.484)

82. Giandomenico Tiepolo. Venice, 1727—1804. *The Rape of Deianira.* Pen and ink with wash on paper, 27.3 x 29.9 cm. Signed in lower right corner: Dom°. Tiepolo f. (1975.1.495)

List of Plates

1. Sienese Artist. *Man in Armor with Sword and Globe in His Hands*. Pen and ink on paper. 174 x 126 mm.

2. Sienese Artist. *Man in Armor with Lance*. Pen and ink on paper. 172 x 134 mm.

3. Stefano da Verona. *Allegorical Figure*. Pen and ink on paper. 305 x 203 mm.

4. Stefano da Verona. *Virgin and Child with Two Saints and Female Donor*. Pen and ink on paper. 230 x 196 mm.

5. Ottaviano Nelli. *The Last Judgment*. Brush drawing in brown and white on prepared blue paper. 281 x 167 mm.

6. Lombard Artist. *Gazelle*. Silver, lead point, and ink with additional colors (gray, white, brown, and black) in brush on paper. 102 x 127 mm.

7. Pesellino. *Allegorical Figure, Possibly Justice*. Pen and ink on paper. 193 x 168 mm.

8. Giovanni dal Ponte. *Studies of Apostles and Allegorical Figures*. Silverpoint with white and bister and brush on red prepared paper. 248 x 184 mm.

9. Michele Giambono. *Knight on Horseback*. Pen and ink on paper. 203 x 146 mm.

10. Antonello da Messina. *Studies for a Group of Figures*. Pen and ink with wash on paper. 121 x 152 mm.

11. Francesco del Cossa. *Venus Embracing Cupid at the Forge of Vulcan*. Pen and brown ink on paper. 280 x 407 mm.

12. Antonio del Pollaiuolo. *Study for an Equestrian Monument to Francesco Sforza*. Pen and brown ink with light-brown wash on paper. 285 x 244 mm.

13. Antonio del Pollaiuolo. *Seated Figure of a Prophet or a Saint*. Pen, brown ink and brown wash heightened with white paint on paper. 279 x 187 mm.

14. Francesco di Giorgio. *A Kneeling Humanist Presented by Two Muses*. Pen and brown ink with brown wash and blue gouache in the background on vellum. 184 x 194 mm.

15. Giovanni Bellini. *Christ's Descent into Limbo*. Pen and brown ink on paper. 270 x 200 mm.

16. Ercole de' Roberti. *The Flagellation*. Pen and brown ink with fine point of brush and brown wash heightened with white on paper. 385 x 235 mm.

17. Leonardo da Vinci. *Studies of a Bear Walking, a Forepaw, and a Seated Female Nude*. Silverpoint on pinkish buff prepared paper. 103 x 134 mm.

18. Perugino. *Studies of Standing Youths*. Silverpoint on pinkish prepared paper. 217 x 177 mm.

19. Perugino. *Studies of Holy Children*. Silverpoint on light gray prepared paper. 238 x 189 mm.

20. Fra Bartolommeo. *The Virgin with Holy Children*. Pen and brown ink over black chalk on paper. 184 x 159 mm.

21. Fra Bartolommeo. *Horsemen Approaching a Mountain Village*. Pen and brown ink on paper. 298 x 206 mm.

22. Luca Signorelli. *Head of a Man*. Black chalk on paper. 299 x 245 mm.

23. Giovanni Cristoforo Romano. *Design for a Funeral Monument*. Pen and ink with brown wash on paper. 296 x 154 mm.

24. Francesco Morone. *The Virgin and Child with Saint Roch and Saint Sebastian*. Point of brush with brown ink, further modeled and heightened in white and blue gouache on paper pasted together in several places. 244 x 355 mm.

1

25. Raffaellino del Garbo. *Head of a Girl*. Silverpoint heightened with white on pinkish prepared paper. Diameter 148 mm.

26. Raffaellino del Garbo. *The Virgin and Saint John*. Pen and ink with wash over traces of black chalk on paper. 178 x 141 mm.

27. Bugiardini. *Saint John the Baptist*. Black chalk heightened with white paint on paper cut on both sides. 417 x 159 mm.

28. Sodoma. *Saint Sebastian*. Pen and ink with wash on paper. 265 x 185 mm.

29. Giovanni Francesco Caroto. *Man and Woman in Adoration*. Point of brush with ink and gouache, heightened with white on blue paper. 203 x 273 mm.

30. Girolamo Romanino. *Pastoral Concert*. Pen and brown ink and brown wash over black chalk on paper. 293 x 410 mm.

31. Giovanni da Udine. *Design for a Wall Decoration*. Pen and brown ink on paper. 273 x 226 mm.

32. Defendente Ferrari. *Madonna and Child with Two Saints*. Pen and ink on paper. 317 x 248 mm.

33. Polidoro da Caravaggio. *Frieze of Classical Figures and Horsemen*. Pen and ink with light wash on paper. 197 x 381 mm.

34. Polidoro da Caravaggio. *Mythological Scene*. Pen and ink with wash, heightened with white paint on blue paper. 286 x 407 mm.

35. Baccio Bandinelli. *Standing Apostle*. Pen and ink on paper. 381 x 183 mm.

36. Baccio Bandinelli. *Seated Man Declaiming from a Book*. Pen and brown ink on paper. 311 x 195 mm.

37. Domenico Campagnola. *Landscape with Satyr*. Pen and brown ink on paper. 262 x 208 mm.

38. Bronzino. *Studies of Seated Male Nude*. Black chalk on paper. 368 x 203 mm.

39. Francesco Primaticcio. *Two Nymphs Carrying a Third*. Pen and ink wash over traces of metalpoint on buff prepared paper. 240 x 280 mm.

40. Venetian Artist. *Saint Jerome in a Landscape*. Pen and brown ink on paper. 178 x 216 mm.

41. Daniele da Volterra. *Jupiter and Io*. Pen and brown ink on paper. 235 x 178 mm.

42. Tintoretto. *Study for a Portrait of a Doge*. Black and white chalk on grayish buff paper. 293 x 190 mm.

43. Tintoretto. *Reclining Figure*. Charcoal on blue paper. 167 x 320 mm.

44. Taddeo Zuccaro. *The Martyrdom of Saint Paul*. Pen and brown ink with brown wash, heightened with white over traces of black chalk on paper. 494 x 368 mm.

45. Luca Cambiaso. *The Four Evangelists*. Pen and brown ink on paper. 440 x 291 mm.

46. Veronese. *Head of a Bearded Man*. Black chalk on faded blue paper. 260 x 199 mm.

47. Veronese. *Study for a Massacre of the Innocents*. Black and white chalk on brownish-red paper. 388 x 375 mm.

48. Annibale Carracci. *Lamentation of Christ*. Red chalk on brownish paper. 242 x 230 mm.

49. Domenico Tintoretto. *Study of a Reclining Nude*. Black and white chalk on grayish paper. 196 x 263 mm.

50. Nicolo Bambini. *The Stoning of Saint Stephen*. Pen and ink with brown wash and traces of red chalk on paper. 203 x 314 mm.

51. Giuseppe Bernardino Bison. *The Adoration of the Magi*. Pen and ink with wash and traces of red chalk on paper. 175 x 240 mm.

52. Luca Giordano. *The Almighty*. Pen and ink on paper. 467 x 349 mm.

2

53. Pietro da Cortona. *Tullia Driving Her Chariot over the Dead Body of Her Father*. Pen and ink with brown wash over black chalk on paper. 265 x 468 mm.

54. Canaletto. *The East Front of Warwick Castle*. Pen and brown ink with gray wash and some color on paper. 316 x 562 mm.

55. Canaletto. *Interior of the Basilica of San Marco*. Pen and brown ink over thick black chalk on paper. 280 x 190 mm.

56. Canaletto. *The Piazza di San Marco from the Arcades of the Procuratie Nuove*. Pen and brown ink with gray wash on paper. 222 x 330 mm.

57. Luca Carlevaris. *Portrait of a Dignitary*. Red chalk on paper. 250 x 170 mm.

58. Francesco Salvator Fontebasso. *Saint John the Evangelist*. Pen and ink on paper. 387 x 264 mm.

59. Jacopo Amigoni. *Portrait of a Young Woman*. Chalk and pastel on paper. 295 x 248 mm.

60. Francesco Guardi. *Macchiette (Sketches of Figures)*. Pen and brown ink with gray wash on paper. 167 x 260 mm.

61. Francesco Guardi. *View of the Grand Canal and the Buildings of San Marco from the Sea*. Pen and ink with gray wash and gouache on paper. 475 x 885 mm.

62. Francesco Guardi. *Panorama from the Bacino di San Marco*. Pen and bister with wash on two sheets joined in the center. 351 x 677 mm.

63. Jacopo di Paolo Marieschi. *The Transfer of the Relics of Saint John to Venice*. Pen and ink with gray wash on paper. 227 x 415 mm.

64. Pietro Antonio Novelli. *Study for a Family Portrait*. Pen and brown ink with sepia wash and white highlights on brown paper. 297 x 375 mm.

65. Pietro Antonio Novelli. *A Monk Displaying a Madonna Shrine to an Old Woman and Child*. Pen and brown ink with sepia wash on paper. 266 x 200 mm.

66. Gian Paolo Panini. *Landscape with Statue and Ruins*. Pen and brush with tinted ink washes and watercolor on paper. 184 x 262 mm.

67. Giovanni Battista Piranesi. *View of Pompeii*. Pen and ink over faint traces of pencil gridwork on paper. 276 x 419 mm.

68. Giambattista Tiepolo. *Allegory with Figures beside a Pyramid*. Pen and ink with brown wash heightened with white over black chalk preliminary drawing on paper. 421 x 275 mm.

69. Giambattista Tiepolo. *Bacchus and Ariadne*. Pen and brown ink with brown wash over black chalk on paper. 311 x 241 mm.

70. Giambattista Tiepolo. *Group of Seated Punchinellos*. Pen and ink with sepia wash over preliminary pencil drawing on paper. 194 x 285 mm.

71. Giambattista Tiepolo. *Virgin and Child Enthroned with Saints Sebastian, Francis, and Anthony*. Pen and ink with brown wash over black chalk on paper. 456 x 300 mm.

72. Giambattista Tiepolo. *Man Leaning on a Horse*. Pen and ink with gray wash over preliminary pencil drawing on paper. 195 x 165 mm.

73. Giambattista Tiepolo. *Zephyr and a Horse*. Pen and ink with brown wash over preliminary pencil drawing on paper. 315 x 201 mm.

74. Giambattista Tiepolo. *Caricature of a Man in a Mask and Tricorn*. Pen and ink with wash on paper. 185 x 102 mm.

75. Giandomenico Tiepolo. *The Baptism of Christ*. Pen and ink with wash on paper. 254 x 172 mm.

76. Giandomenico Tiepolo. *Rest on the Flight into Egypt*. Pen and brown ink with wash over black chalk on paper. 470 x 379 mm.

77. Giandomenico Tiepolo. *The Family Life of Punchinello's Parents.* Pen and brown ink with brown wash over preliminary black chalk drawing on paper. 351 x 467 mm.

78. Giandomenico Tiepolo. *The Dressmaker's Visit.* Pen and brown ink with brown wash over preliminary black chalk drawing on paper. 352 x 468 mm.

79. Giandomenico Tiepolo. *Punchinellos Resting outside the Circus.* Pen and brown ink with wash over preliminary black chalk drawing on paper. 349 x 464 mm.

80. Giandomenico Tiepolo. *Punchinello as a Tailor's Assistant.* Pen and brown ink with wash over preliminary black chalk drawing on paper. 352 x 472 mm.

Introduction

The history of the Robert Lehman Collection, now part of the Metropolitan Museum of Art, encompasses the lives and collecting activities of only two generations of the Lehman family and less than seventy-five years. Philip and Carrie Lehman began collecting seriously in 1905, but in 1928 their collection already contained close to 200 masterpieces of European paintings and decorative arts. Between 1924 and 1969, when he died at the age of 82, their son, Robert Lehman, with the same ambition and determination, acquired the drawings reproduced in this volume plus several hundred more. But the collecting of the Lehmans was not limited to paintings and drawings. Carrie Lehman was devoted to the beauty and craftsmanship of laces, textiles, and accessories; her extensive collection ranging from the fifteenth to the nineteenth century was given by her husband and children to the Museum of Fine Arts in Boston. Robert Lehman, besides advising his parents on the purchases of old master paintings, reached independently into the field of nineteenth- and twentieth-century French paintings and into the decorative arts, mostly of the Renaissance. He amassed an almost unparalleled collection of manuscript illuminations, Italian majolica, Venetian glass, Medieval and Renaissance jewelry and precious stone carvings, bronzes and plaquettes, textiles and furniture, including an extraordinary assembly of picture frames. Like his parents, Robert Lehman was never driven by a desire to gather a representative or encyclopedic collection of great masterpieces. His guiding principles were quality and personal response. With well-trained and discerning eyes, augmented by profound learning and understanding of art history and a mind that was always open to advice, he selected from the best only what appealed to his taste. Thus, in some cases, many great artists and periods of Western art are represented in his Collection solely by paintings; in others, only by drawings. The canvases of the Mannerist schools of the sixteenth century and those of the eighteenth-century Italian masters did not appeal to him; however, the drawings of the same periods did, and he collected them with zeal and discriminating taste. The lack of eighteenth-century French paintings in the Collection is amply compensated by his devotion to French drawings, furniture, and other decorative arts of the same century. The richly painted majolica plates or the early bronzes constitute delightful parallels to the drawings, while the multicolored velvets, gilt brocades, and embroideries reflect the same preoccupation and delight with delicate patterns that is so evident in many of the famous paintings in the Collection.

In spite of this love of variety, there seems to be one overwhelming characteristic of Robert Lehman's collecting—the love and understanding of Italian art. Accordingly, the Italian drawings in his Collection reproduced in this volume should be treated and understood in the context of his whole Collection. Therefore, this discussion will consider these main aspects of the history and contents of the Robert Lehman Collection. After a brief history of the Lehman family and a survey of Italian paintings and decorative arts in the Lehman Collection, it will concentrate on the Italian drawings. This discussion will include a short history of the collecting of Italian drawings in New York, as well as the history, sources, and importance of these sheets.

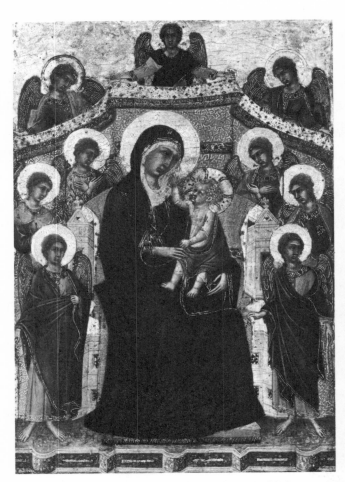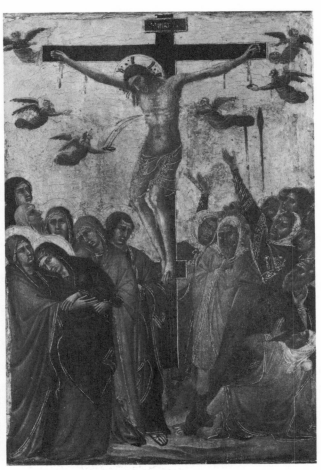

1. Follower of Duccio di Buoninsegna. *Diptych: Madonna and Child, and Crucifixion.* Tempera on panel, 38.1 x 27 cm.

I

Philip Lehman and his son Robert were both bankers and from 1906 until 1969, in succession, headed the prestigious private banking and investment firm of Lehman Brothers in New York. The House of Lehman was founded shortly after Henry Lehman, a twenty-two-year-old son of a cattle merchant in Rimpar, near Würzburg, in Bavaria, emigrated to the United States in 1845. He opened a general store in Montgomery, Alabama; in 1850, when he was joined by his brothers Emanuel and Mayer, they founded the Lehman Brothers partnership. The industrious Lehmans supplied cotton farmers in Alabama with clothing, utensils, and general merchandise. Very often they received raw cotton in payment instead of cash and as they resold the cotton in bulk, they made a profit at both ends. Their activity in cotton trading grew gradually and the business of the Lehman brothers moved into cotton brokerage. They also expanded into other cities. In 1855 Henry Lehman opened a branch in New Orleans, but he soon contracted yellow fever and died. In 1858 Emanuel Lehman opened an office in New York City, but on the outbreak of the Civil War he returned to Montgomery. His son Philip was born during the war. Emanuel and his brother Mayer both

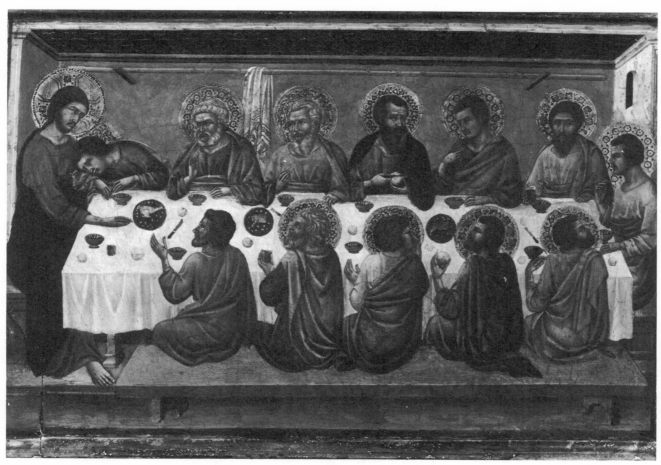

2. Ugolino da Nerio. *The Last Supper*. Tempera on wood panel, 34.3 x 52.7 cm.

served in the Confederate army. Mayer Lehman was on friendly terms with many leaders of the Confederacy, and because of his Northern business connections, he was appointed to a special committee to raise funds to aid and help Confederate prisoners in the camps of the North. Shortly after the end of the war, Emanuel Lehman returned to New York and resumed the operation of the cotton brokerage business. In 1868, he was joined by Mayer, and the two brothers worked together for the next thirty years in the New York cotton and commodity brokerage business. Mayer helped to establish the New York Cotton Exchange and later, a petroleum exchange. In 1887, the Lehman partnership joined the New York Stock Exchange. By 1900, the second generation of Lehmans moved the firm into the realm of underwriting. Philip Lehman led these activities and after World War I he was joined by other members of the family, including his son Robert, who came out of the war as a captain of artillery and became a full partner in 1928.

The prosperity of Lehman Brothers was reflected in the life-style and aspirations of Philip Lehman and his family. In 1905 he built a spacious town house in a well-established and fashionable neighborhood at 7 West 54th Street in Manhattan, facing the stately home of

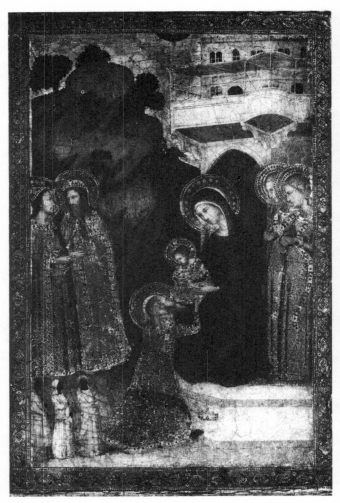

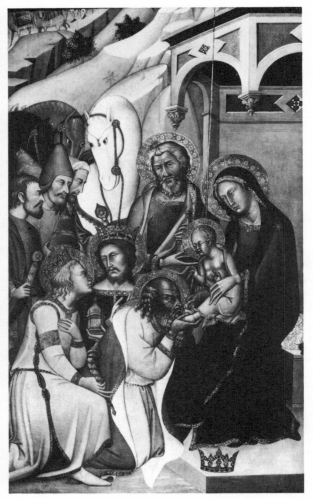

3. French Master. *Adoration of the Magi*. Tempera on panel, 59 x 38.5 cm.

4. Bartolo di Fredi. *Adoration of the Magi*. Tempera on panel, 200 x 120 cm.

John D. Rockefeller. The five-story Lehman house was luxuriously appointed—winding stair-cases were adorned with wrought-iron railings and at the top of all the splendor was in-stalled a large stained-glass dome, designed and crafted by Louis Comfort Tiffany. The sit-ting rooms and the dining room were decorated with marble floors and carved stone fire-places, as well as original Renaissance ceilings and other architectural details; their walls were covered with old velvets and brocades and hung with fifteenth- and sixteenth-century Flemish tapestries. The furniture and other decorations matched the expensive interiors: one room contained fifteenth-century carved cabinets from the Davanzati palace in Florence; in another, Dante chairs and an elaborately carved Italian refectory table represented the desire of the Lehmans to furnish their home in the same manner as such other prominent bankers as the Morgans, Blumenthals, or Kahns. This stately furnishing of the new house was the beginning of the collecting activity of the Lehmans. As they settled in, paintings and other objects were constantly added. First, a large portrait by Romney was acquired, then an early Rembrandt. More Renaissance furniture joined the first few pieces, and soon Flemish chan-

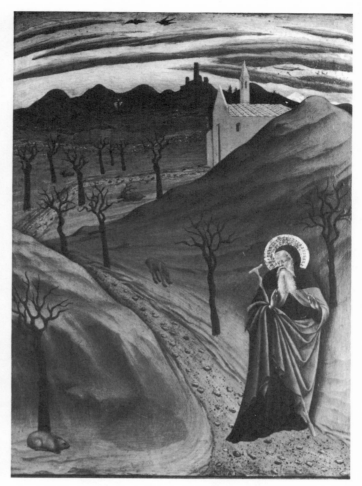

5. Paolo di Giovanni Fei. *Madonna and Child with Saints, Angels, and Eve.* Tempera on panel, 72.4 x 44.5 cm.

6. Stefano di Giovanni Sassetta. *Saint Anthony in the Wilderness.* Tempera on panel, 47.3 x 34.3 cm.

deliers, Italian bronzes, and majolica embellished the rooms. However, in 1910, with the graduation and return of their son from Yale University, collecting at 7 West 54th Street took a new turn. Philip and Carrie Lehman entrusted the acquisition of works of art for their house to Robert Lehman who at Yale had spent most of his free time among the treasures of the Jarvis Collection. Therefore, it comes as no surprise that, like most other American collectors at the turn of the century, he also followed the example of James Jackson Jarvis, pioneer collector of "Italian primitives," whose collection is now one of the prides of the Yale University Art Museum. Robert Lehman thus belongs to a distinguished group of famous American collectors, such as Mrs. Isabella Stewart Gardner in Boston, Dan Fellows Platt in Englewood, N.J., John G. Johnson in Philadelphia, Benjamin Altman and George Blumenthal in New York, who all assembled significant and sometimes very extensive collections of Italian painting. Like the others, Robert Lehman, too, was in no small way influenced by the work of Bernard Berenson. His writings were known to Robert Lehman during the Yale years, and his advice was available to the Lehmans through the firm of Duveen, the internationally

7. Giovanni di Paolo. *Expulsion of Adam and Eve from Paradise*. Tempera on panel, 45.6 x 52 cm.

8. Bernardo Daddi. *Virgin and Angels*. Tempera on panel, 107 x 136 cm.

10

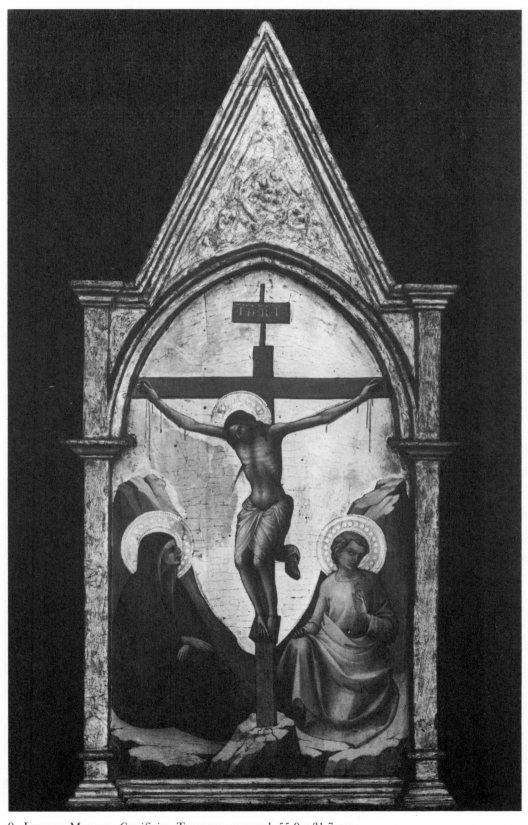

9. Lorenzo Monaco. *Crucifixion*. Tempera on panel, 55.9 x 31.7 cm.

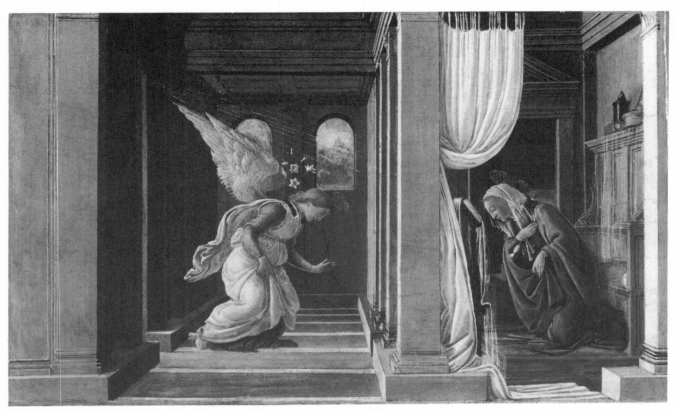

10. Sandro Botticelli. *Annunciation*. Tempera on panel, 23.9 x 36.5 cm.

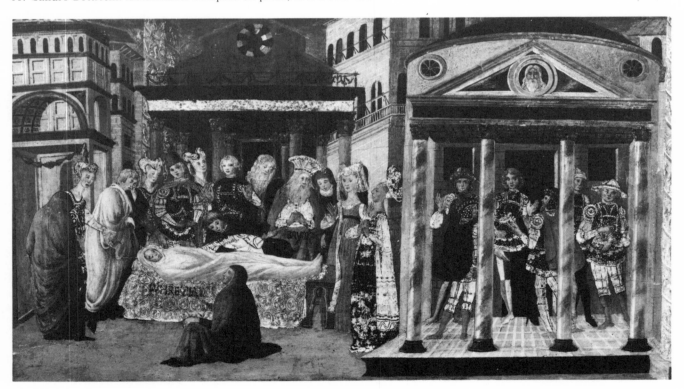

11. Florentine Master. *Story of Lucretia II*. Tempera on panel, 73.7 x 40.6 cm.

12

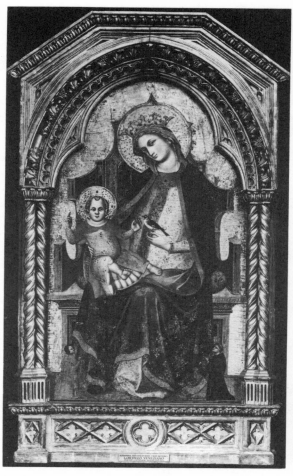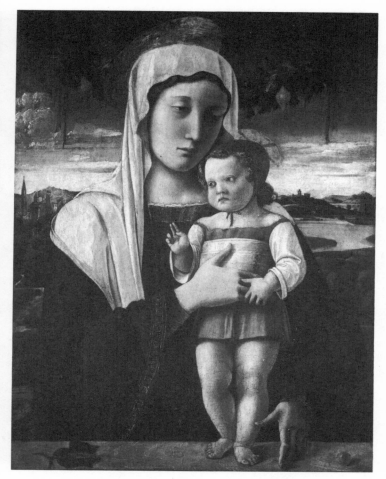

12. Lorenzo Veneziano. *Madonna and Child with Two Donors*. Tempera on panel, 108 x 64.7 cm.

13. Giovanni Bellini. *Madonna and Child*. Tempera on panel, 54.2 x 39.8 cm.

known art dealer. Robert Lehman maintained a lifelong friendship with Berenson, first as an admirer and disciple and later as a fellow connoisseur and scholar of Italian art. The several hundred letters and other documents of the Berenson-Lehman relationship in the Archives of the Robert Lehman Collection are priceless records in the history of American collecting and scholarship.

As Robert Lehman acquired a profound knowledge of Italian art, his keen business sense, honed by the extensive business activity at Lehman Brothers, guided him successfully through the pitfalls of the international art market. He quickly recognized opportunities when they arose, spotting and acquiring without hesitation unrecognized or unappreciated paintings or masters. Naturally, he enjoyed the complete confidence of his parents and, most importantly, their financial support as he plunged deeper and deeper into extensive and expensive purchases. One masterpiece after another entered the collection of the Lehmans— Dutch and Spanish paintings, precious works of the Flemish and French primitives, and, above all, panel after panel of the great masters of early Italian art, especially those of the Sienese school.

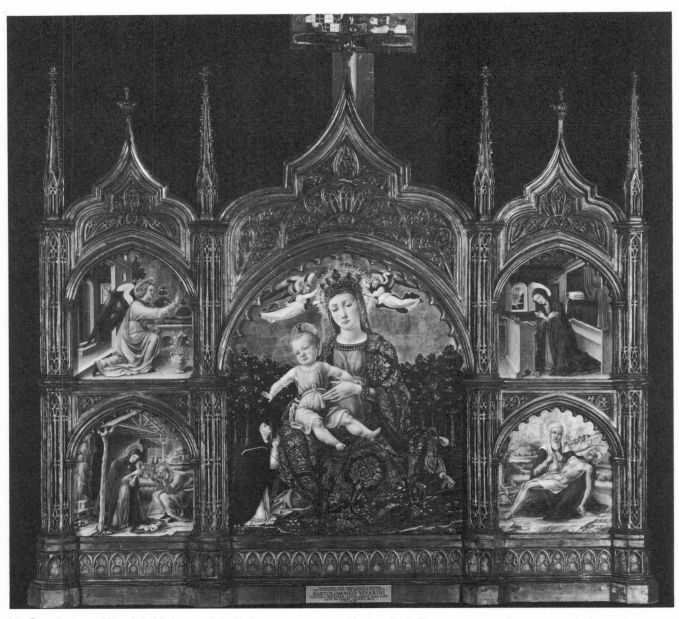

14. Bartolommeo Vivarini. *Madonna and Child, Donor, Annunciation, Nativity, Pietà*. Tempera on panel, center panel 52.5 x 45 cm.; side panels 24 x 21.5 cm.

14

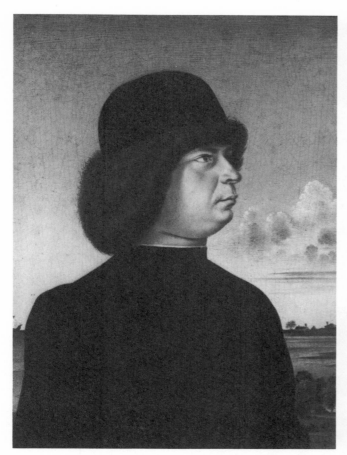 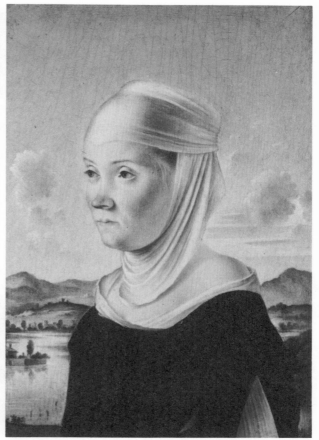

15. Jacometto Veneziano. *Alvise Contarini*. Panel, 8.3 x 7.7 cm. 16. Jacometto Veneziano. *Nun of San Secondo*. Panel, 8.3 x 7.7 cm.

The roots of this special love for the art of Siena are even deeper than the general and profound appreciation of early Italian art. Robert Lehman enjoyed the mixture of brilliant colors and the muted luxury of gold backgrounds. He also appreciated Sienese art because, as he often explained, it was initiated and supported not only by popes, kings, and princes of both religious and secular realms, but also by the wealthy bankers and merchants and other townspeople of the proud city. He also felt and understood the great pride the Sienese took in the art of their painters, sculptors, goldsmiths, embroiderers, and other artists. It was very close to his own pride in his collection and the degrees of creativity it demonstrated and encompassed. This special and sensitive appreciation of artistic genius in its various forms is also clearly manifested in his collecting of so many different types of drawings, such as preliminary sketches and designs, copies, or completely finished presentation pieces.

In the space of two decades, roughly between 1905 and 1928, Robert Lehman and his parents assembled a collection of masterpieces that abounded in outstanding Italian paintings. These were all published in 1928 in a majestic catalogue entitled *The Philip Lehman Collection* written by Robert Lehman himself. After that date, he added several significant old master

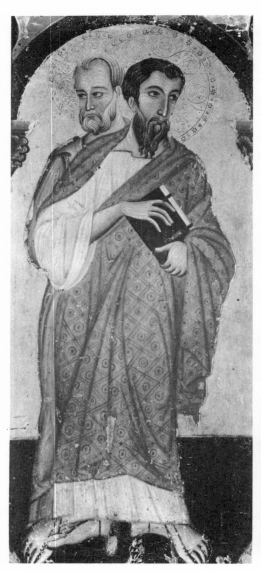

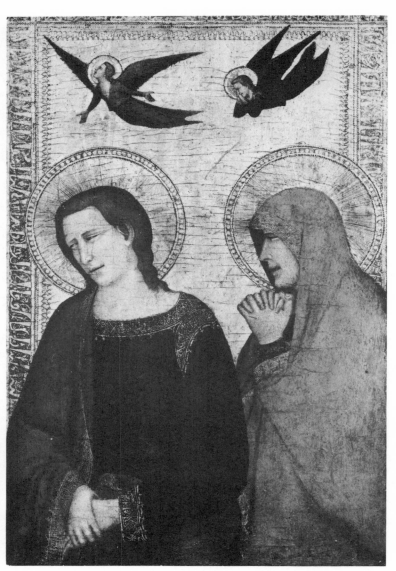

17. Master of Saint Francis of Assisi. *Saints Bartholomew and Simon.* Tempera on panel, 47.6 x 22.3 cm.

18. Roberto d'Odorisio. *Saints John and Mary Magdalene.* Tempera on panel, 58.4 x 39.7 cm.

16

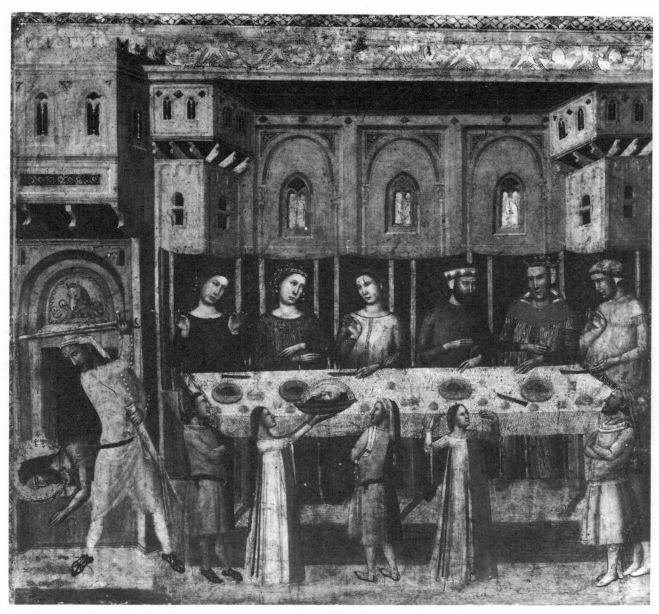

19. Master of the Life of Saint John the Baptist (Baronzio da Rimini). *Feast of Herod*. Tempera on panel, 45 x 49.5 cm.

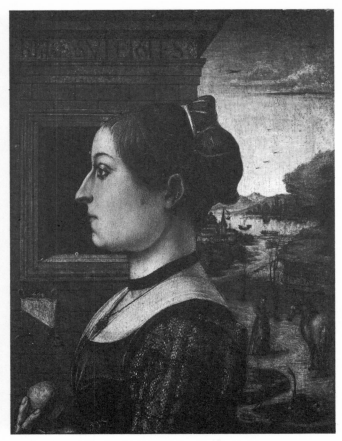

20. Lorenzo Costa. *Portrait of Alessandro di Bernardo Gozzadini.* Tempera on panel, 50.8 x 36.8 cm.

21. Lorenzo Costa. *Portrait of Donna Canonici.* Tempera on panel, 50.8 x 36.8 cm.

paintings to the Collection, but its basic character is still that which is reflected in this volume.

Robert Lehman's curiosity and interest as a collector did not stop at this point. Already in the early 1920s, as he was acquiring paintings for his parents' collection, he turned his attention toward the drawings of the old masters. His first purchases in this field were daring—a fine small drawing now attributed to Antonello da Messina, a large sheet now considered to be a unique work by Rogier van der Weyden. While he continued to purchase individual drawings, in 1924 he acquired a considerable number of sheets from the sale of the Luigi Grassi Collection and, a decade later, an important selection from the sale of Henry Oppenheimer's drawings. After World War II, he further enriched his already substantial assembly of mostly Italian drawings by acquiring some of the famous Dürer drawings from the former Lubomirski Collection and the legendary group of Rembrandts that belonged to Louis Silver of Chicago. Smaller groups were added from the Reitlinger and Skippe sales and also periodically from the firm of Colnaghi in London. Robert Lehman's last, great acquisition was the purchase of 125 Venetian drawings from Paul Wallraf in 1962. By then he owned about a thousand drawings—again, as with the paintings, mostly Italian.

However, the collection of drawings was not the single preoccupation of Robert Lehman dur-

18

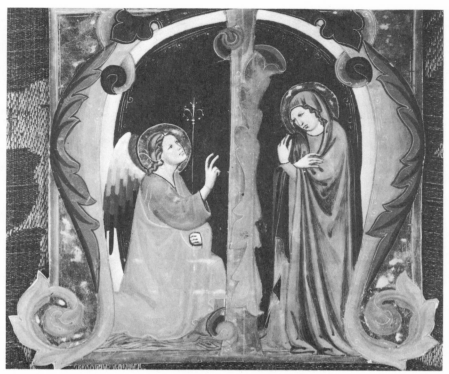

22. Sienese Master. *Initial M: Annunciation.* Vellum, 14 x 15 cm.

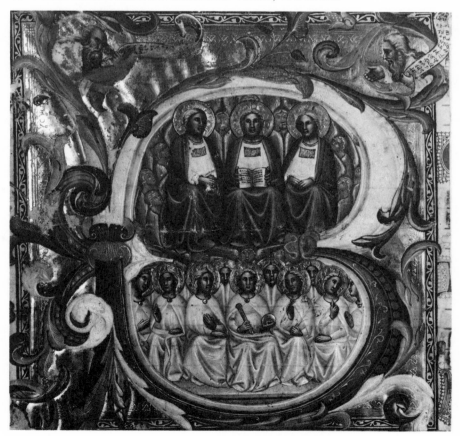

23. Bolognese Master. *Initial B: Trinity and Christ with Angels.* Vellum, 27 x 25 cm.

19

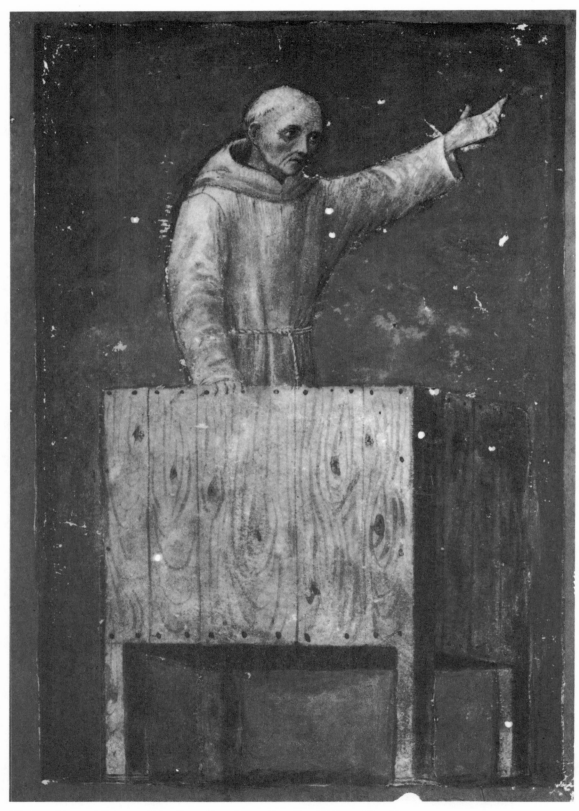

24. Vecchietta. *Miniature: Saint Bernardino of Siena Preaching*. Vellum, 21 x 14 cm.

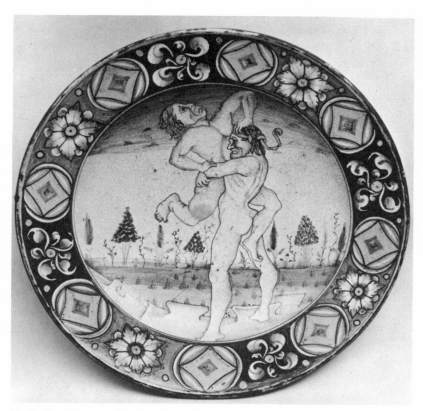

25. Italian. Deruta. *Majolica Plate: Hercules and Antaeus at Center with Border of Medallions, Flower Heads, and Scrolls.* Diameter: 43.2 cm.

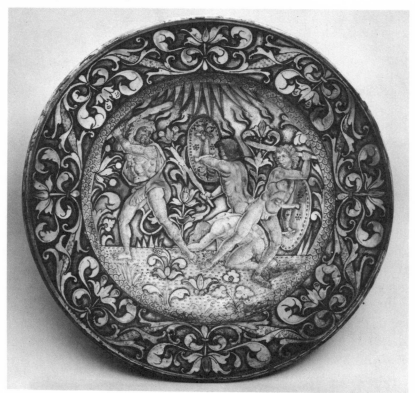

26. Italian. Deruta. *Majolica Plate: Hercules Slaying Giants at Center against a Floral Background within a Yellow Scale Border and Rim Border of Conventional Foliate Design.* Diameter: 46.3 cm.

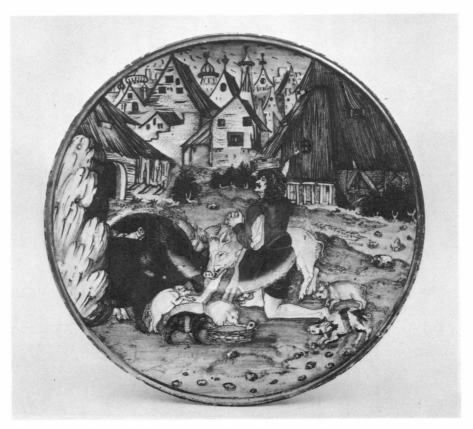

27. Maestro Giorgio Andreoli. *Majolica Plate: The Prodigal Son amid the Swine.*
Diameter: 28.6 cm.

ing the period between the two wars. With discerning eyes and an already highly refined taste, he assembled an almost unparalleled collection of Italian majolica. The nearly 200 pieces represent almost every great center of majolica and almost all their masters. Besides enjoying the brilliant colors and fiery luster of these objects, he always considered the rich designs and animated scenes on the *istoriato* (historiated) pieces as parallels and complements to his drawings. It is unfortunate that he was unable to acquire *in toto* the famous collection of Alfred Pringsheim of Munich, but he still secured its most important parts for his collection. Other famous pieces came from such well-known collections as those of Mortimer Schiff of New York, Henry Oppenheimer of London, and M. Damiron of Lyons. His interest in precious vessels was later manifested in the purchase of a highly select group of almost 100 pieces of Venetian and other early glass. These objects again had famous provenances, almost representing a *Who's Who* of glass collectors, including the Rothschilds in Paris, Pollack, Lichtenstein, and Bondy of Vienna, Gavet of Paris, Taylor and Eumorfopoulos of London, and J. P. Morgan of New York.

Although Robert Lehman had never shown a great interest in collecting sculpture, he nevertheless made an exception in the case of Medieval and Renaissance bronzes, because he appreciated their beautifully polished and engraved surfaces and the creative spirit that emanated from them. Already before World War I, he convinced his parents to purchase a

22

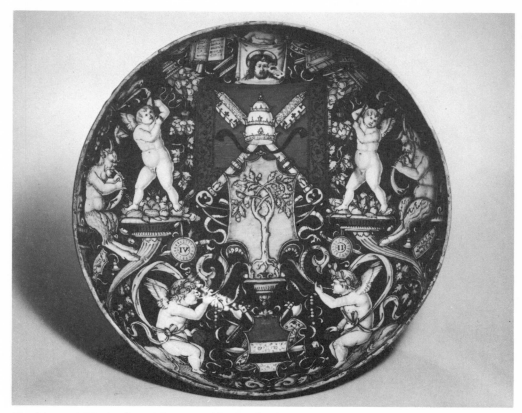

28. Giovanni Maria. Castel Durante. *Majolica Bowl: Arms of Pope Julius II and Manzoli of Bologna Surrounded by Putti, Cornucopias, Satyrs, Dolphins, Birds, etc.* Diameter: 32.4 cm.

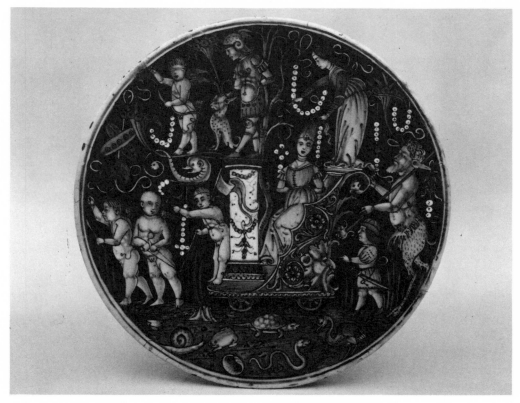

29. Italian. Castel Durante. *Majolica Roundel: Triumph of Love.* Diameter: 21.9 cm.

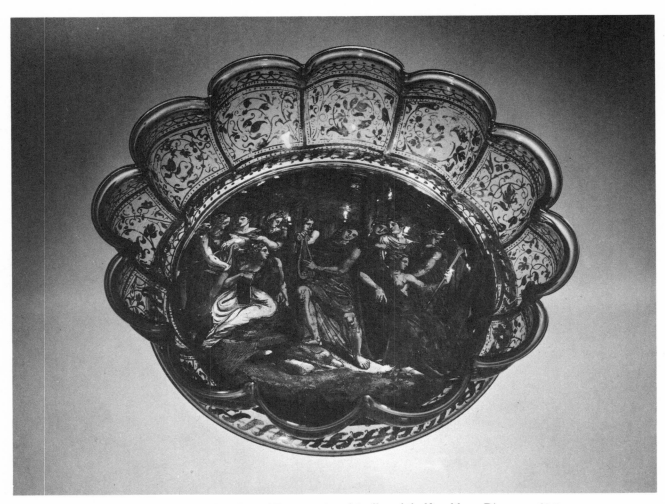

30. Venetian Master. *Glass Bowl with Cold-Painted Representation of Apollo and the Nine Muses.* Diameter: 27.7 cm.

group of Medieval aquamanilia and fifteenth-century Flemish chandeliers assembled by a dealer from the collections of Baron von Oppenheim, M. Chabrieres-Arles, and J. P. Morgan. To these now famous objects, he later added significant Renaissance small bronzes by Riccio, a large number of medals and plaquettes of the Quattrocento from the sale of Henry Oppenheimer, and larger objects, such as candlesticks and andirons, by Tiziano Aspetti. Also in the field of metalwork he gathered an exquisite group of enamels from various sources, among them, several signed works by Suzanne de Court of the Limoges School of the late sixteenth century. As he intimated many times, he was also intrigued from the early days of his collecting by the various jewels and precious objects represented in the paintings in his collection. This interest led him to collect Medieval and Renaissance jewels. From a wide variety of sources, he carefully assembled late Gothic enameled pendants, hat jewels, and later Renaissance objects such as Italian pendants composed of Baroque pearls, precious stones, and ambergris. He especially appreciated cameos and rock crystal carvings. There are several outstanding crystal cups with enameled mounts by Milanese and other Italian masters in the collection.

24

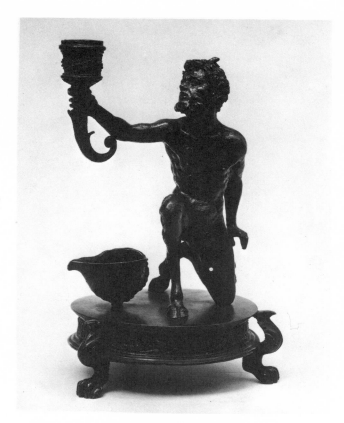

31. Il Riccio. *Kneeling Satyr*. Bronze, h. 24.8 cm.

Other fields of the decorative arts constantly attracted Robert Lehman. Around the few carved Italian furniture pieces that his parents purchased for their house, he built up a collection of cassoni, sgabellos (side chairs), tables decorated with intarsia, and gilt mirror frames. During his many European trips after World War II, he assembled an almost comprehensive collection of Italian and French picture frames, consisting of several hundred pieces. Following his mother's interest, he also collected, piece by piece, Italian, Flemish, and German embroideries of the late Middle Ages, cut and brocaded velvets, and silks. These further augmented and embellished his extraordinary assembly of Renaissance decorative arts.

Already before World War II through travels and artist friends, Robert Lehman had become interested in nineteenth- and twentieth-century French art. With great determination and occasional shrewd purchases, he assembled in the post-war years important paintings by French painters from Corot to Balthus. The crowning jewel of this period of his collecting is the *Portrait of the Princesse de Broglie* by Ingres, but there are famous canvases by the Barbizon painters and the Impressionists, such as Renoir, Pissarro, Sisley, Cézanne, and Degas. From among the Post-Impressionists he preferred Vuillard and Bonnard, the Pointillists, the Fauves, especially Vlaminck and Marquet, and Matisse. With special delight and a wide range, he also gathered the drawings of these schools; thus the collection abounds with sheets by Ingres, Harpignies, Daumier, Guys, Signac, and Villon.

Until a certain point the richness and variety of Robert Lehman's Collection was known only

25

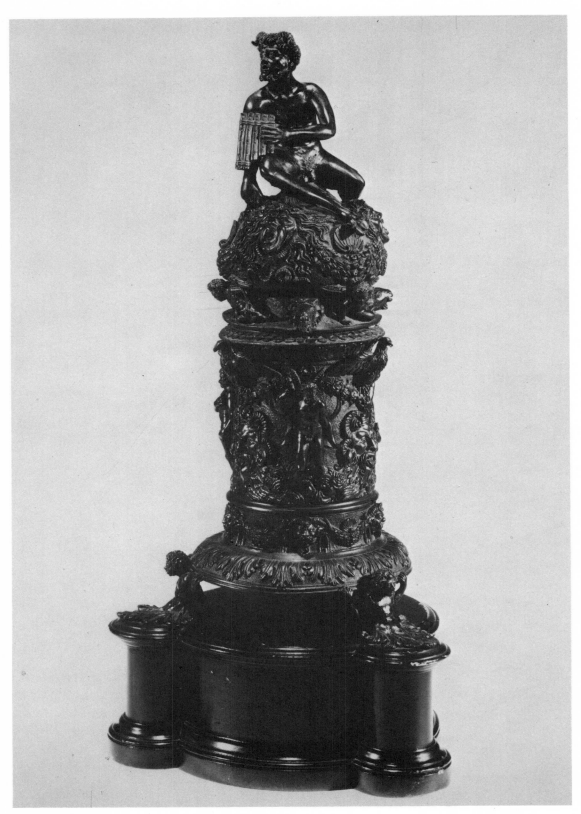

32. Il Riccio. *Incense Burner with the Figure of a Faun.* Bronze, h. 51 cm.

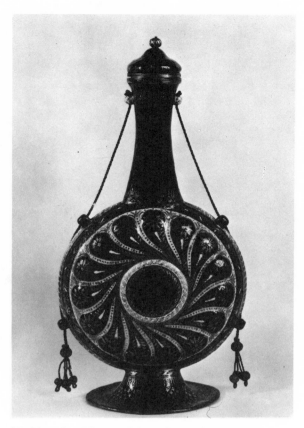

33. Venetian Master. *Pilgrim Bottle*. Painted enamel on copper, h. 33 cm.

to close friends and specialists in the museum and scholarly world. In the 1950s, after the death of his parents, he kept large parts of it, mostly the old master paintings and the decorative arts, in the family house at 7 West 54th Street. The later paintings, French furniture and porcelain, and the jewelry, together with some of the drawings were displayed in his large apartment to the delight of his family and friends. At this time, Robert Lehman, the authoritative and powerful head of Lehman Brothers, advisor to Presidents, was already a trustee and vice-president of the Metropolitan Museum of Art, chairman of the Institute of Fine Arts of New York University, and a well-known connoisseur and patron of the arts. As his collection grew, he began to feel a responsibility to share it not only with the scholarly and art communities, but also with the public. Already in 1954, a selection from his Collection was shown in a few galleries of the Metropolitan Museum to the acclaim of the critics and the New York public. Encouraged by this reaction, he accepted with great delight and pride in 1956 the invitation from the French Government and the Louvre to exhibit the treasures of his Collection at the Orangerie of the Louvre, an honor that was never bestowed on any collector before, nor since. In an unprecedented and generous manner, he lent almost 300 of the most important and precious objects for this exhibition. Besides fifty or more fragile panel paintings, including the Giovanni di Paolos, the Petrus Christus, and the portrait by the Maître de Moulins, sixty drawings, a considerable number of manuscript illuminations, bronzes, jewelry, and majolica were transported to Paris in specially appointed luxury

27

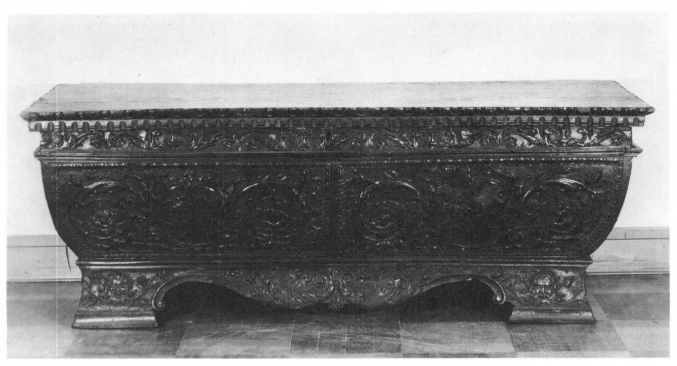

34. Venetian Master. *Cassone with Carved Ornamental Decoration.* Wood, 1. 64.7 cm.

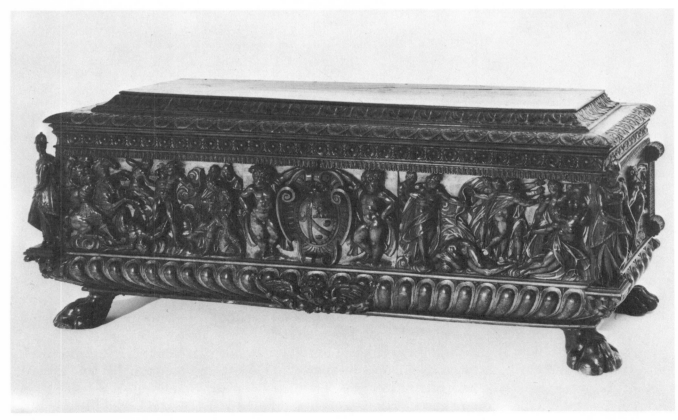

35. Roman Master. *Cassone with Carved Figural Decoration and Arms.* Wood, 1. 73.7 cm.

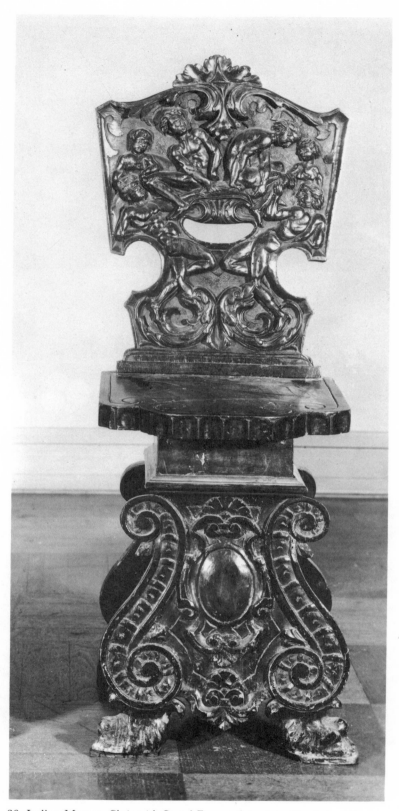

36. Italian Master. *Chair with Carved Figures of Acrobats*. Wood, h. 105 cm.

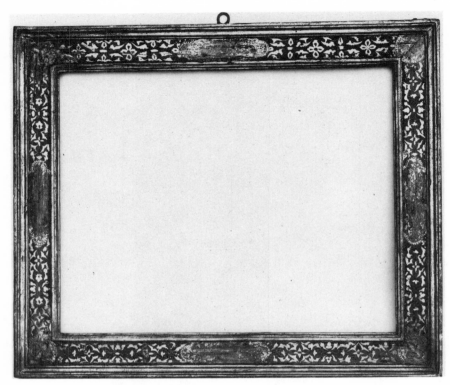

37. Florentine Master. *Picture Frame with Stenciled and Punched Decoration.* Wood, gesso, and gold leaf. 73 x 87 cm.

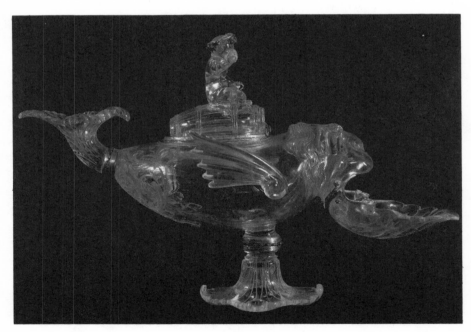

38. Milanese Master. *Cup in Shape of a Marine Monster with the Infant Bacchus on Its Back,* h. 19 cm., l. 30.5 cm.

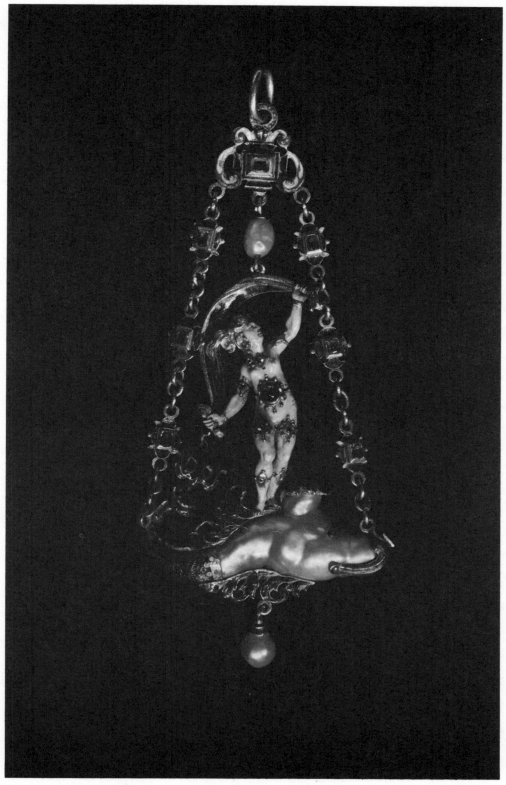

39. Venetian Master. *Jewel in Shape of Venus Marina on a Dolphin.* Baroque pearl gold enameled, and mounted precious stones, h. 7.5 cm.

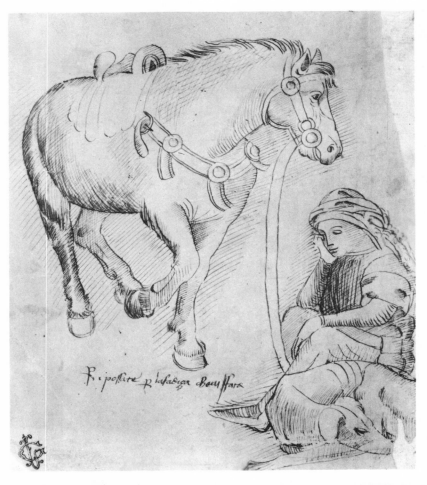

40. Veronese Artist. *A Nobleman with His Horse and Dog.* Pen and ink on paper, 25.4 x 20.3 cm.

41. Venetian Artist. *Design for an Altarpiece with the Madonna della Misericordia.* Pen and ink with traces of wash on paper, 13.8 x 26.4 cm.

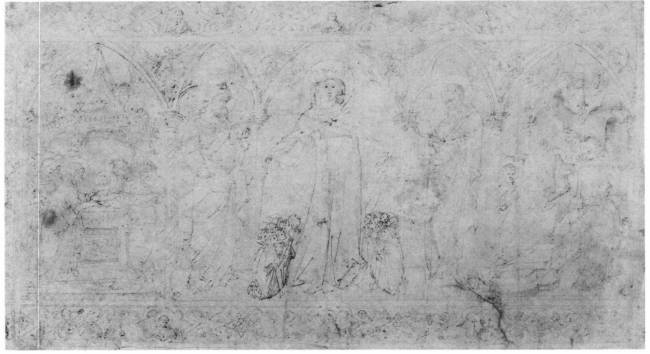

32

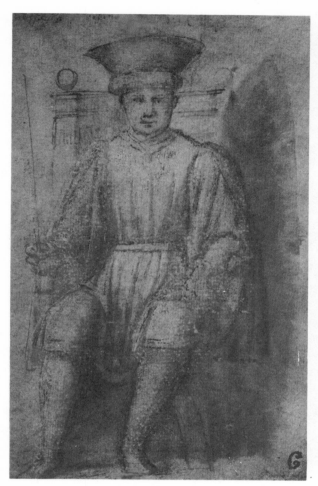 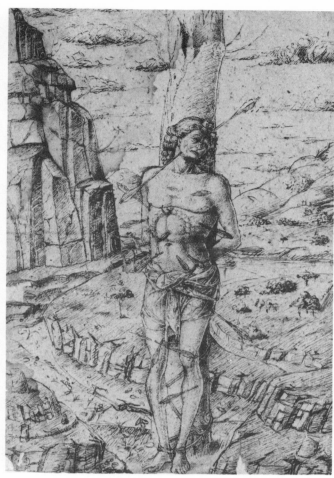

42. Piero della Francesca. *Man Seated on a Throne*. Pen and brown ink, with brown wash on prepared paper, 19 x 12 cm.

43. Ercole de' Roberti. *Saint Sebastian*. Pen and brown ink on prepared paper, 30.2 x 21 cm.

cabins of ocean liners. To re-create the atmosphere of the Lehman house at the Orangerie, large Italian cassoni and other furniture pieces and Flemish tapestries from the Collection were added to this already extraordinary selection.

After the 1956–57 Orangerie exhibition of his Collection and the acclaim it received both abroad and at home, Robert Lehman made an equally unprecedented gesture. He lent an even larger selection—588 objects—to the Cincinnati Art Museum in 1959. There in middle America, for two months his treasures were again admired by the public, many of whom had traveled from far-away cities to see this assembly of famed works of art that included even the most fragile Venetian glass, eighteenth-century snuffboxes, and jewelry.

After the triumph of these exhibitions, Robert Lehman decided to share his treasures with the public on a more permanent basis. Between 1960 and 1962, the family house at 7 West 54th Street was completely redecorated and refurbished; air-conditioning and security

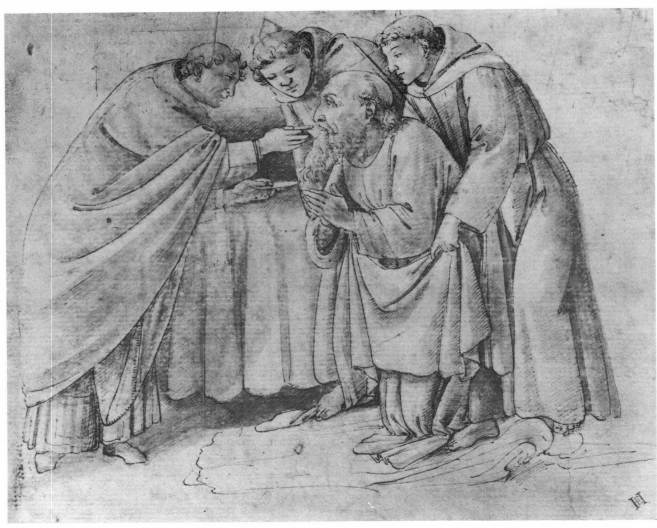

44. Florentine Artist from the School of Sandro Botticelli. *The Last Communion of Saint Jerome*. Pen and ink on paper, 15.9 x 19.7 cm.

arrangements were installed to provide safe and secure conditions, and thus the house was turned into a private museum. The most representative selection of every group and section in the Collection was hung and installed in the rooms of the house from the first to the fifth floor. Every available space, even former wardrobes and passageways, was transformed into exhibition areas. The rooms on the fifth floor were devoted entirely to drawings; several hundred, sometimes framed in old, original frames, hung on every wall almost from the floor to the ceiling. Still, the entire sixth floor had to be equipped to store the several hundred objects that could not be exhibited. Collectors, museum curators and scholars, friends and business acquaintances visited the Lehman house in a steady flow. Groups of graduate students from American universities and from abroad were allowed to study the various objects of the Collection. Between 1962 and 1969, more than 100,000 visitors were led through the rooms and enjoyed Mr. Lehman's hospitality. In 1963, to ensure the proper administration of the Lehman house and the preservation of the objects, and to organize the schedule of visitors, this writer was appointed Curator of the Lehman Collection by Robert Lehman and entrusted with arranging the entire Collection (including all the works of art in his apartment and in storage) on a professional basis and operating it as a private museum. Full documentation on the objects was assembled, photographs and information for inquiries of all kinds were provided on a regular basis. In accordance with the generosity Robert Lehman expressed by the two big loan exhibitions, more and more objects were lent to museums and exhibitions. Even in the Lehman house, special showings of drawings were organized to reveal the wealth of the Collection and to make it available to a wider public.

Robert Lehman died in 1969 and it was his wish that The Robert Lehman Foundation, Inc., to which the whole Collection was willed, should donate it to the Metropolitan Museum of Art as soon as it could be installed in the special wing the museum had promised to build for it. The new Lehman Wing of the Metropolitan Museum opened in 1975, and it functions now as an integrated curatorial department with its own staff, library, and exhibitions, fully maintained from funds provided by the Robert Lehman Foundation. A considerable part of the Collection is exhibited permanently in the galleries of the main floor of the Lehman Wing, the old master paintings and selections from the decorative arts provided with an ambiance similar to that of the rooms in the old Lehman house. The nineteenth- and twentieth-century French paintings are shown in chronological order in the so-called Grand Gallery that surrounds the central courtyard of the Lehman Wing. On the ground floor, special galleries are provided for changing exhibitions of drawings and the decorative arts.

The Collection has a very active exhibition program. Between 1975 and 1982, fourteen exhibitions of drawings from the Robert Lehman Collection were presented, most accompanied by fully illustrated catalogues. This rich material is shared with a wider public in other ways. In the spirit of the founder's generosity, the curator and the staff of the Collection have organized several loan exhibitions during the past years. One of them, a rich selection of objects of art, drawings, and textiles, was shown at the Museum of Western Art in Tokyo in 1976 under the title *Renaissance Decorative Arts from the Robert Lehman Collection*. The 130 objects comprised the first exhibition of this kind ever held in Japan and were greatly admired by the public. Another show, of eighteenth-century Venetian drawings, is presently circulating among several university museums in New York State, not only providing a unique aesthetic experience, but also serving as a valuable tool for the teaching of art history and connoisseurship. An interesting exhibition of forty-four individually framed pages from a complete sketchbook by the American Impressionist Maurice Prendergast has been

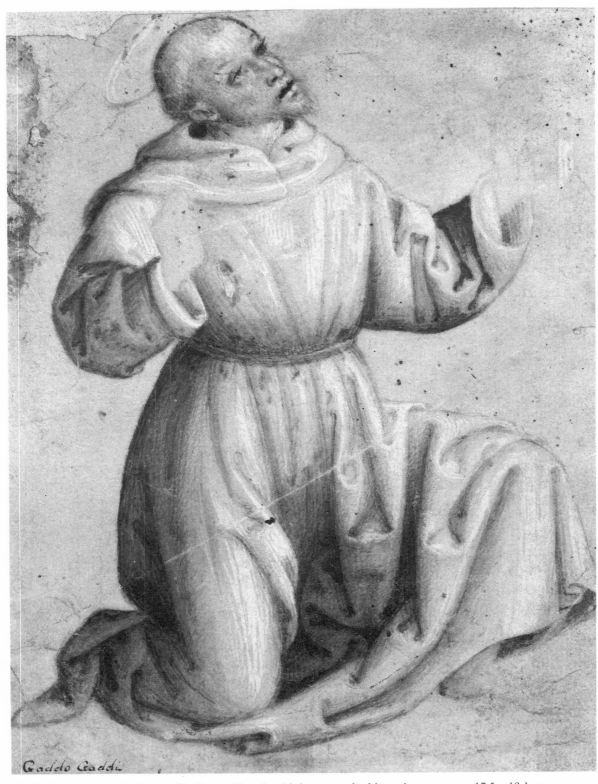

Gaddo Gaddi

45. Umbrian Artist. *St. Francis (?)*. Point of brush with brown and white paint on paper, 17.5 x 13.1 cm.

36

46. Bartolommeo Vivarini. *Madonna and Child with Saint John.* Pen and ink and wash on paper, 20.3 x 14.6 cm.

47. Francesco Morone. *Saint Paul.* Point of brush with white highlights on paper, 26.3 x 10.5 cm.

48. Pietro Perugino. *Head of a Man*. Black chalk on paper, 22.5 x 15 cm.

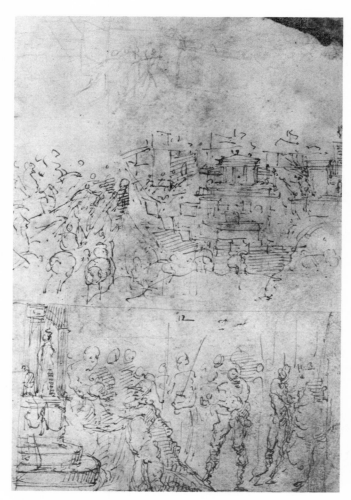

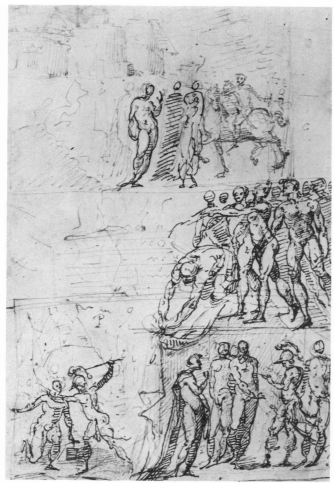

49. Domenico Beccafumi. *Two Episodes from the Life of Esther (?)*. Pen and ink over black chalk on paper, 22 x 14.7 cm.

50. Domenico Beccafumi. *Three Studies*. Pen and ink over black chalk on paper, 22 x 14.7 cm.

acclaimed in museums in Oklahoma City and Memphis, Tenn. In addition, smaller groups or individual paintings and objects are lent to museums around the world, since there is no special restriction on such loans.

The rich holdings and other resources of the Robert Lehman Collection also provide a basis for graduate teaching. Since 1975, ten courses and seminars on various aspects of the history of art have been conducted in the Collection's seminar room based on original works of art in the Collection and in the Metropolitan Museum. Their titles indicate the range of the Collection, *Sienese Art of the Trecento and the Quattrocento, Italian Drawings of the Fifteenth and Sixteenth Centuries, Renaissance Decorative Arts*.

Thus, as Robert Lehman wished, his great assembly of works of art has been fully metamorphosed from a private collection into a public museum for the enjoyment of all.

39

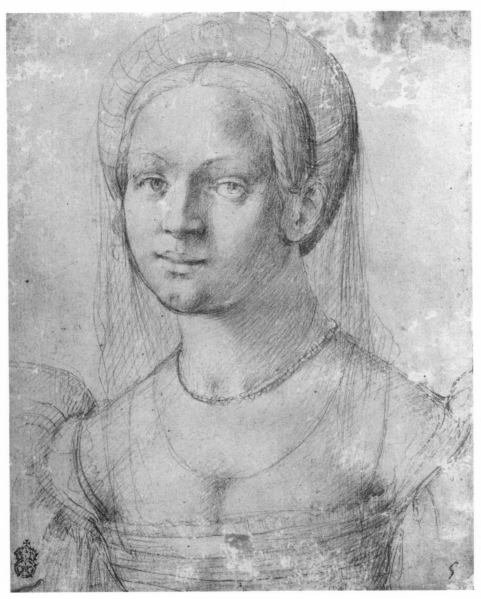

51. School of Pontormo. *Portrait of a Lady*. Silverpoint and red chalk on gray prepared paper, 17.2 x 13 cm.

II

As the preceding pages indicate, the history of Robert Lehman's collecting was permeated by his love, understanding, and thorough fascination with every aspect of Italian art. This emanates from the great variety and intimate beauty of the objects he acquired, but it is enunciated clearly in the catalogue of paintings that he compiled in 1928 with profound care and considerable insight and scholarship. He prepared copious notes on the provenance of every painting and thoughtfully appraised the opinions of earlier scholars, most notably the written expertises by great connoisseurs which were the *sine qua non* for the sale or acquisition of a great painting during the first decades of the century. Later he continued this practice in handwritten remarks, sometimes jotted down in the margins of scholarly publications or arti-

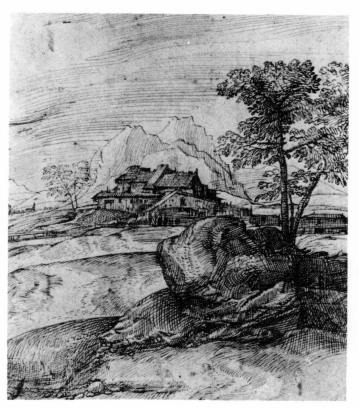

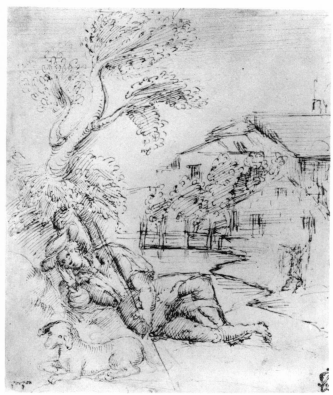

52. Domenico Campagnola. *Landscape with a Rock and Buildings*. Pen and brown ink on paper, 17.3 x 14.8 cm.

53. Venetian Artist. *Shepherd Sleeping or Resting under a Tree*. Pen and ink, traces of black chalk on paper, 25.3 x 20.2 cm.

cles, or on the pages of sale catalogues. His notes are mainly devoted to information about his own objects or others related to them. Often some of these opinions were quoted in the various exhibition catalogues, but some are still in the archives of the Collection. In his last years he spent long hours among his treasures in the house at 7 West 54th Street, improving the hanging, suggesting changes in the framing or arrangement of new acquisitions. During these "workings" hours he would mention unknown or unrecorded facts about many of the objects, reminisced on the circumstances of their acquisition, and often expressed his views on the attributions. But the most revealing aspect of these visits were his thoughts about the relationship between the various works of art in his Collection. As most often these ideas were centered around the Italian paintings and the decorative arts, it seems fitting, and historically accurate, to provide a brief survey of these parts of the Collection as a preamble to the discussion of the Italian drawings.

The art of Siena is the most richly represented among the paintings of the Lehman Collection. The approximately 100 large and small panels constitute a unique vista of Sienese painting from the beginning of the fourteenth century until the end of the fifteenth. There is a rich variety of images on these panels, some of which had once been parts of larger compositions, while others had always served as single devotional objects. The little diptych by a close follower of Duccio from around 1320 (figure 1) intimately reflects the greatness of the master's *Maestà*. The lines and patterns resembling the thin metal bands of cloisonné enamels and the elegantly draped robes also provide a glimpse of various trends in later

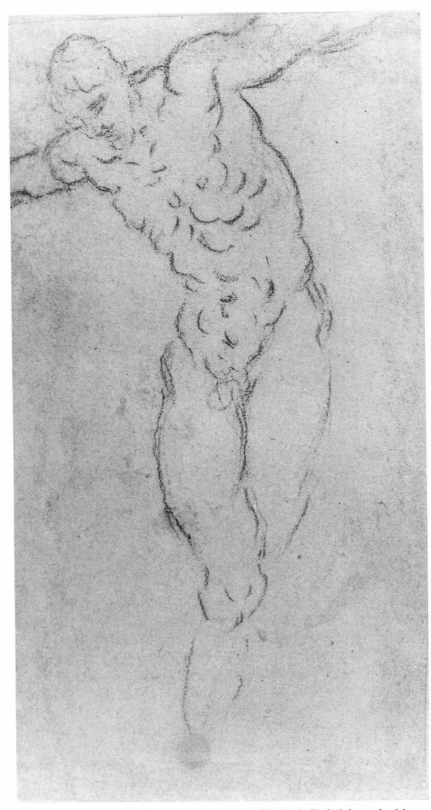

54. Tintoretto. *Figure of Christ for a Crucifixion*. Black chalk, heightened with white paint on blue paper, 32 x 16.7 cm.

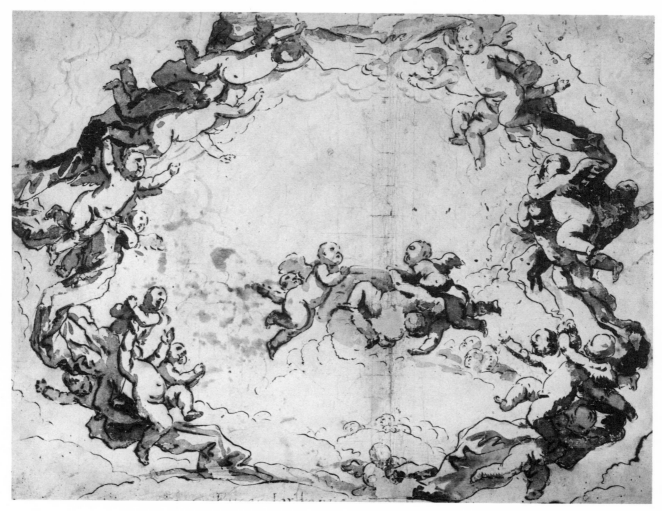

55. Luca Giordano. *Angels*. Sepia, pen and wash on paper, 38.1 x 48.3 cm.

Sienese drawings, similar to those reproduced on Plates 1 and 2. The colorful *Last Supper* by Ugolino da Nerio (figure 2) belonged to the predella of the painter's famous altarpiece of Santa Croce dating from around 1321. To Robert Lehman it was a fascinating painting in other respects too. He was intrigued by the variety of poses and gestures of the apostles and by the inventive and different punched patterns of their halos. The details of the rather everyday interior and of the little utensils strewn around the table amused him and reminded him of the later, more sumptuous tableware that he possessed in the form of majolica and glass. The *Adoration of the Magi* (figure 3), a panel that was part of the so-called Avignon Altarpiece, is now considered to have been painted around 1345 by a French painter. With sensitive appreciation and great insight Robert Lehman described this painting in his 1928 catalogue as follows: "The deep blue mantle of the Madonna is contrasted with the rich brocaded robes of old gold which adorn the Magi and the Angels. The three diminutive Moorish attendants wear delicate colors of white, yellow, and pink. The flesh tones have a patina of old ivory, in harmony with the mellow tone of the whole picture. The pink architecture in

43

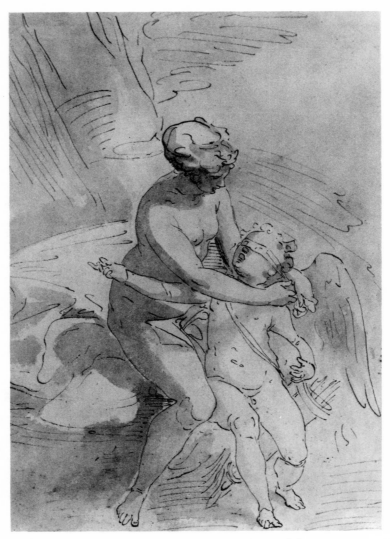

56. Luca Cambiaso. *Venus and Cupid*. Pen and brown ink on paper,
30.5 x 21 cm.

its original scale, is reminiscent of the Persian miniaturists. . . . The Master was perhaps
some French miniaturist who came under the direct influence of Simone Martini while he
worked in Avignon." It might be added that Lehman never failed to point out not only the
minute size of the three attendants, but also the exquisite brush-drawing-like quality and
modeling of their robes. No wonder, then, that he was equally delighted by Bartolo di Fre-
di's *Adoration* from around 1380 (figure 4). Here he always noted the vivid colors and the
genre-like inclusion of the full-size attendants and the three horses. Their facial expressions
as they direct their gaze toward the holy family and the adoring magi, elevate them among
the main participants of the reverent scene. While looking at the *Madonna and Child with
Saints, Angels, and Eve* by Paolo di Giovanni Fei (figure 5), Robert Lehman could dwell on its
details for a long time. He admired the perfect harmony and symbiosis of the figures, the
unity of the painted panel and its ornamented and gem-studded original frame, both created

44

57. Canaletto. *Architectural Study*. Pen and ink on paper, 20 x 14 cm.

by the artist. But most of all he enjoyed the curious dichotomy of the iconography. Indeed, the upper half, with the choir of singing angels and elegant saints with their attributes surrounding the enthroned Virgin, is in the standard vein of late-fourteenth-century Sienese painting; but the lower section of the panel, in almost shocking contrast, is occupied by the recumbent figure of Eve. She is clad in a revealing, transparent garment and even more suggestive furred robe. The instrusion of such a secular figure in the disguise of Eve was observed by Robert Lehman as an early example and significant predecessor to the varied female nude figures among his drawings. *Saint Anthony in the Wilderness* by Sassetta (figure 6), with its lineal patterns and far-reaching fields and mountains, was for him very close to early landscape drawings and manuscript illuminations, in spite of the eery and overpowering combination of grays and pinks in its color scheme. Giovanni di Paolo, the last great master of the Italian International Gothic, is well represented in the Lehman Collection by ten

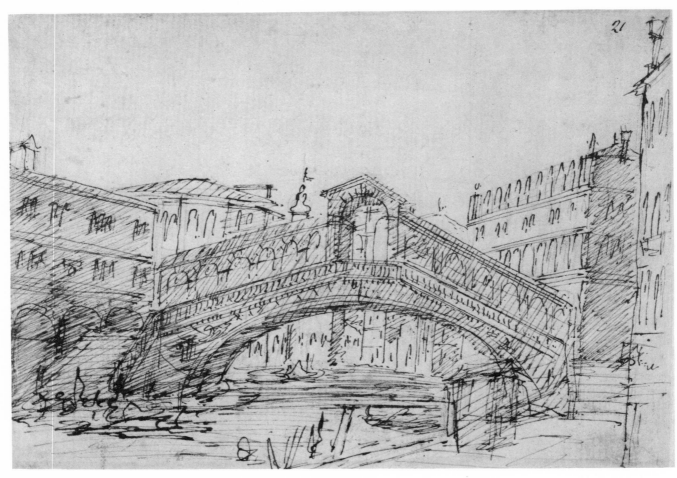

58. Canaletto. *View of the Rialto Bridge*. Pen and ink on paper, 14 x 20 cm.

panels. The *Expulsion of Adam and Eve from Paradise* (figure 7) is probably the most famous. The startling contrast between the strictly geometric, concentric patterns of the universe created by God and the flamboyantly elegant horizontals of the trees and the nude figures of Adam, Eve, and the expelling angel was much admired by Robert Lehman.

Florence and her art did not exert such a great influence over him as Siena. Still, he enjoyed the poetic spirit and new ideas of the Florentines in several outstanding paintings he owned. From among the early ones the *Virgin and Angels* (figure 8) attributed to Bernardo Daddi or to one of his followers was a favorite. The *Crucifixion* by Lorenzo Monaco (figure 9) held special interest for Robert Lehman. The powerful design and linear elaboration demonstrated to him the Sienese origins of the painter, while the facial expressions and delicate modeling recalled the artist's Florentine schooling and his activity as a manuscript illuminator. But most of all, it reminded him of his student days at Yale's Jarvis Collection, which has an extremely similar *Crucifixion* by Lorenzo. From the Quattrocento the late *Annunciation* by Sandro Botticelli (figure 10) was one of the paintings most beloved by Robert Lehman.

46

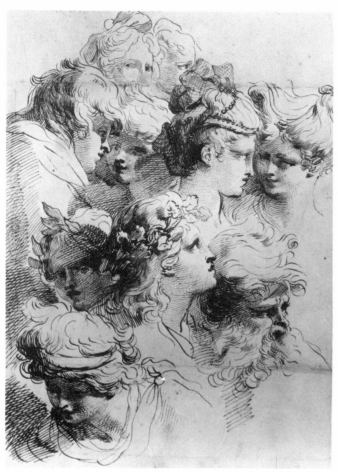

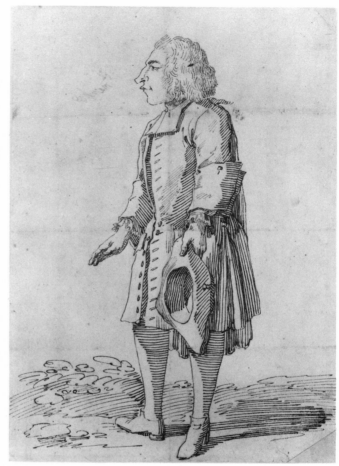

59. Gaetano Gandolfi. *Studies of Classical Heads*. Pen and ink on paper, 28.6 x 20 cm.

60. Pier Leone Ghezzi. *The Polish Count Onajchi*. Pen and ink on paper, 31.4 x 21.3 cm.

He often mused about the tranquillity of the setting, the exquisitely drawn and painted figures, and the subtle artistic devices that combine all these elements into a unified composition. As others, he also fully recognized and appreciated the artist's brilliant handling of the lines of the interior and the light, and his creation of an intricate interplay of triangular patterns. The two panels representing scenes from the story of Lucretia (figure 11) are the sole representatives of a popular Florentine art form, the painted chest or cassone. Robert Lehman once explained that he never acquired more of these sometimes pedestrian paintings, because he preferred the high quality and craftsmanship of the carved wooden chests, of which he gathered twelve outstanding examples.

The art of Venice always held a special attraction for the Lehmans, and Robert himself was greatly fascinated by the splendor and majesty of her vitality and art, and by the Oriental mystery that permeated it. During his collecting he amassed an extraordinary variety of Venetian art, including panel paintings, drawings, bronzes, glass, furniture, and textiles. The commingling of East and West was especially evident in one of his earliest acquisitions, the

47

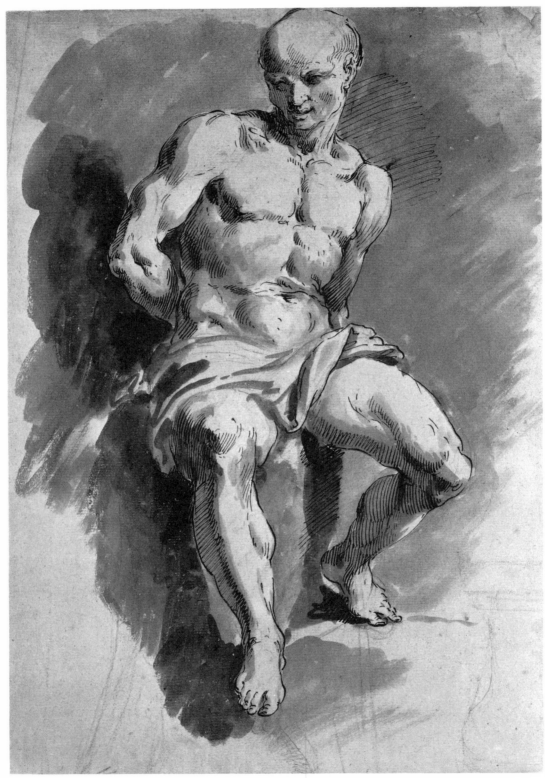

61. Pietro Antonio Novelli. *Study of a Seated Slave*. Pen and ink with sepia wash and white highlights on brown paper, 46 x 31 cm.

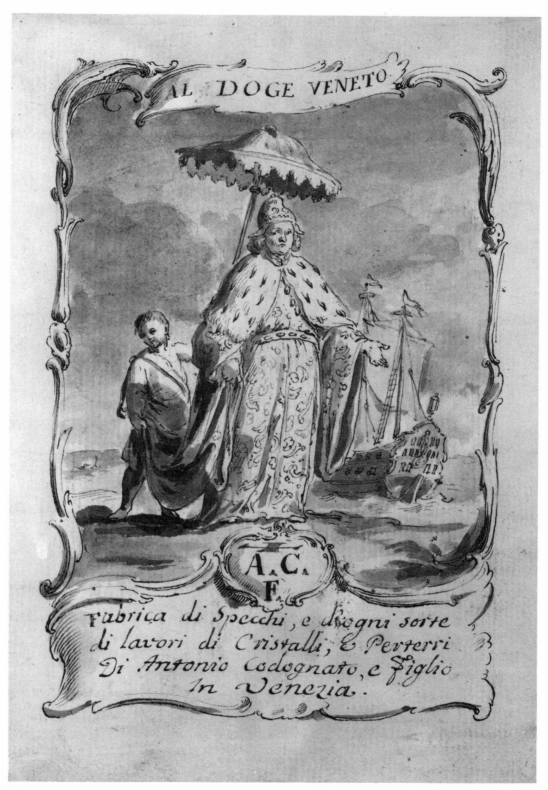

62. Pietro Antonio Novelli. *Study for the Sign of a Venetian Mirror Factory*. Pen and ink with sepia wash on paper, 22.5 x 15.5 cm.

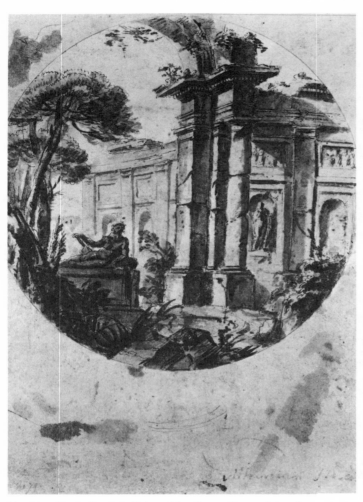

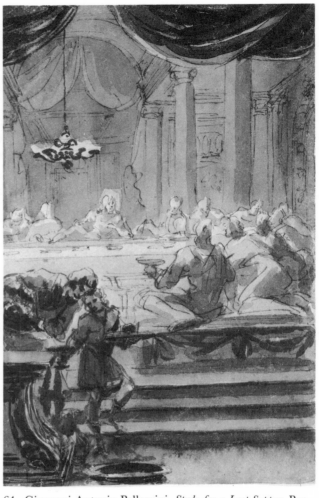

63. Gian Paolo Panini. *Ruins with a Statue*. Pen and brush with tinted washes in tondo form on paper, 26.2 x 18.4 cm.

64. Giovanni Antonio Pellegrini. *Study for a Last Supper*. Pen and ink with sepia and bister washes on paper, 27.1 x 16.9 cm.

imposing panel with the Madonna and Child by Lorenzo Veneziano (figure 12). The sumptuously patterned and decorated garments, embellished with glittering jewels, provided the first impetus for him to secure more and more of the artistic products of the Queen of the Adriatic. Giovanni Bellini's *Madonna and Child* of around 1460 (figure 13) is a deeply emotional re-interpretation of the revered image. Here, instead of the enthroned Queen of Heaven, a humanized mother and child share a serenity and stillness that is enhanced by the landscape in the background. This poetic depiction of nature was recognized by Robert Lehman in many of his later Venetian landscape drawings. Bartolommeo Vivarini's polyptych of around 1465 (figure 14), with its elaborate frame—probably a copy of the original—is closely related to an earlier rare drawing also in the Collection, representing a design for an altarpiece with the Madonna della Misericordia (figure 41). The figures, and their sculptural qualities, are also very close to a drawing by Vivarini himself that was among Robert Lehman's earliest acquisitions (figure 46). The pair of small, delicate portraits of Alvise Contarini and a nun of San Secondo (figures 15, 16) by Jacometto Veneziano display another im-

50

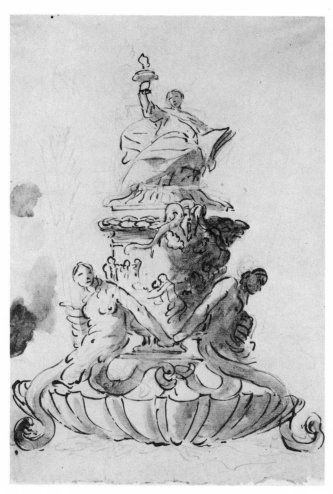

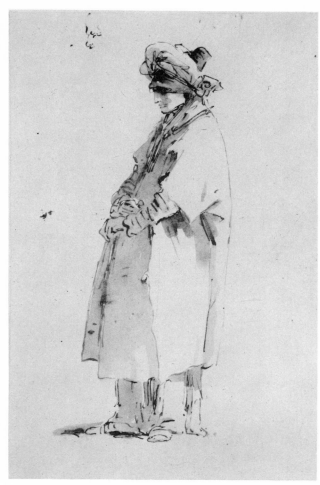

65. Giambattista Tiepolo. *Study of an Inkwell*. Pen and ink with gray wash over preliminary pencil drawing on paper, 45 x 29.5 cm.

66. Giambattista Tiepolo. *Study of a Standing Oriental Figure*. Pen and ink with sepia wash over pencil on paper, 22.8 x 14.2 cm.

portant characteristic of Venetian art that resulted from the influence of humanistic ideas and philosophy. Here the artist explored the human character with unerring eye and depicted it with a brilliant technique. Unfortunately there is no Venetian portrait drawing in the Lehman Collection that can match their quality.

Paintings from the other great centers of Italian art were also eagerly collected by Robert Lehman. The Master of Saint Francis of Assisi painted between 1270 and 1280 the small fragment representing Saints Bartholomew and Simon (figure 17). Their stoic and static figures are in great contrast to the muted grief and sorrow that are depicted by the Neapolitan Roberto d'Odorisio on the panel with Saints John and Mary Magdalene of around 1350 (figure 18). The beautiful and rhythmic quality of the pseudo-Kufic characters that surround the image was also remarked on by Robert Lehman, as it reminded him of the repeating, calligraphic patterns in drawings.

The *Feast of Herod* ascribed to Baronzio da Rimini (figure 19) is filled with precious details of courtly life, love, and tragic death. Although the composition is similar to that of Ugolino's

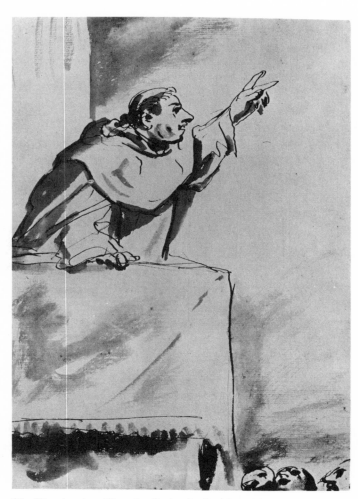

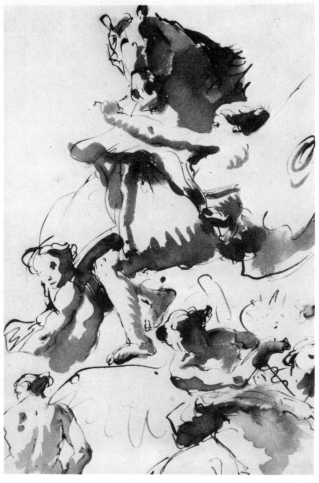

67. Giambattista Tiepolo. *Study of a Preaching Monk*. Pen and ink with brown wash on paper, 27.3 x 19.3 cm.

68. Giambattista Tiepolo. *Zephyr and a Horse*. Pen and ink with gray wash over pencil, 31.5 x 20.1 cm.

Last Supper (figure 2), the ambiance is more luxurious and elaborate. The depiction of the rich costumes, the fancy headdresses, and the palace interior is very close in spirit to some later drawings in the Collection, especially to those by the early Veronese masters. The portraits of Alessandro Gozzadini and his wife Donna Canonici (figures 20, 21), variously attributed to Francesco Cossa (c. 1435–1477) or to Lorenzo Costa (1460–1535), are rare examples of the Renaissance double portrait. Robert Lehman enjoyed their originality and details, and as scholarly research revealed the meanings of the elaborate love and marriage symbolism, his appreciation continued to grow. The allegorical figures of the pelican, the falconer, the young lady wooing the unicorn, and the symbolism of the rabbits playing around the tree stump with a new branch growing out of it always reminded him of his famous drawing *Venus Embracing Cupid at the Forge of Vulcan* which is attributed to Francesco Cossa (plate 11). He also fully understood the meaning and philosophy expressed by the inscription that runs on the frieze of the building that constitutes the background for the portraits: VT SIT NOSTRA FORMA SVPERSTES (So that our image may survive). He knew well that his own portrait would survive in his "images."

52

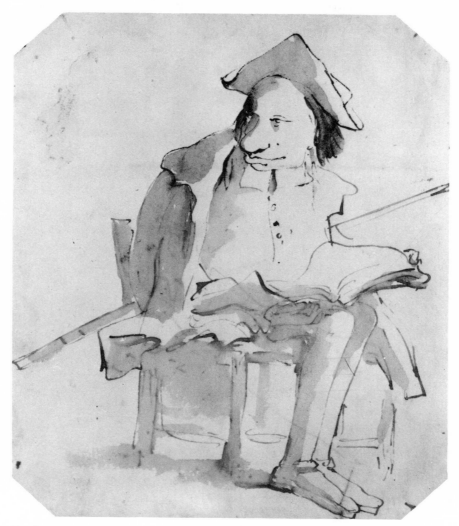

69. Giambattista Tiepolo. *Caricature of a Seated Small Man.* Pen and ink with sepia
wash over pencil on paper, 16.5 x 13.7 cm.

During his travels in Italy, Robert Lehman collected illuminated manuscript pages and cut
miniatures as supplements to his paintings. Most of them are by unknown masters but still
reflect the styles of great painters in the great artistic centers. The letter M with the *Annun-
ciation* (figure 22) is by a Sienese illuminator of the fourteenth century who was a close fol-
lower of the Lorenzettis. Another illuminated initial, which encloses in a letter B the Trinity
and Christ with angels (figure 23), is the work of a Bolognese painter from between 1340 and
1350. The freshness of the color and the immediacy of the gesturing saint as he exhorts the
invisible crowd in the small *Saint Bernardino of Siena Preaching* by Lorenzo di Pietro, called
Vecchietta (figure 24), led Robert Lehman to share the opinion of some scholars which sug-
gests that this little picture might have been painted on the scene during one of the famous
sermons of Saint Bernardino on the Piazza del Campo of Siena in 1450.
Among the treasures of the decorative arts there is one group that Robert Lehman always
related to the drawings: the Italian majolica. Although he admired the variety of their colors

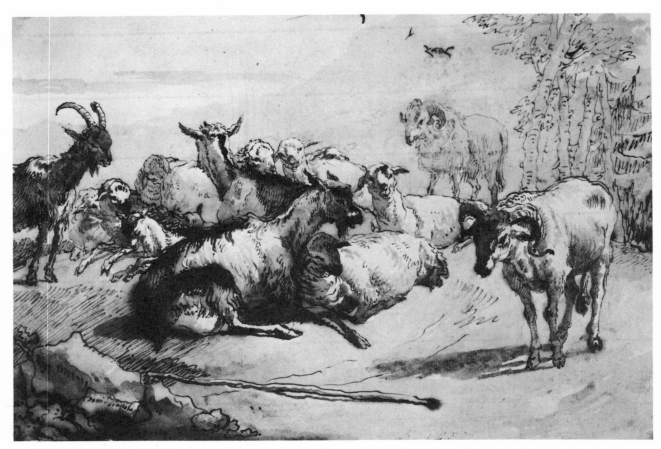

70. Giandomenico Tiepolo. *Sheep and Goats*. Pen and ink with wash on paper, 19.3 x 29.2 cm.

and the radiance of the luster, he always pointed out the excellence of drawing and diversity of designs on the exceptional pieces. He proudly recorded how with patience and perseverance he acquired three large plates that reflect the famous series of the Labors of Hercules by Pollaiuolo. The large Deruta plate (figure 25) that represents the slaying of Antaeus dates from around 1500. The design suggests that its source must have been a drawing or an engraving, although no such composition exists in the known graphic oeuvre of Pollaiuolo. The sources of another Deruta plate from around 1510 (figure 26) are well known. The shield-bearing giants hark back to the nude figures of Pollaiuolo's famous engraving *The Battle of the Naked Men*, while the club-wielding Hercules with the lion skin is similar to his *Hercules and the Hydra* in the Uffizi. Lehman always noted, and with great satisfaction, that these plates after Pollaiuolo's designs and the two drawings by the master also in his possession—the *Study for an Equestrian Monument to Francesco Sforza* (plate 12) and the *Seated Figure of a Prophet or a Saint* (plate 13)—comprise the most interesting and revealing documentation of his influence in sculpture and the decorative arts.

Another illustrious majolica demonstrates the influence of Albrecht Dürer on Italian art. It is a plate painted by Giorgio Andreoli of Gubbio dated 1525 (figure 27). This famed master of Gubbio copied Dürer's engraving of the Prodigal Son that was so generally admired in the

54

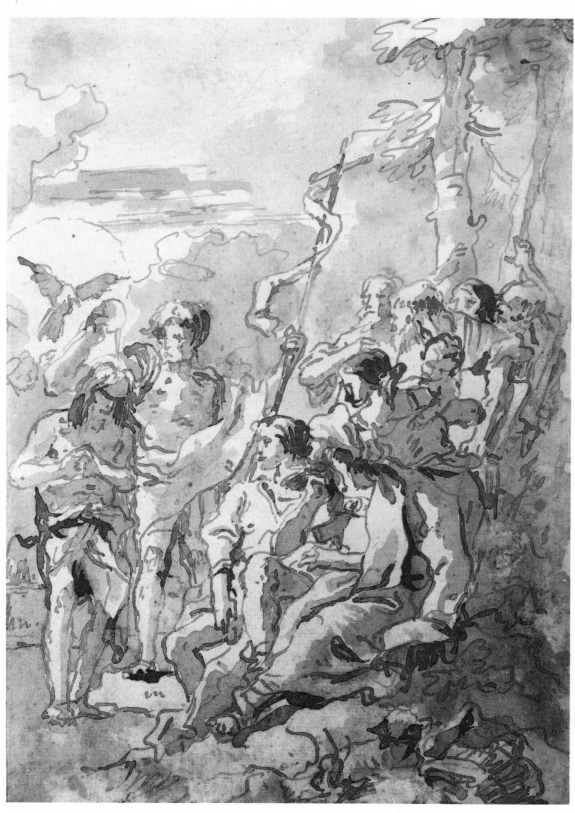

71. Giandomenico Tiepolo. *The Baptism of Christ*. Pen and ink with brown wash on paper, 26.3 x 17 cm.

early sixteenth century in Italy, even by Giorgio Vasari, who called it "most beautiful." An imaginative artist, Maestro Giorgio used large masses of color to reproduce the drama of the original, but showed his real mastery in the imaginative application of the luster.

Countless other majolica pieces display various degrees of relationship to and dependence on drawn or graphic prototypes. The bowl with the arms of Pope Julius II painted by Giovanni Maria in 1508 in Castel Durante (figure 28) contains an orchestrated composition of ornaments from coats of arms and figural decorations, most of which are borrowed from the graphic arts. As a matter of fact, the grotesques seem to recall those in the drawing by Giovanni da Udine (plate 31). Another Castel Durante plate with a mock Triumph of Love (figure 29) is based on various drawings and prints of the celebrated *trionfi* and again in both spirit and manner is very close to Cossa's *Venus Embracing Cupid* (plate 11).

The superior craftsmanship of the Venetian and other Italian glass objects attracted Robert Lehman, as did also the delicately blown shapes of the clear glass, the deep blues, and the precious jasper coloring, which were the main criteria in their acquisition. However, even here he was concerned with design and representation. From among the many painted glasses Robert Lehman always singled out the large bowl with the cold-applied scene of Apollo and the Nine Muses (figure 30). The virtuosity of the twelve-lobed shape and the delicacy of the gold ornamental decoration were perfect complements to the scene represented in the center. The subject apparently derives from Raphael's *Parnassus* in the Vatican, but the glass painter probably copied it from an engraving by Marcantonio Raimondi. The connection to drawings here is again obvious.

The Renaissance bronzes, in spite of their material and sculptural character, were always closely connected with drawings in Lehman's aesthetics. The *Kneeling Satyr* by Andrea Briosco, called Il Riccio (figure 31), fascinated him not only because of its perfectly engraved surface, but also because it bears close resemblance to one of his drawings, *Landscape with Satyr* by Domenico Campagnola (plate 37). Another bronze by Riccio, an elaborate incense burner (figure 32), was always pointed out as the perfect example of careful balancing of figural and ornamental elements. The enameled pilgrim bottle (figure 33), product of a Venetian goldsmith of the early sixteenth century, represented a prominent variation on a theme; Lehman owned a similarly shaped precious bottle in glass and another in majolica. Furthermore, one is even depicted in the drawing by Cossa (plate 11).

Design, ornamentation, and the sculptural quality of the small bronzes were united for Robert Lehman in the various cassoni he gathered. There is a fourteenth-century cassone in the Collection completely covered with ornamental patterns stamped into gesso and covered with gold leaf. The Florentine panels with the story of Lucretia have already been mentioned (figure 11). However, his greater enthusiasm was directed to the early-sixteenth-century Venetian cassone (figure 34) with its ornaments in the Classical manner and the late Roman piece, from around 1550 (figure 35), which resemble sarcophagi. The latter also reminded him of his own drawings by Polidoro da Caravaggio which were inspired by the same ancient monuments as the cassone carvings (plates 33, 34). Among the other examples of Italian furniture he especially liked a pair of chairs that are decorated with carved figures of nude males (figure 36). As this writer was able to prove, these figures with their intertwined muscular bodies resemble groups of acrobats common in engravings around the middle of the sixteenth century which are attributed to various Italian and French artists who gathered in Fontainebleau to decorate the palace of Francis I. Whether the carver of these chairs was French or Italian is difficult to determine, but they may be dated to around 1550. Interest-

56

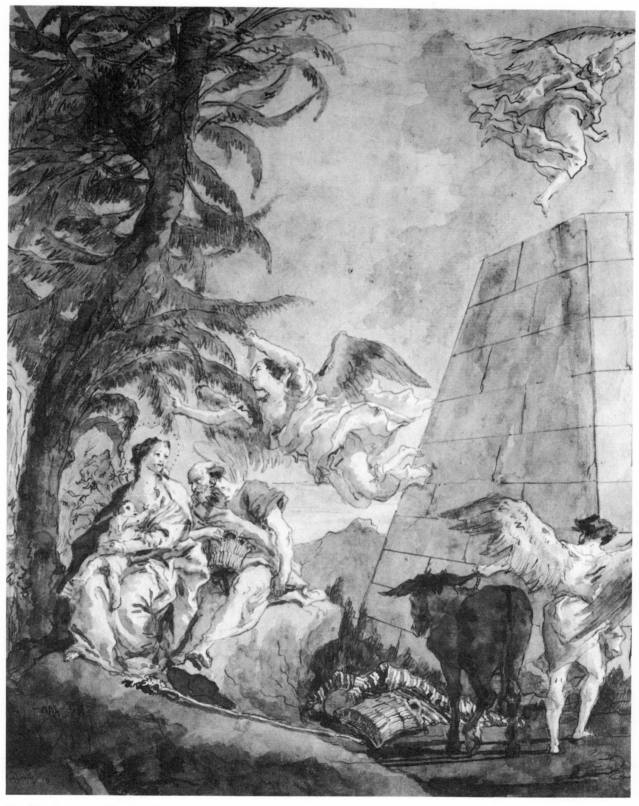

72. Giandomenico Tiepolo. *Rest on the Flight into Egypt*. Pen and brown ink with wash over black chalk on paper, 47 x 37.9 cm.

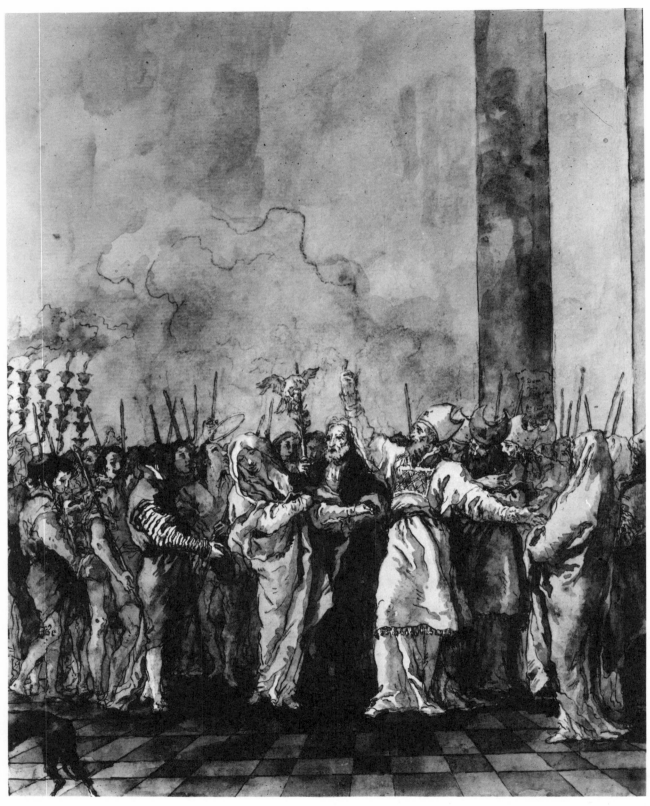

73. Giandomenico Tiepolo. *The Betrothal of the Virgin.* Pen and ink with brown wash over black chalk on paper, 48.3 x 38.6 cm.

58

ingly enough, they are thus also related to one of the most important sixteenth-century drawings in the Lehman Collection, the *Two Nymphs Carrying a Third* by Francesco Primaticcio (plate 39).

Picture frames were regarded by Robert Lehman as primary works of art, equal to furniture or mirrors; he appreciated not only those that were integral parts of a painting (figure 5), but also the ones that had lost their original contents. Frames, such as the large Florentine one with stenciled and punched decoration (figure 37), were always considered as potential embellishments for his drawings, which he preferred to show in old frames.

The love of harmony of design, precious materials, and craftsmanship is manifested in two outstanding Italian jeweled pieces that represent the many Robert Lehman assembled with great care. The rock crystal cup in the shape of a marine monster with the infant Bacchus on its back by a Milanese master (figure 38) was appreciated not only for the virtuoso cutting, but also for the delightful little figure of Bacchus seated on the barrel-shaped cover of the vessel. The genre-like figure was a perfect companion to the various majolica plates in his Collection representing Bacchus. The jewel with Venus Marina on a dolphin (figure 39) dates from the end of the sixteenth century. The white enameled body and the inventive use of the baroque pearl evoked the response to harmony that guided Robert Lehman throughout the many years of his multifaceted collecting activities.

In the early 1920s, when Robert Lehman made his first acquisitions of old master drawings, there were only a few public and private collections in this field in the United States. The Metropolitan Museum of Art received the first considerable group in 1880, when Cornelius Vanderbilt purchased 670 "old master drawings" from James Jackson Jarvis and presented them to the museum. Some years later another assembly of 181 drawings was given to the Metropolitan by Cephas G. Thompson. In 1906, Roger Fry, the English connoisseur appointed Curator of Paintings on the advice of J. P. Morgan, initiated a systematic and discerning program of acquisition. For a long time after Fry's departure the drawings were still part of the Department of Paintings; in 1960 an independent Department of Drawings was created with its own curatorial staff. Another public collection of drawings existed at the Cooper Union Museum; it consisted mainly of a large group of drawings purchased in 1901 by the Misses Hewitt from Giovanni Piancastelli in Rome. These, mostly ornamental, drawings are now part of the drawings department of the Cooper-Hewitt Museum of Design of the Smithsonian Institution in New York.

The most important and influential assembly of great old master drawings, primarily Italian, came to New York in 1910 when J. P. Morgan acquired the collection of Charles Fairfax Murray. These outstanding drawings, now among the prized holdings of the Pierpont Morgan Library, became the exempla and touchstones for every American collector. Outside of New York there were others who were collecting drawings in this period, as, for example, Dan Fellows Platt in Princeton, N.J., or the doyen of American drawing collectors, Paul Sachs at the Fogg Art Museum of Harvard University in Cambridge, Mass. Beginning in 1915, Sachs, a former New York banker and friend of Robert Lehman, assembled his own collection of master drawings and later united it in the form of a gift with the equally impor-

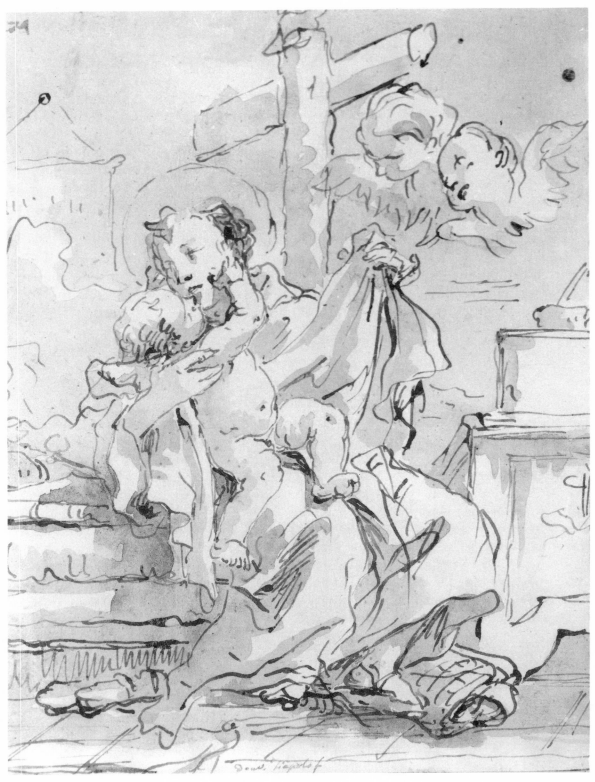

74. Giandomenico Tiepolo. *Saint Anthony and the Christ Child*. Pen and ink with wash on paper, 24.4 x 17.7 cm.

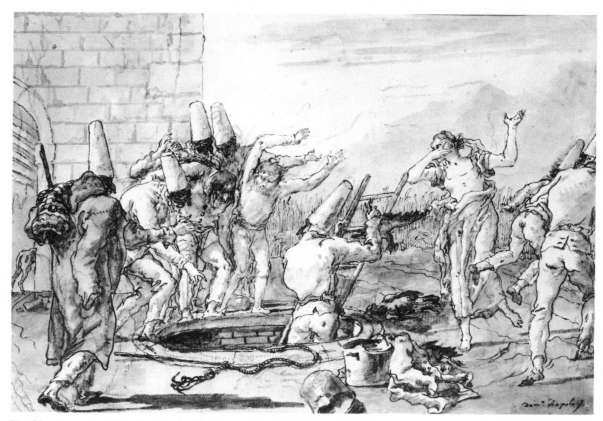

75. Giandomenico Tiepolo. *Punchinello Retrieves Dead Fowl from a Well*. Pen and brown ink with brown wash over black chalk on paper, 35 x 46.5 cm.

tant collection of old prints that he had gathered so assiduously for the Fogg. Sachs was a connoisseur whose interest was not limited to drawings and prints; on a smaller scale he also collected early Italian panels, objects of the decorative arts, etc. In a unique way Sachs was also interested in the scholarly and methodological aspects of collecting. He instituted regular classes of connoisseurship and museum training and, with the co-operation of his students, compiled exemplary catalogues of his own collection and that of the Fogg Museum.

Robert Lehman seemed to follow the example of both Morgan and Sachs. With boldness and voracious appetite—like Morgan's—he pursued this new field of collecting, but he was always guided by his own taste, and his principles were not unlike those of Paul Sachs. In the pursuit of old master drawings Lehman used sources both at home and abroad. In New York he very early discovered the resources of Richard Ederheimer, a pioneer dealer of prints and drawings. Several Italian drawings in the collection were purchased from him, including the one attributed to Piero della Francesca (figure 42). Some other sheets were acquired from such New York collectors as Marius de Zayas or Alphonse Kann. However, the acquisitions of the early years were in the main made abroad. In London, Robert Lehman was helped by the *marchand-amateur* John Hunter and in Paris, by the associates of the firm of Knoedler. Even Philip Lehman offered advice to his son, although he himself never acquired a single drawing.

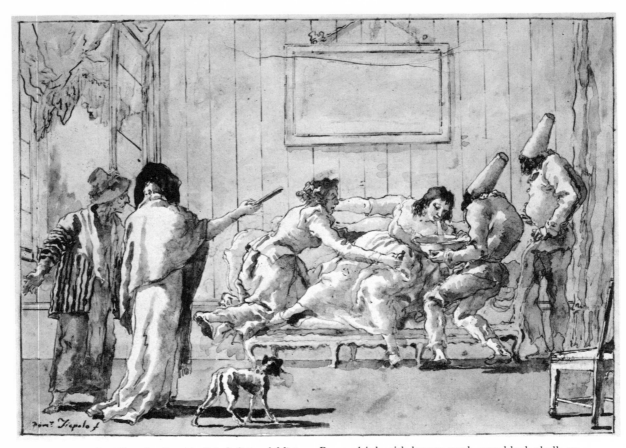

76. Giandomenico Tiepolo. *Punchinello's Indisposed Mistress.* Pen and ink with brown wash over black chalk on paper, 32.5 x 46.7 cm.

It was during this period that Lehman acquired such rare sheets as the two with the early Sienese figures (plates 1, 2), the delicate little gazelle (plate 6), the studies for a group of figures, now attributed to Antonello da Messina (plate 10), the Morone *Virgin and Child* (plate 24), and the Primaticcio *Two Nymphs* (plate 39). An exciting and important opportunity was offered to all collectors of old master drawings when the collection of Luigi Grassi of Florence came up for sale on May 13, 1924. As he later explained, Robert Lehman planned to acquire most of the Italian drawings in this sale, but he was prevented from it by the worsening economic situation that eventually led to the great Wall Street crash. Nevertheless, he became the proud owner of a large and important group of Veronese (plates 3, 4, 29) and Venetian drawings (plates 9, 30, 40, 42, 49) with the Moscardo and Calceolari provenance. Since the importance of many of these sheets was discovered only later, he already displayed the adventurous and bold spirit that became one of the hallmarks of his collecting activity.

Thus, when the first important American exhibition of old master drawings was held in 1934 at the Fine Arts Academy in Buffalo, Robert Lehman, together with Paul Sachs and Philip Hofer, was among the most important private lenders.

In 1936, he added another distinguished group to this already considerable number of Ital-

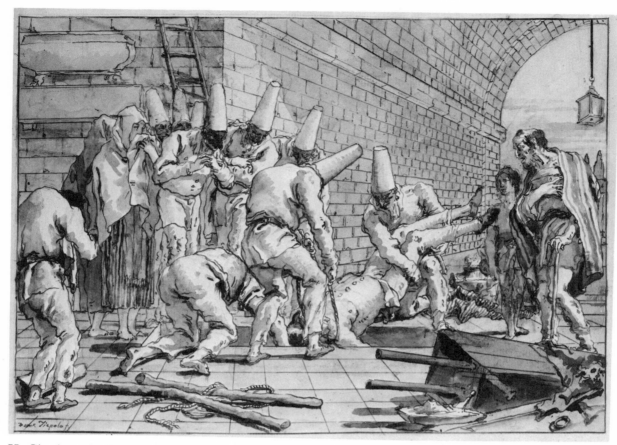

77. Giandomenico Tiepolo. *The Burial of Punchinello*. Pen and brown ink with brown wash over black chalk on paper, 35.3 x 47.3 cm.

ian old master drawings. After careful consideration—revealed by his autograph notes, a whole set of annotated photographs, and a sale catalogue full of remarks, all in the archives of the Collection—he successfully bid on more than twenty lots of the Oppenheimer Sale. Thus, he added drawings of great importance to his collection, among them the Ottaviano Nelli *Last Judgment* (plate 5), the Venetian design for an altarpiece (figure 41), Fra Bartolommeo's *Virgin with Holy Children* (plate 20), Pollaiuolo's *Seated Figure of a Prophet or Saint* (plate 13), and Perugino's *Studies of Standing Youths* (plate 18). The gathering clouds of World War II prevented him from purchasing more, recalling the bleak economic situation at the time of the Grassi Sale. It must be noted, however, that it was about this time that he acquired the famous majolicas of the Pringsheim Collection, thus using his resources to secure other treasures.

The period after World War II was a time of selective additions and refinement. From Philip Hofer came important sheets, among them Pollaiuolo's *Study for an Equestrian Monument to Francesco Sforza* (plate 12) and the sheet by Giovanni da Udine (plate 31). Singular drawings of great importance were also acquired, such as the Francesco di Giorgio from the Le Hunte Collection (plate 14) and the Fra Bartolommeo from the Gabburri Album (plate 21). The group from the Skippe Sale, including the Cossa (plate 11) and Giovanni Bellini's magnifi-

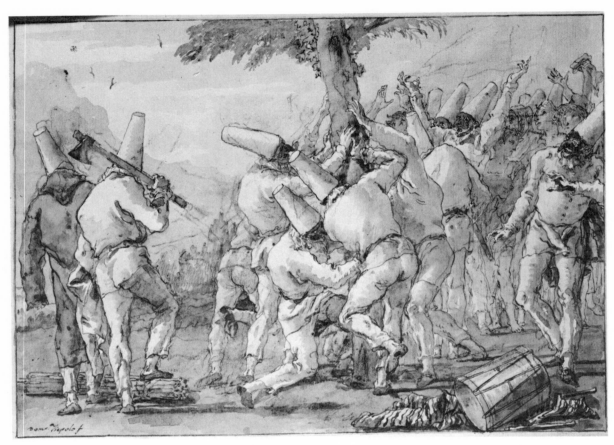

78. Giandomenico Tiepolo. *Punchinellos Felling (?) a Tree.* Pen and brown ink with wash over black chalk on paper, 35.3 x 47.3 cm.

cent *Christ's Descent into Limbo* (plate 15), as well as other important sheets (plates 35, 36), greatly enriched the scope of early drawings in the Collection. Therefore, when the Metropolitan Museum and the Pierpont Morgan Library opened the first of their great exhibitions of Italian drawings "a number of the rarest and earliest" sheets were from the Robert Lehman Collection.

Nor were the later periods neglected. Seventeenth- and eighteenth-century drawings were acquired on the advice of J. Byam Shaw, and in the early 1960s a considerable group of Venetian drawings was purchased from Paul Wallraf. It is interesting to note that Robert Lehman also managed to gather 9 of the 103 drawings from Giandomenico Tiepolo's *Divertimento per li regazzi* (plates 77—80).

In the 1950s the number of Italian drawings in Robert Lehman's collection reached several hundreds. There were a number of sheets that seemed repetitious or did not fully agree with his taste. Because of this, and also as part of his desire to share this wealth, he donated dozens of drawings to various museums and university collections. Thus, the museums of Oberlin College, Yale University, the Rhode Island School of Design, and Princeton University received many Italian drawings from him as welcome additions to their collections.

64

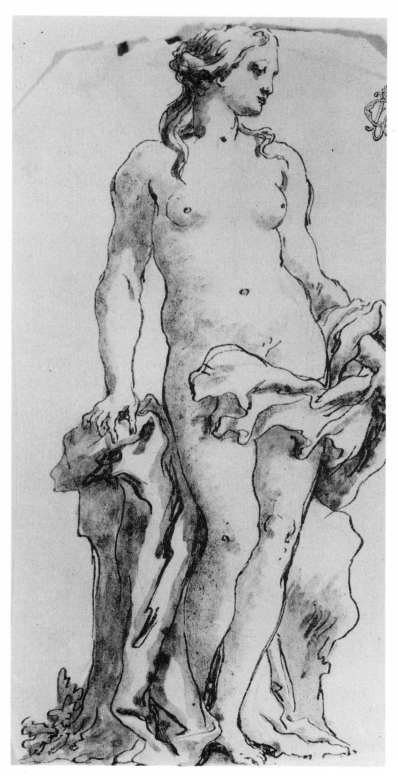

79. Giandomenico Tiepolo. *Goddes*. Pen and ink with wash on paper,
24.2 x 12.8 cm.

Many of these are from groups purchased at the Grassi and Oppenheimer sales and are now fully published in the respective catalogues of these institutions. This generosity was matched by gifts from other sections of the collection: Italian panel paintings were presented, as well as whole small assemblies of Italian majolica or Renaissance medals and plaquettes. Altogether Robert Lehman's gifts throughout his life would fill a good-sized museum.

As Robert Lehman's Italian drawings were presented in several exhibitions between 1956 and 1969 the basic principles and characteristics of his collecting and taste became more and more evident. First of all, he liked large and elaborate drawings. This is not surprising, since his eyes and taste were educated on paintings. He looked for meticulous craftsmanship akin to that of the Sienese panels; he desired the precision of composition and outline that are characteristic of all early Italian painting. Many of the drawings in his Collection seem to have the finality of finished paintings. The best examples of this are the large sheets by Cossa (plate 11), Bellini (plate 15), Morone (plate 24), Romanino (plate 30), Primaticcio (plate 39), Zuccaro (plate 44), Pietro da Cortona (plate 53), Canaletto (plate 54), Guardi (plate 62), and Giandomenico Tiepolo's *Rest on the Flight into Egypt* (figure 72). To a lesser degree, but still with great attention, he also gathered studies that were not so elaborate, but still abounded in rich details of iconography or draughtsmanship. To this group belong, among others, Stefano da Verona's *Allegorical Figure* (plate 3), the *Gazelle* by a Lombard artist (plate 6), the Giambono *Knight on Horseback* (plate 9), Leonardo's *Studies of a Bear* (plate 17), *Saint Jerome in a Landscape* by a Venetian artist (plate 40), and many of the Tiepolos. Together with these he also greatly treasured those of his drawings that apparently belonged to sketchbooks or pattern books of various artists, as the two Sienese drawings (plates 1, 2) that apparently once formed a single large sheet, Giovanni dal Ponte's *Studies of Apostles* (plate 8), the landscape study by Fra Bartolommeo (plate 21), the page from Domenico Beccafumi's sketchbook (figures 49, 50), or Canaletto's late sketch of the interior of the basilica of San Marco (plate 55).

In contrast to his paintings, the majority of the drawings represent secular themes or figures. This characteristic is even more preponderant among the early drawings and apparently provided him with an interesting and challenging countereffect to the religious, devotional aura of the panels. The same interest in secular, mostly mythological scenes can be observed on the majolica pieces he collected during the same period. Robert Lehman was greatly amused by delving into the many-layered meanings of complex compositions, such as Cossa's *Venus Embracing Cupid* (plate 11), Romanino's *Pastoral Concert* (plate 30), or Primaticcio's *Two Nymphs* (plate 39). He also believed that there is more in Giovanni Domenico Tiepolo's Punchinello drawings than the musings of an understanding Venetian artist; he always looked for the signs of deeper social criticism behind the optimistic mask of the golden brown tones of the ink.

As already indicated, many of the religious subjects provided parallels to his paintings. In Stefano da Verona's *Virgin and Child with Two Saints and Female Donor* (plate 4) the elegantly dressed and coiffed figure of the donor intrigued him because she was so unlike any donor figures in his paintings. Bartolommeo Vivarini's *Madonna and Child with Saint John* (figure 46) interested him because it was clearly related to a polyptych of the master he owned.

Interestingly, a surprisingly large number of sixteenth-century drawings in the Collection represent subjects that Lehman never considered collecting in paintings. For instance, he preferred to the high drama of the oil paintings of the Venetian masters, their smaller and more intimate drawings, such as Tintoretto's sensitive *Study for a Portrait of a Doge* (plate 42),

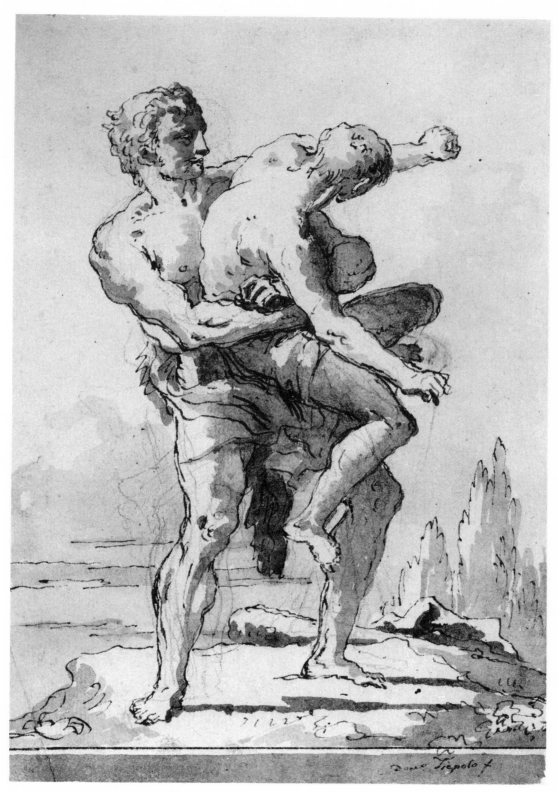

80. Giandomenico Tiepolo. *Hercules and Antaeus*. Pen and ink with wash over pencil on paper, 20 x 14 cm.

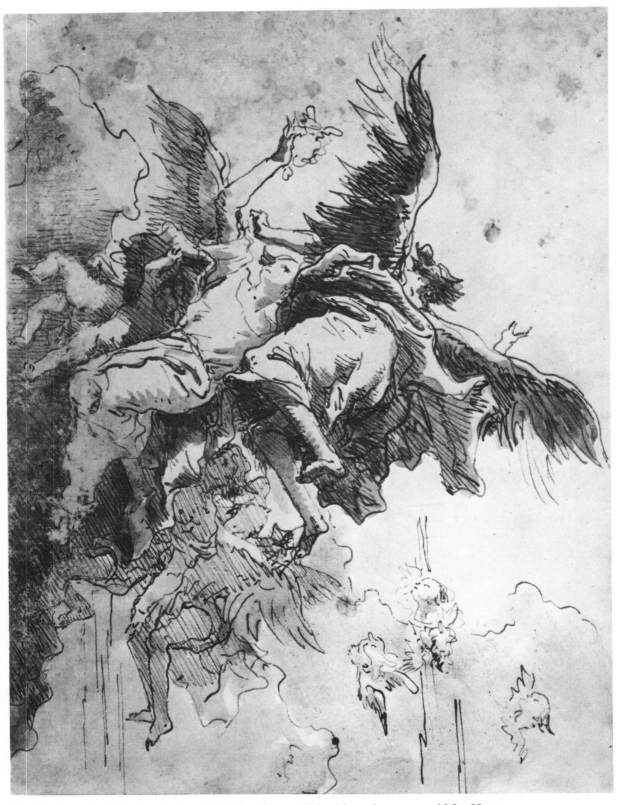

81. Giandomenico Tiepolo. *Angels and Cherubim.* Pen and ink with wash on paper, 16.5 x 23 cm.

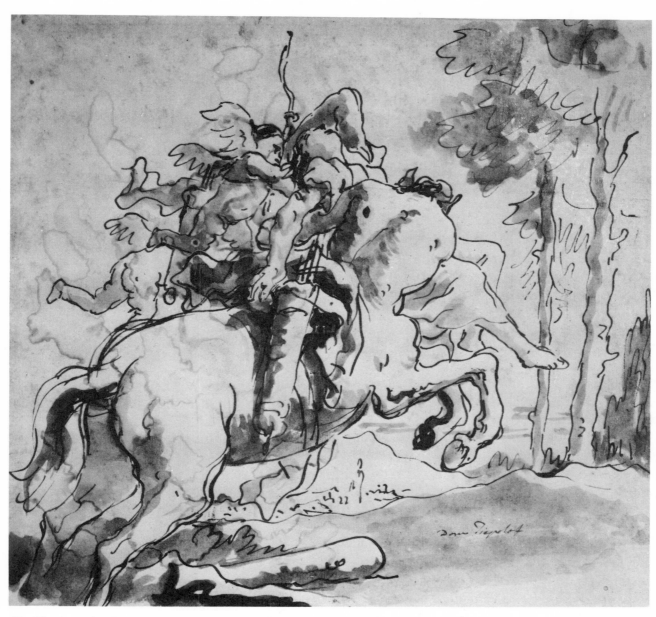

82. Giandomenico Tiepolo. *The Rape of Deianira*. Pen and ink with wash on paper, 27.3 x 29.9 cm.

or Veronese's *Study for a Massacre of the Innocents* (plate 47). In like manner, instead of the large canvases, he gathered the fresh and immediate drawings of the eighteenth-century Venetian veduta painters.

Robert Lehman's apparent lack of interest in sculpture did not prevent him from acquiring drawings by sculptors. Many of these are quite well known, as, for example, the Pollaiuolo *Study for an Equestrian Monument* (plate 12) or Francesco di Giorgio's *Kneeling Humanist Presented by Two Muses* (plate 14). But there are others, lesser known but still interesting, among them Giovanni Cristoforo Romano's *Design for a Funeral Monument* (plate 23), or Bandinelli's two studies (plates 35, 36). In a similar vein, he never showed any interest in frescoes. Nevertheless, the high quality and historical interest of such drawings as Signorelli's cartoon of a head of a man (plate 22) or Giovanni da Udine's *Design for a Wall Decoration* (plate 31) captured his imagination.

The drawings reproduced in this volume also clearly indicate some of Robert Lehman's preferences among the various schools of Italian draughtsmanship and painting. A large number of drawings here are the works of artists from the Northern centers. Verona and Venice are especially well represented, the former by early drawings, the latter by a considerable number of early sheets and by an unparalleled abundance of eighteenth-century drawings. There are many works of Florentine artists of the fifteenth and sixteenth centuries. The number of Sienese drawings, in contrast, is far less, and the more southern centers, such as Rome or Naples, are meagerly represented.

As expected, drawings by the great masters, or attributed to them, abound in the collection. Among these, special importance was attached to those drawings that are related to well-known or extant works of art. These naturally include Pollaiuolo's design for the Sforza equestrian monument (plate 12) and Bellini's *Christ's Descent into Limbo* (plate 15), which is a key piece in the controversy regarding the paintings of the same subject by him and by Mantegna. Other such drawings are Bronzino's *Studies of Seated Male Nude* (plate 38) for the *Adoration of the Shepherds* in Budapest; Taddeo Zuccaro's *Martyrdom of Saint Paul* (plate 44), a study for a fresco in the Frangipani Chapel in San Marcello al Corso in Rome; and Guardi's *Panorama from the Bacino di San Marco* (plate 62), a grandiose preparatory drawing for a large painting now in the Alte Pinakothek in Munich.

However, many of the drawings that now bear famous names were acquired by Lehman without attribution. It is enough to mention those by Stefano da Verona (plates 3, 4), Giambono (plate 9), Antonello da Messina (plate 10), the *Saint Sebastian* by Ercole de' Roberti (figure 43), and the Primaticcio (plate 39). Others were reassigned to the schools or followers of famous masters. *The Last Communion of Saint Jerome* (figure 44), which was formerly thought to be by Botticelli and a study for his famous painting in the Metropolitan Museum, is now attributed to an unknown artist of his school. A silverpoint and red chalk *Portrait of a Lady*, which for a long time carried the name of Pontormo (figure 51), is now simply attributed to a Florentine artist.

Continuing in the spirit of Robert Lehman, who was always open to new ideas, changes in the attributions and interpretations of these drawings are still expected. The catalogue descriptions accompanying the color plates contain a wealth of new scholarly suggestions regarding both artists and subjects. The constant refining of the methods of connoisseurship in drawings, the reconstruction of old albums, portfolios, and collections, and the identification of still-unknown collectors will also add to the better understanding and appreciation of these drawings. It is already known that many of them belonged to famous and renowned collec-

70

tions. Robert Lehman was proud of the fact that at least four of his drawings were part of Giorgio Vasari's famous *Libro* (plates 5, 7, 12, 25). Many of his drawings had passed through such legendary collections as those of Sir Peter Lely, Jan Pietersz. Zoomer, John Skippe, the Cavaliere Gabburri, Sir Joshua Reynolds, Sir Thomas Lawrence, the Marignans, P. J. Mariette, the Earl of Warwick, Pierre Crozat, and Prince Alexis Orloff. But most of all he treasured the idea that unlike the dispersed collections of these famous predecessors, his own would stay intact and would provide enjoyment and education for future generations of connoisseurs, scholars, students, and the public.

During half a century Robert Lehman assembled a remarkable collection of old and more recent master drawings. Although it is not as extensive nor as rich as former royal or princely holdings, or those of public museums with long and distinguished histories, it still ranks high among the collections of drawings because of its personal character and the special relationship and symbiosis with his collection as a whole. The Italian drawings constitute a special group by their sheer number, great variety, and high quality. The importance of these sheets is further enhanced because so many of them are related to well-known monuments of art and all are situated within the rich panorama of Italian art that Robert Lehman collected.

This assembly of drawings also represents an important turning point in the history of American collecting. It is a pioneering collection, but still deeply steeped in the past. Although it is in spirit one of the last of the great nineteenth-century collections, it is at the same time also the first among those that were devoted to special fields, such as Italian, Northern, or French drawings. Finally, by becoming part of a great public collection, Robert Lehman's drawings contribute significantly to the strength and further enrichment of the Metropolitan Museum of Art and all American museums.

71

Bibliography for the Introduction

A Centennial: Lehman Brothers, 1850–1950. New York: Lehman Brothers, 1950.

Cincinnati Art Museum. *The Lehman Collection, New York.* Exhibition catalogue. Cincinnati, 1959.

Colorado Springs Arts Center. *Paintings and Bronzes from the Collection of Mr. Robert Lehman.* Exhibition catalogue. Colorado Springs, 1951.

Gallery Association of New York State. *XVIII Century Venetian Drawings from the Robert Lehman Collection, The Metropolitan Museum of Art.* Exhibition catalogue by George Szabo. New York, 1982.

Lehman, R. *The Philip Lehman Collection, New York. Paintings.* Paris, 1928.

Oklahoma Museum of Art. *Prendergast. The Large Boston Public Garden Sketchbook from the Robert Lehman Collection, The Metropolitan Museum of Art.* Exhibition catalogue. Oklahoma City, 1981.

Paris, Musée de l'Orangerie. *Exposition de la collection Lehman de New York.* Exhibition catalogue. 2d ed., rev. Paris, 1957.

Szabo, G. *The Robert Lehman Collection. A Guide.* New York: Metropolitan Museum of Art, 1975.

————. *Tricolour. 17th Century Dutch, 18th Century English, and 19th Century French Drawings from the Robert Lehman Collection.* New York: Metropolitan Museum of Art, 1976.

————. *XV Century Italian Drawings from the Robert Lehman Collection.* New York: Metropolitan Museum of Art, 1977.

————. *Paul Signac (1863–1935). Paintings, Watercolors, Drawings and Prints. Robert Lehman Collection.* New York: Metropolitan Museum of Art, 1977.

————. *XV–XVI Century Northern Drawings from the Robert Lehman Collection.* New York: Metropolitan Museum of Art, 1978.

————. *Seventeenth Century Dutch Drawings from the Robert Lehman Collection.* New York: Metropolitan Museum of Art, 1979.

————. *XVI Century Italian Drawings from the Robert Lehman Collection.* New York: Metropolitan Museum of Art, 1979.

————. *19th Century French Drawings from the Robert Lehman Collection.* New York: Metropolitan Museum of Art, 1980.

————. *Seventeenth and Eighteenth Century French Drawings from the Robert Lehman Collection.* New York: Metropolitan Museum of Art, 1980.

————. *Eighteenth Century Italian Drawings from the Robert Lehman Collection.* New York: Metropolitan Museum of Art, 1981.

————. *Twentieth Century French Drawings from the Robert Lehman Collection.* New York: Metropolitan Museum of Art, 1981.

Tokyo, National Museum of Western Art. *Renaissance Decorative Arts from the Robert Lehman Collection of the Metropolitan Museum of Art.* Exhibition catalogue. Tokyo, 1977.

Wise, T. A. "The Bustling House of Lehman," *Fortune,* vol. 56 (December 1957), pp. 156–64.

Acknowledgments

The Metropolitan Museum of Art and the President and Directors of the Robert Lehman Foundation, Inc. have encouraged the publication of this volume and permitted new photography of all the drawings reproduced herein.

In the preliminary research and compilation of the bibliography my daughter, Julia Szabo, provided considerable help. My associates at the Robert Lehman Collection, especially Sarah Bertalan and Susan Romanelli, were also very helpful in the various stages of the preparation. Ellen Callmann and Irene Gordon edited the catalogue and the introductory sections respectively. The tedious task of photography was executed by Mark D. Cooper and his staff of the Photograph Studio, and, finally, the administration of all stages of the color reproduction was performed in exemplary fashion by Mary Doherty and Dyane Walters of the Photograph Sales Department of the Metropolitan Museum of Art.

Plates

SIENESE ARTIST
End of Fourteenth Century

1 Man in Armor with Sword and Globe in His Hands

Pen and ink on paper, 174 x 126 mm. Verso: Inscribed in a sixteenth-century hand, Vittore Pisanello.

Provenance: *Unknown. Acquired in 1934.*

Bibliography: *Buffalo Cat., 1934, no. 5; Degenhart-Schmitt, 1968, no. 105; Szabo, 1978, no. 1.*

This drawing and the next (Plate 2) once formed a single large sheet, possibly as part of a sketchbook. They were separated only in the early 1930s. The tip of the lance held by the figure on Plate 2 is visible in the lower right corner of this drawing. The subject here is a young man dressed in fantastic armor and wearing a beaked hat. In his right hand is a sword or dagger, while his extended left hand holds a globe or, as suggested by Degenhart-Schmitt, possibly an astronomical roundel.

Following the inscriptions on both sections, these drawings were attributed to Pisanello when acquired. Degenhart-Schmitt were the first to propose the Sienese attribution, based especially on the fine character of the penwork. Indeed, the details of dress and armor are drawn with sensitive and precise lines, and the drapery folds are indicated with a delicate web of careful crosshatchings. The precious quality of the whole relates this drawing to a group of later Sienese drawings by Jacopo della Quercia, Giovanni di Bindino, and Sassetta (Degenhart-Schmitt, 1968, nos. 112, 113, 118, 227–236). The same authors also compare these two figures with the minute drawing technique of such other Sienese works as late fourteenth-century verre-églomisé panels, for example, the *Virgin and Child* and *Annunciation* in the Fitzwilliam Museum in Cambridge.

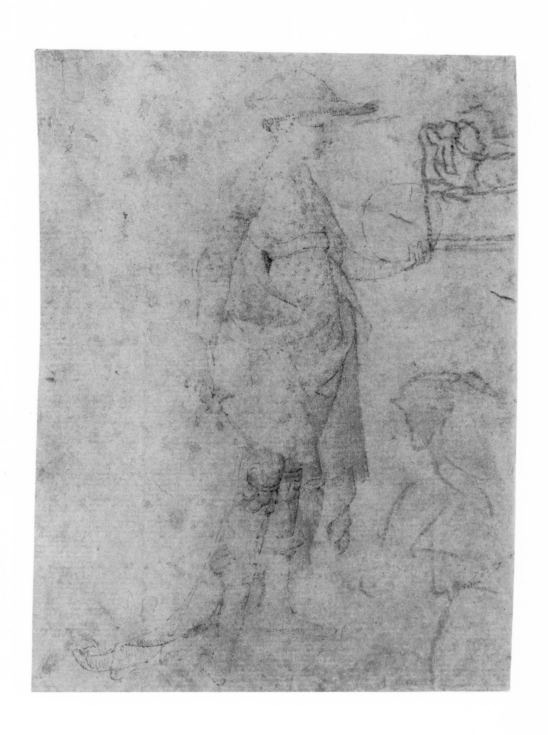

2 Man in Armor with Lance

Pen and ink on paper, 172 x 134 mm. Inscribed in lower left corner in a sixteenth-century hand, Vittore Pisanello. Slight traces of other drawings in various places.

Provenance: *Unknown. Acquired in 1934.*

Bibliography: *Buffalo Cat., 1934, no. 5; Degenhart-Schmitt, 1968, no. 106; Szabo, 1978, no. 2.*

The point of the lance held by this standing figure is on the previous drawing (Plate 1), proving that the two once formed one sheet; the possibility that the entire leaf was part of a sketchbook has not been noted before. Pattern books and sketchbooks by Lombard or Florentine artists of this period are well known, but very few by Sienese masters are mentioned.

This older man wears a distinctive headgear that seems to be made up of a crownlike lower part and a domed center. He firmly grasps the lance in his left hand, but the position of his right is unclear, though a few faint traces of lines suggest he may be holding a shield. Like the young man on the previous sheet, this one is also characterized by an elongated body and an elegant, fantastic costume. In this respect both are closer to earlier Sienese works than to those from the first half of the fifteenth century. The figures of Servius and the knight on Simone Martini's famous frontispiece for Petrarch's *Vergil* are markedly similar to these even though the Vergil manuscript is dated between 1338 and 1344, roughly half a century earlier than our sheet (Brink, 1977, pp. 83—85). Simone's powerful influence, even in the depiction of such fantastic figures, continued for a long time, as may be seen in the warriors by the Master of the Saint George Codex or in the two panels by an anonymous master, one of which is now in Aix-en-Provence and the other in the Robert Lehman Collection; even Giovanni di Paolo Fei demonstrates possibilities of some transmittal (cf. Szabo, 1975, pls. 7, 13).

STEFANO DA VERONA (STEFANO DA ZEVIO)

Painter, born in Verona, probably in 1374; mentioned in Veronese documents of 1424, 1425, and 1438; died 1451. Stefano's only signed and dated picture is the *Adoration of the Magi* (1435) in the Brera in Milan. Signed frescoes, much damaged, are in Sant'Eufemia in Verona, and a signature that may be genuine appears on a drawing in the collection of the Institut Néerlandais in Paris. These and the sheets in the Albertina, and the reliably attributed Stefano frescoes which are closely related to them, should be taken as the starting point for any reconstruction of his graphic oeuvre rather than, as Fiocco (1950, p. 520) and Fossi Todorow (1970, p. 17) suggest, the more freely drawn sheets in London, Dresden, the Uffizi in Florence, and the Ambrosiana in Milan. Degenhart was surely right in recognizing these latter as Stefano's later works. Stefano was at first influenced by Altichiero and later probably by Michelino da Besozzo. The leading master of the International Style in Verona, Stefano differs from Michelino's noted elegance of line by his strong expressive quality and the predominantly graphic treatment that characterizes even his paintings and frescoes.

3 Allegorical Figure

Pen and ink on paper, 305 x 203 mm. Inscribed in lower right corner possibly by the artist, or in a contemporary hand. Auant. *Also inscribed in upper right corner,* Fatt. . . . *Various other, illegible inscriptions are in the upper half of the sheet.*

Provenance: *Collection of the Moscardo Family, Verona; Conte Lodovico Moscardo, Verona; Marquis de Calceolari (until 1920); Luigi Grassi, Florence (Lugt Supplement 1171b).*

Bibliography: *Grassi Sale Cat., 1924, no. 116; Degenhart, 1954, pp. 106–8; Orangerie Cat., 1957, no. 127; Cincinnati Cat., 1959, no. 193; Muraro, 1957, p. 15; Steenbock, 1966, p. 14; Szabo, 1975, pl. 103; Szabo, 1978, no. 3; Hibbard, 1980, p. 222, fig. 395.*

Sweeping movement and vigorous draughtsmanship characterize this exceptional drawing. The hatching that the artist used in depicting the bearded, swiftly moving figure is so rich that it even misled some early critics into calling him a wild man. Degenhart was the first to describe him rightly as an allegorical figure and to attribute the sheet to Stefano. Somewhat later, in the catalogue of the Orangerie exhibition, Beguin proposed that he represents the Wind, who is accompanied by thunder symbolized by the bundle of sparks (?) held in his right hand. However, this solution offers no explanation for the shield and for the shoe or some other kind of footwear on the figure's right foot, which has been ignored in previous publications.

Allegorical figures with a shoe on one foot and the other bare are not common in the art of the fifteenth century. This peculiar attire is better known from Urs Graf's *Landsknechte* of the beginning of the next century (Weisbach, 1942, pp. 105–113). However, in several depictions of Petrarch's *trionfi* the figure of Saturn is shown in a short, shabby garment and with one foot in a shoe while the other is bare. Unfortunately, his attributes do not include the shield or the "sparks." In earlier times one foot shod and the other unshod was sometimes the distinguishing sign of the Gallic Mercury, as has also been observed by Weisbach, but the symbols of this deity, the caduceus in the left hand and the money bag in the right, have nothing in common with those in this drawing. The so-called sparks may even be a bunch or sheaf of flowers (*fascis*) and could thus symbolize either fascination (evil-doing) or unification and strength.

Notwithstanding the difficulties in the identification, the figure exudes an exuberant mood and movement by the windswept hair, the forward thrust of the arms, and the graceful sweep of the right leg. The inscription, consciously or by accident, sums up these feelings in the word *Auant*. Through this vigorous forward movement and his attributes, this mysterious man is surely related to those represented in various *trionfi*. As an allegorical figure he is closely related, both in feeling and in style, to Stefano's other well-known allegories, such as the versions of *Charity* in Berlin and Florence (Steenbock, 1966, figs. 1, 3) or the *Mathematica* and *Dialectica* in Florence (Steenbock, 1966, fig. 4; Fiocco, 1950, fig. 15).

STEFANO DA VERONA

4 Virgin and Child with Two Saints and Female Donor

Pen and ink on paper, 230 x 196 mm. Cut on all sides. Verso: faint traces of various figures and inscription in lower right corner in a nineteenth century hand, Gentile da Fabriano.

Provenance: *Collection of the Moscardo Family, Verona; Conte Lodovico Moscardo, Verona; Marquis de Calceolari (until 1920); Luigi Grassi, Florence (Lugt Supplement 1171b).*

Bibliography: *Grassi Sale Cat., 1924, no. 115; Degenhart, 1937, p. 528; Orangerie Cat., 1957, no. 113; Cincinnati Cat., 1959, no. 195; Szabo, 1978, no. 4.*

The well-organized and balanced composition is probably a design for a votive panel. The Virgin and Child are adored by a kneeling and praying young woman, whose profile and coiffure display individual characteristics. She is introduced by an unidentified female saint, a martyr, judging by the palm frond in her left hand. The name of the bishop saint on the Virgin's left is also not known since his miter and long staff do not allow closer identification.

The drawing is characterized by a careful linear quality, a great attention to the definition of the volume of the figures, and a limited use of hatchings. These were the signs that presumably induced Degenhart as early as 1937 to attribute the drawing to Stefano himself and place it among his early works. Most recent studies of Stefano's drawings confirm the validity of his judgment; Beguin, however, assigns it to an immediate collaborator of the artist. The importance of the drawing is increased by the portrait-like quality of the donor, a rare occurrence in the drawings of Stefano.

OTTAVIANO NELLI (OTTAVIANO DI MARTINI)

Born in Gubbio around 1375; active in his birthplace in Umbria, as well as in the Marches, and in Urbino; mentioned in various documents between 1400 and 1440; probably died before 1450. Ottaviano was a painter who continued the activity of Guido Palmerucci and was influenced also by the Salimbeni brothers. In his native town he executed frescoes in several churches, among them a *Last Judgment* in Sant'Agostino. Other works by him are in the Chapel of the Palazzo Trinci in Foligno, and his collaborators worked in the Church of San Domenico in Fano and in Fossato di Vico. His figures are somewhat squat, strongly outlined, and placed in dense, dramatic compositions. There are no safely attributed drawings known by him.

5 The Last Judgment

Brush drawing in brown and white on prepared blue paper, 281 x 167 mm. Restored and painted on three sides and framed by lines drawn in ink. These restorations were probably added by Giorgio Vasari, who is probably also responsible for the inscription in the lower left corner, Ottaviano.

Provenance: *Giorgio Vasari (?); H. Oppenheimer, London.*

Bibliography: *Oppenheimer Sale Cat., 1936, no. 26; Degenhart-Schmitt, 1968, no. 256; Ragghianti Collobi, 1974, p. 29; Szabo, 1978, no. 9.*

Since the sixteenth-century hand that inscribed *Ottaviano* was probably Vasari's, we presumably owe to him the first recognition of the connection to Ottaviano Nelli or his school. That the dense and somber but undramatic Last Judgment represented here was well known in Italy is demonstrated by the existence of a Florentine "niello" print in the Cabinet Edmond de Rothschild in the Louvre that is almost identical with the drawing and may be dated to the third quarter of the fifteenth century (Blum, 1950, no. 6).

Degenhart-Schmitt pointed out that both the drawing and the print hark back to a common prototype, probably one of Nelli's frescoes, comparable in style to those in the Palazzo Trinci in Foligno. However, they feel that the drawing is a copy by an assistant of the master and locate its qualities closer to the frescoes in San Domenico in Fano, which are attributed to the workshop of Nelli.

In the absence of drawings securely attributed to Nelli, a comparison between the qualities of finished frescoes and reduced versions or copies of them even by the master is unjustified. In the case of this drawing, the understanding and careful transcribing of a seemingly larger composition, the thoughtful use of white highlights, and the attention to details seem to indicate a superior hand, that of Nelli. The style of an inferior copyist or follower is evident in a similar drawing in the British Museum (brown wash heightened with white and yellow on blue-gray paper) representing the martyrdom of Saint Catherine of Alexandria (Popham-Pouncey, 1950, no. 283, pl. CCXLVIII). There the composition falls apart, the figures are awkward, and the use of the highlights is haphazard. This comparison is a further indication that Vasari's original attribution should be retained.

6 Gazelle

Silver, lead point, and ink with additional colors (gray, white, brown, and black) in brush on paper, 102 x 127 mm. Traces of pentimenti along the profile.

Provenance: *F. R. Martin, London.*

Bibliography: *Martin, 1910, p. 5; Buffalo Cat., 1934, no. 6; Degenhart, 1941, pp. 31, 54, 80, no. 157; Tietze-Conrat, 1946, p. 189; Orangerie Cat., 1957, no. 118; Cincinnati Cat., 1959, no. 197; Fossi Todorow, 1966, no. 345; Fossi Todorow, 1970, pp. 83, 89—90; Szabo, 1978, no. 10.*

This highly accurate and sensitive depiction of a Thomson gazelle (Gazella dorcas Thomsoni), native to East Africa, has elicited attributions to several great artists of the fifteenth century. F. R. Martin, the first to publish it, considered it to be a work by Gentile Bellini because of its similarity to a gazelle in the famous painting in the Louvre attributed to the school of the Venetian artist, variously called *The Reception of Domenico Trevisano, Procurator of San Marco, in Cairo* or *The Audience of the Venetians in Damascus* (cf. C. D. Rouillard, 1973, pp. 297—304). The Venetian origin seems plausible, not only because of the ongoing contact between Venice and North Africa and the Venetian artists' knowledge of the Near East, but also because of the special fascination this graceful little animal had for the Venetians. This is manifested in various depictions of the gazelle in manuscript illuminations and paintings, but most of all in the fact that in or before 1520 Girolamo Cornaro owned a live specimen and kept it in his garden (Shapley, 1945, pp. 27—30).

Shortly after it was acquired by Robert Lehman in 1929 in London, the drawing was connected with the oeuvre of Antonio Pisanello by, among others, Berenson (in verbal communication), mostly on the assumption that the superlative treatment of the animal's lithe body and the coloring seem to parallel the delicate animal studies by that great artist of the International Gothic. Degenhart in 1941 pointed out that the shadows, such as those under the hoofs of the gazelle, are unknown in Pisanello's drawings and suggested that this study is the work of a Lombard master. Following his suggestion, attention was called to the presence of various colors and the brush technique. These seem further to imply that the gazelle is related to animal studies of Lombard illuminators, such as those by Giovannino de' Grassi or by an anonymous master in the Louvre (Fossi Todorow, 1970, pp. 83, 90), and it should thus be dated to the first decades of the fifteenth century.

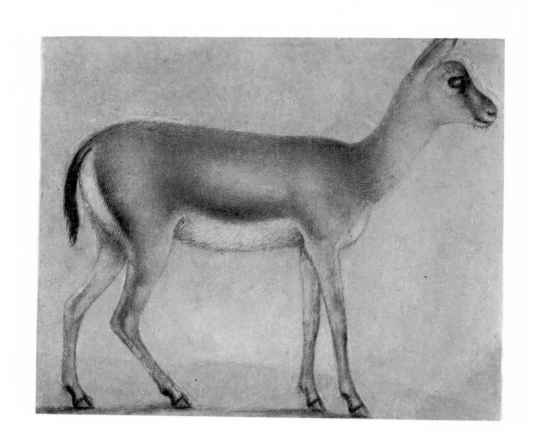

Florentine, born 1422, died 1457; painter of religious paintings, decorative panels, and cassoni. Pesellino's life and some works are well documented. In 1442 he married Tarsia, daughter of Silvestro da Puppio; in 1447 he was admitted to the Guild of Saint Luke. In 1455 he is reported painting an altarpiece for the Compagnia della Santissima Trinità in Pistoia, but because of his death it was finished by Fra Filippo Lippi.

Influenced by Lippi and Fra Angelico, Pesellino also produced a large number of skillfully composed and painted decorative works; among the well-known ones are the two panels representing the Triumphs of Petrarch in the Isabella Stewart Gardner Museum in Boston. Other cassone panels painted by him and his workshop are in Bergamo and London, and a pair in the Birmingham Museum of Art (Alabama) representing the Seven Virtues and the Seven Liberal Arts with their famous exponents.

Pesellino's manner is charming and pleasing. His panels are colorful, and the stories and figures are richly embellished with descriptive detail, attributes, and symbols. Special attention is always lavished on the elaborate dress and scenery. Some of his compositions and groups are sources for paintings of such later Florentine artists as Botticelli and Filippino Lippi.

7 Allegorical Figure, Possibly Justice

Pen and ink on paper, 193 x 168 mm. Verso: A sketch of an infant and the remains of a decorative frame drawn in pen and ink by Giorgio Vasari; inscribed in a seventeenth-century hand, Tadeo Gaddi.

Provenance: *Giorgio Vasari (?); Unknown. Acquired in the 1930s.*

Bibliography: *Degenhart-Schmitt, 1968, p. 554, fig. 789; Ragghianti Collobi, 1974, p. 64, fig. 154; Szabo, 1978, no. 12.*

As attested by the decorative frame drawn by Vasari on the verso, the drawing was once part of his *Libro de' Disegni*. His attribution is not known, but it might have been to Taddeo Gaddi, the Florentine artist indicated by the seventeenth-century inscription. Degenhart-Schmitt and Ragghianti Collobi assert that the figure is a sixteenth-century copy of the *Iustitia* of the cassone panel in Birmingham, Alabama. However, there are distinct differences between the two (cf. Shapley, 1970, pp. 110–11). For instance, the Birmingham *Justice* is represented with a scalloped halo, while this figure is adorned with a spiked crown embellished with a diadem on the front. The usual attributes appear on the panel, sword in right hand, scale in left; in the drawing she holds the sword in her right hand, but her extended left hand supports a large globe, possibly an orb borrowed from the attributes of her most illustrious exponent, Solomon. The robe is also more elaborate, with indications of an embroidery-like design at the neck and on the sleeve.

In spite of the doubts and the iconographic differences, the harmonious figure and her elaborate attributes still bind this drawing to the ambience of Pesellino; for example, it might be by Domenico di Michelino, to whom several of Pesellino's works have been attributed.

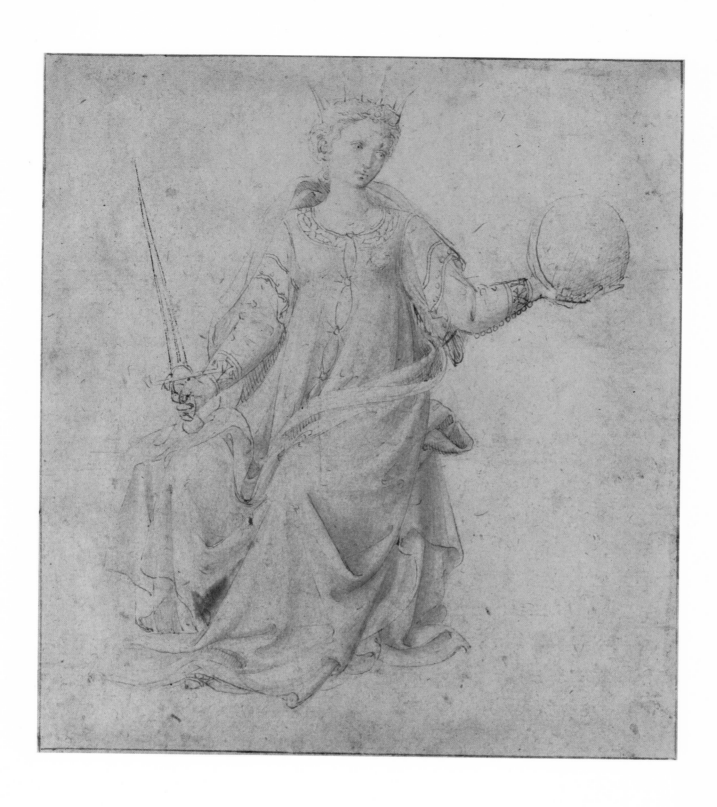

GIOVANNI DAL PONTE (GIOVANNI DI MARCO)

Florentine painter, born about 1385; died late in 1437; probably resided on the Piazza di San Stefano near the Ponte Vecchio and acquired his nickname from that. He received his training in the workshop of Spinello Aretino and later was influenced by Lorenzo Monaco and Masaccio. His style, still bound to earlier traditions of Florentine art, places him among the artists of the transitional group together with the so-called Maestro del Bambino Vispo.

Giovanni dal Ponte's activity as a painter of altarpieces, frescoes, and cassone panels is well documented. In 1408 he became a member of the Guild of Saint Luke; in tax declarations of 1427 and 1430 he is mentioned as a cassone painter; several of his altarpieces are dated 1410, 1430, 1434, and 1435. In contrast to the many well-dated and well-documented paintings, no drawings can be attributed to him with any certainty. Vasari mentions having a watercolor by him in his *Libro* which represented Saint George killing the dragon and also contained a skeleton, but it is not known.

8 Studies of Apostles and Allegorical Figures

Silverpoint with white and bister and brush on red prepared paper, 248 x 184 mm. Later additions in pen and black ink on several figures and the Roman numeral XXXII in upper right corner. Traces of old repainting and restoration along the edges.

Provenance: *Unknown.*

Bibliography: *Buffalo Cat., 1934, no. 2; Orangerie Cat., 1957, no. 102; Cincinnati Cat., 1959, no. 194; Degenhart-Schmitt, 1968, no. 196; Ragghianti Collobi, 1974, pp. 36, 41; Szabo, 1978, no. 13.*

When the drawing was acquired in the early 1930s it was attributed to Giovanni dal Ponte; however, there is no direct relationship between this sheet and the securely attributed and dated works of the artist. The three large figures represent cardinal virtues displaying their attributes. Temperance, in the upper left, is shown with two vessels, the mixed liquid flowing between them; Hope, at the right, with uplifted arms; and finally the diademed Justice in the lower left corner, with a long sword in her right hand and a globe in her left. Three small seated figures of apostles in the lower right quarter may be studies for an Ascension scene.

Degenhart-Schmitt, while pointing out the lack of any known drawing by Giovanni dal Ponte, compare this sheet with the miniatures of a Breviary in the Biblioteca Laurenziana dated shortly after 1426. As they seem to discover some similarities between the figures on the drawing and those representing the three Marys at the tomb of Christ in this Florentine manuscript, they assign a date in the early 1430s to this sheet.

In the wider context of Giovanni dal Ponte's dependence on his contemporary Lorenzo Monaco (c. 1372–1424), it is far more interesting to compare this drawing with one described by Vasari and attributed by him to Lorenzo: "In my book of drawings I have, by the hand of Don Lorenzo, the Theological Virtues done in chiaroscuro with good design and beautiful and graceful manner, insomuch that they are peradventure better than the drawings of any other master whatsoever of those times." (Vasari, *Lives*, vol. 2, p. 58). As Ragghianti Collobi also noted, both the subject and technique mentioned by Vasari correspond perfectly with this sheet, which also possesses the qualities of "good design" and "beautiful and graceful manner." The correspondence between the drawing and Vasari's description, combined with the repainting and restoration of the edges which are similar to those of Vasari, a well-known mender of old drawings, give rise to the possibility that this drawing, too, may have been part of his *Libro*.

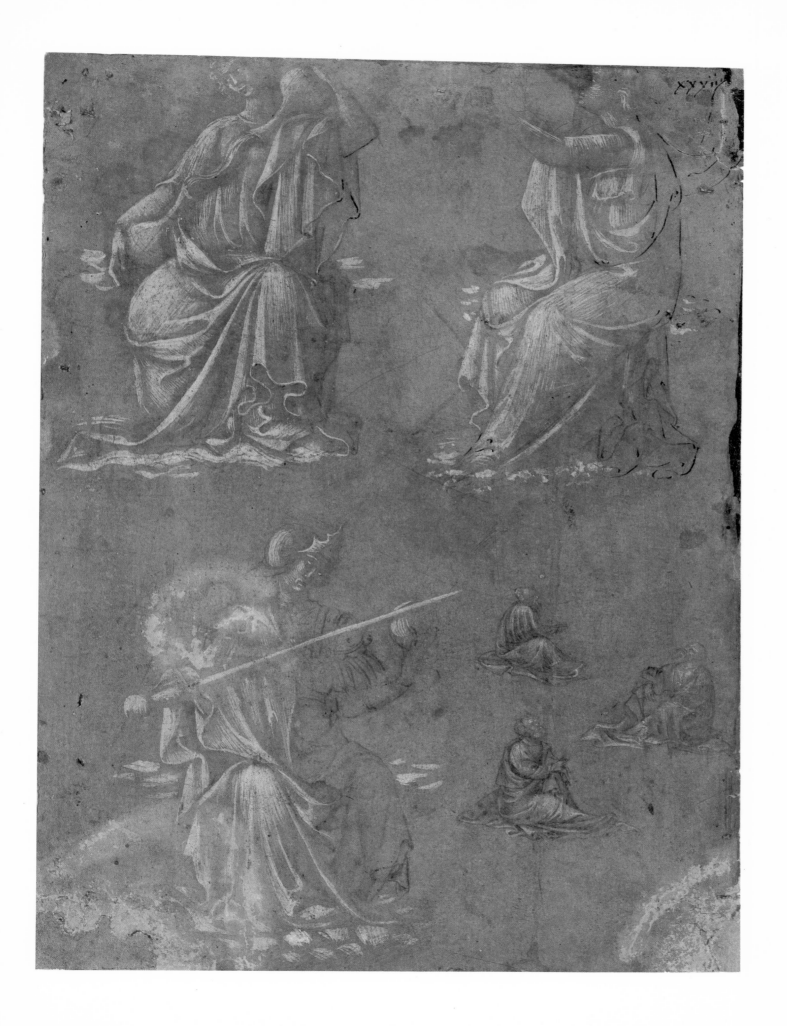

MICHELE GIAMBONO (MICHELE DI TADDEO BONO)

Venetian painter and mosaicist, active between circa 1420 and 1462. Giambono's name appears first in a document of 1420; he is next mentioned in 1440 when, together with the sculptor Paolo Amadei, he received a commission to paint a panel for the Church of San Michele in San Daniele, Friuli. Among his other dated works is a Paradise panel for the Church of Sant'Agnese (now in the Accademia, Venice). Between 1449 and 1451, he worked on the mosaics of the Mascoli Chapel, and several times he served as arbitrator and advisor for various artistic projects, among others the judgment of Donatello's *Gattamelata* in Padua.

Influenced by Jacobello del Fiore, Gentile da Fabriano, and Pisanello, Giambono was one of the last exponents of the Venetian phase of the International Gothic. In contrast to some of his predecessors, Giambono's paintings are forceful, with a strong emphasis on large sculptural figures, elaborate decoration, textiles, and lavish embroidery. However, they lack the subtlety and refinement of his forerunners. Many of his paintings are signed *MICHAELI.IOHANNIS.BONO.BENETVS.PINXIT.* However, since none of the drawings attributed to him carry any signature, their relation to Giambono's oeuvre is still debated.

9 Knight on Horseback

Pen and ink on paper, 203 x 146 mm. Inscribed in pencil in an eighteenth-century hand in lower left corner, Giambono.

Provenance: *Collection of the Moscardo Family, Verona; Conte Lodovico Moscardo, Verona; Marquis de Calceolari (until 1920); Luigi Grassi, Florence (Lugt Supplement 1171b).*

Bibliography: *Grassi Sale Cat., 1924, no. 81; Buffalo Cat., 1934, no. 2; Tietze, 1945, no. 701, p. 167; Orangerie Cat., 1959, no. 102; Cincinnati Cat., 1959, no. 200; Szabo, 1978, no. 14; Szabo, Notes, 1981, pp. 34—37.*

The basis for the firm attribution to Giambono has always been the close relationship between the drawing and one of the artist's most important paintings, a panel representing San Crisogono, now in the Church of San Trovaso in Venice (Zava Boccazzi, 1966, pl. XIII). This panel, though neither dated nor signed, is generally assigned to the artist's middle period, 1440—45. The later date is especially favored, because of the presence of the Holy Cipher of Saint Bernardino of Siena on the saint's shield, which appears only after 1444. There are strong correspondences between the painting and the drawing, among others the powerful horses, the well-balanced composition, and particularly the successful accommodation of the knight to his mount. Further similarities are in the structure and representation of the armor and the elaborate harness. On the other hand, the knight in the drawing is somewhat younger, and the movement of both horse and rider seems to be much freer.

It is well established that the horse in Giambono's equestrian figure on the San Crisogono panel is derived from the bronze horses of San Marco (F. Valcanover, "The Horses of San Marco in Venetian Painting," in *The Horses of San Marco*, 1979, pp. 84, 87). This dependence is even stronger in the drawing where it is specific, in contrast to the painting, where the relationship is of a general nature. It is very likely that Giambono based this horse on the right pole horse of the quadriga, the second from the left as one faces San Marco. The stance, the body, and the details of the anatomy are quite analogous. On the other hand, there are distinct differences, simply because the artist adjusted the chariot horse to the requirements of a mount that must harmonize with its rider. Consequently some parts of the anatomy that are freely moving on the bronze horse seem to be constrained in the drawing by the elaborate harness and saddle. As this composition also bears a resemblance to some equestrian representations by Pisanello, a later dating than that of the San Crisogono should be considered. Giambono may have received some fresh insight into the nature of the equilibrium between horse and rider while working in San Marco between 1449 and 1451, or while serving on the arbitration committee of the *Gattamelata* in 1453, therefore raising the possibility of dating this drawing to the early 1450s.

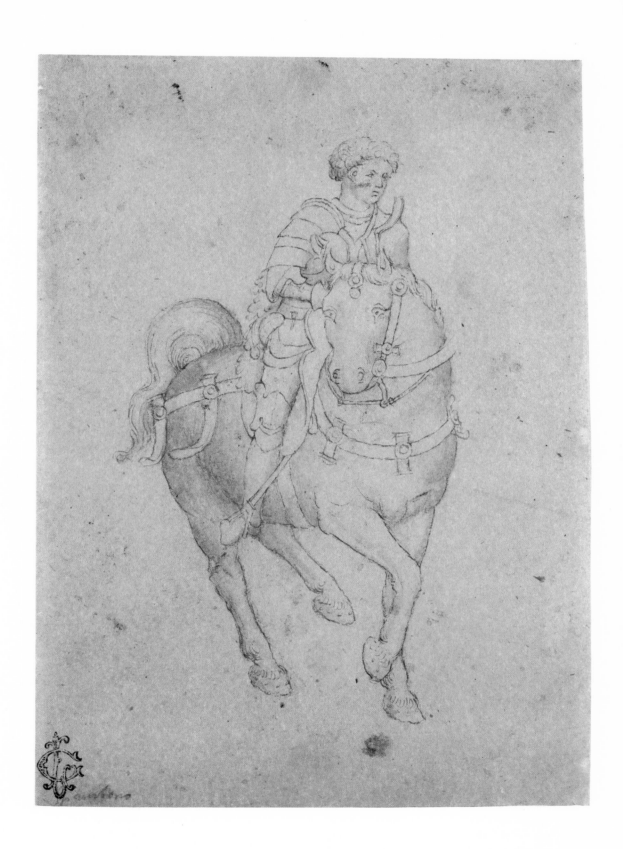

ANTONELLO DA MESSINA (ANTONELLI DI GIOVANNI DEGLI ANTONI)

Painter, active in his native Messina, in South Italy, and in Venice; probably born around 1430, a date that may be deduced from Vasari's placing his death in February 1479. In 1524 Antonio Summonte recorded that Antonello was an apprentice to the mysterious Neapolitan painter Colantonio. In his *Lives* first published in 1550, Vasari states that Antonello, after seeing some oil paintings of Jan van Eyck in the court of Naples, went to Flanders and in Bruges learned the methods of working in oil from Jan. Vasari further states that Antonello in turn taught the secret of oil painting to Domenico Veneziano. Any relationship with either artist is impossible chronologically, since Antonello was only nine years old the year Jan van Eyck died and Domenico probably died before Antonello's first visit to Venice.

The documents discovered in Sicilian archives which mention Antonello are more dependable. From these it is known that his father was a "marble-mason," i.e., sculptor; in 1456, 1457, and 1461, Antonello is described as being head of a workshop that had apprentices. Between 1461 and 1465 he was active in various places in South Italy, possibly in Naples and Reggio Calabria. His earliest work, the *Salvator Mundi* (Christ Blessing), is dated 1465 (London, National Gallery). There is no mention of Antonello between 1465 and 1472/73, but in 1473/74 his presence in South Italy is clearly documented. In 1475 Antonello appears in Venice and commences work on the San Cassiano Altarpiece. He worked continuously on this project until March 1476, when a letter from the nobleman Pietro Bon records his satisfaction at the way Antonello carried out this commission. Probably as a result of the success of this altarpiece, Antonello was offered the post of Court Painter in Milan to replace Zanetto Bugatti, but for reasons unknown to us he was back in Messina by September 14, 1476, and seems to have spent the rest of his life in his native city.

The influence of Flemish painting, both in composition and in technique, was a dominant force in Antonello's oeuvre. But the Northern manner was always fused with the rich Italian traditions, as far-ranging as the great mosaics in the Cathedral of Palermo and the portraits of the Venetians.

10 Studies for a Group of Figures

Pen and ink with wash on paper, 121 x 152 mm. The sheet is cut on all sides and a large piece is missing from the upper left corner.

Provenance: *Unknown. Acquired in Paris in the 1920s.*

Bibliography: *Buffalo Cat., 1934, no, 11; Frankfurter, 1939, pp. 128–29, fig. 18; Longhi, 1953, pp. 27–28, 30, fig. 27; Orangerie Cat., 1959, no. 85; Cincinnati Cat., 1959, no. 236; Causa, 1964, p. 4, fig. 4; Murray, 1966, p. 5, fig. 3; Sciascia-Mandel, 1967, pp. 88, 104; Szabo, 1978, no. 16.*

Ever since the acquisition of this drawing these six figures have been described as female mourners, possibly for a Crucifixion scene. Close examination, however, reveals that only five share the same characteristics and are women. They have comparatively small heads and large bodies draped in ample robes gathered in rich folds on the ground. They resemble sculptures in their almost monolithic mass and avoidance of detail, with faces and heads indicated in a rather perfunctory manner. The sixth figure, partially visible between the two robed women on the left, is markedly different: the face is more detailed—almost individualistic—and the mantle is replaced by a wide hat. In addition, while the five women gaze stolidly at each other within the confines of their group, this sixth figure looks out with raised head and piercing glance, almost challenging the onlooker, and may be identified as a male.

The technique is very refined; lines are sparsely used, shapes, shadows, and folds are formulated with minute stippling of the pen and possibly by a fine brush, reminiscent of Flemish drawings. It is therefore not surprising that at the time the drawing was acquired it was attributed to the Flemish artist, Petrus Christus (active from 1443 to 1473). Although it cannot be connected to any of his known paintings and bears no resemblance to any of the drawings attributed to him, this sheet in general shows a great affinity to Flemish art of the mid-fifteenth century. Frankfurter proposed a comparison to "the concept of heavily draped male and female mourners" on Burgundian tombs of the fifteenth century and suggested that this drawing is "one of the few connected with the great Burgundian sculptors."

In a radical departure from these Northern attributions, Longhi identified the sheet as a study by Antonello da Messina for his *Crucifixion* formerly in the Bruckenthal Museum in Sibiu, now in the Muzeul de Artă in Bucharest (Sciascia-Mandel, 1967, no. 1, pl. 1). According to him, the figures are studies for the five mourning women standing at the foot of the cross in this small painting (23.5 cm), the earliest attributed to the artist and usually dated circa 1460–65. Furthermore, if this sheet preceded the *Crucifixion*, as Longhi contends, then it is also the earliest known datable drawing by Antonello and hence becomes the earliest tangible evidence of Flemish influence in his art, giving some support to Vasari's reference to such a connection.

In spite of the obvious similarity in composition, the seemingly convincing attribution, and its consequent acceptance by most scholars, Robert Lehman and a few other connoisseurs still preferred the association with Petrus Christus and a Flemish origin. Indeed, close examination reveals basic differences: the lamenting figures in the painting are more Italianate and animated, displaying a variety of poses, facial expressions, and gestures unlike the stolid and calm women of the drawing. On the other hand, the treatment of drapery in the drawing, with the rich variety displayed by the triangular folds, is more elaborate and Flemish than the plain vertical fall of the robes in the painting. The same differences may be detected when the drawing is compared with others attributed to Antonello (Fiocco, 1951, pp. 51–53; Sciascia-Mandel, 1967, p. 104) or to his paintings.

These dichotomies and differences can be reconciled by exploring a somewhat different solution. The figures with the relatively small heads and large bodies, the rich folds of the drapery arranged on the ground, seem to be closer to those of the Virgin and the angel in the so called *Friedsam Annunciation* in the Metropolitan Museum of Art (Wehle-Salinger, 1947, pp. 13–16; Ward, 1968, pp. 184–187). Although this panel is variously attributed to Hubert van Eyck, Jan van Eyck, or Petrus Christus, it is certainly post-Eyckian and not by Christus, and is undoubtedly by another major artist active in Bruges in the early 1450s. It displays some influences of Petrus Christus, as well as innovations in portrait painting that later culminated in the art of Hans Memling. The strong Flemish technique of the drawing implies that Antonello might have done this drawing while in Bruges and carried it back to Italy, later utilizing it in the preparation of the Sibiu *Crucifixion* without, however, transposing the figures directly to the painting. This is a more plausible solution than the assumption that the mature Antonello, married and the head of a prosperous workshop in Messina, would travel North for a protracted period between 1465 and 1472. Notwithstanding these problems, the drawing is a precious and important document and must be considered as one of the primary sources for the history of Flemish influence in Italy in the fifteenth century (cf., in general, Paolini, 1979, pp. 13–17; Paolini, 1980, pp. 156–65, where she also cites the *Friedsam Annunciation* as related to some of Antonello's paintings).

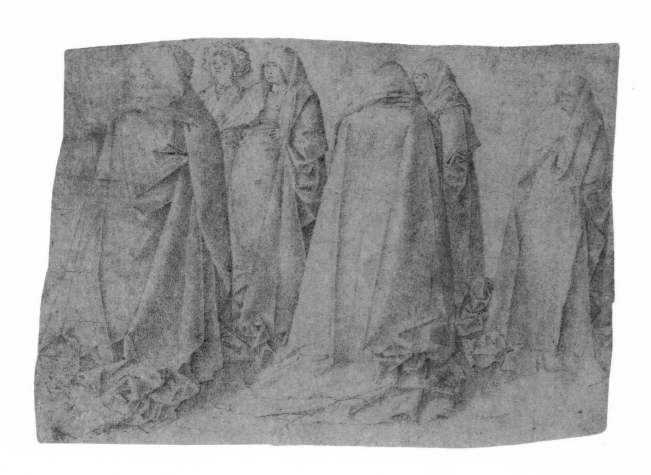

FRANCESCO DEL COSSA

Painter and designer of intarsia; born about 1436 in Ferrara; died 1478, probably of the plague, in Bologna. Francesco del Cossa, the son of a stonemason, painted his earliest frescoes in his native city in 1456. Cossa was subject to various stylistic influences in Ferrara where the Este family patronized such outstanding artists as Pisanello, Jacopo Bellini, Leon Battista Alberti, Piero della Francesca, and Andrea Mantegna. Besides panel paintings, such as the *Madonna* in the Kress Collection (Washington, D.C., National Gallery of Art) or the *Annunciation* for the Church of the Osservanza, he also designed stained glass windows and intarsia. The pinnacle of his career was the altarpiece for the Foro dei Mercanti which he completed in 1474 and the decoration of the Vault of the Garganelli Chapel in San Pietro in Bologna (1477; destroyed 1605).

11 Venus Embracing Cupid at the Forge of Vulcan

Pen and brown ink on paper, 280 x 407 mm.

Provenance: *Jan Pietersz. Zoomer (Lugt 1511); John Skippe; Descendants of John Skippe, the Martin Family, including Mrs. A. C. Rayner Wood; Edward Holland Martin.*

Bibliography: *Fry, 1906–7, no. 14; Parker, 1927, no. 24; Popham, 1930, no. 147; Columbia Exh., 1959, no. 6; Ruhmer, 1958, pp. 40–41; Bean-Stampfle, 1965, no. 8; Szabo, 1975, pl. 196; Images of Love and Death, 1975, no. 59; Szabo, 1977, no. 3; Szabo, 1978, no. 17.*

This exceptionally large and magisterial sheet is unquestionably North Italian. But the complex iconography, its purpose, as well as any precise attribution still present a great variety of problems and at best only tentative solutions.

The central focus of the composition is Venus, seated on a rocky mount, holding the winged Cupid who stands between her legs crossed at the ankles and embraces her. His blindfold is raised to his forehead. Venus and Cupid are surrounded by four attendant maidens, possibly the Hours; the two on the left seem to arrange Venus's hair, the third holds a perfume vial, and the fourth an elaborately framed mirror. As if in antithesis to their refinement, the rocky mount under them has a dark opening before which are the crude tools of the blacksmith, hammer on the anvil, tongs against the stock, and a sturdy three-legged stool. Vulcan himself is weaving a fence around the mount. In contrast to the graceful garments of Venus and her group, he is raggedy, with a hammer stuck in his belt. Inside and outside the fence are nine winged putti in various poses, some with bow and arrow, some with only a quiver. The two who embrace at the gate in the center may be Eros and Anteros. In the upper left, from the direction of a palazzo with elaborate architectural details, three young women, perhaps the Graces, approach the enclosure through a rear gate. Each is holding an unidentified object. In the sky above them is a half-figure of a bull, the sign of Taurus. In the upper right corner, a winged, cherub-like figure is blowing flowers toward Venus's group. In the distant background, cities and castles on hilltops complete the composition. In addition, various animals further embellish the rich iconography: two rabbits are playing on the mount, a peacock is perched on the fence, and there are songbirds on the branches of the trees.

Ever since Fry first published the drawing in 1906, the richly inventive and involved iconography has been connected with the elaborate allegories of the cycle of frescoes in the Schifanoia Palace at Ferrara, painted by Ercole de' Roberti, Cosimo Tura, and, between 1469 and 1470, Francesco Cossa. It has further been suggested that the drawing may be "a model for a counterpart to the Mars-Venus fresco" (Columbia Exh., 1959, no. 9). The symbolism seems to confirm this theory; the enclosure with the fence probably represents a bond of marriage, further underlined by the presence of the peacock, a bird of Juno, the guardian of marital fidelity. The embracing Eros and Anteros may signify the emphasis on mutual love. The flower-blowing cherub may be Zephyrus and, together with the zodiacal bull, would imply that the scene represents the month of April, which is also governed by the planet Venus.

Whether the virtuoso drawing is by Cossa or by one of his associates is hard to ascertain, because no documented drawings are known (Bean-Stampfle, 1965, p. 23). The complicated cross references of the allegorical representations seem to indicate careful planning and also reveal that the theme of the drawing was partially inspired by Pellegrino Prisciano, the probable author of the Schifanoia cycle. Besides the thematic variety, the excellence in drawing, the elegant figures, and the playful putti strongly imply that if the drawing is not an autograph work of Cossa, it is by another major master and not by a somewhat lackluster follower like Parentino, as suggested by Ruhmer. A careful analysis and comparison with other Ferrarese drawings of the period, such as the *Orpheus* in the Uffizi, might shed a new light on this and other drawings attributed to Cossa (Tempesti-Tofani, 1974, no. 32).

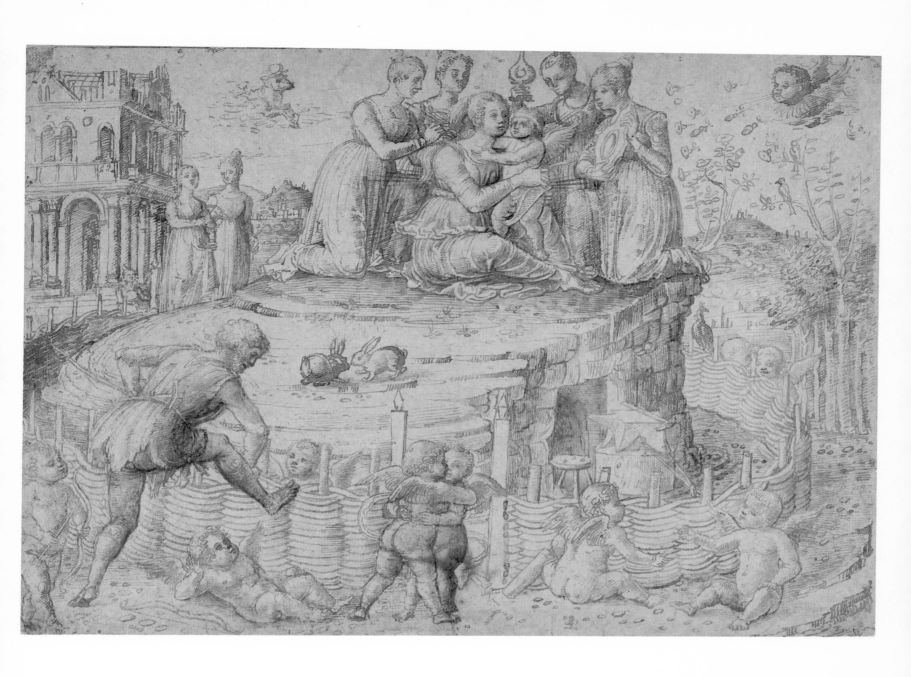

ANTONIO DEL POLLAIUOLO

Painter, sculptor, and goldsmith; born 1431 or 1432 in Florence; died 1498 in Rome, buried there in the church of San Pietro in Vincoli.

Antonio del Pollaiuolo—whose name stems from *pollaiolo,* i.e., "poultry vendor," which describes his father's enterprise at the old market in Florence—began his education as an apprentice goldsmith working under famous artists in this field, such as Maso Finiguerra and Pietro Sali. But his attention must have been directed very early to the work of Donatello, who serves as the basic source of inspiration for that synthesis of form and movement that Pollaiuolo achieved by animating his powerful images by means of an exaggerated linear tension. Among his works which attain a truly outstanding level of quality are the very beautiful silver relief panel for an altar representing the Birth of John the Baptist (1477—83), now in the Museo dell'Opera del Duomo, Florence, the small bronze *Hercules and Antaeus,* in the Bargello at Florence, and the tombs of Pope Sixtus IV, in the Vatican Grottoes, and Pope Innocent VIII, in Saint Peter's.

Antonio's work forms a decisive stage in the evolution of fifteenth-century Florentine art because of the fundamental role he played in the transformation of that specifically Renaissance concern for the relationship between the figure and space which occurred in the middle of the century, when the earlier insistence on a geometric balance between form and space gives way to a system in which the figure dominates the environment which spreads out as a distant panorama beyond him. Among Pollaiuolo's paintings these characteristic elements of his style can best be seen in the two small panels depicting the Labors of Hercules in the Uffizi, the *Apollo and Daphne* and the *Martyrdom of Saint Sebastian* in the National Gallery, London, the splendid *Rape of Deianira* in the Yale University Art Gallery, New Haven, and the famous *Portrait of a Lady* in the Museo Poldi Pezzoli in Milan.

12 Study for an Equestrian Monument to Francesco Sforza

Pen and brown ink with light-brown wash on paper, 285 x 244 mm. The outlines of the rider and the horse are pricked for transfer; the background is covered with a dark-brown wash. Inscribed at upper right in capital letters, GATAMEL.

Provenance: *Giorgio Vasari (?); Simon Meller, Budapest-Paris; Philip Hofer, Cambridge, Mass.*

Bibliography: *Vasari,* Lives, *p. 297; van Marle, vol. XI, p. 370; Meller, 1934, pp. 76—79, 204—6; Buffalo Cat., 1934, no. 9; Kurz, 1937, p. 13; Berenson, 1938, p. 27, no. 1908A; Tolnay, 1943, p. III, pl. 42; Colacicchi, 1945, pl. 77; Tietze, 1947, no. 13; Ortolani, 1948, pp. 169, 220—21; Orangerie Cat., 1959, no. 119; Halm-Degenhart-Wegner, 1958, p. 26; Cincinnati Cat., 1959, no. 203; Berenson, 1961, p. 59, no. 1908A; Degenhart-Schmitt, 1964, p. 58, fig. 12; Bean-Stampfle, 1965, no. 6; Pope-Hennessy, 1971, fig. 87; Spencer, 1972, p. 741; Spencer, 1973, pp. 23—35; Ragghianti Collobi, 1974, p. 78; Szabo, 1975, no. 173; Bush, 1978, pp. 47—49; Szabo, 1978, no. 19; Ettlinger, 1978, no. 34; Hibbard, 1980, p. 230, fig. 409; Szabo, Notes, 1981, pp. 35—37.*

This drawing, and the closely related one in the Staatliche Graphische Sammlung at Munich, were once part of Vasari's *Libro* and were described by him in detail in the *Lives.* As primary works of art both are of great importance for the evaluation of Pollaiuolo's creative process and drawing style. In addition, they comprise a set of unusual documents for the seminal period in the development of the equestrian monument in Italy. Finally, the two sheets are precious representatives of the earliest period of connoisseurship in drawings and are important elements of Vasari's *Libro.*

Pollaiuolo's role in the ill-fated Sforza project, his sources and ideas unfold from the close study of these drawings and the related literary material. The idea of an equestrian monument to Francesco Sforza was originally conceived in 1473 by his son, Galeazzo Maria Sforza. It was to honor and perpetuate his father's memory and the establishment of the Sforza dynasty in Milan. Several artists and craftsmen made proposals for the monument, but their offers were not satisfactory (cf. Bush, 1978, pp. 47—49). Pollaiuolo may have begun work any time after 1473, but it is most likely that his serious involvement in the project started around 1480 and ended by 1483 at the latest, when Leonardo da Vinci offered his services and design to Lodovico Sforza, "which is to be to the immortal glory and eternal honour of the prince your father of happy memory, and of the illustrious house of Sforza," and was awarded the commission for the bronze (Richter, 1939, vol. II, sect. 1340).

Pollaiuolo's approach and careful plans for the monument are well documented by the two drawings and by the writings of their one-time owner, Giorgio Vasari. He describes them precisely: "And after his [Pollaiuolo's] death there were found the design and model that he had made at the command of Lodovico Sforza for the equestrian statue of Francesco Sforza, Duke of Milan, of which design there are two forms in our book; in one the Duke has Verona beneath him, and in the other he is on a pedestal covered with battle pieces, in full armour, and forcing his horse to leap on a man in armour. But the reason why he did not put these designs into execution I have not yet been able to discover" (Vasari, *Lives,* vol. III, p. 242).

The earlier of Pollaiuolo's designs for the monument is this drawing, not only because Vasari mentions it first, but also because the contours of the rider and the horse are pricked for transfer, while the figure of Verona is not. This seems to indicate that only the main figures were copied and used on the later version, the drawing in Munich (Halm-Degenhart-Wegner, 1958, p. 26). Power and strength, unity of horse and rider are masterfully expressed by the decisive lines and carefully applied washes. The composition is well balanced and augmented by the facial expressions of the prince, the figure of Verona and even of the horse—all suggesting conquest and triumph.

The sources for Pollaiuolo's design were varied and are still not sorted out fully. It seems, however, that besides pictorial precedents such as manuscript illuminations, reliefs, and coins (Bush, 1978, p. 49; Spencer, 1973, pp. 23—25) and the influence of Donatello's *Gattamelata* (1447—53), the bronze horses of San Marco also played a large role in formulating his concept and ideas of the equestrian monument (cf. Szabo, 1971, pp. 35—36). The figures of Verona and the man in armor that provide supports for the rearing horse are important solutions to a problem that vexed so many Renaissance artists, including Leonardo. It is not surprising, therefore, to find echoes of these two drawings in many of his later drawings for various equestrian monuments and statues (cf. Bush, 1978, pp. 52—55).

This drawing and the one in Munich were apparently preserved after Pollaiuolo's death—there is no word of the modello—by the person who inscribed it with the name *GATAMEL[ATA].* Later, they were acquired by Vasari for his *Libro.* He carefully mended this sheet and added the dark-brown ink in the background, most likely so it would conform to the Munich sheet (Degenhart-Schmitt, 1964, p. 58). It is a melancholy fact that Pollaiuolo's and Leonardo da Vinci's proud projects, meant to be cast in bronze, survive only on fragile paper that proved to be *aere perennius.*

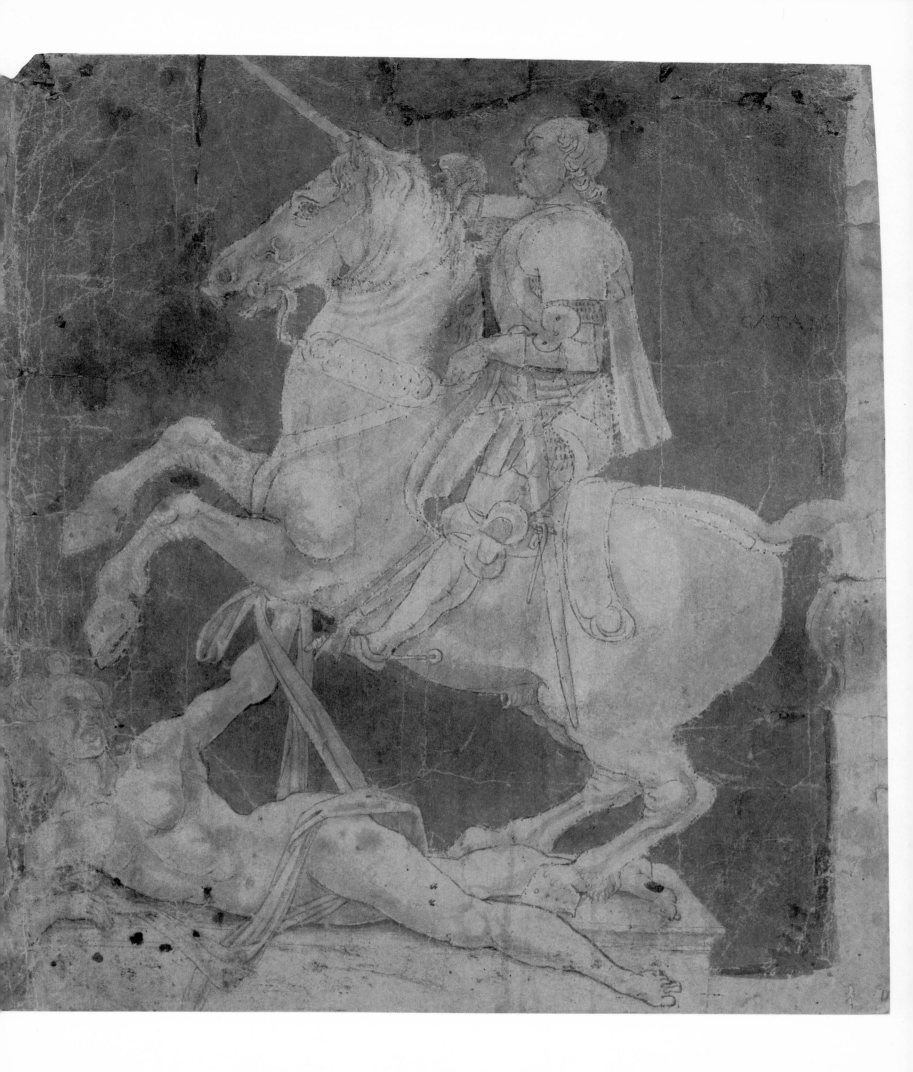

13 Seated Figure of a Prophet or a Saint

Pen, brown ink and brown wash heightened with white paint on paper, 279 x 187 mm. Finely pricked for transfer; horizontal fold in the middle; a section from the lower left corner is missing.

Provenance: *Nicholas Lanière (Lugt 2885); C. M. Metz, London; Henry Oppenheimer, London.*

Bibliography: *Metz, 1789, no. 7; Italian Drawings, Royal Academy, 1930, no. 35; Clark, 1930, p. 176; Byam Shaw, 1935, p. 59; Oppenheimer Sale Cat., 1936, no. 38; Berenson, 1938, no. 669B; Kennedy, 1938, pp. 151–52; Cincinnati Cat., 1959, no. 202; Berenson, 1961, no. 669B; Bean-Stampfle, 1965, no. 7; Szabo, 1977, no. 1; Szabo, 1978, no. 20.*

An impressive list of names and attributions has been attached to this drawing ever since Metz engraved it (in reverse) in 1789 and assigned it to Piero della Francesca. A connection with Pollaiuolo was first mentioned in 1930, when A. E. Popham included it in the great Italian drawings exhibition at the Royal Academy, Burlington House. In a review written on this occasion, Kenneth Clark suggested that it might be a cartoon for embroideries and ascribed it to Castagno. Byam Shaw and K. T. Parker (Oppenheimer Sale Cat.) assigned the drawing to the oeuvre of Francesco Botticini. In 1938 Berenson proposed that, "Perhaps it is the pricking that suggests drawings for embroideries and inclines me to wonder whether it is not rather a copy and a faithful one, after C. [Castagno] by Raffaele dei Carli [Raffaelino del Garbo]." He maintained this possibility later, not only in print, but also in private communication to Robert Lehman, and his suggestion was accepted by Bean-Stampfle, the authors of the catalogue for the Italian drawings exhibition of 1965 in New York.

Yet another attribution was proposed by Ruth Wedgwood Kennedy in 1938. While carefully considering and then rejecting Castagno and Pollaiuolo, she suggested that the drawing shares some similarities with the prophets and evangelists of Alesso Baldovinetti in San Miniato al Monte. Kennedy remarks further that the "extreme care with which even the pricking has been done almost attests Alesso's patient hand." Although this attribution is very convincing, it must be pointed out that the proportions of the figures are quite different, namely, this reading apostle has a relatively large head, while those in the San Miniato frescoes are characterized by smaller ones. There are other differences in the treatment of the beards and the drapery which further advise caution in accepting Kennedy's attribution.

The recurring observation that the fine pricking suggests that this drawing could have been a cartoon for an embroidery probably provides the solution to the unsettled problem of attribution. Kennedy already remarked that "the seated figures of saints on the narrow band of embroidery at the top of the paliotto of Sixtus IV . . . are about the size of the drawing" (Kennedy, 1938, p. 228). This embroidered altar-frontal in the Treasury of San Francesco at Assisi was probably designed by Pollaiuolo. He might have been assisted in this project by his brother, who also worked with him on the bronze tomb of Sixtus IV in the Vatican Grottoes (Ettlinger, 1953, pp. 251 ff.). Therefore, it could be proposed that both Pollaiuolo brothers had a hand in this drawing, although for the time being there is no dependable separation of their respective drawing styles. The fine pricking on the other hand was most likely done by the embroiderer who executed their joint design.

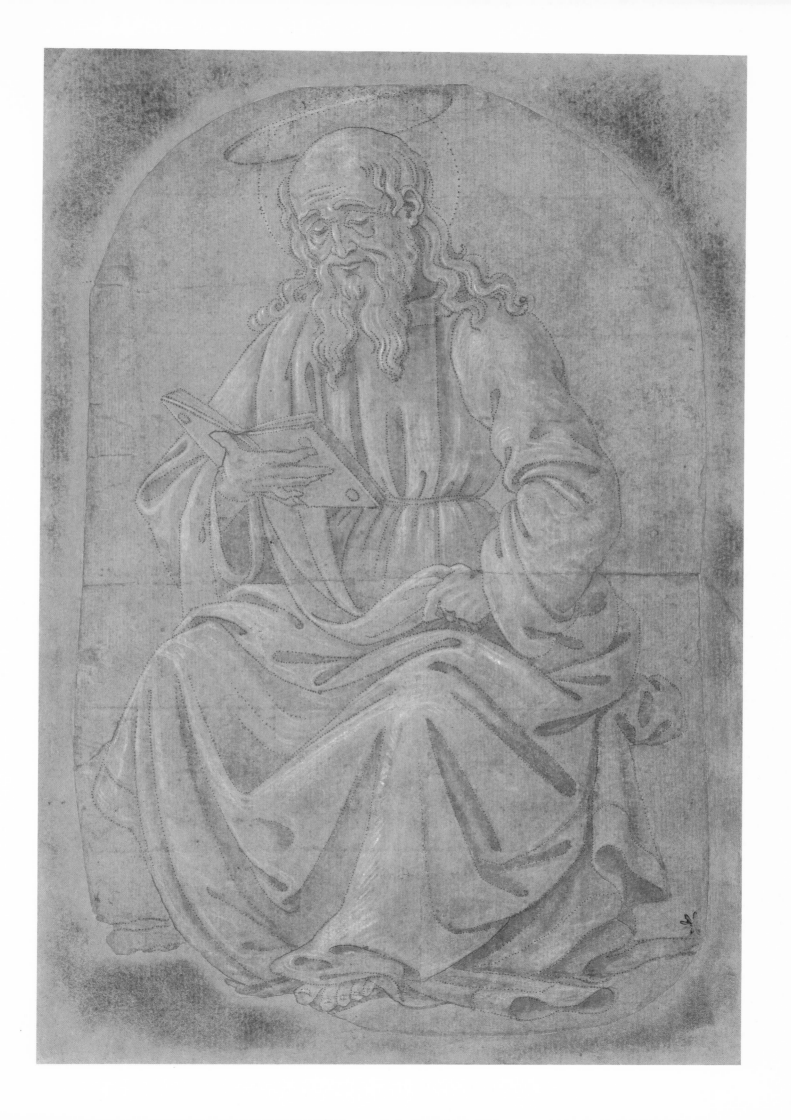

FRANCESCO DI GIORGIO (FRANCESCO DI GIORGIO MARTINI)

Painter, sculptor, architect, and engineer; born in Siena in 1439; died between November 1501 and February 1502. Less known than his younger Florentine contemporary, Leonardo da Vinci, Francesco di Giorgio was nevertheless another "Renaissance man," as Leon Battista Alberti had been earlier and Michelangelo would be later. It is assumed that Francesco was taught by Vecchietta and later was associated with Neroccio de' Landi. As a painter he created outstanding large-scale works such as the *Coronation of the Virgin* (1472) and the *Nativity* (1475), both now in the Pinacoteca in Siena. As a sculptor and bronze caster, he is best known for the two bronze angels made for the high altar of the cathedral in Siena (1497) and for poetic small bronze reliefs and plaquettes. Francesco was greatly appreciated in his native city and elsewhere. Between 1477 and 1482 he worked for Federigo da Montefeltro, Duke of Urbino. In 1486, he returned to Siena where he was appointed official engineer and architect. Besides building over one hundred fortresses and other secular buildings, even as far away as Naples, he planned the cupola of the cathedral of Milan (1490).

An author as well as a famous architect and military engineer, Francesco di Giorgio wrote several theoretical treatises, among them, the *Opusculum de architectura* for the Duke of Urbino (c. 1475); another entitled *Macchine*; an annotated booklet of drawings, *Monumenti antichi* (1480–90); a translation of Vitruvius; and, finally, the *Trattato di architettura civile e militare* (1495).

14 A Kneeling Humanist Presented by Two Muses

Pen and brown ink with brown wash and blue gouache in the background on vellum, 184 x 194 mm. Inscribed on the tablet in pale chalk, Franco Francia Bolognese. *Also inscribed in pen and ink by a later hand in lower left corner,* Franco Francia.

Provenance: *The Le Hunte Family Collection, Artramont, Co. Wexford, Eire; Misses M. H., L. E., and M. D. Le Hunte.*

Bibliography: *Orangerie Cat., 1959, no. 98; Columbia Exh., 1959, no. 7; Bean-Stampfle, 1965, no. 10; Chastel, 1969, pp. 167, 171; Szabo, 1975, no. 175; Szabo, 1977, no. 3; Szabo, 1978, no. 21.*

The man in the center is described as a humanist. His hands are joined in prayer and therefore it is possible that he is kneeling. Over his right shoulder, parts of a hat are visible, a further indication of his secular standing. He is flanked by two seated female allegorical figures that probably represent Muses or Virtues. Each holds a book and the one on his left appears to wear a garland of flowers and leaves (laurel?) in her hair. The three figures are harmoniously placed into the round opening, the inside of which is coffered and decorated with rosettes, and are surrounded by a wide framework that is broken only on the bottom by a large tablet (*tabula ansata*).

This very appealing drawing was first attributed to Francesco di Giorgio by Philip Pouncey, former Keeper of Prints and Drawings of the British Museum, which owns a manuscript on engineering and military subjects illustrated with drawings by the Sienese artist (MS 1947-1-17-2; Popham-Pouncey, 1950, no. 55, pp. 32–38). Pouncey recognized that several figures in this manuscript are closely related to those in the drawing and that there are close correspondences between them in style, handling, and spirit. The relationship is especially evident with the figure of Abundance on folio 2 of the British Museum manuscript (Popham-Pouncey, 1950, pl. XLVIII). Since the manuscript belongs to the period between 1477 and 1482, a later date for the drawing, such as circa 1475, is possible rather than an earlier one, on the basis of a comparison with the artist's *Nativity* in the Pinacoteca in Siena (Columbia Exh., 1959, p. ii).

The attempt to suggest modeling in the round, the use of somewhat inconsistent perspective, the careful construction of the round framework (the large hole in the lower right palm of the man confirms that the artist used a compass) seemed to indicate to previous commentators a design for a sculptural project. However, the introduction of the blue paint into the background and the relative flatness of the drawing might be signs of a project for a *trompe l'oeil* painting. Although such illusionistic compositions are not known in Francesco's oeuvre and are not indicated in any of his theoretical works, they were not unusual in the art of his time, especially in Lombardy. For instance, he could have been influenced by the illusionistic paintings of the Milanese artist Vincenzo Foppa, his *Madonna and Child with Saints John the Baptist and John the Evangelist* (Milan, Pinacoteca di Brera), for example, or more likely, his roundel in fresco of an apostle in the Portinari Chapel at Sant'Eustorgio, also in Milan, dated 1468 (Dalai Emiliani, 1971, pp. 126–128). Traces of such influence and a greater assimilation of antique elements can also be detected in one of Francesco's late paintings, the *Nativity* in San Domenico, Siena (1480–90). In that painting, the coffered ceiling of the triumphal-archlike structure in the background has the same type of incorrect and hesitant perspective as the one in the drawing, again arguing for a later dating (Weller, 1943, pp. 232–33, fig. 94).

The manifold ties to painted compositions of all kinds indicate that the highly elaborate drawing probably was a demonstration model for a painted project, something like Philip Pouncey's suggestion in a verbal communication, "an illusionistic painting rather high on a wall opposite a painting of the Madonna and Child of the donor's benefactions" (quoted in Bean-Stampfle, 1965, p. 24). If this is so, then this highly unusual composition, in which a humanist-donor is presented by two Muses or Virtues instead of two saints or angels, is an innovation probably due to Francesco di Giorgio's contacts with the scholars and poets in the court of Federigo da Montefeltro and to their influence (Chastel, 1969, p. 171). The humanistic character of the composition may be further emphasized by the suggestion that the two Muses represent the two directions of poetry according to Aristotle's *Poetics:* the one with the garland, the high poetry, and the other one, the low (cf. Egan, 1959, pp. 306–7). Thus, the humanist in the center probably was a poet, whose features and name may one day be identified.

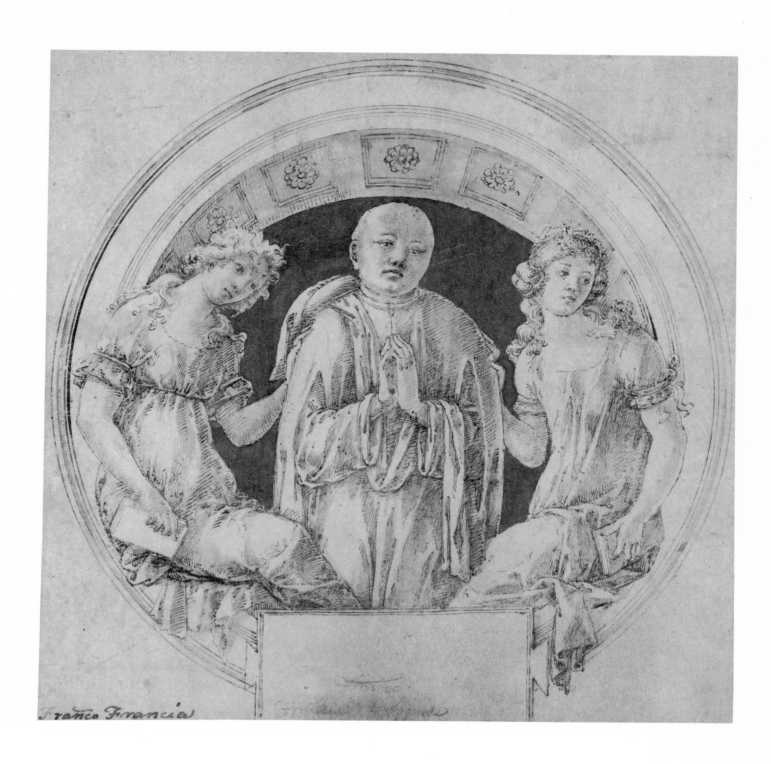

Franco Francia

GIOVANNI BELLINI

Son of Jacopo Bellini, brother of Gentile; born in Venice about 1430; died there, as Sanudo noted in his *Diarii*, on November 29, 1516.

After training first under his father, whose work frequently reveals his fascination with problems of perspective, Giovanni was drawn to the art of Antonio Vivarini and subsequently to that of Andrea Mantegna, who in 1453 had married Giovanni's sister. As early as 1459 Giovanni had his own workshop in Venice, but occasionally still collaborated with his father and brother. From 1460 until the time he painted his *Coronation of the Virgin* in Pesaro about 1470, Giovanni was much influenced by Mantegna, but in his interpretation of Mantegna's plastic form, color was always dominant. The *Pietà* in the Brera is the high point of this particular phase of Giovanni's development.

The trip to the Marches to paint the Pesaro altarpiece, during which he also visited Ferrara, Rimini, and Urbino, was fundamental for the substantial change in Bellini's style. Through the example of Piero della Francesca he was led to conceive a perspective system "in which light regulates the relationships between form and color." Also important was the arrival in Venice in 1475 of Antonello da Messina, under whose influence Giovanni's pictorial technique became softer and more diffuse. His painting gradually became more lyrical and deeper in its religious expression. This is the period of the *Resurrection* (Berlin) and the *Madonna and Saints* in the Uffizi. By the time of the triptych in the Frari in Venice, dated 1488, Bellini had fully achieved his atmospheric sfumato color.

In 1479 he was charged with the execution of some large canvases for the Sala del Gran Consiglio of the Palazzo Ducale, a commission that occupied him (with the help of numerous collaborators) until after 1493. With these works, which were destroyed by a fire in 1577, Giovanni assumed the role of official painter of the Venetian Republic.

Receptive to the trends of the new times, in the opening years of the sixteenth century his paintings became progressively more luminous, his colors modulated in soft and fluid tones, as in the *Baptism* in Santa Corona in Vicenza (1502) and the *Madonna and Saints* in San Zaccaria in Venice (1505). In the works of his last years, such as the altarpiece of 1513 in the church of San Giovanni Crisostomo, Bellini's color became warm and richly shadowed, demonstrating his assimilation, principally from Giorgione, of the new naturalism of High Renaissance painting.

15 Christ's Descent into Limbo

Pen and brown ink on paper, 270 x 200 mm.

Provenance: *Jan Pietersz. Zoomer (Lugt 1511); John Skippe; Descendants of John Skippe, the Martin Family, including Mrs. A. C. Rayner Wood; Edward Holland Martin.*

Bibliography: *Heinemann, 1962, no. 179, p. 54; Bean-Stampfle, 1965, no. 3; Hoffmann, 1971, p. 102; Early Italian Engravings, 1972, p. 210; Pignatti, 1974, no. 2; Szabo, 1978, no. 23.*

The focal motif of this monumental drawing is Christ reaching into the rocky mouth of hell to rescue the Old Testament forefathers (cf. Schiller, 1971, figs. 167–169). His long standard, topped by a cross, is firmly set on the rocky ground that is strewn with parts of the broken gate. To the left of the mouth of Hell are the bearded Adam motioning toward the cross, Eve draped and covering her left ear from the sounds of the devil who elicits her painful grimace, and another totally naked figure partly obscured by Adam. To the right, the figure holding a large, simple cross is Dismas, the Good Thief (for the iconography, see Hoffmann, 1971, pp. 85–86). In the upper part are the flying figures of four devils with terrifying faces and bodies, the one on the right reaching for Dismas's cross.

The dramatic composition is executed with a monumental and masterly handling of the bodies and a great attention to detail. In general, it belongs to a group of drawings which, during the past century, have alternately been given to Giovanni Bellini and his brother-in-law Andrea Mantegna. These fluctuating attributions are complicated even further by the existence of some prints, drawings, and several paintings or copies by the two Venetian artists, all representing this very same scene of Christ's descent into Limbo. The problems involved were succinctly summarized by Byam Shaw in 1953: "This is a variant of two Mantegnesque compositions, known from various sources: (1) two engravings of Mantegna's immediate school, probably from a drawing by the master (A. M. Hind, *Corpus of Early Italian Engravings*, 500, 501); (2) a picture by Giovanni Bellini in the Bristol Gallery, based on one of the engravings referred to; (3) a drawing in the Ecole des Beaux-Arts, Paris, which appears to be Bellini's preparatory drawing for (2); (4) a picture by Mantegna in the Stephen Courtauld Collection, of which an eighteenth century engraving exists (Borenius, *Four Italian Engravers*, pp. 52–53). The present drawing is most nearly related to (1), (2) and (3), though not corresponding in detail" (Byam Shaw, 1953, no. 21).

The apparent closeness to Giovanni's oeuvre has already been questioned by Heinemann, who favors the "orbita di Andrea Mantegna." His opinion was taken up with new vigor by others, including Pignatti, who attributes the drawing to Mantegna and defines it as "an intermediate stage in the development of the subject between the engraving and the Courtauld picture" (*Early Italian Engravings*, 1972, p. 210, and Pignatti, 1975, p. 6). It seems, however, that the figures in this drawing are more pliant than those of Mantegna, their undulating contours and delicate shading placing them much closer to Bellini. Moreover, in contrast to Mantegna's austere scene, this composition is richer in detail. The face of the Old Testament figure just emerging from Limbo at Christ's right foot is remarkable, as are the expressions of the devils bellowing their horrifying wail. The unusual viewpoint from which the figure of Christ is shown is most expressive, and his act of redeeming the Old Testament figures from Hell is emphasized by the rich and inventive curls of the banner which, just above his head and in the very center of the composition, form the letter "S" for "Salvator," the Saviour of the World.

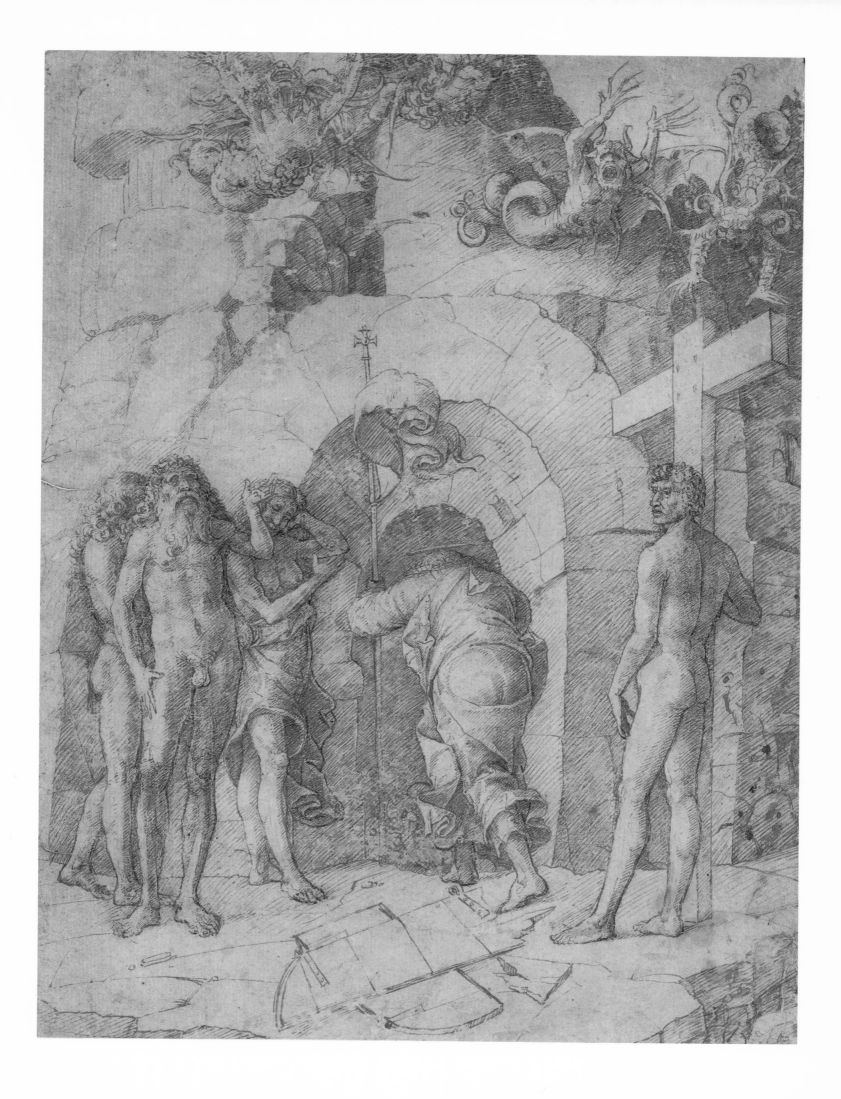

ERCOLE DE' ROBERTI

Born in Ferrara about 1456; documented there in 1479; worked in Bologna in 1481 and at frequent intervals thereafter; died in Ferrara in 1496.

Ercole's first authenticated and documented datable work, the large altarpiece made for Santa Maria in Porto, Ravenna (1480/81), now in the Brera in Milan, shows influences of the school of Ferrara, e.g., Cosimo Tura and Francesco del Cossa, and also evidence of the artist's exploration of Venetian art.

From 1486 to his death Ercole was employed at a large salary by the house of Este in Ferrara and was entrusted with many special commissions which took him to Mantua, Rome, and Hungary. He is without doubt the most elegant and sophisticated, as well as the most mature master of the expressive and spiritual triumvirate he forms with Tura and Cossa. From his early work, which scintillates with artificial and bizarre elements, he evolved a calmer manner, more classical in detail, under the influence of Cossa, Mantegna, and Venice, but he never quite relinquished the fundamentally harsh quality of his art.

16 The Flagellation

Pen and brown ink with fine point of brush and brown wash heightened with white on paper, 385 x 235 mm. There are some pentimenti on the torso of Christ, traces of staining and abrasions in various places.

Provenance: *August Grahl, Leipzig (Lugt 1199); Marius de Zayas, New York; Alphonse Kann, New York.*

Bibliography: *Sammlung Grahl, Leipzig (n.d.), no. 340; Buffalo Cat., 1934, no. 13; Cincinnati Cat., 1959, no. 209; Bean-Stampfle, 1965, no. 20; Szabo, 1978, no. 24.*

The delicate yet pronounced sfumato of the head and upper torso of Christ dominates this large composition. This kind of minute working of an area with the point of the brush is in noticeable contrast to the linearity of the other figures and parts of the architecture that provides a receding framework for the whole composition. As a mat-ter of fact, the artist deliberately uses contrasts: Christ is tied to an Ionic column while the two flagellants are set against pilasters. Despite the monumental impression of the composition and the fine details emphasized by the brushwork and highlights that approximate painting, the drawing cannot be connected with any of Ercole's surviving work. The softness of the sfumato and the contours separate this work from the earlier drawings by Ercole, such as the Saint Sebastian in the Robert Lehman Collection (Szabo, 1978, no. 24), which still show the influence of his teacher, Cossa. However, the same chracteristics are present in other later drawings, such as the copies after Mantegna, that are dated after 1478 (Ruhmer, 1962, pp. 244–47). The equilibrium of the composition and the absence of violent expressions and movements is also in conformity with the character of Ercole de' Roberti's later oeuvre which has been described as "calmer . . . more classical in detail."

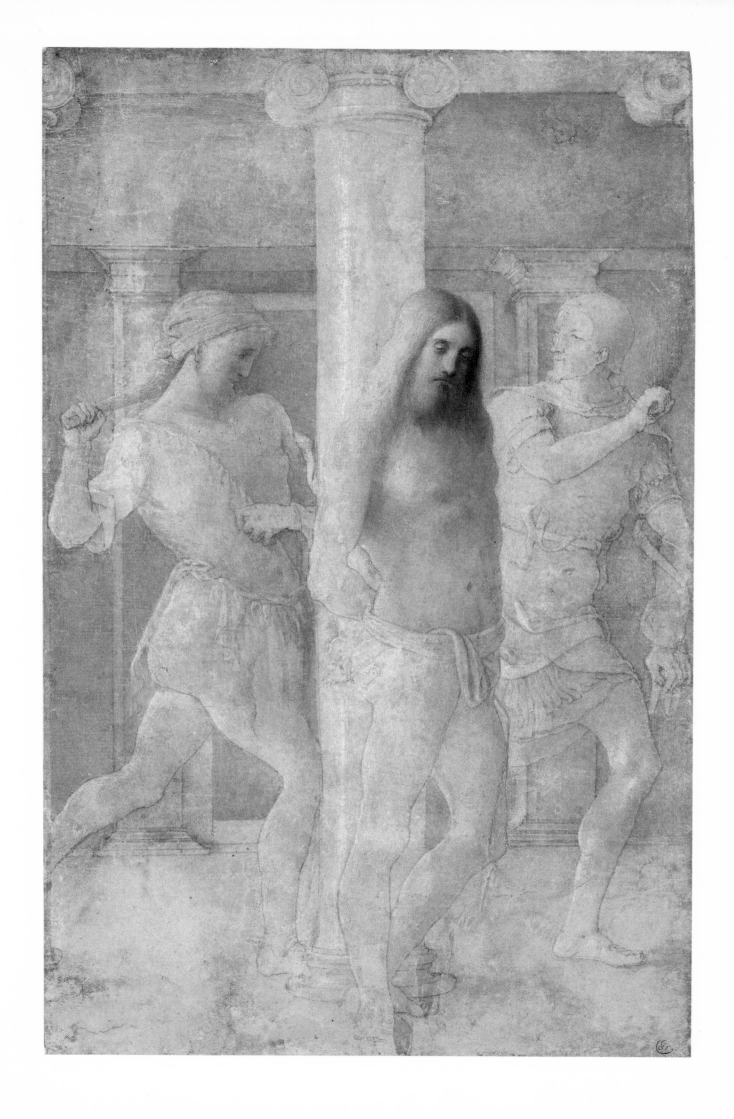

LEONARDO DA VINCI

Painter, sculptor, engineer, architect, and scientist; born in Vinci on April 15, 1452, son of Ser Piero da Vinci and a peasant girl named Caterina; died in Amboise, France, on May 2, 1519.

By 1469 Leonardo was living with his father in Florence where he had entered the workshop of Verrocchio. He was still there in 1472 when he was admitted to the painters' guild, the Compagnia di San Luca. In 1481 he was commissioned by the monks of San Donato to paint an altarpiece for their monastery, the *Adoration of the Magi,* now in the Uffizi, which he left unfinished when he entered the service of Lodovico Sforza in Milan. There, between 1495 and 1498, he painted the *Last Supper* in the Refectory of the Convent of Dominican friars at Santa Maria delle Grazie. At the end of 1499, when French troops occupied the city and imprisoned Lodovico, Leonardo returned to Florence, stopping on the way in Mantua and Venice.

By 1500 Leonardo was back in Florence after an absence of eighteen years. In 1501 he exhibited the *Virgin and Child with Saint Anne,* the cartoon for an altarpiece commissioned from him by the Servite monks of the Annunziata. This work, too, was left uncompleted when he went to the Romagna in the service of Cesare Borgia, with whom he remained for about eight months. In 1503 he returned to Florence where he received the important commission to paint the *Battle of Anghiari* on the wall of the council chamber of the Palazzo Vecchio; this, too, was left unfinished when he returned to Milan, where he remained, with occasional journeys to Florence, until 1513. In 1517 he went to France, at the invitation of the king, Francis I, where he lived the last years of his life.

In the multiplicity of his activities and interests Leonardo, the artist-scientist, was the quintessence of the Renaissance idea of the universal genius. Relentless in his search for knowledge, Leonardo submitted the process of cause and effect in the natural world to rigorous investigation. He was fascinated above all by the laws of movement, the transformation and development of living things, and by human and animal expressions. Through the analytical study of such problems he arrived at archetypal forms and essential relationships which impart a mysterious, magical power to his few remaining paintings and his very numerous drawings and writings.

Through his insight into natural laws he re-created nature in the light of an ideal universe. For this reason his works had a radiant force and served as a stimulus not only in the centers where he was active, but in the whole of Italy, as well as in the Low Countries and France. There was hardly a great painter of the time, from Michelangelo to Raphael, Giorgione, Correggio, Dürer, and Quentin Massys, and perhaps even Hieronymus Bosch, who did not at one time or other feel Leonardo's influence.

17 Studies of a Bear Walking, a Forepaw, and a Seated Female Nude

Silverpoint on pinkish buff prepared paper, 103 x 134 mm.

Provenance: *Sir Thomas Lawrence (Lugt 2445); Private collection, England; L. V. Randall.*

Bibliography: *Clark, 1937, pp. 66–67; Popham, 1937, p. 87; Berenson, 1938, no. 1010; Cetto, 1950, p. 15; Berenson, 1961, no. 1049E; Orangerie Cat., 1957, no. 106; Cincinnati Cat., 1959, no. 206; Bean-Stampfle, 1965, no. 18; Szabo, 1975, pl. 174; Szabo, 1978, no. 27.*

In his plan for an anatomical treatise, Leonardo stated that, "I will discourse of the hands of each animal to show in what they vary; as in the bear, which has the ligatures of the sinews of the toes joined above the instep" (Richter, 1939, vol. II, sect. 822). A number of anatomical studies of bears attest to the thorough way the artist pursued his subject. Three silverpoint drawings from the early-nineteenth-century collection of Sir Thomas Lawrence reappeared in the 1930s. One, representing a bear walking, is the present study; the second, of the head of a bear, and the third, showing paws, belong to Lt. Col. N. R. Colville, London (Bean-Stampfle, 1965, p. 28). Finally, at Windsor Castle, four remarkable detailed studies representing the dissection of the hind foot of a bear are also part of Leonardo's project and belong with this drawing as well (Wright, 1919, p. 203).

It seems that Leonardo sketched the bear, its head, and its forepaw from life and later was able to dissect the dead animal. It is hard to determine when and where these anatomical studies took place since there is no agreement about their dating or that of the other silverpoint drawings by the artist. Popham placed them early in Leonardo's Florentine period; Clark suggested that they were done in Milan around 1490. The latter seems to be more likely, because of the opportunity Leonardo had to see bears in Milan, which is

near the Alps, where there was a large population of European brown bears (Ursus arctus) in the fifteenth century, which continued even into the nineteenth. This species has a distinctive ruff of longer hair growing through the matted fur around the neck and the shoulders during the summer months, which is easily recognizable in this drawing (cf. Couterier, 1954, passim).

The powerful study of the bear overshadows the slight sketch of a nude woman underneath it. Her head with downcast eyes, bare upper torso, and large abdomen are discernible as is her upper right leg, bent in a somewhat undecorous sitting position. Clark noted that he was "not able to connect this figure with any of Leonardo's other work." Most other commentators do not even mention it, tacitly accepting that the two figures are unrelated. However, the pose of the Virgin in several small studies for the *Virgin and Child with Saint Anne* in the British Museum (1505) seems to be similar to that of the woman in this drawing. Her "indecent" posture, in conjunction with symbolical roles attached to the bear during the Middle Ages and the Renaissance, suggests a possible relationship between the bear and the nude woman. In general, the bear represents an evil principle and, in the later Middle Ages, is the attribute and symbol of ire, violence, and luxury (cf. Stauch, 1937, cols. 1446–47). Specifically, the bear is connected to unchastity and lust, and this seems to imply that Leonardo's linking might not be altogether accidental. The sitting position of the woman, together with the parted upper legs and large abdomen (sign of pregnancy), could also refer to childbirth, since delivery occurred in that position throughout the Middle Ages and the Renaissance. Consequently the linking of the woman and the bear could be an allusion to the story of Callisto's transformation into a bear after giving birth to Arcas, as it appears in a later drawing by Domenico Campagnola (Pignatti, 1974, no. 10). This aspect of the drawing and its connection with Leonardo's studies of the Virgin also signal that there could be some connection with the role of the bear in Marian symbolism (Stauch, 1937, cols. 1444–45).

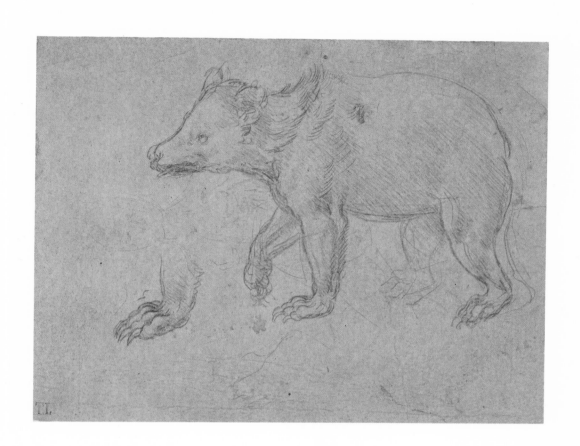

PERUGINO (PIETRO DI CRISTOFORO DI VANNUCCI)

Born in Città della Pieve about 1450; worked in Florence, Rome, and Perugia; died in Fontignano (Perugia) in 1523. Perugino was influenced by the art of Piero della Francesca and Verrocchio, with whom he may have studied in Florence. Among his earliest works are the scenes from the life of Saint Bernardino of Siena (1473) now in the gallery of Perugia. In 1479 he was called to Rome to paint a fresco in the apse of Old Saint Peter's (later destroyed). Shortly thereafter, in 1481, together with Botticelli, Ghirlandaio, and Cosimo Rosselli, he worked in the Sistine Chapel, where he left his masterpiece, *Christ Giving the Keys to Saint Peter* (1482). In this important work Perugino harmoniously combined the plastic figures derived from Verrocchio in the foreground with the broad and well-defined spatial structure of the background characteristic of Piero della Francesca.

Perugino produced his most significant work between 1488 and the end of the century: the *Annunciation* in Santa Maria Nuova in Fano, the *Vision of Saint Bernard*, in Munich, and above all, the *Apollo and Marsyas* in the Louvre, in which he established a perfect harmony between figures and landscape. The compositional scheme of the *Apollo and Marsyas*, in which Perugino completely excluded architecture as a perspective means, appears again in his *Lamentation over the Dead Christ* of 1495, painted for the nuns of Santa Chiara in Florence and now in the Palazzo Pitti. Here, the broad and open landscape is deprived of any dynamic function; it exists as a tranquil expanse that accompanies the slowly turning plastic forms of the foreground figures. This pleasing style was shortly to be compromised by sentimentality in the *Assumption of the Virgin* (Uffizi) and the frescoes in the Collegio del Cambio in Perugia, finished in 1500. In this same year the seventeen-year-old Raphael began his career in Perugino's workshop.

18 Studies of Standing Youths

Silverpoint on pinkish prepared paper, 217 x 177 mm. Traces of pentimenti along the left lower legs of both figures and the right foot of the smaller one.

Provenance: *Conestabile Collection; J. P. Heseltine, London; Henry Oppenheimer, London.*

Bibliography: *Ricci, 1912, p. 264; Fischel, 1917, p. 155, no. 90, pl. 156; Orangerie Cat., 1957, no. 117; Cincinnati Cat., 1959, no. 205; Szabo, 1978, no. 28.*

The delicate combination of the silvery gray silver-point and light-pink ground, as well as the elegant and poised figures, exudes a Florentine-Umbrian ambience. The drawing was first attributed to Raphael, then later to Pinturicchio. Finally, Fischel proposed that it is a study for the young king in Perugino's fresco *The Adoration of the Magi* in Città della Pieve (Fischel, 1917, p. 155). While it is often compared to other, similar studies by the artist, most commentators emphasize the drawing's refinement and elegance. Berenson in several communications to Robert Lehman suggested that it might be by the very young Raphael, who was Perugino's student around 1500.

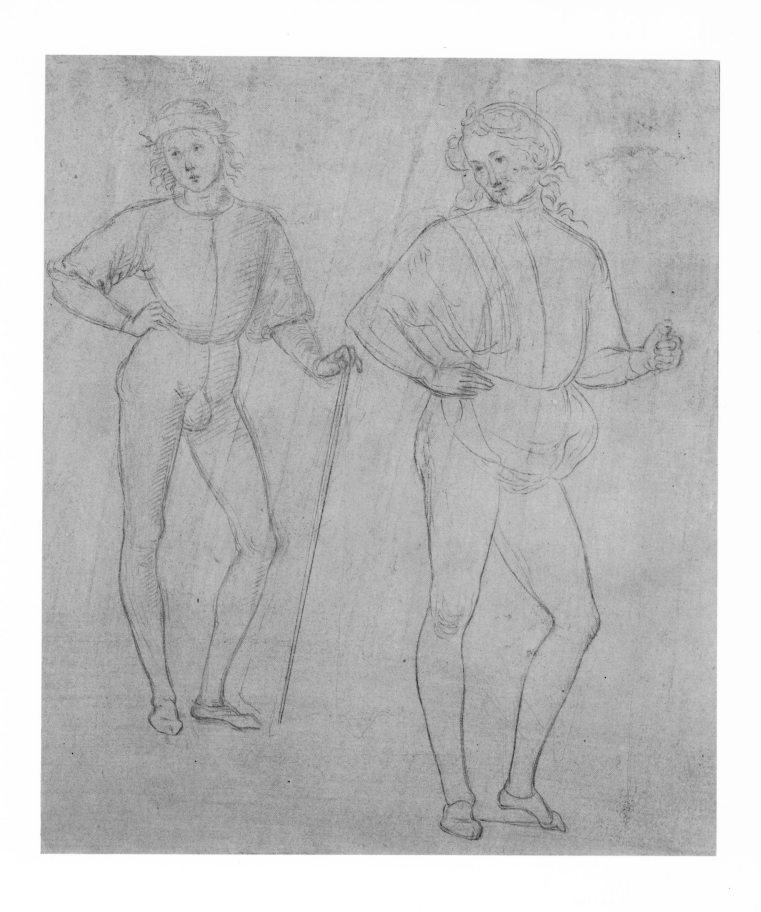

19 Studies of Holy Children

Silverpoint on light-gray prepared paper, 238 x 189 mm. Inscribed on the verso, Raffaello.

Provenance: *J. P. Heseltine, London; Henry Oppenheimer, London.*

Bibliography: *Heseltine, 1913, no. 39; Fischel, 1917, p. 235, no. 180; Szabo, 1978, no. 29.*

The five holy children and the features of yet another who is barely visible in the center are not really studies, but carefully arranged parts of a composition that is as yet unidentified. Several details, unnoticed until now, support this interpretation. In the center of the composition, the Child Jesus is seated on a dead tree stump and leans against a new branch growing out of it. Above his head hangs a tablet inscribed with the letters SPQR, which are obvious later additions. The tree stump and the new branch are direct references to the Old and New Testaments. In addition, the new branch with the tablet probably symbolizes Christ's cross and must originally have been inscribed with the traditional letters INRI. Together, the stump and new branch also symbolize rebirth and resurrection and were frequently used during the Renaissance (Ladner, 1961, pp. 303–22). The head of the praying Christ Child is turned toward his right where the kneeling and adoring St. John holds an open book for him. Two other children approach Christ from the other side.

The one in front pays homage with arms and hands crossed on his chest. The one behind him holds a staff on which a bird is perched, most likely a dove and probably a symbol of the Holy Spirit. The fifth child in this group, just discernible in the center, has no attributes or symbols. In contrast, the sixth, in the very center of the drawing at the bottom, is well drawn. He is in a classical reclining pose, leaning on a disklike object that defies further identification.

The figures are very carefully drawn with clear contours and extremely fine shadings and crosshatchings to indicate volume. There are no comparable drawings in the artist's known oeuvre, nor are there any similar compositions among his paintings. However, comparable figures of holy children appear in paintings that are firmly attributed to Perugino and are also relatively well dated. The Christ Child and the robed figure of Saint John the Baptist appear in the background of the *Saint Jerome* dated circa 1480–83 (Washington, D.C., National Gallery of Art; Camesasca, 1959, pls. 38–39), and the pose of the child in the *Madonna del Sacco* of circa 1495–99 seems to be the same (Florence, Palazzo Pitti, Galleria Palatina; Camesasca, 1959, pl. XXII, no. 57). The adoring child saint has a parallel in the figure of the infant Saint John the Baptist in the *Virgin and Child* of 1504–5, signed *Petrus Pervsinus Pinxit* (Nancy, Musée des Beaux-Arts; Camesasca, 1959, pl. 174). On the basis of these similarities, this drawing should tentatively be dated to the period between 1490 and 1505, though further research may eventually reveal its meaning and exact date.

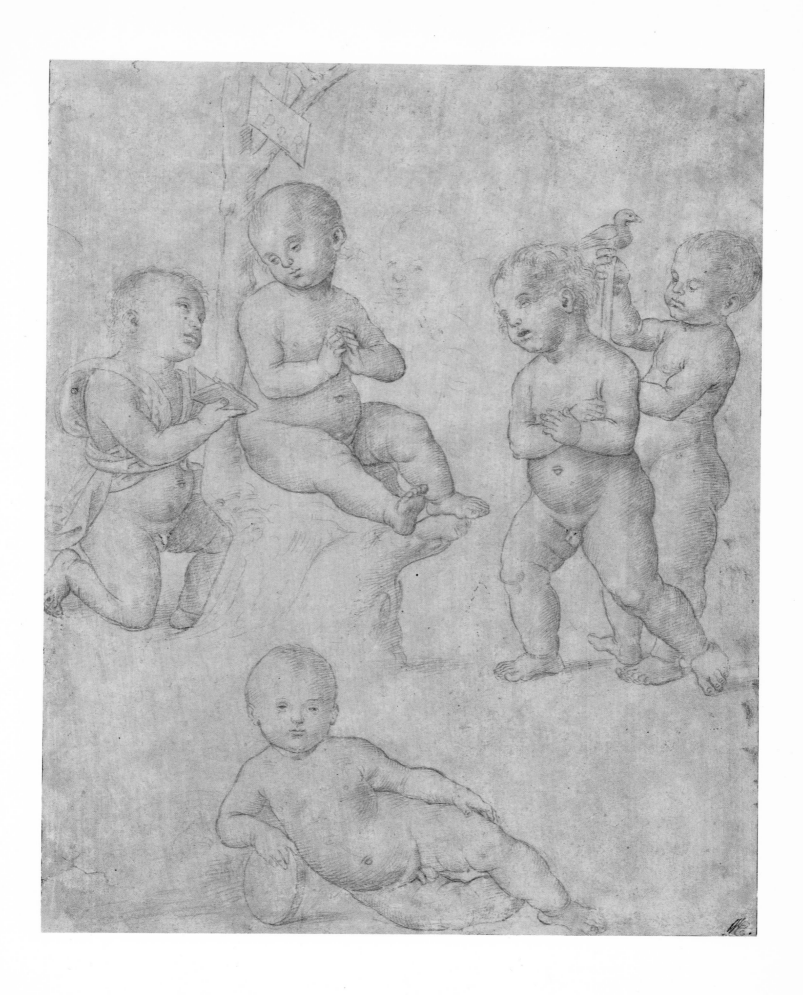

FRA BARTOLOMMEO (BACCIO DELLA PORTA)

Born in Florence 1472; between March and April of 1508 in Venice; in 1514 in Rome; died 1517 in the Dominican monastery of San Marco in Florence or in Pian di Mugnone near Caldine.

Between 1484 and 1490 Fra Bartolommeo worked in Cosimo Roselli's shop and there met Piero di Cosimo, as well as Mariotti Albertinelli, with whom he was often to collaborate. In 1496, deeply moved by Savonarola's preaching, he burned some of his work and ceased painting. In 1500 he entered the monastery of San Domenico in Prato. Four years later the prior of the monastery of San Marco in Florence persuaded him to resume painting, and in 1505 he became head of the painting workshop of San Marco.

Fra Bartolommeo elaborated the various tendencies of late-fifteenth-century Florentine art, combining them with new ideas acquired from Leonardo, and developed an artistic expression based on careful and stable compositions and a vision of nature suffused with a new spiritual dimension. From an art of extreme delicacy he gradually developed a language of great monumentality and rhetorical impressiveness, in the formation of which his visits to Venice and Rome certainly played a notable part.

20 The Virgin with Holy Children

Pen and brown ink over black chalk on paper, 184 x 159 mm. Verso: The child at the extreme right is traced through and there is a sketch of another child.

Provenance: *Count Ottolini; J. P. Heseltine (Lugt 1507); Henry Oppenheimer, London.*

Bibliography: *Knapp, 1903, p. 314, no. 4; Berenson, 1903, no. 430; Gabelentz, 1922, p. 133, no. 307; Berenson, 1938, no. 459G; Popham-Wilde, 1949, p. 193; Berenson, 1961, no. 459G; Bean-Stampfle, 1965, no. 28; Haraszti-Takács, 1967, pp. 59—60; Szabo, 1978, no. 33.*

The Virgin and Child are drawn with elaborate shadings and cross-hatchings while the three holy children are rather sketchy. Gabelentz associated this sheet with several others in the Uffizi and at Windsor Castle, dating all of them around 1505 (Gabelentz, 1922, nos. 73, 174, 874). He proposed that they represent "part of a sequence of pen sketches for a projected picture, presumably a tondo, representing the standing Virgin holding the Christ Child with the Infant Christ on the left and combinations of angelic and saintly attendants" (quoted by Bean-Stampfle, 1965, p. 32). This dating would place the drawings right after Fra Bartolommeo's return to painting when he became the head of the workshop of San Marco.

This drawing also sheds light on the methods of drawing as practiced by Fra Bartolommeo. Haraszti-Takács, noting that the Christ Child's left arm is truncated and handless and that the Virgin is also represented without hands, proposed that both could have been drawn from wooden models or puppets (*modelli di legname*), the Virgin from a relatively large one. This would accord with Vasari's contention that "in order to be able to draw draperies, armour, and other suchlike things, he caused a life-size figure of wood to be made, which moved at the joints; and this he clothed with real draperies, from which he painted most beautiful things, being able to keep them in position as long as he pleased, until he brought his work to perfection. This figure, worm-eaten and ruined as it is, is in our possession, treasured in memory of him" (Vasari, *Lives*, vol. IV, p. 161). Figures drawn from models appear in several drawings by Fra Bartolommeo in the Uffizi, further suggesting that he probably originated this method of dressing the model with drapery for the purpose of study and sketching (Maggini, 1977, pls. 4, 5, 7, 8).

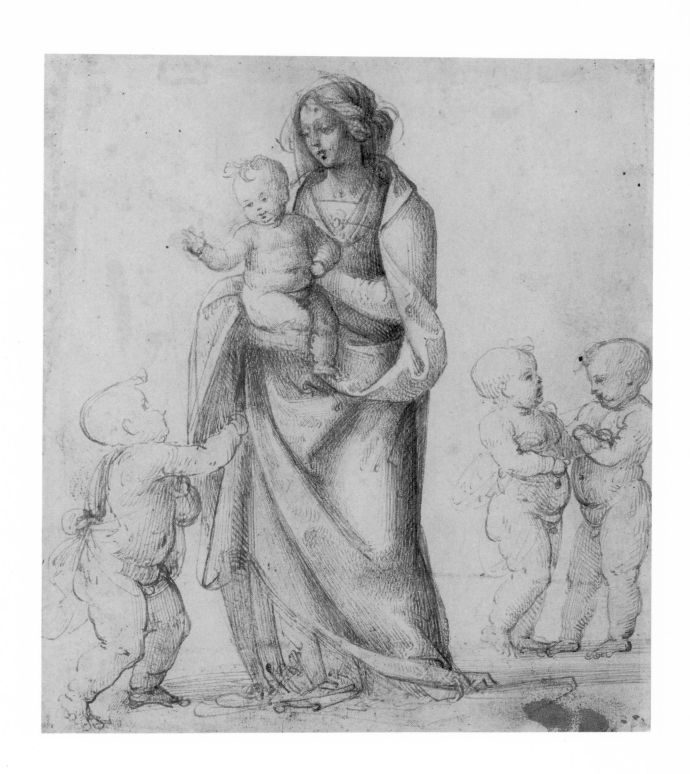

21 Horsemen Approaching a Mountain Village

Pen and brown ink on paper, 298 x 206 mm.

Provenance: *Fra Paolino da Pistoia, Florence; Suor Plautilla Nelli, Convent of Saint Catherine, Piazza San Marco, Florence; Cavaliere Francesco Maria Nicolo Gabburri, Florence; William Kent; Private collection, Ireland.*

Bibliography: *Fleming, 1958, p. 227; Kennedy, 1959, pp. 1—12; Bean-Stampfle, 1965, no. 30; Szabo, 1978, no. 34.*

This fleeting and wide-ranging landscape was once part of an album with forty other landscape studies by Fra Bartolommeo. It was assembled in 1730, bound in sheepskin, and provided with a frontispiece bearing the arms of Cavaliere Gabburri (1675—1742). The title page attributed the landscape studies to Andrea del Sarto, but now they are safely tied to the autograph oeuvre of Fra Bartolommeo and are considered to be "among the earliest pure landscape studies in European art" (Bean-Stampfle, 1965, p. 33).

The exact place represented here and the date of the drawing are both unknown. In some of the other drawings the topography is easily identifiable, among them the buildings of the Convent of Santa Maria Maddalena in Pian di Mugnone near Caldine, on a sheet now in the Museum at Smith College (Kennedy, 1959, pp. 4—7). Approximate dating for this drawing is provided by the watermarks on a number of other sheets from the Gabburri Album, for the paper can be identified as Florentine of 1507 and 1508 (Kennedy, 1959, pp. 8—9). Various speculations also connect some of the landscape drawings with Fra Bartolommeo's trip to Venice in March and April of 1508.

An interesting aspect of this drawing is that another one in the Gabburri Album, closely related to it, shows the same landscape but from "a more distant and slightly different vantage point" (Collection of Count A. Seilern, Prince's Gate, London). The Seilern drawing "was used for the landscape in Giuliano Bugiardini's *Rape of Dinah* which, as described by Vasari, was begun by Fra Bartolommeo and finished by Bugiardini," the only instance in which one of the Gabburri landscapes is directly connected with a painting (Härth, 1959, pp. 124—30).

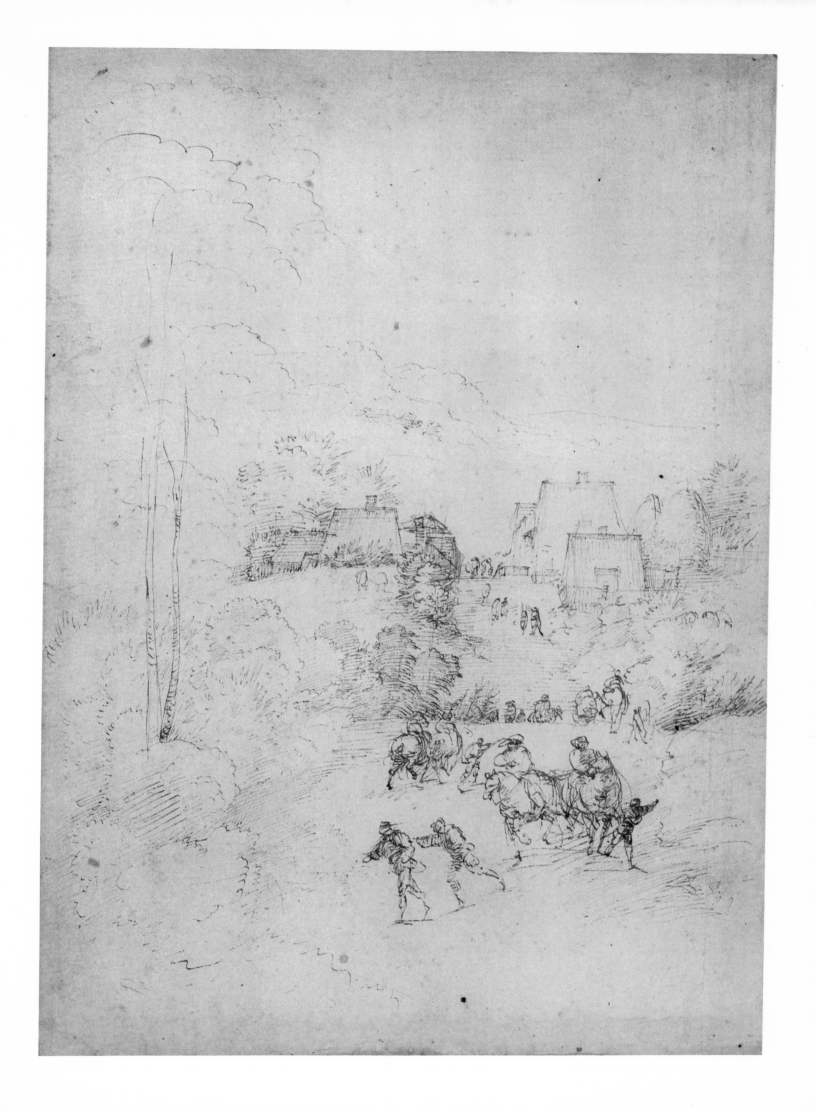

LUCA SIGNORELLI

Painter, born in Cortona between 1445 and 1450; died there in 1523. Luca Signorelli's style was based on the one hand on Piero della Francesca, whose major work, the frescoes in San Francesco, was on view in nearby Arezzo, and on the other, on the Florentine expressive use of the figure, especially as it was interpreted by Antonio Pollaiuolo. In Signorelli's youthful works, such as the frescoes in the Sacristy of San Giovanni in the Sanctuary of the Santa Casa of Loreto (1478–80), the *Flagellation* (c. 1480) now in the Brera in Milan, and the *Education of Pan* painted for Lorenzo the Magnificent, formerly in the Berlin Museum and destroyed during World War II, he did, in fact, achieve an interesting stylistic cohesion of Piero della Francesca's handling of space and light and Pollaiuolo's plastic vigor.

Over the years Signorelli's figures and compositions concentrated on an incisive and metallic design and on the effects of a strong chiaroscuro which became increasingly harder and more strained. This tendency is already foreshadowed in his most famous work, the frescoes he painted between 1499 and 1504 on the walls of the San Brizio chapel in the cathedral of Orvieto represenoing the End of the World. His later works make clear that he was unable to sustain the monumentality he desired; his figures declined into an oppressive and inert heaviness, and his compositions into complicated schematizations.

22 Head of a Man

Black chalk on paper, 299 x 245 mm. Pricked for transfer, later reworked with pen and ink; marked in the same ink, O. X.

Provenance: *Unknown.*

Bibliography: *Berenson, 1961, no. 2509G*; Szabo, 1978, no. 37; Hibbard, 1980, p. 237, fig. 424.*

The masterful characterization and the strict profile unquestionably place this drawing in Signorelli's oeuvre. Berenson noted the pricking and described the sheet as probably for a figure in a Nativity scene from the first decade of the sixteenth century. The pricking, the later reworking with pen and ink, and the marks all seem to confirm Berenson's observations as well as the drawing's role as a cartoon for a fresco. However, the portraits of the members of the Vitelli family painted by Signorelli between 1490 and 1500 display similar strict profiles, a consistently downward gaze, and slight bend of the head, which suggests an earlier dating and the possibility that this drawing was used by the artist in composing portraits (Salmi, 1953, nos. 22a, 23a–b).

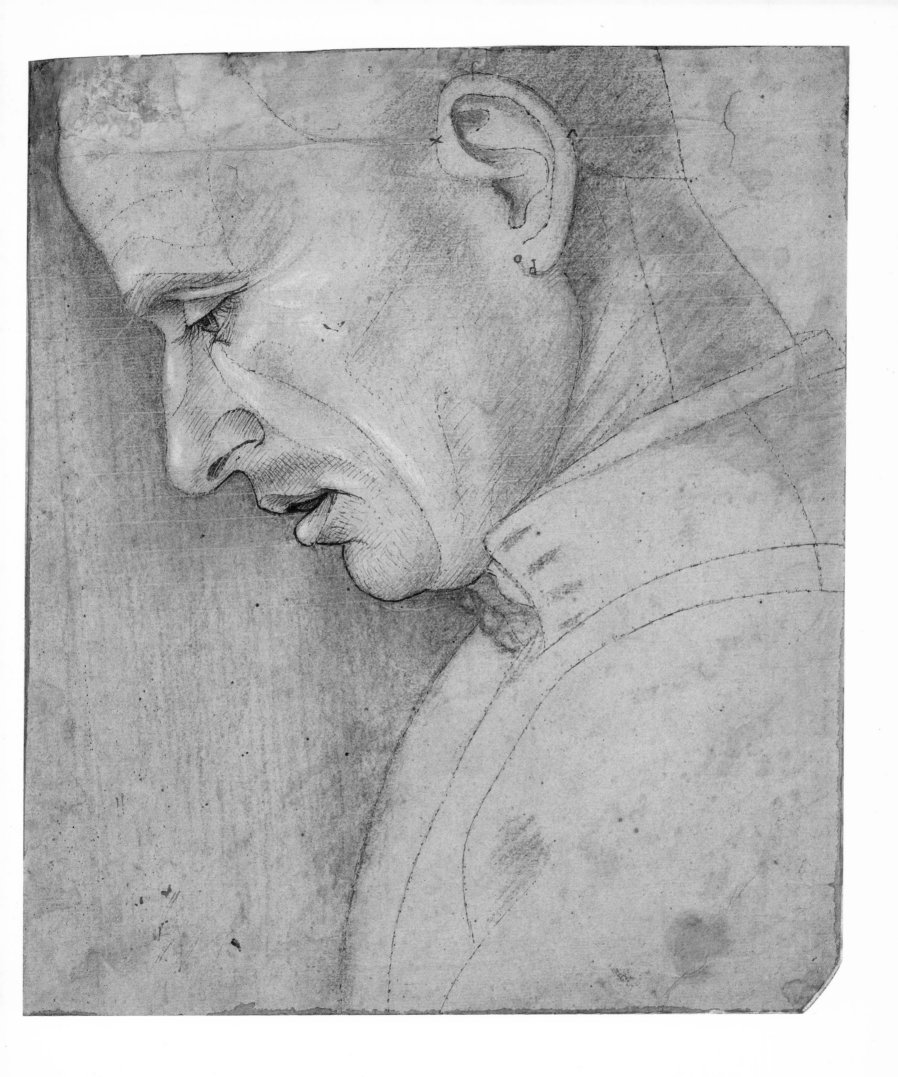

Sculptor, medalist, and architect; born shortly before 1470 in Rome; died 1512 in Loreto. Son of Isaia da Pisa, a sculptor of Pisan origin, Giovanni received his first artistic education from his father and thoroughly assimilated the classical tendencies of Rome. However, most of his activity took place in Northern Italy in the courts of Ferrara, Milan, Mantua, and Pavia. In 1491, Lodovico Sforza (Il Moro) invited him to Milan where he executed the marble bust of Beatrice d'Este (now in the Louvre). One of the principal early works of Giovanni Cristoforo is the superb mausoleum of Gian Galeazzo Visconti in the Certosa of Pavia (1493—97). In 1498 he worked in Mantua, and the bust of Francesco Gonzaga and the medal of Isabella d'Este are from this period. He also designed the tomb of Pier Francesco Trecchi in San Vincenzo in Cremona (1502). As an architect, Romano was associated with Bramante in the building of the dome in Loreto. During his travels and sojourns at various courts he created a number of successful medals that are characterized by strict adherence to classical prototypes and are influenced by his activity as cameo-cutter. Giovanni Cristoforo also procured objects of art and antiquities for his numerous patrons, including Isabella d'Este and Pope Julius II. His own collection included antiques: among other works, statuettes of *Mars*, *Cupid*, and *Cleopatra*, eighty-seven silver and thirty-four bronze medals, and a large number of cameos and intaglios.

23 Design for a Funeral Monument

Pen and ink with brown wash on paper, 296 x 154 mm. Inscribed in lower center in an early-sixteenth-century hand, Manenia.

Provenance: *Unknown. Acquired in the 1930s.*

Bibliography: *Szabo, 1977, no. 6; Szabo, 1978, no. 38; Treasures, Cat., 1979, no. 24.*

The drawing is a design for a large-scale funerary monument to be carved in stone. However, it is executed in a crisp, detailed style, reminiscent of metalwork and medals. Technique, style, and iconography constitute a compendium in miniature of Giovanni Cristoforo's achievements as a sculptor, bronze caster, medalist, and student of classical antiquity.

The roundel in the center with its frontal portrait bust echoes those on Roman tombstones and displays the artist's sure hand at characterization developed fully in the small scale of medals. The portrait is surrounded by a framework of twelve circular and square cameo-like scenes. The two roundels at the top represent the Annunciation, the two on the bottom, the Creation of Adam and Eve. The eight square fields show geographers and astronomers with their scientific instruments, such as armillary spheres, compasses, etc. They probably reflect the interests or occupation of the deceased. The classical inspiration of the rich candelabra motifs on the two sides and the elaborate cornice and base are subtly balanced by the religious character of the rest of the decoration. In accordance with the spirit of the monument the lower frieze contains a Last Judgment that imitates the crowded relief style of ancient sarcophagi. The crowning of the projected monument is a beautifully executed group of the Virgin and Child flanked by the figures of two Christian Virtues, Hope and Faith, and two winged putti bearing torches. The empty cartouche below the Judgment scene was probably intended for the name of the deceased but for some reason was left empty, as on the similar drawing for a funeral monument by Francesco di Giorgio Martini reproduced earlier (Plate 14).

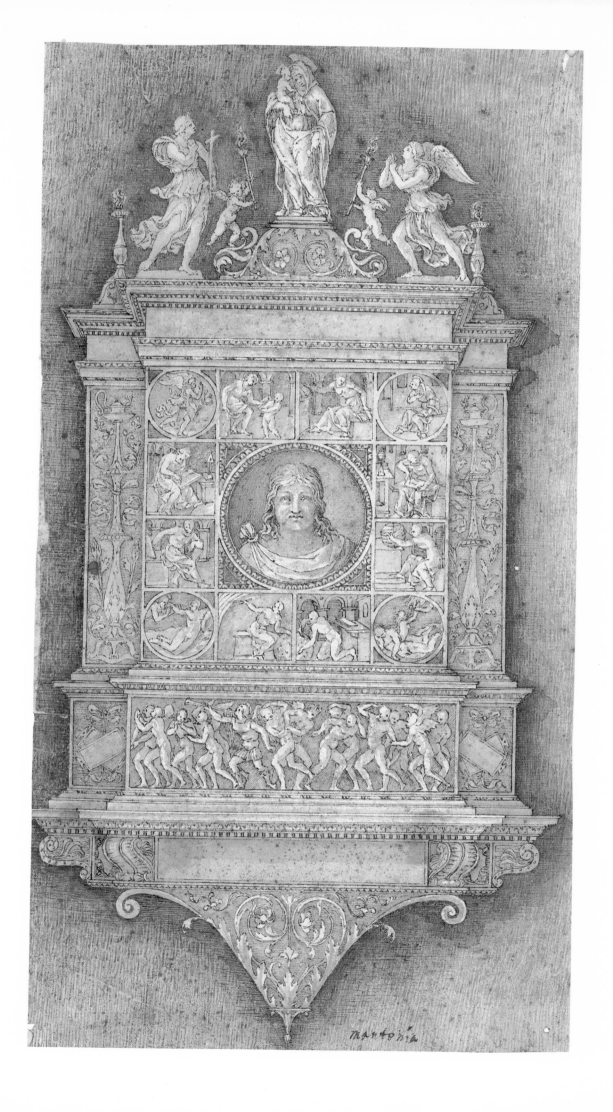

mantonia

FRANCESCO MORONE

Painter; born 1471 in Verona; died there 1529. Though he was the pupil of his father Domenico Morone and later his assistant, Francesco was mainly influenced by the draughtsmanship and colors of Andrea Mantegna. A prolific painter of large altarpieces and frescoes, his masterpiece is the decoration of the sacristy of Santa Maria in Organo in Verona, where the walls and ceilings are filled with compositions adapted from Mantegna's Camera degli Sposi. Morone transmitted the tradition of fresco painting from his father and teacher to his son Giuseppe and his grandson Francesco.

24 The Virgin and Child with Saint Roch and Saint Sebastian

Point of brush with brown ink, further modeled and heightened in white and blue gouache on paper pasted together in several places, 244 x 355 mm. Inscribed by a later hand, but still of the sixteenth century, in lower right corner, Fra^{co} Moron.

Provenance: *Unknown. Acquired in 1934.*

Bibliography: *Tietze-Conrat, 1943, pp. 86—87; Orangerie Cat., 1957, no. 115; Moskowitz, 1962, vol. I, no. 82; Bean-Stampfle, 1965, no. 26; Szabo, 1978, no. 44.*

Morone's technique and compositional procedures are interestingly revealed in this "collage" drawing. Evidently the group of the enthroned Virgin and Child originally was flanked on the right by the Infant John the Baptist, as may be seen by the remains of the saint's scroll inscribed in capital letters, *AGNVS DEI ECCE/PECATA M.* After the original central part was carefully cut out, the kneeling figure of Saint Sebastian was added to it as the recipient of Christ's blessing. This addition can only have been made by the artist himself, since the saint's face is actually executed on the paper of the central section. On the other side of the drawing, the kneeling figure of Saint Roch was cut away and then rejoined to the composition. He is slightly off register, the gaze of neither saint is directed toward the central group, and the figures were changed and corrected at various stages.

The drawing procedure is equally complicated. The Virgin and Child are modeled with the point of the brush in white using a fine hatching technique. After the parts had been assembled further white was added to cover the traces of patching. Finally, blue was introduced to strengthen the volume of the drapery and add more contrast.

The staging of the composition suggests that the drawing was probably a model for an altarpiece that invoked the help of the Virgin and the two saints against the plague, but no painting by Morone with this exact subject has survived (Wittkower, 1927, pp. 199—212). However, a considerable number of frescoes painted by him between 1510 and 1515 still exist in small churches, palaces, and villas in Verona which depict the Virgin with various saints, including Saint Sebastian and Saint Roch. It is therefore possible that this drawing was a model for such a fresco and that the changes were made to adjust the composition and the saints to the requirements of the particular commission. This connection would also indicate a later date, in the first decade of the sixteenth century, rather than the early date proposed by Tietze-Conrat.

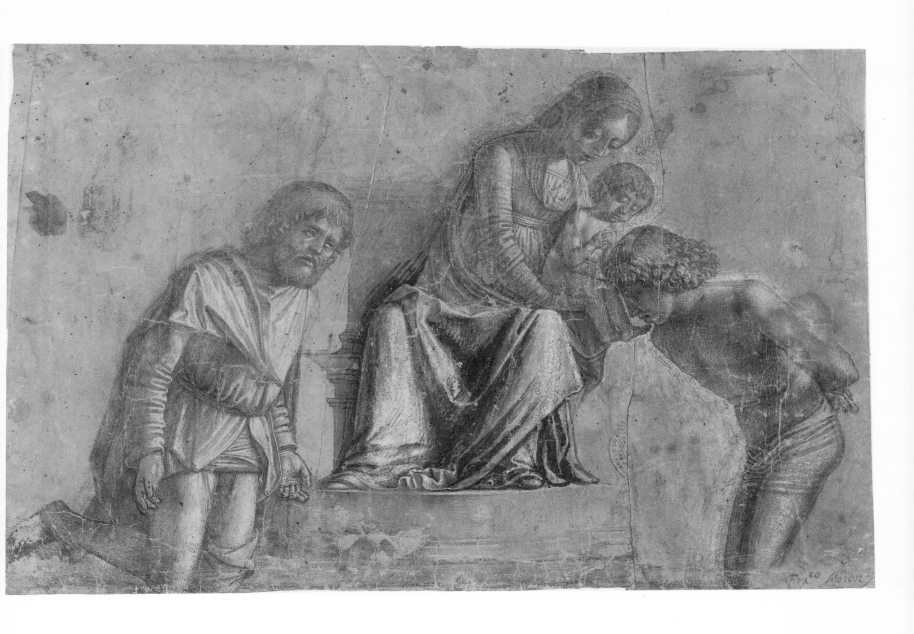

RAFFAELLINO DEL GARBO

Painter; born in Florence circa 1466; died after 1524. There is little information about his training. Rather eclectic, he is linked with Filippino Lippi as well as Domenico Ghirlandaio and Piero di Cosimo, and he was also subject to Umbrian influence. Vasari praises him as an uncommonly talented and dexterous draughtsman.

25 Head of a Girl

Silverpoint heightened with white on pinkish prepared paper, diameter 148 mm. Damages and reworkings visible throughout the drawing.

Provenance: *Giorgio Vasari; Mariette (Lugt 1852); Thomas Dimsdale (Lugt 2426); Henry Oppenheimer, London.*

Bibliography: *Kurz, 1937, p. 34; Berenson, 1938, no. 767; Ragghianti Collobi, 1974, p. 99, fig. 273; Szabo, 1979, no. 2.*

Once very delicate, the drawing has suffered extensively during the last four centuries. Its inclusion in a long line of distinguished collections, possibly starting with Giorgio Vasari's *Libro*, attests to its origi-nal beauty. In 1937, O. Kurz proposed that this drawing is one of those "Quatre Etudes de Figures & Tètes, au bistre, rehaussé de blanc, de la Collection du Vasari" by Raffaellino that were later in Mariette's collection. Despite the obvious difference in the basic technique—silverpoint here—Ragghianti Collobi accepts this identification. What remains of this drawing underneath the damages and subsequent restorations is certainly a far cry from Vasari's enthusiastic description of Raffaellino's drawings: "They are partly drawn with the style, partly with the pen or in water-colours, but all on tinted paper, heightened with lead-white, and executed with marvellous boldness and mastery; and there are many of them in our book, drawn in a most beautiful manner" (Vasari, *Lives,* vol. IV, p. 175).

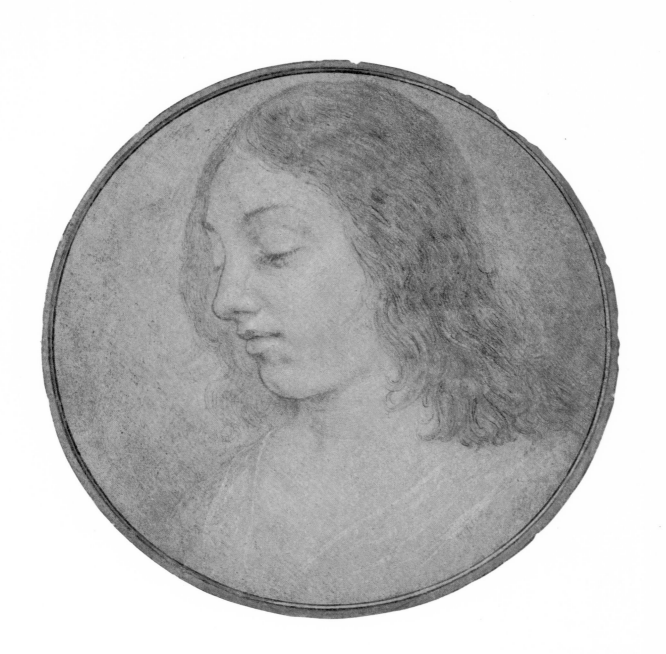

26 The Virgin and Saint John

Pen and ink with wash over traces of black chalk on paper, 178 x 141 mm. Vertical dividing line in center; both figures are pricked for transfer. Inscribed in lower corner in a sixteenth-century hand, And. del Castagno.

Provenance: *Luigi Grassi (Lugt Supplement 1171b).*

Bibliography: *Szabo, 1979, no. 3.*

The finish, the size, but above all the fine pricking, suggest that the drawing was a design for an embroidery. The vertical division also indicates that the two figures could have been used separately for this purpose. Despite the name of Andrea del Castagno inscribed on it and a former attribution to Filippino Lippi, both figures are by Raffaellino del Garbo. The summary, yet delicate delineation of the figures and their features and the treatment of the drapery have much in common with a drawing representing the Mater Dolorosa in the British Museum that is also attributed to Raffaellino del Garbo (MS 1860-6-16-45; Popham-Pouncey, 1950, no. 66). The pattern of pricking is very similar on both, further confirming the destination and use of the drawing. Vasari sorrowfully noted about Raffaellino: "In the end he was reduced to undertaking any work, however mean; and he was employed by certain nuns and other persons, who were embroidering a great quantity of church vestments and hangings at that time, to make designs in chiaroscuro and ornamental borders containing saints and stories, for ridiculous prices. For although he had deteriorated, there sometimes issued from his hand most beautiful designs and fancies, as is proved by many drawings that were sold and dispersed after the death of those who used them for embroidery" (Vasari, *Lives,* vol. IV, p. 178). This would suggest that the drawing is a late work, probably from around 1520.

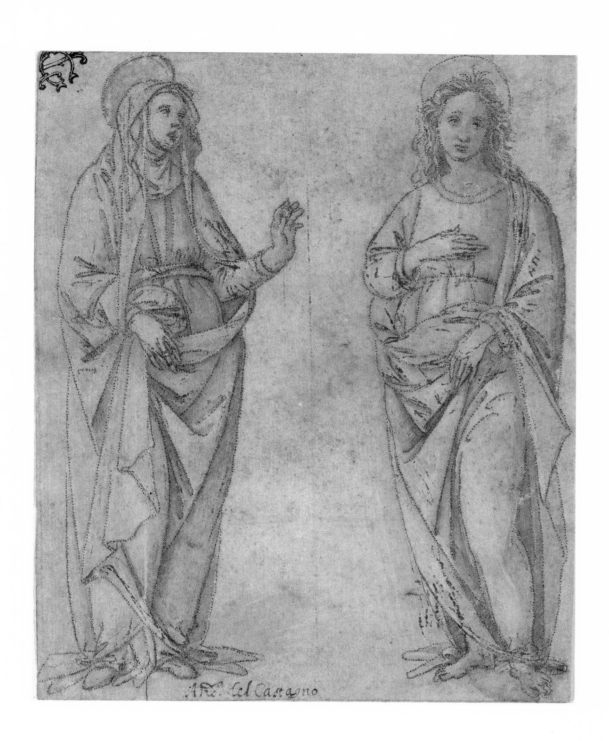

BUGIARDINI (GIULIANO DI PIERO DI SIMONE)

Painter; born in Florence 1475; died there in 1554. Bugiardini received his formal training in the workshop of Domenico Ghirlandaio and later was an assistant to Mariotto Albertinelli. An early work, *Virgin with Saints Magdalene and Bernardino* of 1503 (Florence, Museo di San Marco), clearly shows Albertinelli's influence.

Bugiardini's artistic development took a sharp turn when he was called to Rome by Michelangelo in 1508. His figures became fuller and his palette more colorful, enriched with a type of contrast learned from Michelangelo, which may be seen in such a painting as *The Holy Family with Saint John* (Leningrad, Hermitage). After his sojourn in Rome, Bugiardini worked in Bologna between 1527 and 1530 (*Madonna with Saints Anthony and Catherine*, Bologna, Pinacoteca), but eventually he returned to Florence. In his mature work he continued to employ the soft contours and style of Andrea del Sarto. His most ambitious work is *The Martyrdom of Saint Catherine* (Florence, Santa Maria Novella).

27 Saint John the Baptist

Black chalk heightened with white paint on paper cut on both sides, 417 x 159 mm. Handwritten notation on the verso, Bugiardini B.B.

Provenance: *Maurice Marignane (Lugt 1782); Hubert Marignane (Lugt Supplement 1343a).*

Bibliography: *Szabo, 1979, no. 4.*

Berenson had attributed the drawing to Bugiardini prior to its acquisition by Robert Lehman in 1960 from Colnaghi in London, and he reaffirmed this attribution later in private communications. The full and soft figure and its careful anatomical construction betray the influence of Michelangelo. Therefore, it is possible that the drawing dates from the artist's years in Rome or soon after, and it is certainly from his mature years.

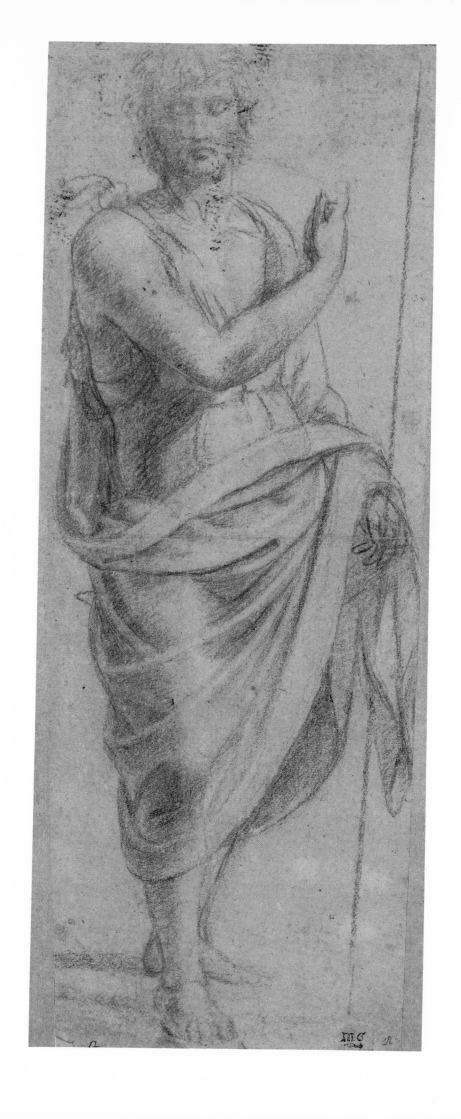

SODOMA (GIOVANNI ANTONIO DEI BAZZI)

Born in Vercelli 1477; in Rome 1508 and 1512; died in Siena in 1549. In his native town, between 1490 and 1497 Sodoma was a pupil in the shop of Martino Spanzotti. In 1500 he arrived in Siena with a certain amount of fame, judging from the numerous and important commissions with which he was soon entrusted. In such paintings as the frescoes of 1503 in the church of Sant'Anna in Camprena, and above all, in the frescoes of the cloister of the monastery of Monte Oliveto Maggiore begun toward 1506, he showed himself capable of grafting onto the Leonardesque foundation of his early Lombard training the suggestions he could derive from the Sienese work of Baldassare Peruzzi or Pinturicchio.

In Rome in 1508 he collaborated with Raphael in painting the ceiling of the Stanza della Segnatura of the Vatican Palace, and in 1512 he painted in fresco *The Marriage of Alexander and Roxane* in the bedroom of Agostino Chigi in the Villa Farnesina. In this work the classical character of Raphael's inspiration is translated into a softly feminine and sensuous decorative idiom essentially derived from Leonardo. These characteristics were to be progressively accentuated in the paintings produced after his return to Siena, such as the frescoes in the church of San Bernardino of about 1518, the banner with Saint Sebastian of 1525 (Florence, Palazzo Pitti), the frescoes with scenes from the life of Saint Catherine carried out between 1526 and 1528 in the church of San Domenico, and those of the Sala del Mappamondo in the Palazzo Pubblico executed in 1529. In these works, not least because of the apparent pressure of so many commissions, Sodoma's style degenerated into empty schemes of a mawkish pedantry.

28 Saint Sebastian

Pen and ink with wash on paper, 265 x 185 mm. Verso: Three small studies, a figure with a lance, a grimacing face, and an ornamental detail, by a different hand (reproduced Szabo, 1979, no. 5B).

Provenance: *Victor Koch, London.*

Bibliography: *Szabo, 1979, no. 5A.*

The attribution to Sodoma is based on the strength of the drawing's affinities with his *Saint Sebastian* in the Palazzo Pitti (no. 1279). This celebrated picture originally was commissioned as a gonfalon (banner suspended from a crossbar) by the Confraternity of Saint Sebastian in Camollia, Siena, in May of 1525 and was finished by November of 1531, according to dates when payments were made to the artist (Hayum, 1976, pp. 191–92). The gonfalon became a talisman and was well known in Italy. Drawings of it were circulated, and some Lucchese merchants wanted to buy it for 300 gold scudi, according to Vasari, who also highly praised the picture.

It is hard to tell whether this drawing is a study for the painting or a copy made after its great success. It differs from the gonfalon in many respects. The figure of the saint is nude and he turns his head upward to his left. Arrows pierce his right arm, right thigh, and torso below the left breast. The somewhat mechanical and weak lines would seem to indicate that the drawing is a late work, a copy made by Sodoma for one of his former patrons, such as Prince Chigi, who reportedly brought a drawing of the *Saint Sebastian* to Rome (Hayum, 1976, p. 193).

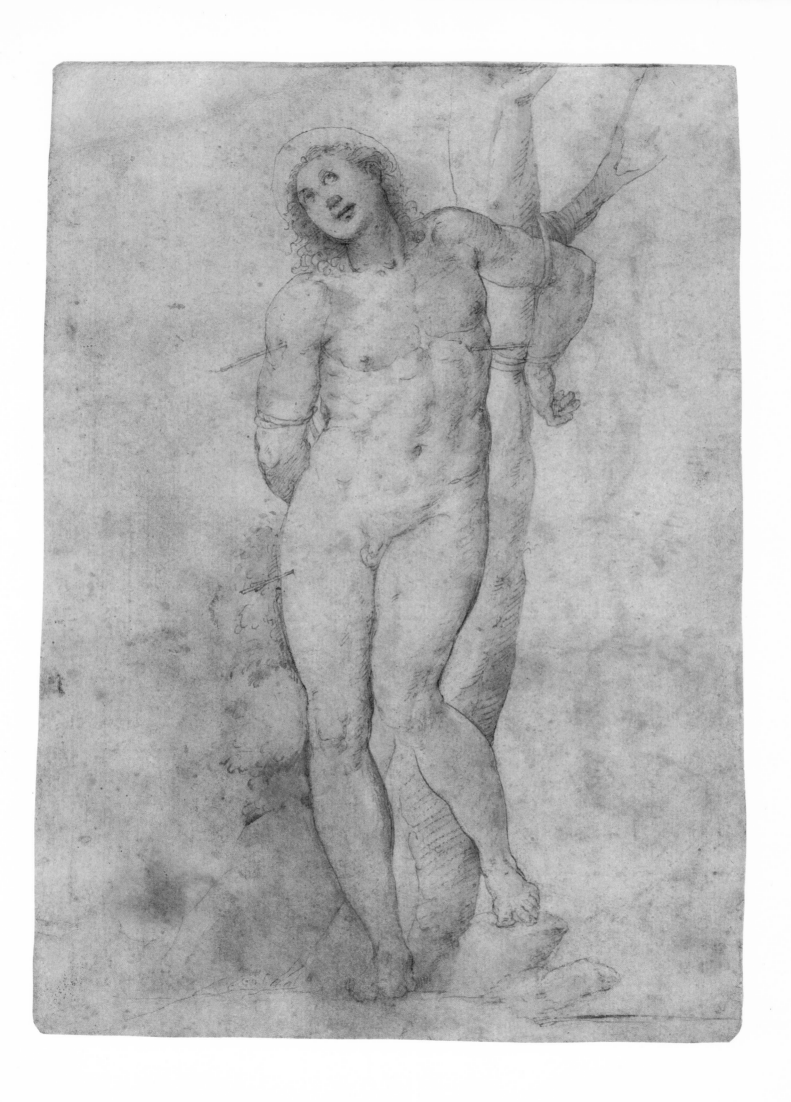

GIOVANNI FRANCESCO CAROTO

Painter; born in Verona circa 1480; died there circa 1550. Caroto received his early education in Verona, a city rich in artistic tradition then dominated by the art of Liberale da Verona, but he also assimilated a wide variety of other influences during his formative years. He was a pupil of Andrea Mantegna, from whom he acquired the tendency toward sculptural form. After working for many years in Lombardy, late in his career he came under the influence of Correggio. Caroto's eclectic character is revealed in his landscape paintings, such as those in Santa Maria in Organo, and in the numerous altarpieces that are still in the museums and churches of Verona, such as the *Madonna in Glory with Saints* of 1528 in San Fermo Maggiore.

29 Man and Woman in Adoration

Point of brush with ink and gouache, heightened with white on blue paper, 203 x 273 mm. Traces of very fine pricking on the robe and left leg of the male figure. Inscribed at lower right in a sixteenth-century hand, Francesco Caroto. *Also inscribed on the verso,* Fra Caroto.

Provenance: *Collection of the Moscardo Family; Conte Lodovico Moscardo, Verona; Marquis de Calceolari (until 1920); Luigi Grassi, Florence (Lugt Supplement 1171b).*

Bibliography: *Szabo, 1979, no. 6.*

The skillful combination of colors, including that of the paper, exudes the artistic ambience and coloris-tic traditions of Verona. In this respect, also, the technique is quite similar to the sheet by Francesco Morone reproduced in this volume (Plate 24). The right side of this drawing is cut off, but parts of a dais or throne and some drapery remain on the left, which suggest that the whole may have represented an Adoration scene. A drawing by Caroto in the Rasini Collection in Milan with the enthroned Virgin and Child and a saint provides a basis for the reconstruction of the original composition of a Virgin and Child in the center approached on both sides by groups of adorants (Franco Fiorio, 1971, p.113, figs. 49–50).

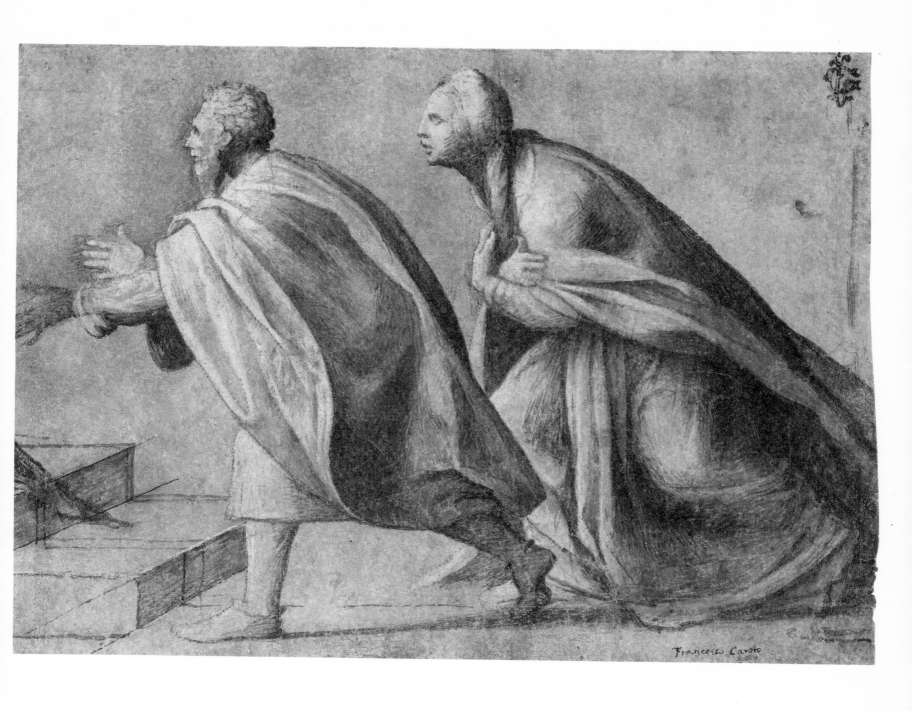

Francesco Caroto

GIROLAMO ROMANINO

Born in Brescia about 1484–87; died there after 1559. Romanino's earliest work and development stem from Venetian art and a sojourn in Padua in 1513, during which he painted the large altarpiece of the Madonna and saints, now in the museum of that city, in which the influence of Giorgione and Titian is evident. A stay in Cremona put him in contact with Emilian Mannerism, with particular consequences for his artistic language, which took on new, sophisticated, and expressive qualities. Subsequently Romanino worked principally in the area of Brescia, where the greater part of his oeuvre remains.

Romanino's graphic production is extremely interesting. At first his drawing was related to the work of Northern draughtsmen, particularly Albrecht Dürer. Later he tended to a sfumato manner close to Giorgione and Titian. Finally Romanino developed a graphic style of linear vivacity and marked Mannerist accent, nourished by Correggesque influence and Parmigianino's fluid line.

30 Pastoral Concert

Pen and brown ink and brown wash over black chalk on paper, 293 x 410 mm. Inscribed in pencil at lower right, Giorgione.

Provenance: *Collection of the Moscardo Family; Conte Lodovico Moscardo, Verona; Marquis de Calceolari (until 1920); Luigi Grassi, Florence (Lugt Supplement 1171b).*

Bibliography: *Orangerie Cat., 1957, no. 124; Cincinnati Cat., 1959, no. 216; Bean-Stampfle, 1965, no. 54; Szabo, 1979, no. 7; Oberhuber-Walker, 1973, p. 93.*

This large and ambitious composition is the most elaborate of three Romanino drawings of musical groups including a faun. Although these drawings are grouped together, they still represent distinct variations of the *concert champêtre*, both technically and iconographically. The lute players on a sheet of studies in the Uffizi is a pen drawing (*Mostra di strumenti musicali*, 1952, fig. 12). The pastoral concert in the Janos Scholz Collection, New York, is a fleeting and spontaneous red chalk drawing with four figures—two women playing a flute and a lute, the faun with a flute, and a young gentleman in a plumed hat holding a sword. This, the third, is more controlled and deliberately composed. The five figures are all gathered in the center under a tree. Three richly dressed young women and the faun are all playing string instruments; the fifth figure, probably also a young woman, is behind the faun and

seems to listen intently to the music. The composition is further tightened by the fact that all four players gaze attentively toward the center of the group as if reading music. In the background to the left, behind rolling hills, there are sketchy outlines of buildings; the right side of the drawing is empty or unfinished. In contrast to the two others, this drawing has an air of purpose and a feeling of completeness in spite of the partially unfinished figures, instruments, and setting.

The three drawings are thought to be early ideas for or associated with the frescoed lunettes of musicians in the loggia of the Castello del Buon Consiglio in Trento that were painted by Romanino 1531–32 (Ferrari, 1961, pl. 65). The connection is very distant and the contrived frescoes are a far cry from the immediacy of the drawings. It has also been pointed out that all share a dependency on the *Fête Champêtre* in the Louvre, variously attributed to Giorgione or to the young Titian (Fehl, 1957, pp. 153–68; Egan, 1959, pp. 303–13). Of the three, however, only this drawing approximates the mythic, poetic level of its famed predecessor or has a comparable structure, including the tree and the distant buildings. It is not hard to imagine that the artist could have planned to fill the void on the right side with a shepherd and his flock similar to the small group in the right background of his *Nativity with Four Saints* (London, National Gallery; Ferrari, 1961, pl. 49), thus completing not only the composition but also the metamorphosis of the mythological and allegorical theme into the pastoral genre.

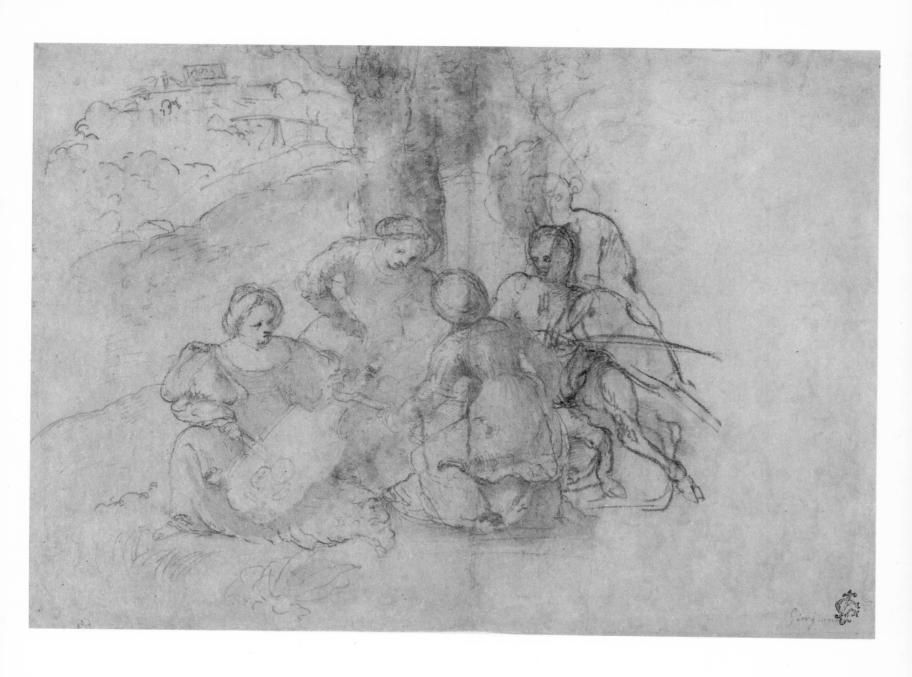

Painter, stucco-sculptor, and architect; born in 1487 in Udine into a family of embroiderers; died there in 1564. Called Nanni, therefore sometimes mentioned as Giovanni Nanni or Giovanni dei Ricamatori. As a young man he studied with the painter Giovanni Martini da Udine and later, 1510—11, with Giorgione. On the recommendation of Baldassare Castiglione he was accepted into the workshop of Raphael, with whom Giovanni worked as a painter and stucco-sculptor on the bath of Cardinal Bibbiena's apartments in the Vatican (1516), on the Psyche Room in Agostino Chigi's Villa Farnesina (1517—18), and on the loggia of the Vatican (1518—19). Giovanni was employed by Cardinal Giulio de' Medici, later Pope Clement VII, for whom he painted frescoes and produced stucco reliefs in the loggia of the Villa Madama, and by Pope Leo X (Giovanni de' Medici) for the decorations of the Sala dei Pontefici in the Vatican (1521).

During his long and extremely productive life Giovanni directed extensive decorative work in Florence, Rome, and Udine, made designs for stained glass and intarsia, and produced plans for various architectural projects. Giovanni da Udine's oeuvre is permeated with the style of the grotesque decorations from the ancient Roman Domus Aurea (the excavated palace of Nero) which he spread throughout Italy.

31 Design for a Wall Decoration

Pen and brown ink on paper, 273 x 226 mm. Inscribed in several places in Italian with various color notations.

Provenance: *J. P. Heseltine, London; Philip Hofer, Cambridge, Mass.*

Bibliography: *Szabo, 1977, no. 10; Szabo, 1979, no. 9.*

This sheet is a prime illustration of the influence of the Domus Aurea on Giovanni da Udine. He must have visited and studied the painted and stucco decoration there quite frequently (Dacos, 1969, fig. 29), and he left his signature on the vault of the Cryptoporticus for posterity. The elements of this drawing reflect Giovanni's virtuosity in decorative painting and stucco modeling. Several details may be compared to works that are firmly attributed to him. The ogival, round, and rectangular fields with beaded framework, for instance, are common in Raphael's loggia (Dacos, 1977, pls. LXVIII—LXIX, XCVIII—CI). The grotesque birds, animals, sea creatures, and floral motifs of the drawing all bear some resemblance to his decorative frescoes at the Villa Madama. But the airy festoons and the elegant figures, such as the Pallas Athene (?) in the center of this drawing, resemble most closely the ceiling frescoes with grotesques discovered not long ago in the Palazzo Baldassini in Rome and attributed to Giovanni da Udine (Montini-Averini, 1957, pl. XVII, pp. 33–44). Since Antonio da Sangallo built the Baldassini Palace between 1514 and 1522, the drawing should be placed into the same period. No definitive statement, however, can be made without a careful study of these decorations and a comparison of them with Giovanni da Udine's extant drawings, as well as a comparison of the handwriting here with the artist's autograph account book in the Biblioteca Comunale in Udine (Montini-Averini, pls. XXIV—XXVI).

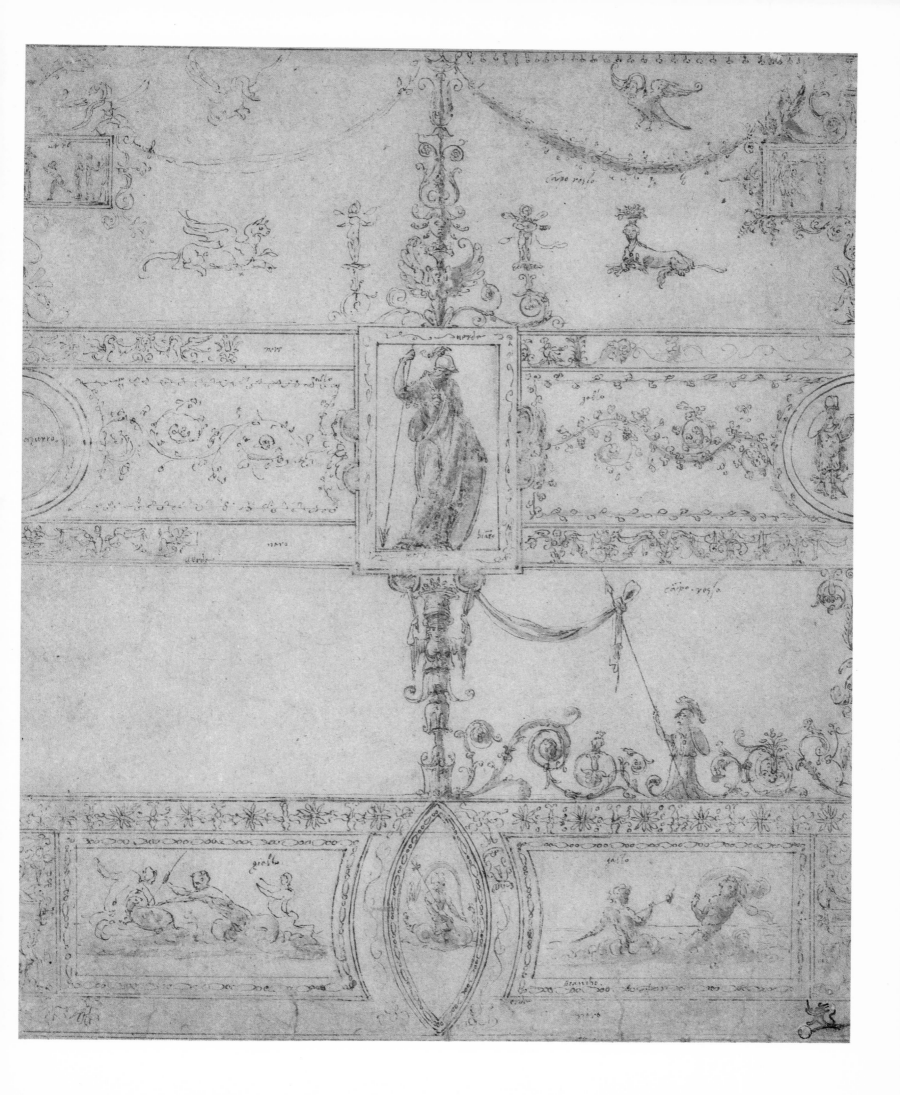

DEFENDENTE FERRARI

Born circa 1490 in Chivasso (Piedmont); died about 1535 in Ferrara. Very little is known of Defendente's training, but a slight influence of Martino Spanzotti and Macrino d'Alba can be detected in his earliest works. Later the art of Gaudenzio Ferrari and even Albrecht Dürer left their mark on his paintings. A few securely dated paintings provide a chronology of his work: *The Birth of Christ* is dated 1510 (Turin, Museo Civico) and *Enthroned Madonna* from 1519 (San Giovanni in Cirie). The earliest dated and signed altarpiece by Defendente Ferrari is the *Adoration* in the Cathedral of Ivrea, of 1521.

32 Madonna and Child with Two Saints

Pen and ink on paper, 317 x 248 mm. On the left a strip of paper with the figure of the young saint was added by the artist.

Provenance: *Unknown.*

Bibliography: *Szabo, 1979, no. 12.*

The long elegant figures and the oval faces, especially that of the Madonna, clearly reveal the hand of Defendente. These very same characteristics may be observed in his paintings from the early 1520s. As the artist replaced the section on the left, the original composition may have had another saint. There may even have been a larger group, since the side with the bishop saint is also cut. It has proved difficult to connect the drawing to any surviving work by the artist (Viale, 1954, passim), particularly as neither of the two saints can be identified.

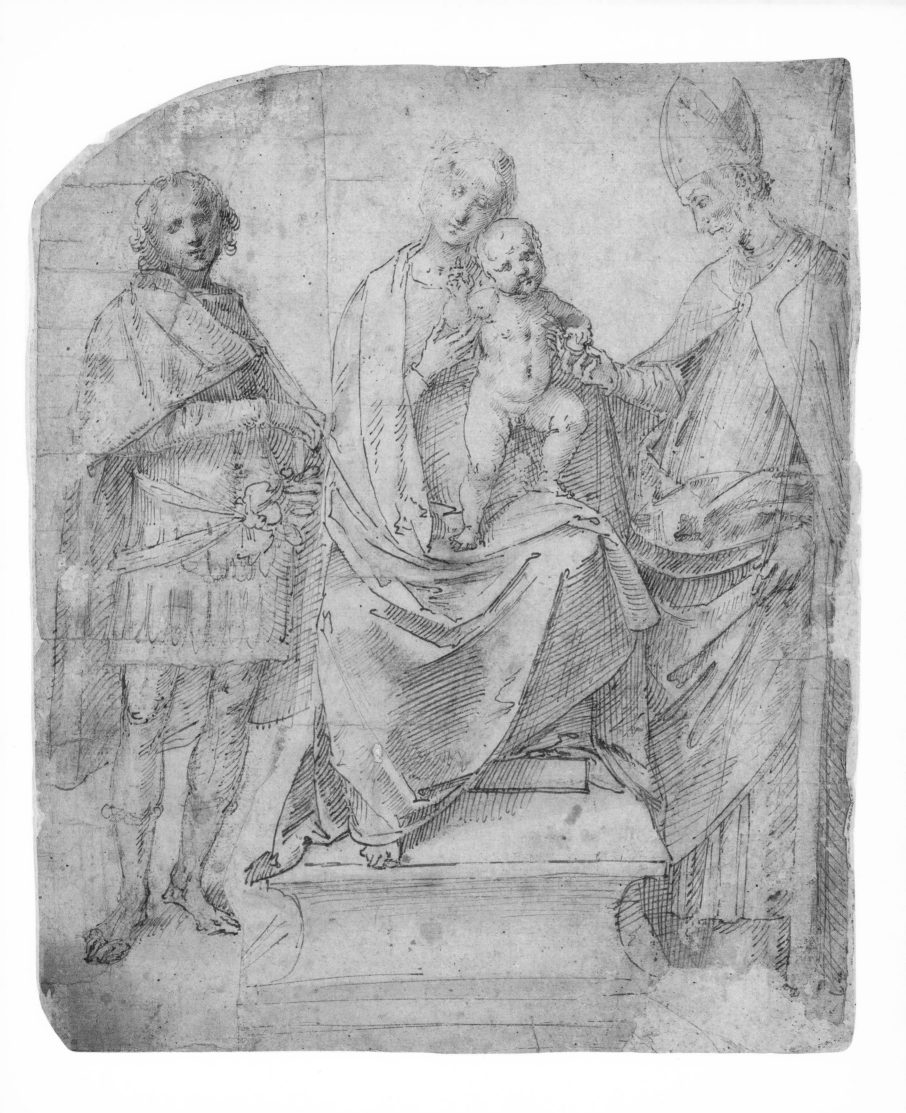

POLIDORO DA CARAVAGGIO (POLIDORO CALDARA)

Called Polidoro da Caravaggio after the Lombard town where he was born between 1490 and 1500; worked in Rome and Naples; founded a school in Messina, where he died probably in 1543.

According to Vasari, Polidoro was discovered by Raphael among the workmen in the Vatican loggia when he was eighteen years old. However that may be, his first known works seem to have been painted in collaboration with other pupils of Raphael, particularly Perino del Vaga. Following Peruzzi's example, Polidoro, in collaboration with the obscure Florentine artist Maturino, decorated façades with mythological and historical paintings inspired by ancient art. His interpretation of the ancient relief style had great importance for all the foreign artists who passed through Rome, not excluding Peter Paul Rubens. After the sack of Rome in 1527, Polidoro went to Naples and finally to Messina, where he was influenced by the current of Flemish realism that dominated in that city.

Polidoro is one of the most original and creative of Raphael's pupils. Even his early work shows such a distinctive character, it would seem that his artistic formation was largely complete when he arrived in Rome. His predilection for classicizing landscapes and genre motifs is evidently derived from Northern art. His relationship to Florentine masters such as Rosso and followers of Andrea del Sarto, which clearly emerges in the style of his red chalk drawings, may perhaps be explained by his close association with the Florentine Maturino. Polidoro was a master in the rendering of mood and, above all, a virtuoso in the handling of light, conceiving his figures and landscape in formal terms of strangely contrasting masses of floating, undulating chiaroscuro.

33 Frieze of Classical Figures and Horsemen

Pen and ink with light wash on paper, 197 x 381 mm. Inscribed at lower right, Polidoruse.

Provenance: *Unknown.*

Bibliography: *Szabo, 1979, no. 14.*

Like many other drawings by Polidoro, this one clearly demonstrates his method of interpreting the style of reliefs and sculptures of classical antiquity. The precise source for the three horsemen is unknown, but they seem to indicate that the inspiration was a triumphal procession on a relief.

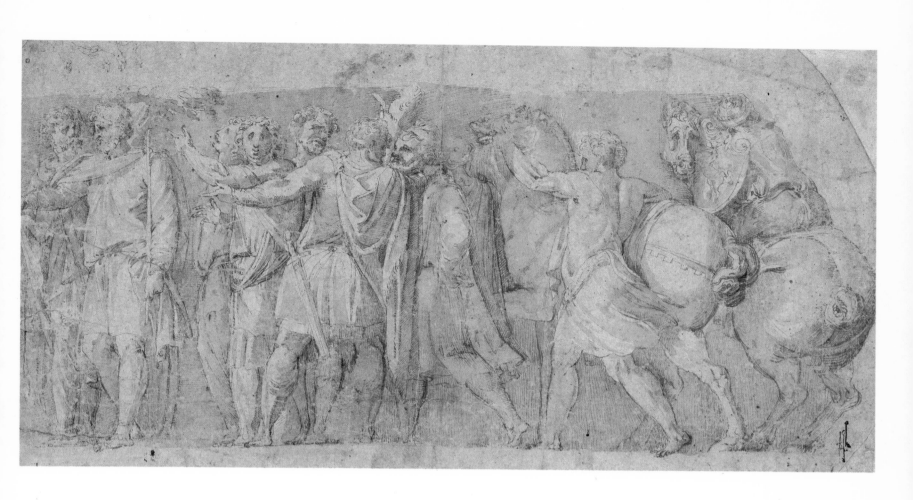

34 Mythological Scene

Pen and ink with wash, heightened with white paint on blue paper, 286 x 407 mm. Inscribed in ink above, 91 Leghi; inscribed at center, nº: cento diciotto; inscribed at upper right, Chereo ut verso (?). Verso: An unfinished study representing a Roman emperor (?) receiving homage (reproduced in Szabo, 1979, no. 15B).

Provenance: *Unknown.*

Bibliography: *Szabo, 1979, no. 15A.*

The four figures, unquestionably in the manner of classical sculptures, probably represent a still unidentified mythological scene. Groups and figures like this abound in the oeuvre of Polidoro, especially in the frescoes he painted on the façades of various buildings in Rome (Kultzen, 1961, pp. 207–12). As it is well known that he left for Naples after the sack of Rome in 1527, and later went to Messina, the drawing should be dated to the later 1510s or soon thereafter. It is interesting to note that the handwriting is very similar to that on the drawing representing the Procession of Cybele in the British Museum which is also dated to the Roman period of Polidoro da Caravaggio (Marabottini, 1969, pl. LXXIV, no. 1).

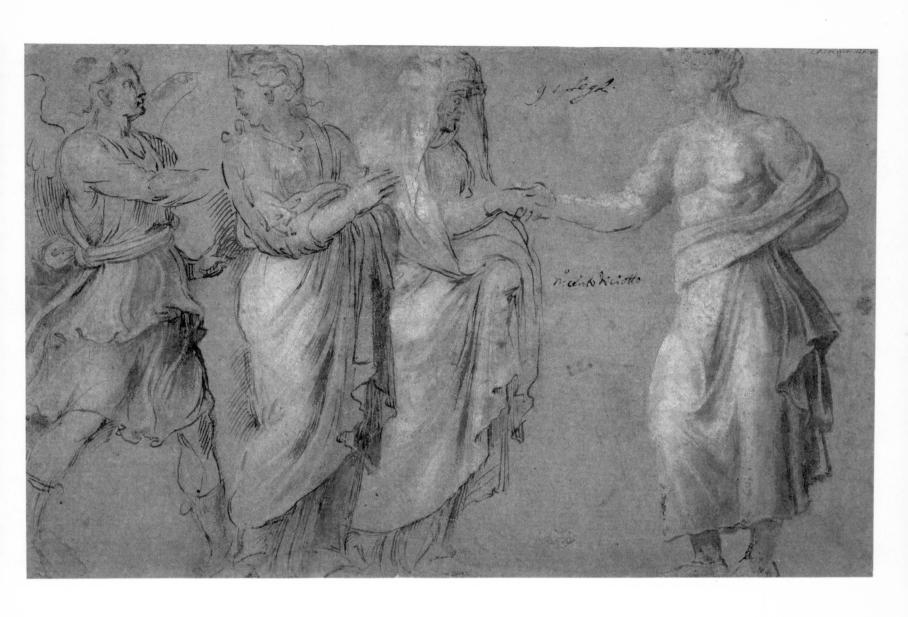

BACCIO BANDINELLI

Sculptor; born in Florence 1493; died there in 1560. Bandinelli was at first a student of his father Michelangelo di Viviano, a successful goldsmith, and later of the sculptor Giovanfrancesco Rustici. It was in Rustici's shop, industriously copying Michelangelo's cartoon for the *Battle of Cascina*, that Bandinelli acquired his notable skill as a draughtsman, which also determined the cultivated academicism of his sculptural style. His draughtsmanship shares certain characteristics with that of Rosso.

An artist much appreciated in the Medici circle, he received numerous commissions from various members of that family, both in Florence and Rome. Pope Leo X (Giovanni de' Medici) ordered from him, among other things, a copy of the ancient sculpture *Laocoön* that was to have been sent as a gift to Francis I, king of France.

Subsequently Pope Clement VII (Giulio de' Medici) entrusted to him the major part of the work on the funerary monuments destined for Leo X and himself in the church of Santa Maria sopra Minerva. In addition, Bandinelli received other important commissions in Genoa and Bologna. In the latter city he met Emperor Charles V, to whom he offered a bronze relief of the Deposition, and who bestowed upon him the honor of Knight of the Order of Saint James.

Among the artist's more famous works produced in Florence are: *Hercules and Cacus* (1533–34), in the Piazza della Signoria; the monument to Giovanni delle Bande Nere (1544), commissioned by Grand Duke Cosimo I for the transept of San Lorenzo and finally set up in the square in front of the church during the later part of the nineteenth century; the marble reliefs with figures of prophets and apostles that decorated the octagonal railing of the choir of the cathedral, now in part in the Museo dell'Opera del Duomo; and finally, again for the cathedral, the gigantic sculptural complex that was to have formed the high altar and which is now divided among the cathedral, the cloister of Santa Croce, and the Bargello Museum.

35 Standing Apostle

Pen and ink on paper, 381 x 183 mm. The corners are cut.

Provenance: *Jan Pietersz. Zoomer (Lugt 1511); John Skippe; Descendants of John Skippe, the Martin Family, including Mrs. A. C. Rayner Wood; Edward Holland Martin.*

Bibliography: *Skippe Sale Cat., 1958, no. 10a; Szabo, 1979, no. 17.*

This standing figure of an apostle is a typical sculp-

tor's drawing in the way it emphasizes volume and detail only when necessary, as in the hand holding the book. Popham suggested that it is part of the series of apostles, of which several are in the Ambrosiana and in the Uffizi (Skippe Sale Cat., 1958, p. 15). He also thinks that this series may be connected with the apostle figures that Bandinelli made for the monuments of popes Leo X and Clement VII in Santa Maria sopra Minerva, Rome. This drawing, together with others of apostles from the series, was engraved by Jan de Bisschop and published as Plate 34 in his *Paradigmata Graphices*, the Hague, 1671.

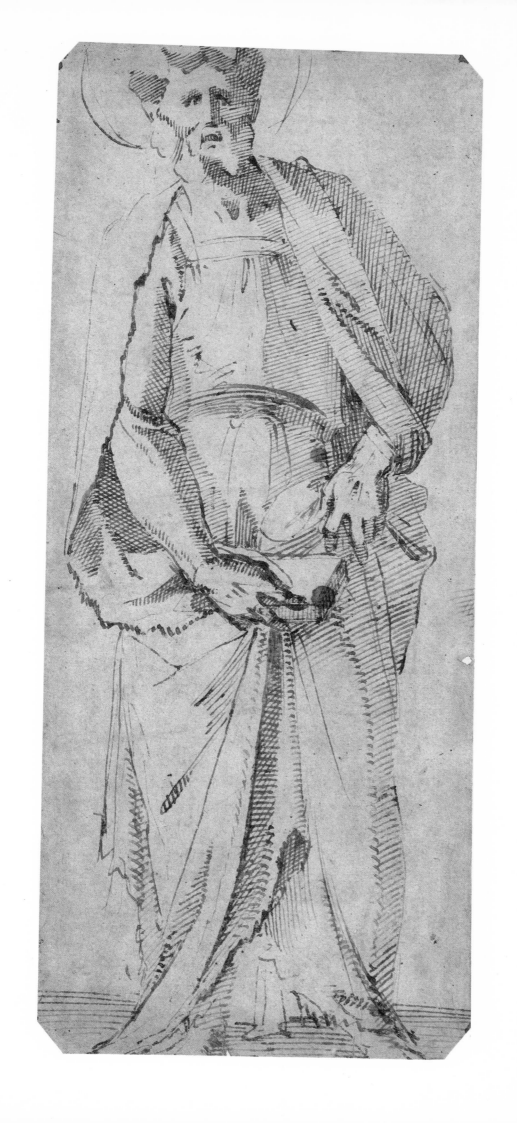

36 Seated Man Declaiming from a Book

Pen and brown ink on paper, 311 x 195 mm.

Provenance: *Jan Pietersz. Zoomer (Lugt 1551); John Skippe; Descendants of John Skippe, the Martin Family, including Mrs. A. C. Rayner Wood; Edward Holland Martin.*

Bibliography: *Skippe Sale Cat., 1958, no. 10b; Szabo, 1979, no. 18.*

As Popham pointed out, this sheet is a good example of Bandinelli's style of sketching from life. As he noted, it should be compared with a study of the standing figure of a young man at Chatsworth (Skippe Sale Cat., 1958, p. 15).

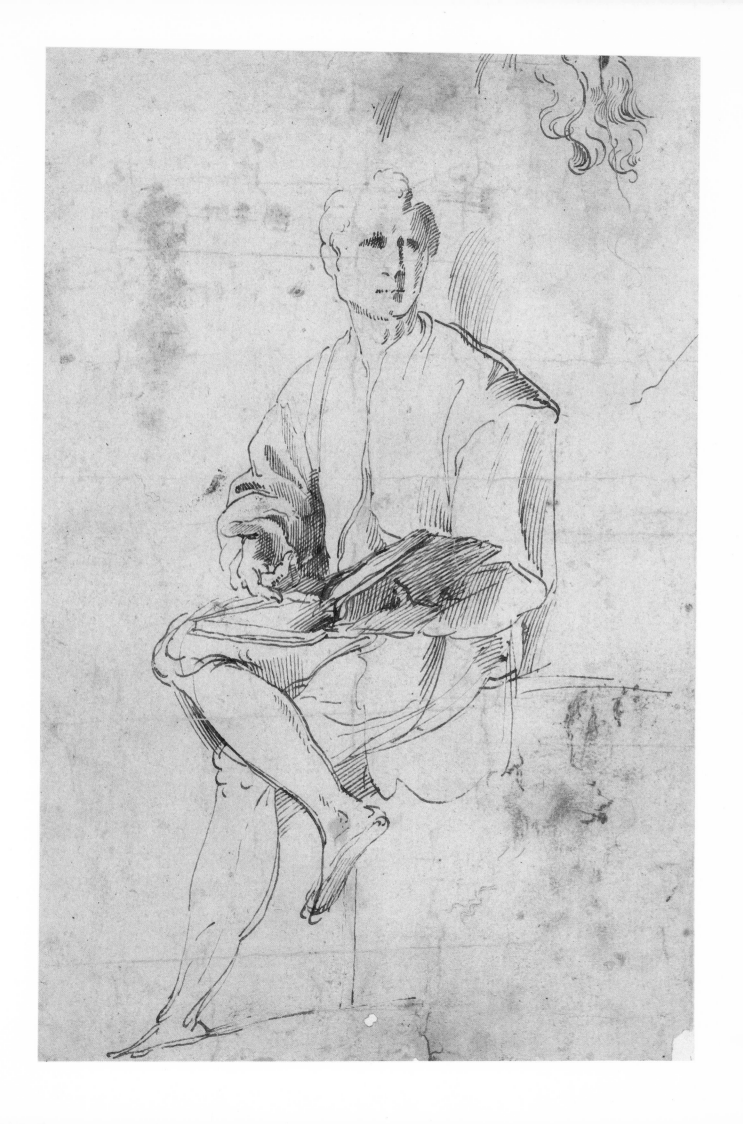

DOMENICO CAMPAGNOLA

Painter, engraver, and woodcut artist; the adopted son of Giulio Campagnola, born of a German father in 1500; died in Padua 1564.

Domenico was for a certain period in Titian's workshop. Little is actually known of his activity as a painter, which he carried out principally in Padua. His activity as an engraver, in which he manifested a personal style very close to that of his drawings, was limited to the years 1517—18, the same period to which his woodcuts belong. His woodcuts and drawings of landscapes, in which he transformed Titian's style into a linear, calligraphic language of more immediate legibility, had a remarkable importance for landscape painting in the whole of Europe and even an artist such as Pieter Bruegel drew inspiration from them.

37 Landscape with Satyr

Pen and brown ink on paper, 262 x 208 mm. Watermark: Anchor in a circle, similar to Briquet 587.

Provenance: *Unknown. Acquired 1959, from W. H. Schab, New York.*

Bibliography: *Graphic Arts of Five Centuries: Prints and Drawings, New York, W. H. Schab Gallery, 1959, no. 127; Szabo, 1979, no. 23.*

This lively sheet contains an almost complete inventory of the subjects, draughtsmanship, and style that made Domenico Campagnola so influential, not only among his Italian and Northern contemporaries, but also with later artists, such as the Carracci and even Watteau. The hilly ridge that runs diagonally from the lower left to the upper right divides the composition into two almost equal halves. In the left foreground is a recumbent satyr, his right forearm on a syrinx, and his left resting on the head of a sleeping dog. The satyr points quite markedly toward the right of the composition where a man and a woman, leading a mule, approach. Among the trees in the upper reaches of the pictorial field are two nude female figures (no doubt wood nymphs), one sitting and one standing. The other half of the drawing is filled with another well-known motif of Campagnola's: a small town or village consisting of various buildings, some rustic, others more elaborate, that clings to the foot of a mountain range.

The penwork is very fine and dense, especially in the satyr, his dog, and the trees; in contrast, the nymphs and the surrounding trees are drawn with a delightful lightness and apparent enjoyment of line. All these characteristics indicate that the drawing is from the artist's later period, for which a more detailed chronology of his activity is still wanted. The thoughtfully arranged composition, the deliberate actions and movements of the figures, such as the pointing finger of the satyr, the couple with the mule, and the nymphs, all suggest that the artist probably had a definite subject in mind rather than just a random assembly of genre or mythological characters. Unfortunately, as with many other works by Domenico Campagnola, the exact meaning still escapes us.

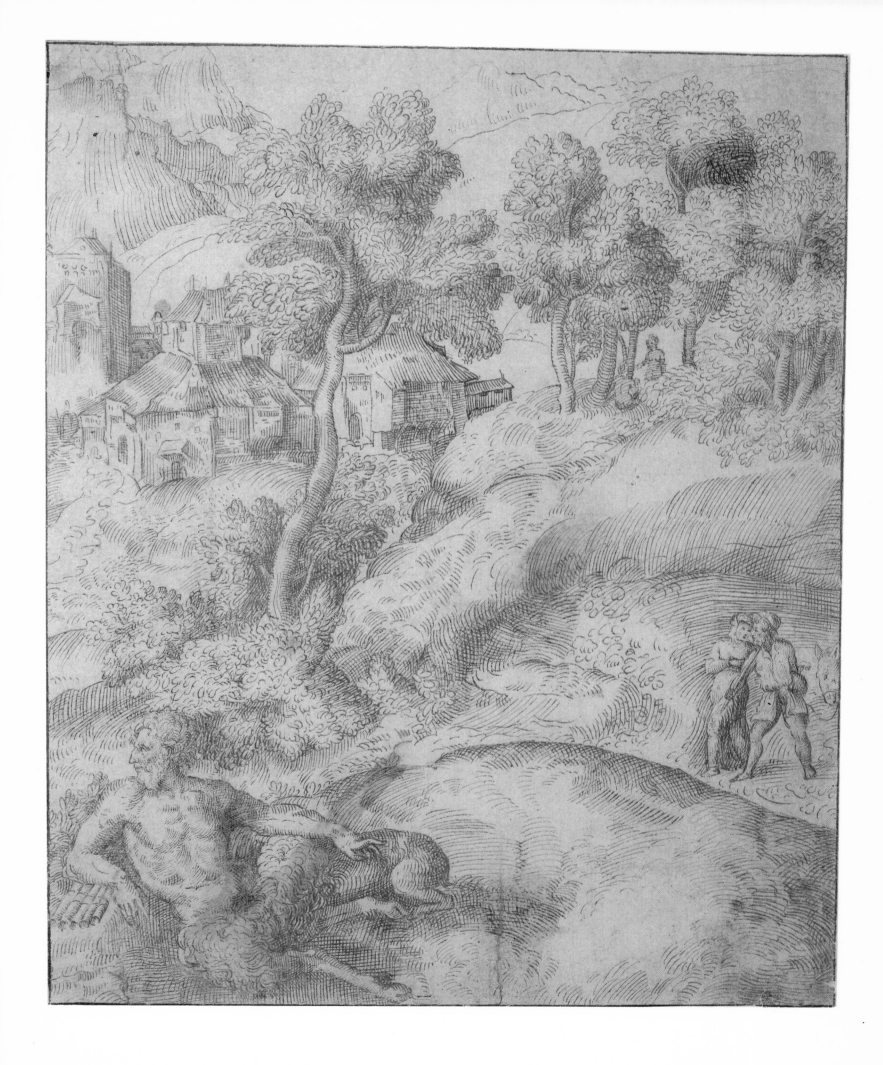

Painter, born near Florence on November 7, 1503; died in Florence in 1572. Agnolo di Cosimo di Mariano, called Bronzino, began his career when the Mannerist style was already an accomplished fact. He spent a short time in the workshop of Raffaellino del Garbo, which had no significant effect on his formation, and received his real education from his master Jacopo Pontormo, whom he assisted on the frescoes in the Certosa of Galluzo and those of the church of Santa Felicità in Florence.

Bronzino did not share Pontormo's solitary and withdrawn nature. Very early he entered the aristocratic world of the Medici, for whom he became court painter. He collaborated on the decorations erected in Florence for the marriage of Duke Cosimo I to Eleanora of Toledo, and his part in this enterprise must have been highly admired for he was immediately entrusted with another prestigious commission, the decoration of Eleanora's private chapel in the Palazzo Vecchio, a work in which Bronzino left one of the best examples of his refined and cerebral style. Again for the Medici he painted a series of extraordinary portraits, among them the famous *Portrait of Eleanora of Toledo and Her Son Giovanni de' Medici*, executed around 1550 and now in the Uffizi. For the Medici also he created various cartoons for a series of tapestries destined for the Sala del Dugento in the Palazzo Vecchio. From this moment on, however, Bronzino was caught up in the moralistic spirit of the Counter Reformation, the effects of which are most noticeable in his religious paintings. His style assumed a suffocating elaborateness that was a far cry from the profane elegance that had been one of the outstanding features of his art.

38 Studies of Seated Male Nude

Black chalk on paper, 368 x 203 mm.

Provenance: *Sir Joshua Reynolds (Lugt 2364); H. S. Reitlinger (Lugt 2274a).*

Bibliography: *Van Schaack, 1962, no. 6; Szabo, 1971, no. 24.*

The two figures are studies for the young shepherd in Bronzino's signed painting *The Adoration of the Shepherds* (Budapest, Museum of Fine Arts; Emiliani, 1960, no. 30; Baccheschi, 1973, no. 26). Van Schaack recognized this relationship and corrected the earlier attribution to Pontormo (Van Schaack, 1962, p. 70). Vasari, too, records the small panel in Budapest as an outstanding work by Bronzino, "For Filippo d'Averardo Salviati he executed a Nativity of Christ in a small picture with little figures, of such beauty that it has no equal, as everyone knows, that work being now in engraving . . . " (Vasari, *Lives*, vol. X, p. 5).

As Van Schaack points out, "In the drawing and the painting the figures hold almost identical poses, but for the final version Bronzino chose a viewpoint more to the left and in front of the model. . . . Only the position of the legs has been altered but the left still remains slightly raised above the right" (Van Schaack, 1962, p. 70). There are, however, other differences between the painting and the drawing. Here the large figure is nude and holds what seems to be a syrinx, which is not present in the painting. These shepherd's pipes would have been perfectly appropriate in the painting and a second shepherd even plays a bagpipe to entertain the Christ Child. The Budapest painting is usually dated between 1535 and 1540; a slightly earlier date should be assigned to this drawing. Furthermore, it is interesting to note that the immediacy of the drawing style from life is close to Bronzino's *Study for Saint Michael*, circa 1532, in the Louvre, thus suggesting a more exact date, one around 1535 (Smyth, 1971, pp. 7–8, pl. 8).

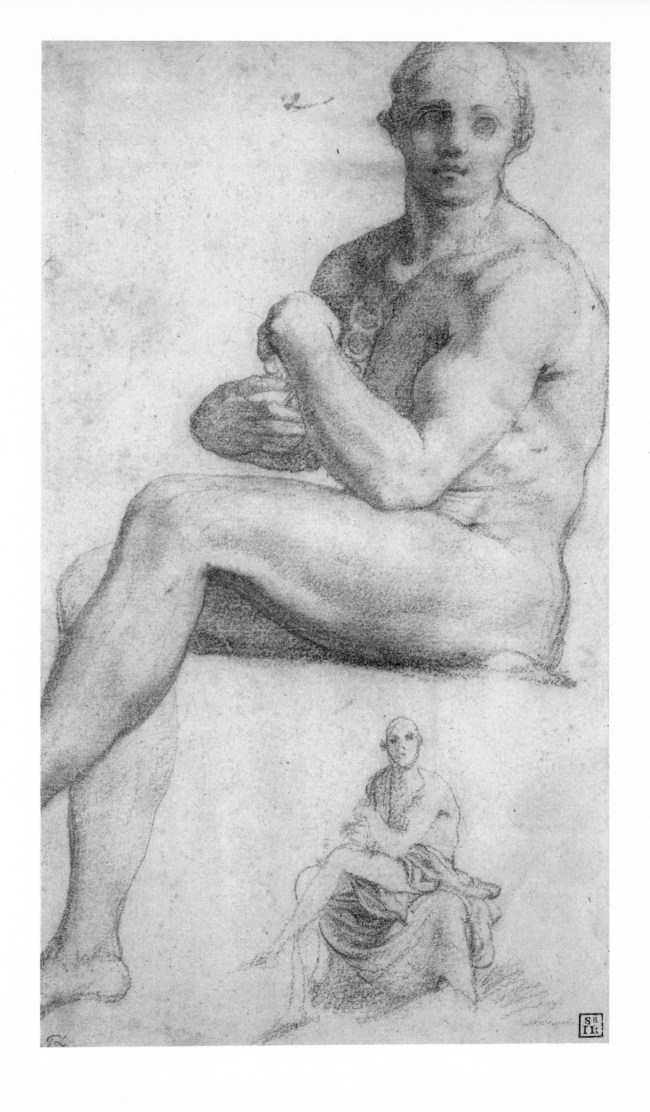

FRANCESCO PRIMATICCIO

Painter, sculptor, architect; born about 1504 in Bologna; died 1570 in Paris. Primaticcio probably received his first artistic training from Fracuzzi and Bagnacavallo, but Giulio Romano, with whom he worked in Mantua from 1525 to 1532, may be considered to be his true teacher. In 1532 Primaticcio was summoned to France by Francis I, and at Fontainebleau, together with Rosso Fiorentino, who had arrived earlier, he became head of the School of Fontainebleau, thus playing a primary role in the development of international Mannerism. Between 1540 and 1542, and again in 1546, Primaticcio had the opportunity of studying and absorbing the art of Rome, where he was sent in the service of the French king. At Fontainebleau from 1552 onward he enjoyed the collaboration of Niccolò dell'Abbate, who in some cases painted from Primaticcio's designs.

Primaticcio's grand decorative cycles at Fontainebleau have in large part been destroyed (Gallery of Ulysses, 1541–70), or are now in very poor condition (Ballrom, 1552–56). The best aspects of his art have been preserved in his wonderful light-filled red chalk drawings which reveal a master capable of blending Giulio Romano's classicizing ideal with Rosso's spirited decorative fantasy and the graceful elegance of Parmigianino's mature style. His lively and sophisticated compositions, combining vigor with delicacy, had a notable influence in France, in the Low Countries, and, by means of engravings, in Italy.

39 Two Nymphs Carrying a Third

Pen and ink wash over traces of metalpoint on buff prepared paper, 240 x 280 mm. Cut on the left side.

Provenance: *P. J. Mariette (Lugt 1852); Lagoy; Earl of Warwick (Lugt 2600); Victor Koch, London.*

Bibliography: *Buffalo Cat., 1934, no. 27; Orangerie Cat., 1957, no. 121; Cincinnati Cat., 1959, no. 219; Zerner, 1969, LD. 81; L'Ecole de Fontainebleau Cat., 1972, no. 389; Szabo, 1977, no. 14; Szabo, 1979, no. 25.*

On the left side the hoof and calf of a satyr are still visible, indicating that the drawing is incomplete. Nevertheless, these fragments have helped to relate the composition to an engraving by Léon Davent which represents, in reverse, the same group of three nymphs approaching a sitting, libidinous satyr (Adhémar, *Supp.*, p. 86; Zerner, 1969, LD. 81). A pendant drawing in the Hermitage, Leningrad, shows a satyr carried by two others in the same manner as here (Dimier, 1900, no. 224). That drawing is also cut, but the engraving of it by Davent includes the figure of a libidinous nymph that must have completed the composition (Adhémar, *Supp.*, p. 286; Zerner, 1969, LD. 81). As the engravings are dated 1547, these drawings, which unquestionably served as their models, must be dated a little earlier.

The engravings throw further light on the use and destination of the compositions. According to Herbet, they represent stucco reliefs that adorned the rooms of the so-called Appartement des Bains that is often mentioned in old descriptions of Fontainebleau (Herbet, 1869–1902, p. 23; Herbet, 1937, p. 155). This theory is accepted by Beguin, who also suggests that the style of the present drawings is very close to others securely attributed to Primaticcio and also connected with the decoration of the Appartement des Bains (Orangerie Cat., 1957, p. 86). She emphasizes especially their similarity to those depicting the History of Callisto (in the Louvre and British Museum, Dimier, 1900, nos. 11, 164) and the Bath of Venus and Mars (Louvre; Dimier, 1900, no. 17).

The spirited representation of nymphs and satyrs has no precedent in Primaticcio's oeuvre. In general, the satyr displays a familiarity with small bronzes by Riccio and with the graphic work of Domenico Campagnola. However, the most probable source for this drawing and its pendant in the Hermitage must have been compositions in illuminated manuscripts or their copies, such as the large page by Bernardo Parentino in the volume containing Domitius Calderinus's *Commentarii in Juvenalem* (Florence, Biblioteca Laurenziana, MS Plut. 53.2, fol. 57; Salmi, 1954, pp. 133–34). The whole framework at the beginning of the *Commentarii in Satyra Ivvenalis* is decorated with satyrs and satyresses, some fighting or pairing off, but most playing musical instruments. The lower part of the framework consists of one single large composition. On the left, two satyrs lead a third unwilling one toward a reluctant nymph who is carried by two others in almost the same pose as on this drawing. This direct connection provides new support for Primaticcio's Paduan sources, which must have been available to him through small bronzes, drawings, and engravings.

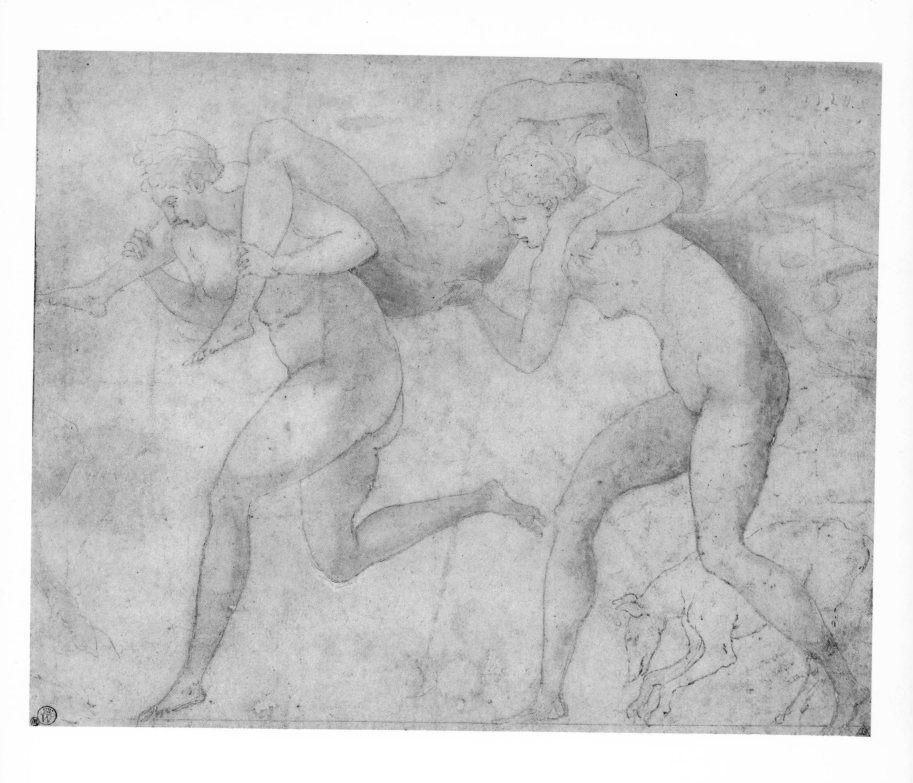

40 Saint Jerome in a Landscape

Pen and brown ink on paper, 178 x 216 mm.

Provenance: *Luigi Grassi, Florence (Lugt Supplement, 1171b).*

Bibliography: *Berenson, 1938, no. 1589J; Langton Douglas, 1946, p. 128, plate LXXX; Orangerie Cat., 1957, no. 112; Cincinnati Cat., 1959, no. 201; Bean, 1960, discussed in no. 1010; Berenson, 1961, no. 1859J; Heinemann, 1962, p. 286; Puppi, 1962, p. 148, fig. 107; Bean-Stampfle, 1965, no. 4; Wazbinski, 1968, p. 8, fig. 8; Pignatti, 1974, no. 7; Szabo, 1979, no. 26; Ragghianti, 1972, p. 132, fig. 28.*

This sheet is one of the earliest examples of Italian landscape drawing. The free-flowing lines which become lighter and lighter as the watery landscape reaches farther into the distance and the dense but playfully drawn timbered buildings in the center exude an exotic but still familiar ambience and feeling. The qualities of this "little masterpiece" have elicited constant praise but not consistency of attribution since it surfaced at the Grassi sale in 1924. Berenson ascribed it to Piero di Cosimo and noted the "Flemish" and "Japanese" feeling in it. His attribution was accepted by Langton Douglas. In contrast, the Venetian character was strongly stressed by other connoisseurs and commentators. Robert Lehman preferred an association with Giovanni Bellini; others mention the influence of Alvise Vivarini, Giorgione, and Bartolomeo Montagna (for a summary of opinions see Bean-Stampfle, 1965, p. 20). Pignatti's reaffirmation of the Giorgione connections is noteworthy. Inconclusive as these attributions are, together with the presence of the Northern half-timbered buildings (borrowed from Dürer?), they nevertheless suggest a dating to the first decades of the sixteenth century.

The importance and the beauty of the landscape have overshadowed the figure of Saint Jerome and the iconographic problems of this complex drawing. For instance, it was suggested that the writing saint before the opening of a cavelike cell could also be Saint John on Patmos. However, as Wazbinski also noted not long ago, the saint is definitely Saint Jerome, and the drawing is a remarkable illustration of humanistic ideas popular in Northern Italy during the fifteenth century which represent this saint as the example of the *Vita Solitaria* and *Vir Melancholicus*. This cult of Saint Jerome reaches back as far as Petrarch and was rekindled by later writers such as Angelo Decembrio and Pietro Bembo. They all emphasize the solitary meditation of the saint sitting before his cell as his mind wanders through the savage and magnificent forests, the snow-covered mountains, the cool valleys, and the far-reaching rivers (Wazbinski, 1968, pp. 6–8, 16). In this sense, the freely drawn figure of Saint Jerome seems to be a deliberate contrast to the compressed, dense group of half-timbered buildings that are also antipodes of nature, adding another artistic and poetic dimension to this celebrated drawing.

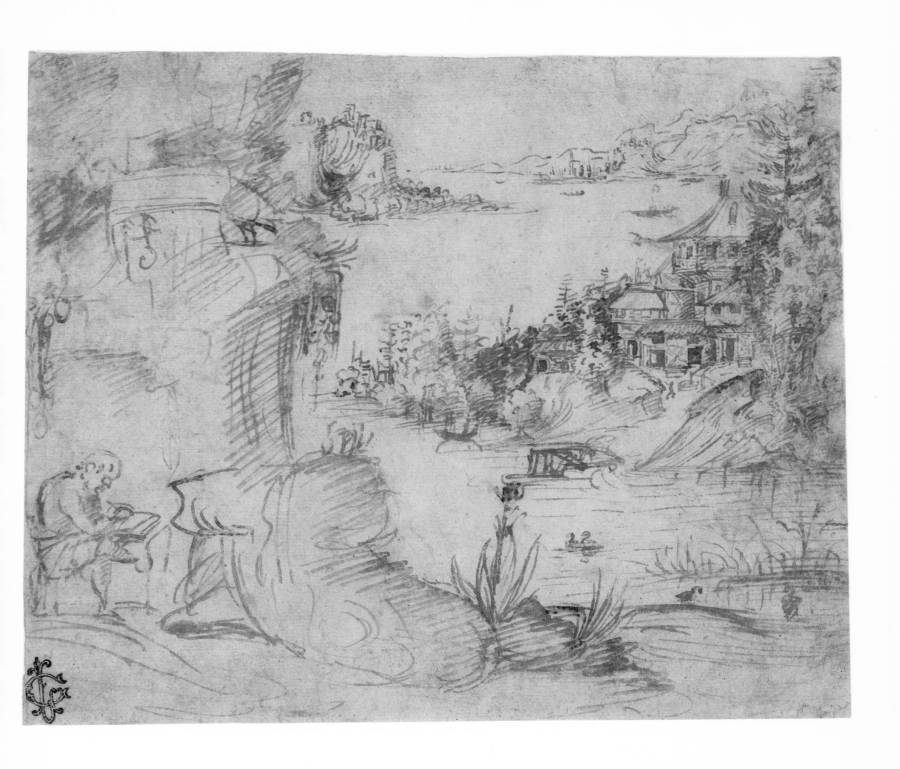

DANIELE DA VOLTERRA (DANIELE RICCIARELLI)

Painter and sculptor; born around 1509 in Volterra; died in Rome in 1566. Daniele da Volterra received his early training in the workshops of Sodoma and Baldassare Peruzzi and probably went from Siena to Rome in 1535 with the latter. The first secure mention of Daniele in Rome dates from 1541; there he first worked with Pierino del Vaga and was later associated with Michelangelo. The art of that great sculptor and painter left a lasting mark on Daniele's work; the best portrait of Michelangelo is also one of Daniele's most successful sculptures (Florence, Casa, Buonarroti). He worked in Florence, Carrara, and his native Volterra, producing a large number of religious and decorative frescoes. Among his panel paintings, the best known is the *David and Goliath* (Paris, Louvre).

41 Jupiter and Io

Pen and brown ink on paper, 235 x 178 mm. Squared with black chalk for transfer. Verso: Pen and ink study by another hand of a male nude stabbing himself (reproduced in Szabo, 1979, 35B).

Provenance: *Unknown. Acquired in 1955 from Prejean, New York.*

Bibliography: *Szabo, 1979, no. 35A.*

This lively drawing represents the mythological story of Jupiter seducing Io, daughter of Inachus, under the cover of clouds and foggy mist (Ovid's *Metamorphoses*, Book I). Subsequently Jupiter turned the girl into a beautiful white cow in order to deceive the suspicious Juno. The story is represented here in a spirited and veiled manner. The erotic pose and gestures follow the accepted artistic conventions of the time. The well-formed figures demonstrate not only Daniele da Volterra's sure drawing hand but also his thorough knowledge of decorative sculpture. His inventive talent is evident in the way he compresses the rest of the story into the small supportive figures in the lower left corner where Io's parents are desperately searching for their lost daughter.

The careful squaring is an indication that this composition was intended to be transferred to a larger scale, possibly a cartoon for a wall painting. However, the recent catalogue raisonné of Daniele da Volterra lists no subject that could be related to this one. Among the drawings attributed to him, the *Pentheus and the Maenads* (Vienna, Albertina) and the study for *Adam and Eve* (London, British Museum) seem to be comparable to this composition, if not in style, at least in spirit (Barolsky, 1979, figs. 47, 102).

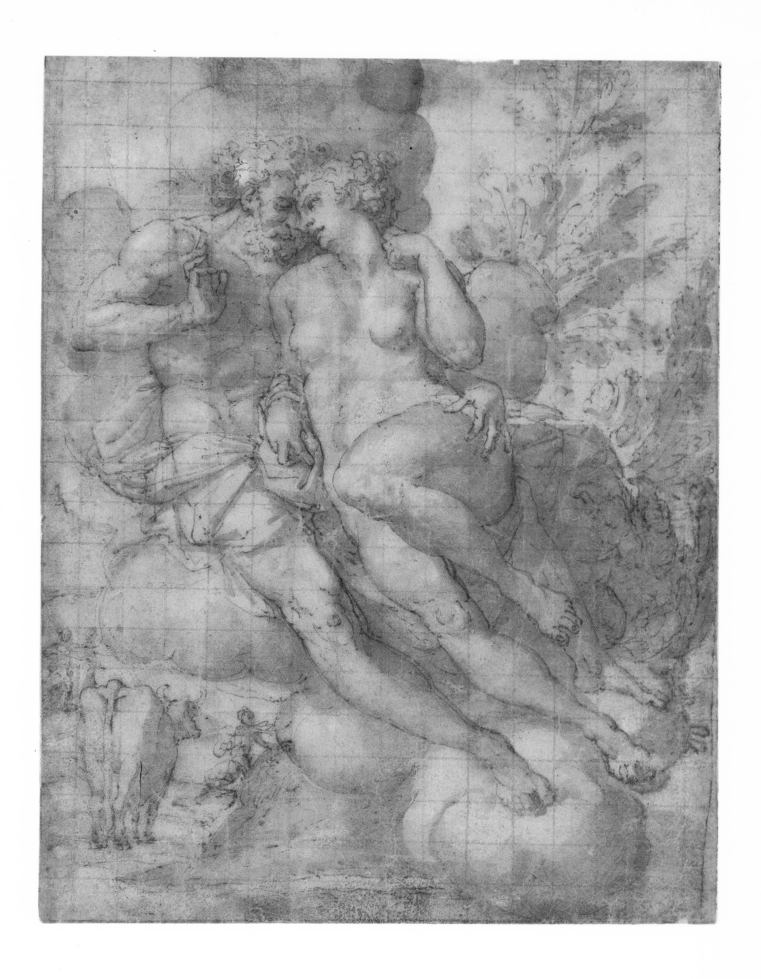

TINTORETTO (JACOPO ROBUSTI)

Born in Venice in 1518; died in May 1594. It is not known who Tintoretto's early masters were, but the names of Titian, Bonifacio de' Pilati, Schiavone, and Paris Bordone have all been suggested. Raffaello Borghini's statement that Tintoretto derived his drawing from Michelangelo and his color from Titian is a literary commonplace, although his drawings after Michelangelo's sculptures demonstrate Tintoretto's strong interest in this master's work. Actually Tintoretto's formation was influenced by Tuscan and Roman art and the work of Parmigianino. All these elements reflect the particular artistic situation of Venice in the 1540s, which also formed the style of the early work of Giuseppe Porta, Jacopo Bassano, and Schiavone.

Tintoretto was the foremost painter of vast compositions in Venice in the second half of the sixteenth century. His style is characterized by dynamic tension and grandiose spatial conceptions, an expressive intensity and virtuosity of poses, and a vigorous modeling of plastic form. These qualities make him the counterpart of the great fresco painters of Rome and Tuscany in the Venetian idiom of oil on canvas. A painter of dramatic action and heightened states of mind, Tintoretto is one of the major masters of the sixteenth century. On a level with his paintings of religious, historical, and mythological subjects are his fine portraits.

42 Study for a Portrait of a Doge

Black and white chalk on grayish buff paper, 293 x 190 mm. Inscribed at lower left with number, 189.

Provenance: *Luigi Grassi, Florence (Lugt Supplement, 1171b).*

Bibliography: *Grassi Sale Cat., 1924, no. 136; Szabo, 1979, no. 36.*

The straight vertical lines and abrupt broken folds of the drapery that characterize this drawing are in sharp contrast to the continuous serpentine lines of most of Tintoretto's drawings (cf. Plate 43). The vo-luminous folds of the robe lend a certain air of majestic authority to the whole. This befits the figure, whose official position is clearly indicated by his *corno ducale,* the cap of a doge. The sketchy outlines of the face prohibit the identification of the person, nor can it be ascertained whether the drawing is a study for a portrait or for a figure in a larger composition. The concept of the extensive drapery and its modeling is similar to the *'Drapery Study* (Rome, Galleria Corsini, no. 125523) and the *Kneeling Bishop* (Florence, Uffizi, no. 13017; cf. Delogu, *Tintoretto,* pls. 18–19). These studies are usually placed after 1500 and the same general dating may be suggested for this drawing as well.

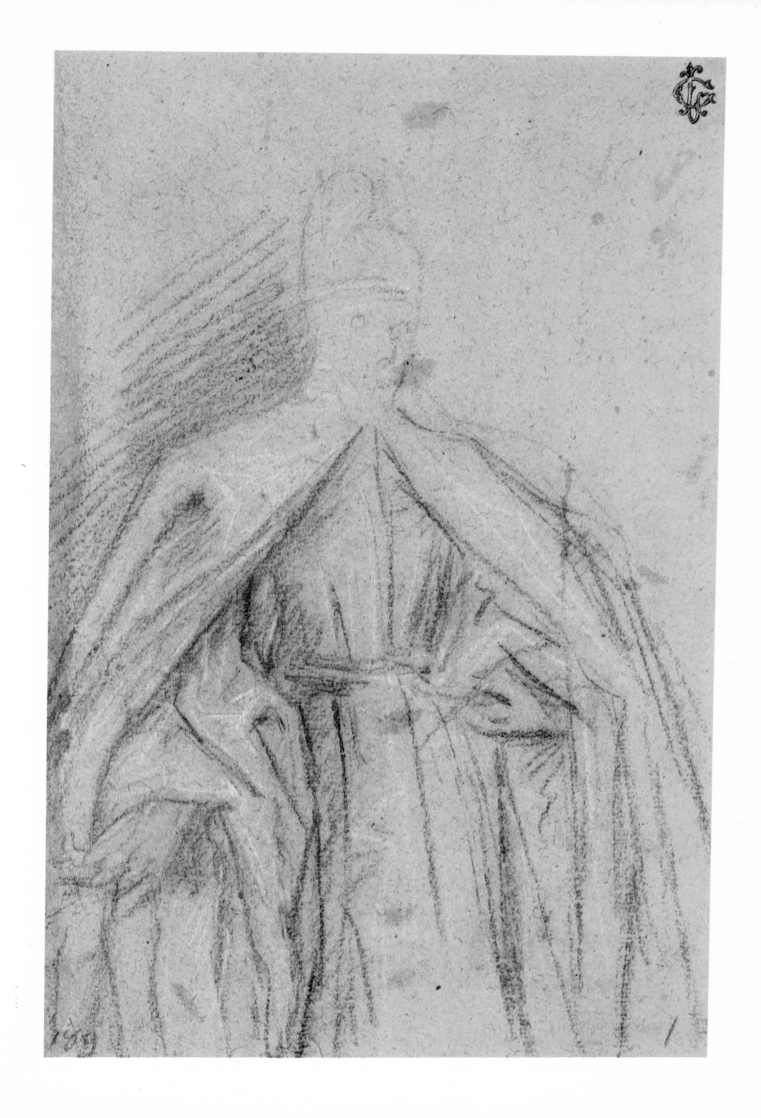

TINTORETTO (JACOPO ROBUSTI)

43 Reclining Figure

Charcoal on blue paper, 167 x 320 mm. Squared with charcoal for transfer. Inscribed in a nineteenth-century hand in the lower right corner, G. Tintoretto. *Verso: A figure of Christ for a Crucifixion in black chalk, heightened with white (reproduced in Szabo, 1979, no. 37B).*

Provenance: *Sir Joshua Reynolds (Lugt 2364); Ludwig Burchard.*

Bibliography: *Pignatti, 1974, no. 20; Szabo, 1979, no. 37A.*

The powerful reclining figure belongs to a group of Tintoretto's drawings that is characterized by continuous, serpentine lines emphasizing volume and form. Pignatti compares this drawing to a *Saint Theo-* *dore* (Florence, Uffizi, no. 12966) that is a study for the ceiling frescoes in the Albergo di San Rocco, usually dated 1564. Some particular quality of this and many similar drawings by Tintoretto must have exercised a powerful appeal for Sir Joshua Reynolds, whose collector's mark is in the upper right corner. This is curious in light of Reynolds's statement in his famous *Second Discourse* (December 11, 1769) in which he observed: "The *Venetian* and *Flemish* schools, which owe much of their fame to colouring, have enriched the cabinets of the collectors of drawings, with very few examples. Those of Titian, Paul Veronese, Tintoret, and the Bassans, are in general slight and undetermined. Their sketches on paper are as rude as their pictures are excellent in regard to harmony of colouring."

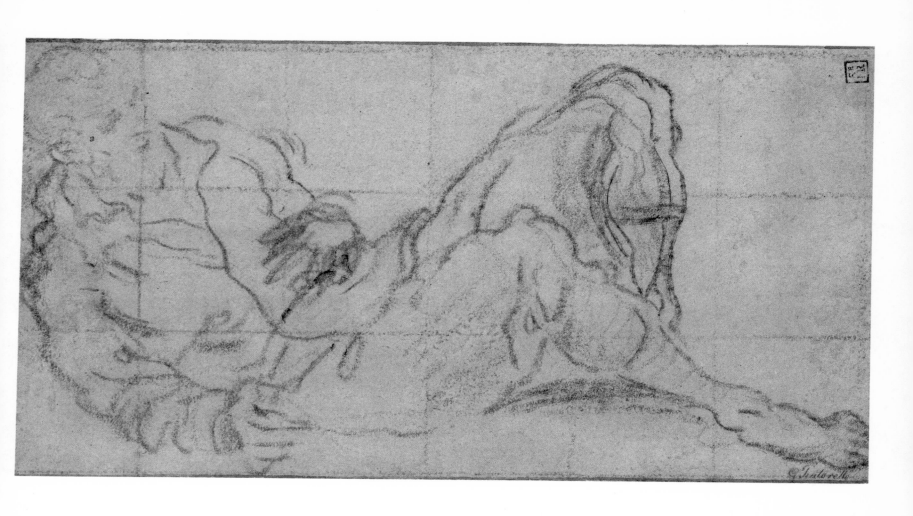

TADDEO ZUCCARO

Painter, brother of Federico; born in Sant'Angelo in Vado near Urbino in 1529; moved to Rome early in life and died there 1566.

Taddeo's painting represents a very particular moment of Mannerist expression: it partakes not only of the style of the Roman school, but also of the tense and vibrant sensibility of the Flemish Mannerists. This latter interest is manifested in Taddeo's choice of the highly sensual treated with an accentuation of the graphic design and startling effects of color, at times of a marked acidity. His drawings are of exceptional quality and in them, with great inventive liberty, he transcribes his hallucinatory world by means of tense and vibrant forms.

44 The Martyrdom of Saint Paul

Pen and brown ink with brown wash, heightened with white over traces of black chalk on paper, 494 x 368 mm. Verso: Inscribed in ink in a seventeenth-century hand, Taddeo Zuccaro 5.4.

Provenance: *Sir Peter Lely (Lugt 2092).*

Bibliography: *Bean-Stampfle, 1965, no. 135; Gere, 1969, no. 147, pl. 82; Szabo, 1975, p. 104, p. 178; Szabo, 1977, no. 12; Szabo, 1979, no. 38.*

The extraordinary quality and brilliance of this large drawing were early recognized and appreciated by Sir Peter Lely (1618–1680), whose distinguished collector's mark it bears. Whether the great English painter had identified the subject or knew of its relation to any of Zuccaro's works is not known. The scene on the sheet was identified by Gere as a study for the fresco in the center of the vault of the Frangipani Chapel in San Marcello al Corso in Rome (Gere, 1969, no. 147). It is documented that Taddeo Zuccaro decorated this chapel with scenes from the life of Saint Paul. Since he received the commission about 1556–58, the drawing would obviously date about 1556.

The great care and the elaborate details that are lavished on every part of the drawing and the virtuoso draughtsmanship embellishing the figures suggest that it might have been a presentation piece made in order to obtain this commission. The extraordinary richness is even more significant since some parts of the commission, such as the attendant crowds, are simplified and greatly reduced in the fresco. The bold swinging figure of the executioner is memorable and curious, since he swings an ax instead of the traditional sword.

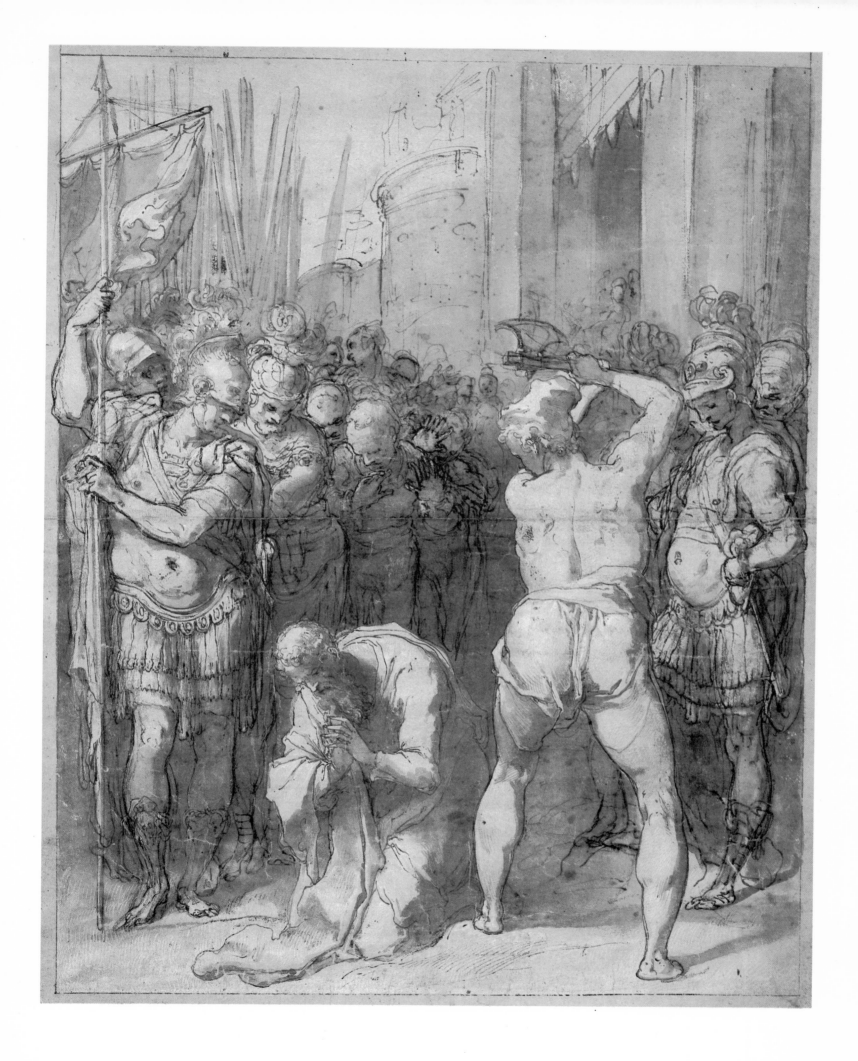

LUCA CAMBIASO

Born in Monéglia (Genoa) in 1527; died in Madrid in 1585. Cambiaso first studied and worked with his father, the painter Giovanni Cambiaso. Soon, however, he was attracted to the Mannerist art of Genoa which derived from Perino del Vaga, who was active there after the sack of Rome. Cambiaso's frescoes of 1547 in the Palazzo Spinola all'Acquasola reveal that he was also influenced by the work of Beccafumi and Pordenone. His *Adoration of the Magi* in the Galleria Sabauda in Turin indicates a development parallel to that of Pellegrino Tibaldi. In the period between 1550 and 1570 Cambiaso carried out some of his major undertakings in Genoa. This included his work in the Lercari Chapel of the cathedral and in the church of San Matteo, as well as decoration in the Villa delle Peschiera and the Palazzo Pallavicini. His most inspired Mannerist works date from the 1560s and 70s, remarkable for the light effects of his night scenes, as well as for his bizarre geometric abstraction of form that is strikingly demonstrated in his drawings. In 1583, together with his son and Lazzaro Tavarone, Cambiaso went to Spain to work for Philip II at the Escorial. To this atmosphere, permeated by the mentality of the Counter Reformation, his art responded perfectly with scenes of an abstract religiosity in total harmony with the huge vaults of the monastery.

45 The Four Evangelists

Pen and brown ink on paper, 440 x 291 mm.

Provenance: *Unknown.*

Bibliography: *Szabo, 1979, no. 44.*

In this tight composition, the four Evangelists, ac-companied by their attributes, are shown in animated discussion. From the left foreground, counter-clockwise: Saint Mark, with an open book on his knees, seated on the lion; Saint Luke with his ox; Saint John with the eagle; and, finally, Saint Matthew accompanied by his angel. This late drawing may be from Cambiaso's Spanish years, between 1583 and 1585.

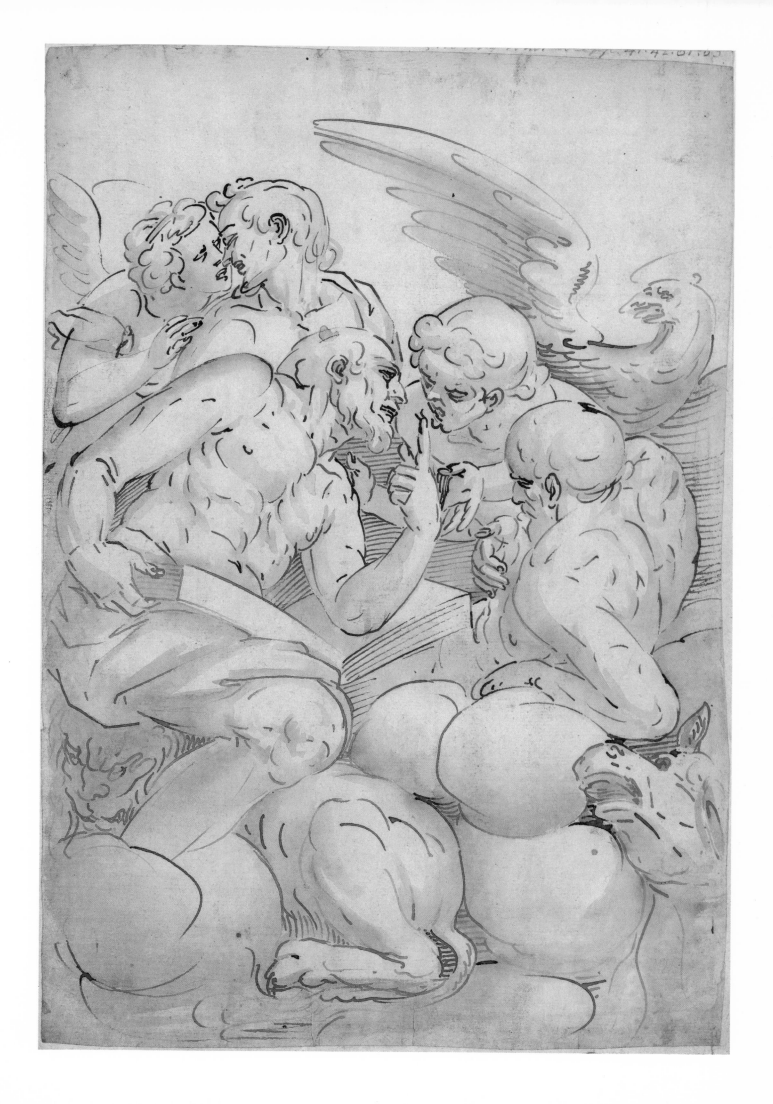

VERONESE (PAOLO CALIARI)

Born in Verona in 1528; died in Venice on April 19, 1588. Veronese was the pupil of Antonio Badile. His earliest known works date from the early 1550s: his frescoes in the Villa Soranza (Treville di Castelfranco) executed in 1551, and a *Temptation of Saint Anthony* of 1552 (Caen, Musée des Beaux-Arts). Perhaps already in 1553 Veronese was settled in Venice. Among his first works there are the ceiling paintings in the Palazzo Ducale and the three scenes from the story of Esther painted on the ceiling of the nave in the church of San Sebastiano (1555–58). In the years 1556–57 he was judged to be the best among the major Venetian painters. There is an indirect reference to a trip to Rome made at the end of the 1550s, which is also the period of Veronese's masterpiece, the frescoes in the Villa Barbaro at Maser (1559–61).

In addition to the luminous color of his teacher Badile, Veronese took an interest in the various Mannerist currents then reaching Venice from Rome, Florence, and Parma. He must have studied the works of Giulio Romano, Parmigianino, Niccolò dell'Abbate, Francesco Salviati, Giuseppe Porta, and others. But in contrast to Zelotti, for example, who experienced analogous influences, for Veronese the contact with Venetian art, and above all Titian, was of far greater importance. His extraordinary capacity of observation, his sense of light and the changing effects of color in his landscapes and upon precious fabrics, the subtlety of his colors themselves, his grace, lightness, and richness of invention, as well as his restrained but penetrating emotional expression place him far above any of the other grand Venetian decorators.

No one was capable of responding better than Veronese to the attractions of a secular and allegorical decorative art abounding in mythological representations. The splendor of his painted fabrics and his grand festive settings endowed even his religious paintings with those wordly overtones that in 1573 brought him before the Inquisition. In many ways Paolo Veronese was one of the most significant precursors of eighteenth-century art. His numerous drawings, in various techniques, are almost always related to the execution of his canvases and served as precious models in the hands of his successors.

46 Head of a Bearded Man

Black chalk on faded blue paper, 260 x 199 mm. Inscribed in ink by an eighteenth-century hand at lower left, Di Paulo Veronese. *Numbered at lower right in chalk,* 10.

Provenance: *From an old collection in Verona.*

Bibliography: *Buffalo Cat., 1934, no. 30; Tietze-Tietze-Conrat, 1944, no. A2125; Szabo, 1979, no. 46.*

This sensitively executed drawing was rather perfunctorily treated by the Tietzes, who remarked that "while the type of the profile seems to fit, or at least not to contradict Veronese's art, the penmanship is definitely not his." Aside from mistaking the technique, they failed to recognize the outstanding qualities of the drawing, which is only slightly marred by old water stains. The careful modeling of the ear and around the eyes is surely worthy of Veronese. It also escaped the earlier authors that the drawing represents the kneeling adorant in the well-known *Pala della Famiglia Marogna* in San Paolo, Verona, a work securely attributed to Veronese and dated 1565 (Fiocco, 1928, pl. LIII). The drawing approaches the qualities of the *Head of a Negro* that is unanimously accepted as one of the master's outstanding drawings (Private collection, cf. Bean-Stampfle, 1965, no. 131).

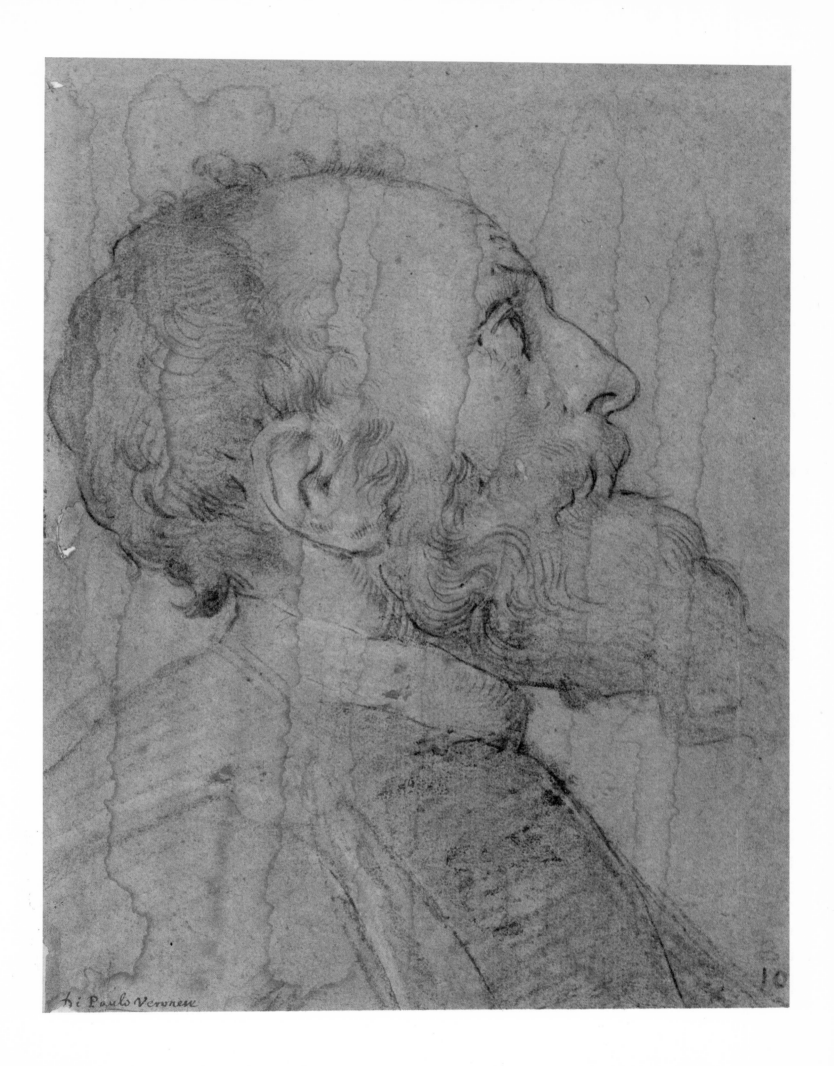

di Paulo Veronese

10

47 Study for a Massacre of the Innocents

Black and white chalk on brownish-red paper, 388 x 375 mm. Verso: Traces of a black chalk drawing of an unidentifiable subject.

Provenance: *Unknown.*

Bibliography: *Szabo, 1979, no. 47.*

Although this drawing cannot be tied to any of the artist's surviving works, the loose pictorial style and the swift lines suggest the hand of Paolo Veronese. The dense grouping of violently moving figures is also comparable to some late drawings of the master that are on similar red prepared paper (Bean-Stampfle, 1965, no. 128). The combination of this red background with the black and white chalk endows the drawing with a chiaroscuro quality Veronese used in a large number of compositions. The artist's family still owned ninety-four of these drawings in 1682.

Another link with Veronese's art is a pen-and-ink study of the same subject by Palma il Giovane in the Albertina that displays a distinct similarity in the groupings and in the violent movements of the figures (Koschatzky-Oberhuber-Knab, 1971, pl. 69). Since it is likely that Palma, as a student and successor of Tintoretto, could have seen this drawing or similar chiaroscuro works by the older master, his pen drawing echoed a subject that is otherwise unknown in Veronese's art.

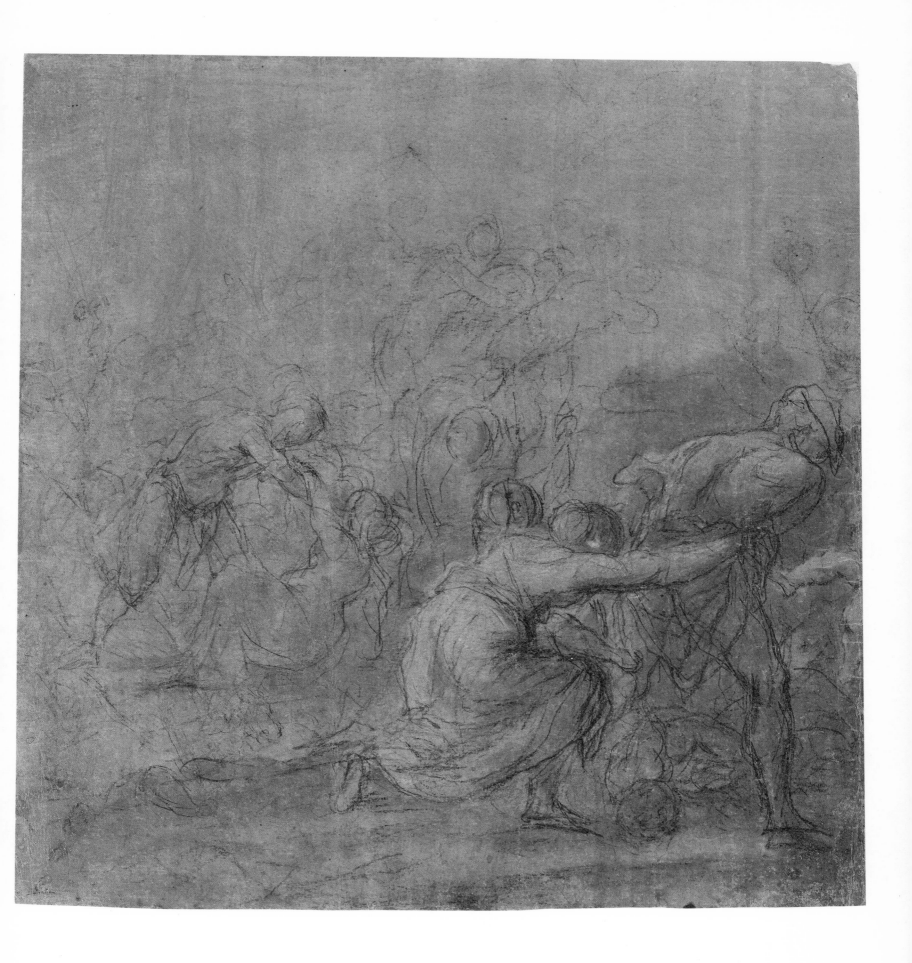

Born in Bologna in 1560; died in Rome in 1609. Annibale and his brother Agostino (1557—1602) studied with their cousin Lodovico (1555—1619). In 1585—86 they founded the Accademia degli Incamminati which, in deliberate opposition to late Mannerist practice, proclaimed the study of nature free from preconceived ideas and rules. In Parma and Venice, Annibale studied the works of Correggio, Parmigianino, Niccolò dell'Abbate, Titian, Tintoretto, and the Bassano family. In 1595 Cardinal Odoardo Farnese summoned him to Rome and there, between 1597 and 1604, he created his masterpiece, the fresco decoration of the gallery of the Palazzo Farnese, in which, during the years 1597 and 1600, Agostino also participated.

Annibale's repertory spans the gamut from realistic genre scenes, of which he produced many in his early years in Bologna, to the ideal figure, developed in Rome through his devotion to the art of antiquity, Raphael, and Michelangelo. This ideal aspect of his art — later to be defined as academic — was soon recognized as the opposing trend to the realism of Caravaggio and his followers. Yet, as a master of realistic portraiture and idealized, heroic landscapes, Annibale was an innovator.

Mariette owned one of the most important collections of Annibale's drawings, including sheets that once belonged to Crozat and the painter Pierre Mignard, as well as others that derived from Annibale's own close friends, Aneloni and Agucchi. In their pictorial breadth and freedom Annibale's drawings were related to the Venetian tradition and found their real successor in the graphic work of Guercino.

According to Bellori, when Annibale died his students followed his bier "kissing in death the hand that had given spirit and life to darkness."

48 Lamentation of Christ

Red chalk on brownish paper, 242 x 230 mm. Inscribed in ink in lower right corner, Caracci.

Provenance: *Sir Edward Poynter.*

Bibliography: *Szabo, 1979, no. 51.*

Although it was formerly attributed to Lodovico Carracci (1555—1619), the artist's cousin, this drawing is now attached to Annibale's oeuvre. Annibale and his brother Agostino maintained a large workshop that included many family members, as well as students, all of whom copied and imitated the master's work. The use of the red chalk and the brownish paper is a supporting argument for the attribution to his shop and to Annibale himself.

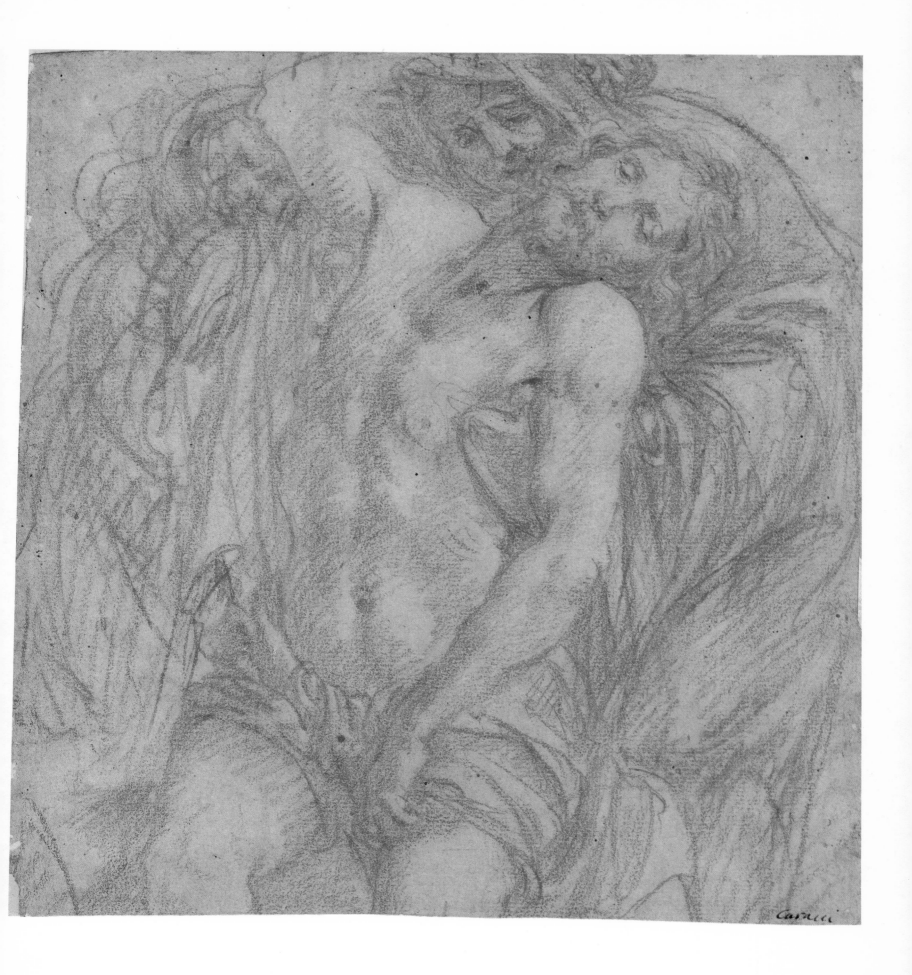

DOMENICO TINTORETTO

Son of the famous Jacopo; born in Venice about 1560; died there in 1635. Domenico's own artistic personality was at first inevitably overwhelmed by the practice of his father's workshop and only after Jacopo's death in 1594 could he develop his own individuality. It was Ridolfi, in his *Maraviglie dell'arte* of 1648, who first drew attention to the originality of Domenico's art, singling out his ample imagination and culture which produced compositions rich in allegorical significance and of a refined, academic execution. While today such an evaluation of Domenico's painting is debatable, it does fit his graphic work. His graphic production includes at least two hundred sheets, almost half of which are in the stupendous sketchbook in the British Museum. Many of these drawings, in their reflection of Baroque literary themes, as well as in the free linear style of their brushwork, are remarkably evocative and rank among the very best of Venetian graphic production of the early seventeenth century.

49 Study of a Reclining Nude

Black and white chalk on grayish paper, 196 x 263 mm. Inscribed in an eighteenth-century hand in lower right corner, Tinto[10].

Provenance: *Luigi Grassi, Florence.*

Bibliography: *Grassi Sale Cat., 1924, no. 134; Tietze-Tietze-Conrat, 1944, p. 267, no. 1535; Orangerie Cat., 1957, no. 129; Szabo, 1979, no. 54.*

This drawing, along with ten others, was attributed to Jacopo Tintoretto in the sales catalogue of the Luigi Grassi Collection. Now, however, they are believed to be by his son, Domenico, an attribution first proposed by the Tietzes.

Another seven of these studies from life are in the Robert Lehman Collection (cf. Szabo, 1979, nos. 55–61). Their free linear style and the artist's interest in exploring the variety of views of the reclining nude characterize all of them. Domenico's emphasis on shape and volume provides an interesting contrast to Jacopo Tintoretto's figure studies in which attention is focused on the continuous serpentine line (cf. Plate 43).

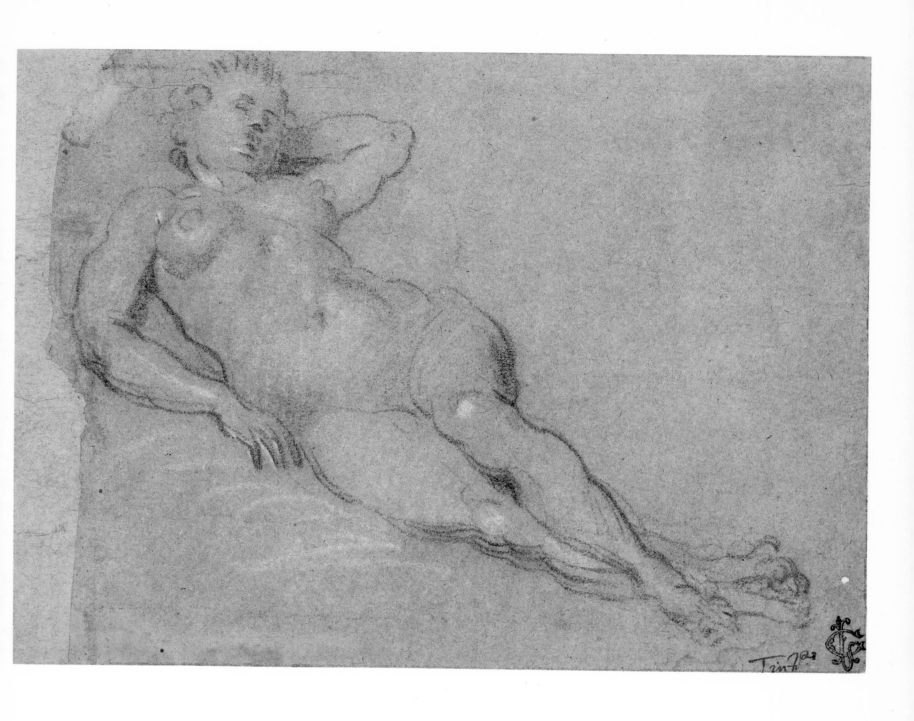

NICOLO BAMBINI

Painter; born in Venice in 1651; died there in 1736. Bambini received his early training in the workshop of Mazzoni in Venice and later worked in Rome under Carlo Maratta. Most of his frescoes are in Venice, including his earliest, the ceilings in San Moisè, the *Birth of Christ* in Santo Stefano, and the *Adoration of the Magi* in San Zaccaria. He also painted frescoes in the chapel of the archbishop's palace and other religious buildings in Udine.

50 The Stoning of Saint Stephen

Pen and ink with brown wash and traces of red chalk on paper, 203 x 314 mm. Verso: Part of the same scene with Saint Stephen and three other figures (reproduced in Szabo, 1980, no. 2B).

Provenance: *Armand Louis de Mestral de St. Saphorin; Janos Scholz, New York.*

Bibliography: *Szabo, 1980, no. 2A.*

Bambini received his early training in Venice and later worked in Rome as Carlo Maratta's pupil. After his return to Venice, he became a prolific painter of frescoes and altarpieces for churches and palaces not only in Venice but in Udine as well. This drawing, full of dramatic movement and pathos, clearly reflects his indebtedness to the Roman tradition. The quick penwork and fluent use of wash, however, are definitely Venetian. The degree of elaboration and the variation of the same composition on the verso seem to indicate that the drawing was made as a design for an altarpiece. However, there are no related paintings in the artist's known oeuvre. Comparisons with Bambini's other works date this drawing to his later years, around 1725.

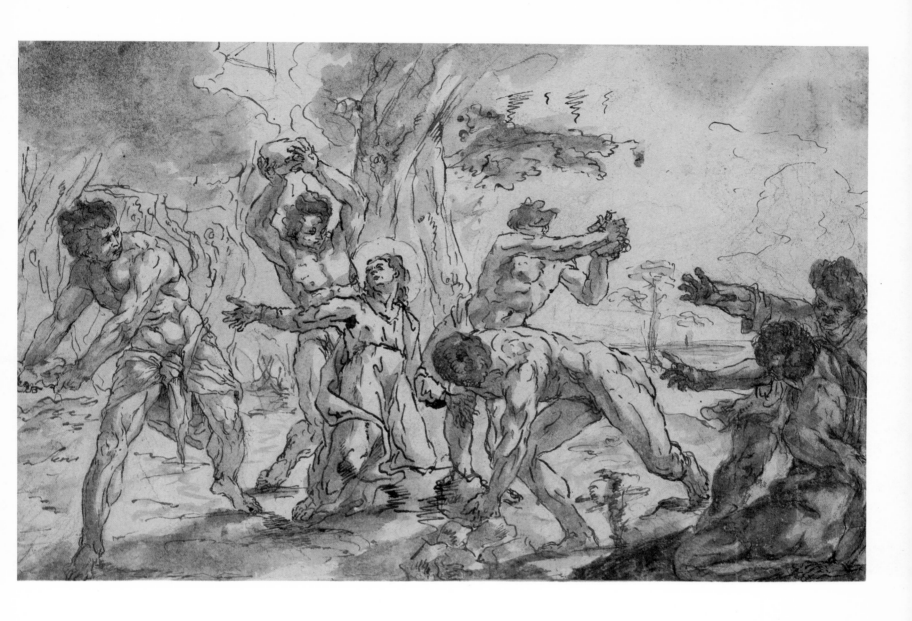

GIUSEPPE BERNARDINO BISON

Born in Palmanova (Udine) in 1762; in Brescia and Milan 1831; between 1834 and 1838 traveled as far as Rome and Naples; died in Milan in 1844.

Bison may be looked upon as the extreme product of Venetian eighteenth-century art. Arriving in Venice in 1777, he had the opportunity of coming into contact with the Longhis, Giandomenico Tiepolo, and Francesco Guardi. Thus, even if Costantino Cedini is officially recorded as his teacher, Bison actually looked to greater figures, drawing suggestions from them that he at times interpreted in an extravagant manner. Traces of just such a stylistic formation can be clearly seen in his numerous drawings, found for the most part in the Cooper Union Museum in New York; the Bertarelli Collection in the Castello Sforzesca and the Osio Collection, both in Milan; and in the Miotti Collection in Tricésimo near Udine.

After the youthful decorative works carried out in Treviso and Padua, in 1800 Bison began to work in Friuli and in Trieste, where he has left frescoes in the Capitaneria di Porto, the Borsa (today the Camera di Commercio), and the church of Santa Maria Maggiore (1816). Interpreter of a sort of Rococo revival—in which he was still related to the Venetian Settecento—Bison soon developed a pre-Romantic expressiveness.

51 The Adoration of the Magi

Pen and ink with wash and traces of red chalk on paper, 175 x 240 mm. Signed at lower right, Bison.

Provenance: *Paul Wallraf, London.*

Bibliography: *Morassi, 1959, no. 1; Szabo, 1981, no. 3.*

Bison was not a native of Venice but received his artistic education in that city during its most fertile period when the Tiepolos, Canalettos, and Guardis were creating a rich variety of styles and techniques. These achievements are all reflected in Bison's eclectic works in Trieste, Treviso, Ferrara, and Montone. Although this drawing is not related to a known work of the artist, according to Morassi the style and quick penwork indicate the last years of the eighteenth century.

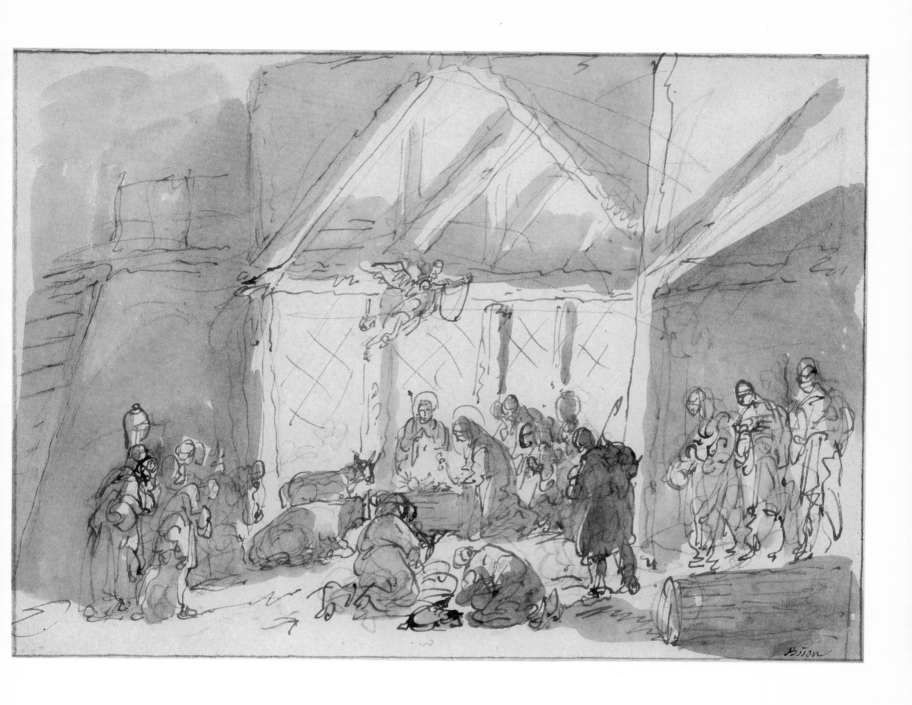

LUCA GIORDANO

Painter of panels and frescoes; born in Naples in 1632; died there in 1705 after a long and active life. Luca was trained by his father Antonio Giordano. He acquired an ability to imitate the paintings of older masters, and it is recorded that he sent the king of Spain sixteen large paintings in the style of Reni, Tintoretto, Veronese, and Ribera. Luca was strongly influenced by Ribera and such Venetian painters as Zanchi, Liberi, and Mazzoni. After a period of travels, he returned to Naples, where he painted a large number of frescoes and paintings. During his second trip to Venice in 1667 Luca painted the *Assumption* for Santa Maria della Salute, which reveals the influence of Sebastiano Ricci. After working in Florence in 1682 and 1683, he was invited to Spain by Charles II and was appointed Court Painter in 1692. During the ten years Luca spent in Spain he produced a large number of wall paintings and canvases not only for his royal patron, but for the nobility of Spain as well.

Most of Luca Giordano's drawings are related to large compositions and display the same dexterity as his paintings. The chronology of his drawings has not yet been determined.

52 The Almighty

Pen and ink on paper, 467 x 349 mm. Inscribed along the lower edge in ink a seventeenth-century hand, Schizzo originale di Luca Giordano.

Provenance: *Unknown.*

Bibliography: *Unpublished.*

The composition is most likely a study for a fresco.

The rather sketchy depiction of the flying angels and the use of wash suggest that the drawing may have been made during Luca Giordano's stay in Spain between 1692 and 1702 (cf. Milkovich, 1964, pp. 4–5). Similar groups of playful angels appear in some prints of the artist's work executed after his return from Spain, thus confirming a dating in the last decade of the seventeenth century.

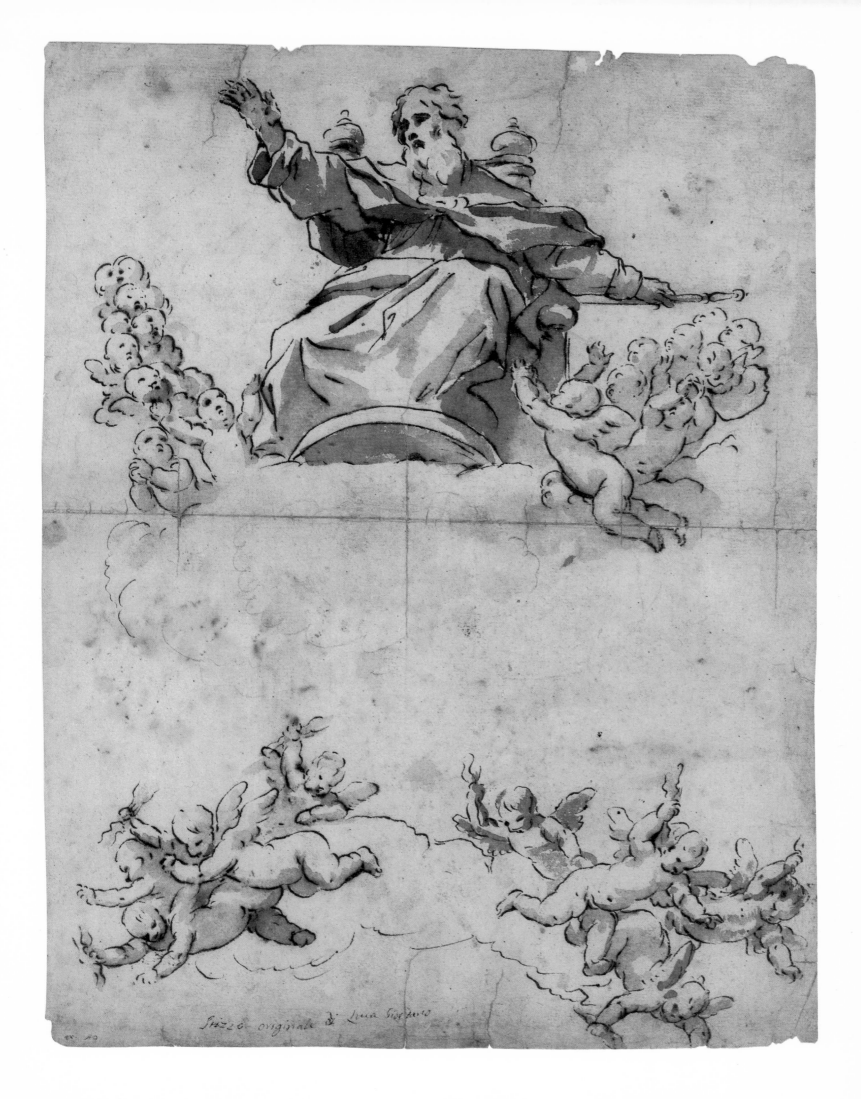

Schizzo originale di Luca Giordano

Painter and architect, descended from a long line of builders and masons; born 1596 in the Tuscan town of Cortona, from which he derives his name; died in Rome in 1669.

Cortona was the pupil of the Florentine painter Andrea Commodi who was working in Cortona. After a brief sojourn in Florence he joined Commodi in Rome in 1612–13; when Commodi left the city, Cortona went to the workshop of Baccio Carpi. In Rome the young artist studied the work of Raphael, Michelangelo, the Carracci, and Caravaggio, as well as that of Borgianni and Rubens. Through his first patron, the Marchese Sacchetti, and the poet Marino Marini he gained entry to the circle of Pope Urban VIII, under whose patronage he became one of the leading painters and architects of Rome. He was active also in Florence, where between 1641 and 1660 he designed the fresco decorations of various rooms in the Palazzo Pitti.

Along with Bernini, Pietro da Cortona made a fundamental contribution to the creation of Roman High Baroque art. Together with Poussin, Mola, and his own pupil Pietro Testa, he frequented the circle of Cassiano dal Pozzo. He was *principale* of the Accademia di San Luca from 1634 to 1638, the years that witnessed the dispute with the Dutch Schildersbent and the theoretical debate with Andrea Sacchi and the exponents of the classical ideal. In addition to the architectural work he left in the city, his celebrated ceiling in the Palazzo Barberini (1633–39) and the decoration of the Chiesa Nuova (1648–65) mark the apogee of Baroque fresco decoration.

From the very beginning Pietro da Cortona pioneered a grand and monumental manner of painting, in terms of large areas of rich color applied with an audacious pictorial looseness and freedom, which influenced not only his many students, but also some of the most outstanding of the later Baroque decorators, such as Baciccia and Luca Giordano. His graphic style had an analogous development, progressively deviating from the Florentine tradition of *disegno*. In fact, it is only in the dense play of lines of some of his pen-and-ink drawings, a technique he used as a parallel to his studies in chalk or brush, that one can find a distant echo of the Tuscan manner.

53 Tullia Driving Her Chariot over the Dead Body of Her Father

Pen and ink with brown wash over black chalk on paper, 265 x 468 mm. Squared for transfer in black chalk. Numbered in lower right corner, 8.

Provenance: *Pierre Crozat; Jean-Denis Lempereur, Paris; Prince de Conti, Paris; Baron Dominique Vivant-Denon, Paris; Sir George Mounsey, London.*

Bibliography: *Vivant-Denon-Amaury-Duval, 1829, vol. II, pl. 113; Mireur, vol. II, 1910, pp. 216–17.*

In the sales catalogue of Baron Vivant-Denon's collection, this sheet was described as a "dessin capital." The careful preparation of the dense composition, the rich variety of figures and movements, but most of all the virtuoso finish of washes all justify this judgment and those of other famous collectors who owned this drawing.

The subject of Tullia driving her chariot over the body of her father is represented as described in Ovid's *Fasti* (50. 6. 585–610). The high drama of the story is underlined with dramatic gestures and violent movements, such as those of the horses. The careful elaboration of details and the rich variety of washes attach a special importance to this drawing. This prominence is emphasized by the fact that the other three versions of the subject by Pietro da Cortona or his school are less detailed (Blunt-Cooke, 1960, no. 607). It is therefore safe to propose that this detailed version may have been prepared as a presentation folio for the prospective customer of a fresco. The same tendency toward elaboration and monumentality occurs in some other compositions by Pietro da Cortona, for example the *Coriolanus before Rome* in the Kupferstichkabinett in Berlin, which dates in the 1630s.

The Berlin drawing is marked by the numeral 12 written in the same hand and placed in the same position as the number 8 on this one. It may be concluded that these two and other as yet unrecognized drawings belonged to a series representing scenes from Roman history. Whether he prepared them for frescoes, or possibly for engravings, future research may be able to determine.

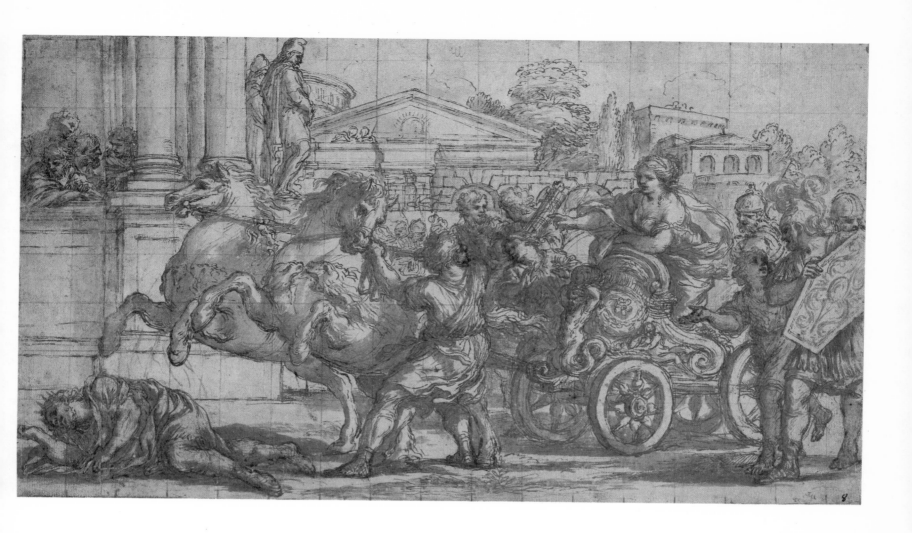

CANALETTO (ANTONIO CANAL)

Painter and etcher; born in Venice in 1697; died there in 1768. Prepared by his own earliest artistic experience, his knowledge of Carlevaris's topographical views, and his father's activity as a scenographer, Canaletto began drawing from nature during a stay in Rome about 1719–20. It was through this new method of representing reality that his style developed, in which drawing constantly verified by nature itself played an important part. In this way he also created a completely new type of color, which accorded with the calculated sightings of his perspective views. The patient study of perspective and light, the "reason" that always governed Canaletto's language, never smothered his authentic artistic expression, which has left us the most vivid image of the Venetian cityscape.

Canaletto's paintings enjoyed enormous success among the English, for whom he painted large series of views, from the thirty-eight for Consul Smith and the twenty-six for the Duke of Bedford (1725–35), to those for the Duke of Buckingham and Lord Carlisle. Subsequently Canaletto made several trips to England and remained there from 1746 to 1755. When he returned to Venice he was imitated by contemporary painters, from among whom there emerged the highly original Francesco Guardi.

In 1744 Canaletto published his collection of thirty etchings entitled *Vedute: Altre prese dai luoghi altre ideale.* These prints, exceptional in their luminosity, are images of those immensely pleasant places along the Brenta populated with villas, and other places in Venice. Together with those of Tiepolo, published in about the same period, they constitute one of the most important monuments of eighteenth-century Italian etching.

54 The East Front of Warwick Castle

Pen and brown ink with gray wash and some color on paper, 316 x 562 mm.

Provenance: *Hon. Charles Greville, Warwick; Paul Sandby, London (Lugt 2112); Lady Eva Dugdale, Royal Lodge, Windsor Great Park; Adrien Fauchier-Magnan, Neuilly-sur-Seine; Philip Hofer, Cambridge, Mass.*

Bibliography: *Finberg, 1920–21, p. 68; Orangerie Cat., 1957, no. 89; Cincinnati Cat., 1959, no. 228; Constable, 1962, pp. 339, 536, no. 759; Bean-Stampfle, 1965, no. 157; Constable-Links, 1976, no. 759, pl. 14; Szabo, 1981, no. 6.*

This drawing is a "particularly brilliant . . . veduta" of the East Front of Warwick Castle. The building, its surroundings, and the groups of figures in the foreground are drawn with great precision and embellished with a virtuoso use of wash and color. The castle itself is represented with the exactitude of an architectural drawing but also with great élan. On the left is Caesar's Tower. The gateway and the Clock Tower behind it are near the center of the drawing. To the right is the imposing, crenellated Guy's Tower. Behind the walls on the extreme right are a tollhouse and houses of the town of Warwick. The heavy mass of the building is broken up by the trees and counterbalanced by the extensive lawn in front of the castle and the wide skies above it. Both spaces are enlivened by people moving about singly and in groups and by the flight of birds around Guy's Tower. Constable suggested that the drawing is from Canaletto's early stay in England, probably from 1749. Because of its high degree of finish and the rich variations of color values created by the virtuoso use of washes, the drawing has the qualities of a painting. Therefore, it is not surprise that this *veduta* is generally accepted as the basis for Canaletto's large and famous painting of the same subject executed for Francis Greville, Earl Brooke, and later Earl of Warwick (Constable, 1962, p. 399).

Canaletto's paintings and some of the drawings of Warwick Castle remained in the family for a long time. However, this and another drawing were given by Charles Greville, the second son of Earl Brooke, to his friend, Paul Sandby, whose collector's mark is in the lower left corner.

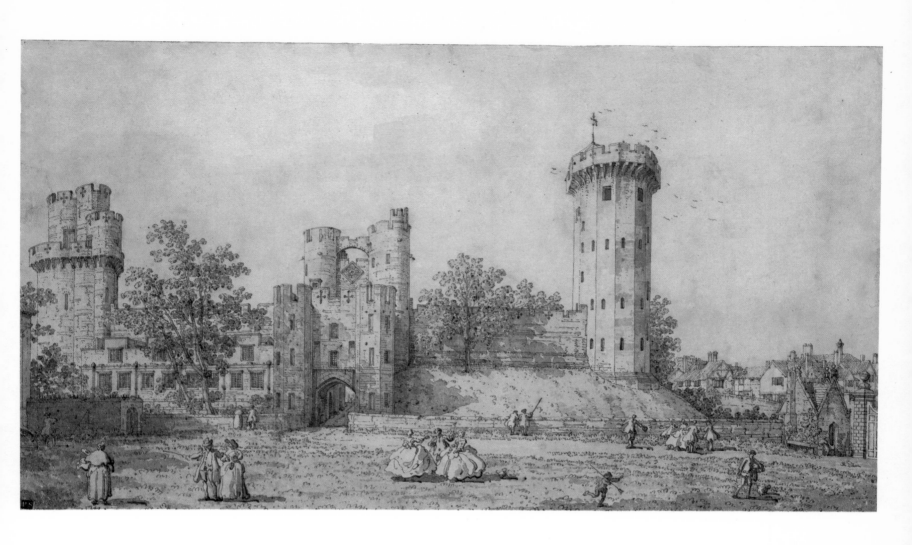

CANALETTO (ANTONIO CANAL)

55 Interior of the Basilica of San Marco

Pen and brown ink over thick black chalk on paper, 280 x 190 mm. Inscribed at lower right in a nineteenth-century hand, Cannalletto.

Provenance: *Italico Brass, Venice; Janos Scholz, New York; Paul Wallraf, London.*

Bibliography: *Morassi, 1959, no. 8; Constable-Links, 1976, no. 561, pl. 102; Binion, 1980, pp. 374–75; Szabo, 1980, no. 2; Szabo, 1981, no. 8.*

This rapid sketch is in the free-flowing style of the so-called *maniera cifrata* that the artist used in the later years of his life. He frequently drew the interior of San Marco, and on a similar sketch, now at the Kunsthalle in Hamburg, he proudly noted: "de Anni 68 cenza Ochiali L'anno 1766," that is, he made this drawing "in his sixty-eighth year without eyeglasses in the year 1766" (Morassi, 1959, p. 12). This drawing and others in the same style or with the same provenance may have been pages in one of Canaletto's sketchbooks. A very similar sketch of the interior of San Marco (Leipzig, Museum der Bildenden Kunste) is described as "made within the same hour" as the Lehman drawing (Binion, 1980, p. 375).

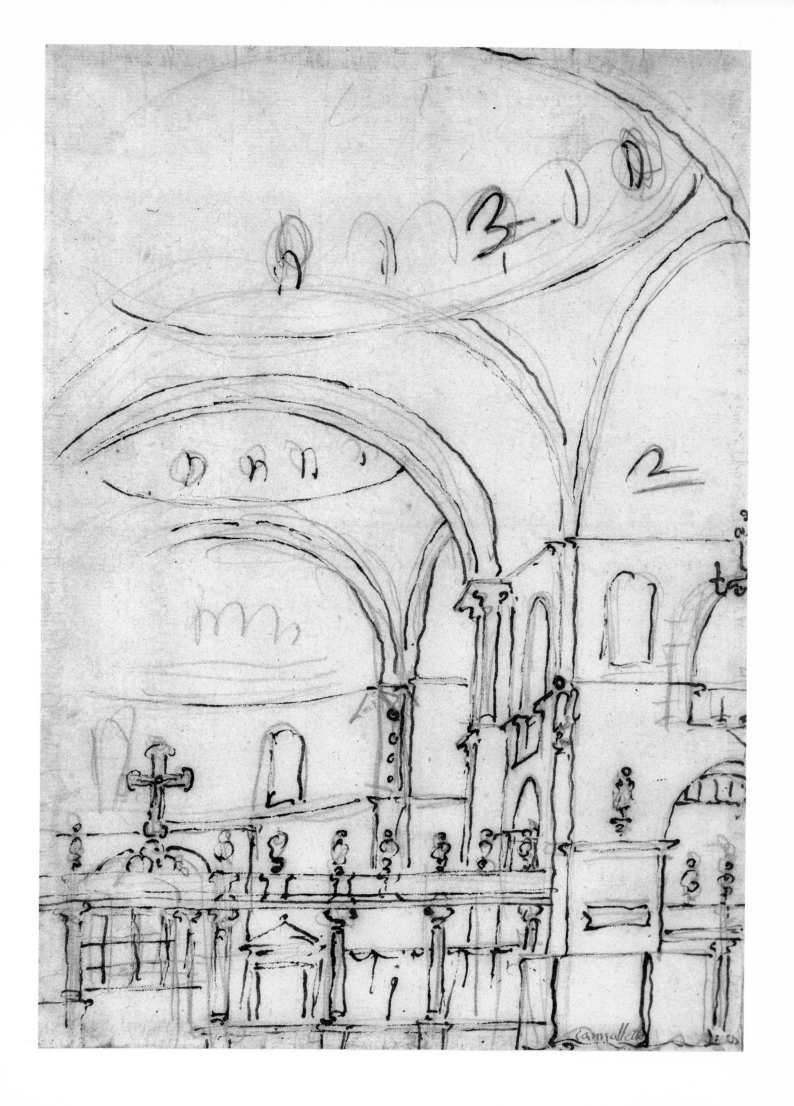

CANALETTO (ANTONIO CANAL)

56 The Piazza di San Marco from the Arcades
of the Procuratie Nuove

Pen and brown ink with gray wash on paper, 222 x 330 mm.

Provenance: *Otto Gutekunst, London; Villier David, Friar Park, Henley; Paul Wallraf, London.*

Bibliography: *Hadeln, 1929, p. 14; Parker, 1948, no. 57, p. 40; Morassi, 1959, no. 120; Constable-Links, 1976, no. 526, pl. 95; Szabo, 1980, no. 3; Szabo, 1981, no. 9.*

In this important and beautiful sheet from the later years of Canaletto's life, the rich and colorful activity on the piazza is masterfully depicted with rapid strokes and the deft use of wash. The complex composition is skillfully framed by the quick but thoroughly authentic depiction of the various buildings surrounding the piazza—the Procuratie Vecchie, the Torre dell'Orologio, San Marco, the Campanile. The panorama ends at the arcades of the Procuratie Nuove, with the famous Café Florian already in its present location in Canaletto's time.

The animated drawing, with its groupings of people, dogs, and buildings, epitomizes this famous center of Venice. It is also a moving document of Canaletto's total understanding and love of his native city.

Another version of this composition is in Windsor Castle (Parker, 1948, no. 37). However, Morassi considers that version a workshop copy of the Lehman drawing and not by Canaletto's own hand (Morassi, 1959, p. 81).

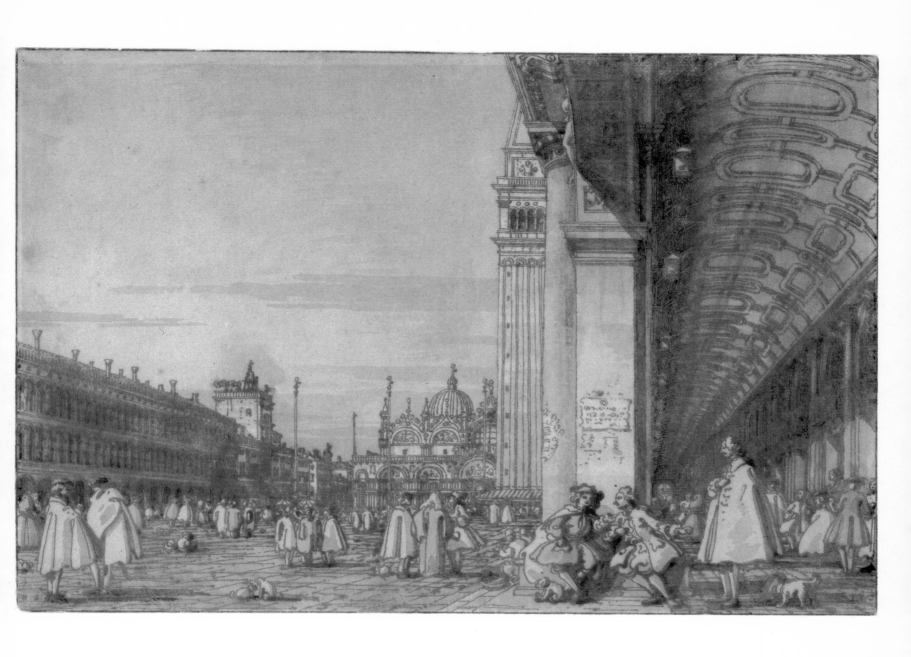

LUCA CARLEVARIS

Painter and mathematician; born in Udine in 1663; died in Venice 1730. Because of the mathematical training he brought to his painting, Carlevaris became the founder of eighteenth-century Venetian topographical and view painting. His artistic sources lie in Rome where he became acquainted with the topographical work of Gaspar van Wittel (1653–1736). Later, around 1700, Carlevaris settled in Venice where he specialized in depicting views of the city in precise and rigorous paintings. These works and a set of over one hundred engraved views of Venice are considered the foundation on which Canaletto and Guardi built.

57 Portrait of a Dignitary

Red chalk on paper, 250 x 170 mm.

Provenance: *Paul Wallraf, London.*

Bibliography: *Morassi, 1959, no. 18; Pignatti, 1974, no. 98; Szabo, 1980, no. 9; Szabo, 1981, no. 25.*

Luca Carlevaris was a self-taught painter and engraver. His activity was centered in Venice where he worked under the patronage of the Zenobio family, whose palaces he also decorated with paintings. Examples of Carlevari's numerous *vedute*, both painted and drawn, are in almost every European museum. However, Pignatti remarks that "drawings by Carlevaris are very rare in American collections" (Pignatti, 1974, p. 96). This drawing, probably the portrait of a senator, is even more exceptional since it represents a full-length figure.

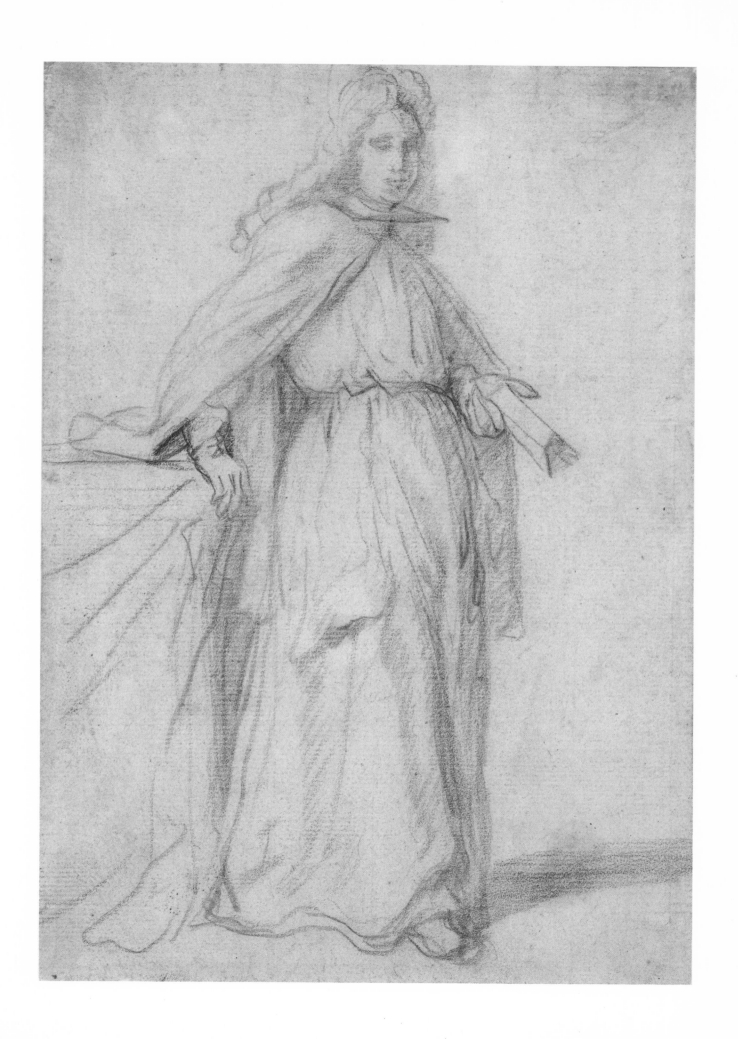

FRANCESCO SALVATOR FONTEBASSO

Painter and engraver; born in Venice in 1709; died there in 1769. Fontebasso was a pupil of Sebastiano Ricci, whose paintings he engraved in a series of virtuoso sheets in 1730; he also studied with Zanetti and spent a short time in Rome. After his return to Venice, he became a member of the Accademia and painted a number of frescoes in the houses of Venetian patricians (Palazzo Duodo, c. 1753; Palazzo Barbaro, etc.). In 1760 Fontebasso was invited to St. Petersburg where he executed not only frescoes in various Imperial palaces, but also portraits and genre paintings. He was appointed a teacher at the Imperial Academy of Arts there in 1762 but returned to Venice that same year. As a successful painter he was given many important commissions and was elected the president of the Accademia in 1768. Fontebasso's graphic oeuvre is extensive. A large number of his drawings survive, which are either studies for various frescoes or preparatory drawings for engravings. Together with Gaspare Diziani he also prepared engraved illustrations for a five-volume edition of Dante in 1757.

58 Saint John the Evangelist

Pen and ink on paper, 387 x 264 mm. Numbered in pen and ink in the upper right corner, 23. Vertical ruled lines on the two sides; also ruled at the top.

Provenance: *Unknown. Purchased from Charles E. Slatkin Galleries, New York.*

Bibliography: *Szabo, 1981, no. 27.*

This sheet is from an album that was probably broken up before 1924. Other pages, all of which have the same framing with ruled lines, are in various public and private collections (cf. Bean, 1966, nos. 98–99). A sheet in the Metropolitan Museum of Art, depicting two standing male figures and a seated woman, bears the number 41; thus the album must have had at least that many pages and probably more (Bean-Stampfle, 1965, no. 181). The attribution of this album to Fontebasso is not accepted by several scholars and connoisseurs (Scholz, 1967, p. 296). Certainly these drawings display a variety of techniques and some inconsistencies of style. According to Byam Shaw, the rather heavy figures show the influence of Piazzetta, while the brittle penwork of the heavy cross-hatchings reflects Sebastiano Ricci's style (Byam Shaw, 1954, pp. 317–25).

RB

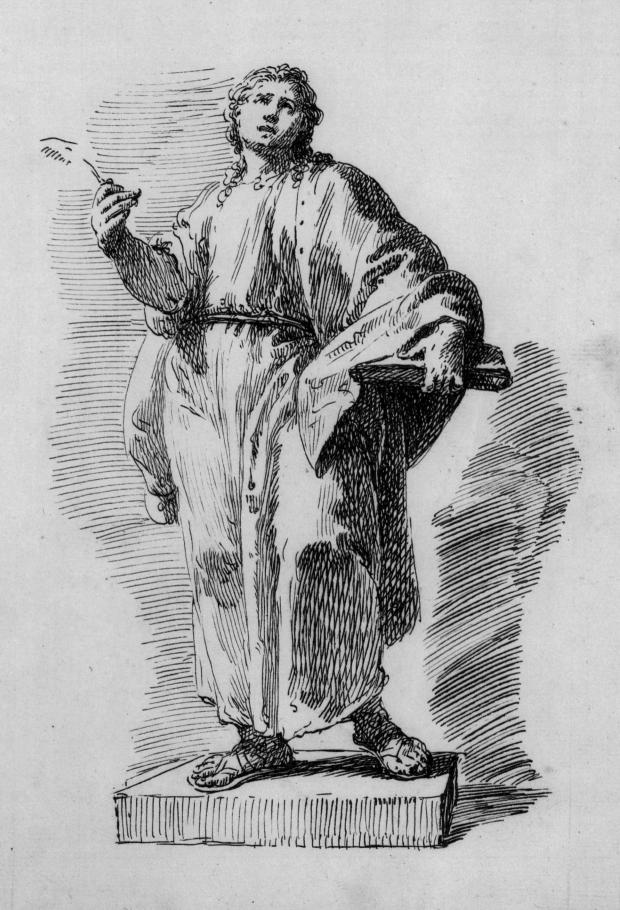

JACOPO AMIGONI

Painter and engraver; born in Venice in 1675; after a long and active life died in Madrid in 1752. A talented but light imitator of Sebastiano Ricci and Solimena, Amigoni was also influenced by the Tiepolos and the genre character of contemporary French art. After completing his education in Venice and working on the frescoes in the Oratorio of San Eustachio, he departed for the North, where he was in the employ of the Elector of Bavaria for several years. For the castle in Schleissheim, Amigoni painted a series of frescoes with mythological scenes and with stories of the Trojan War. Besides frescoes he also painted a number of oil paintings, three altarpieces for the Marienkirche in Munich, and another for Benediktbeuren. A considerable number of Amigoni's paintings are still in German museums. In 1729 he was called to England where he executed frescoes for the palace of Lord Thonkerville and for Covent Garden Theater. Amigoni was a favorite portrait painter of royal houses and the aristocracy. He has been credited with promoting the fashion for pastel portraiture. In 1747 he was invited to Spain and became the court painter of Ferdinand VI. Amigoni's Spanish years produced frescoes in the palaces of Aranjuez and Buen Retiro and several paintings and portraits of the royal family.

59 Portrait of a Young Woman

Chalk and pastel on paper, 295 x 248 mm.

Provenance: *Unknown. Acquired in 1965 from M. Komor, New York.*

Bibliography: *Szabo, 1981, no. 1.*

The pleasing portrait of this young woman is not signed or dated, but the style and the costume both indicate that it is from the 1740s, the most active period of the artist's life. Amigoni promoted pastel painting and practiced it with great skill. One of his daughters became so well versed in the art she became a teacher of this medium and is aptly credited with the dissemination of this technique in Spain.

In the absence of dated and signed pastel portraits, both the attribution and the date of this and similar works are uncertain.

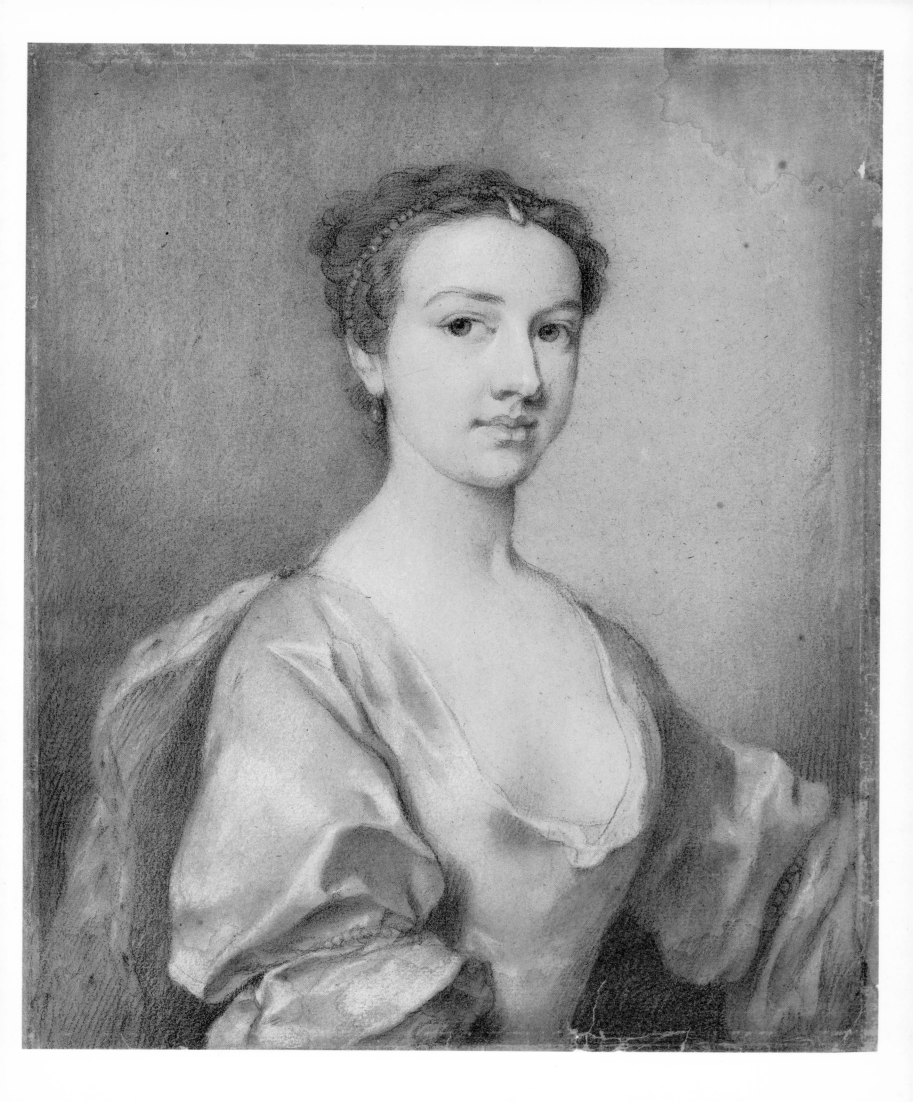

FRANCESCO GUARDI

Born in Venice in 1742; died there in 1793. Francesco Guardi began as the pupil and assistant of his brother Gian Antonio, a history painter, who directed the parental workshop after the premature death of their father Domenico in 1746. Francesco's earliest production included history subjects and altarpieces, but views of Venice were to become his marvelous, exclusive realm.

Guardi took Marco Ricci and Canaletto as his models, both of whom he copied more or less freely at first; from Marieschi he derived his summary brushstroke. Magnasco, too, must have impressed him considerably, for his figure painting and drawing comes near to Magnasco's fantastic realism and capricious transfigurations. Finally, Guardi's figures, rendered in terms of linear abbreviations that are at the same time realistically expressive, would seem to be related to Callot, whose world of fantasy often borders on his own.

Francesco's art was born directly from the atmosphere of the lagoon city of Venice and its artistic tradition of intense pictorialism, which reached its acme in him. However, there are also views of the Venetian mainland from his hand; in 1778 and 1782, during two trips through the Valsugana to the town of Mastellina where his family originated, he made some splendid drawings of the mountain landscape of the region. The largest collection of Guardi drawings, totaling about three hundred sheets, is in the Correr Museum in Venice. Other important collections are in the British Museum, London, and the Metropolitan Museum in New York.

60 Macchiette (Sketches of Figures)

Pen and brown ink with gray wash on paper, 167 x 260 mm.
Verso: Five macchiette (reproduced in Szabo, 1981, no. 31b).

Provenance: *Mrs. Clive Pascal, London; Paul Wallraf, London.*

Bibliography: *Morassi, 1959, no. 21; Morassi, 1975, cat. no. 564; Szabo, 1980, no. 12; Szabo, 1981, no. 31a.*

Macchiette are representations of figures formed largely from various tones of wash, a technique perfected by Guardi. Here, ladies and noblemen and children are shown under the arcades of a public building or a large house. They may be onlookers at a ceremonial procession, such as the crowning of Doge Alvise Mocenigo which took place in 1763. Other Venetian artists depicted this occasion and it is quite possible that Guardi made this and other sketches at that time.

The complex movements and groups of figures are handled with a great deftness matched by the virtuoso use of wash. This drawing is a remarkable product of Guardi's mature years.

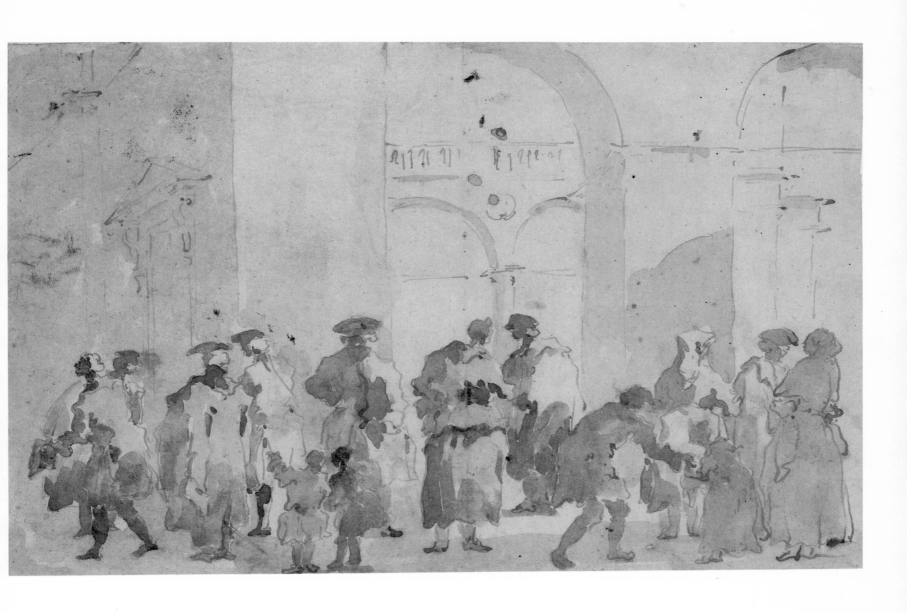

61 View of the Grand Canal and the Buildings of San Marco from the Sea

Pen and ink with gray wash and gouache on paper, 475 x 885 mm. In a cartouche along the lower edge, a coat of arms and the inscription: Prospeto delle Fabriche Publiche di SAN MARCO dalla parte del Mare con il Teatro disegnato per l'ultimo Quarto delli Fondachi Publici detti del Sal, e nell Anno 1787. Viniliato a sua Eccell: Missr. LODOVICO Co: MANIN K. e Proccr: di S. Marco ora SERENISSIMO DOGE felicemente REGNANTE. *Flanking this inscription are lists of buildings with numbers corresponding to those in the drawing. Inscribed in lower right corner,* F. G. Pinxit. *Also inscribed in lower left corner,* P.B.A.A.C. Inv. Teat.

Provenance: *Private collection, Berlin; Paul Chevalier, Paris.*

Bibliography: *Fiocco, 1933, pp. 360–67; Cincinnati Cat., 1959, no. 231; Morassi, 1975, pl. 151, fig. 633; Szabo, 1980, no. 13; Szabo, 1981, no. 32.*

This late drawing by Guardi was acclaimed by Fiocco, the great scholar and connoisseur of Venetian art, as "rich with a magisterial vitality and freshness . . . one of the most significant by the sensitive painter" (Fiocco, 1933, p. 364). Its abundant details, the elaborate inscriptions, and the list of buildings are all indications that it was intended for an etching or engraving.

From Fiocco's publications (listed by Morassi, 1975, pl. 151) it is known that this and another drawing in the Museo Correr in Venice are related to the proposed Teatro Manin. Other drawings and documents have shown that Guardi was involved with the planning of this theater, which was never built.

In an oral communication in 1963, Byam Shaw remarked that "the figures in the foreground and the architecture in the back are quite good, but the wash is somewhat heavy. Hence Francesco could have been assisted by his son Jacopo Guardi." Morassi proposed that this drawing was done by Giacomo (Jacopo) under his father's direction, who later "authenticated it with his initials."

The fact that the buildings are listed and numbered implies that this drawing was made for someone outside of Venice, since a Venetian would have no trouble recognizing them.

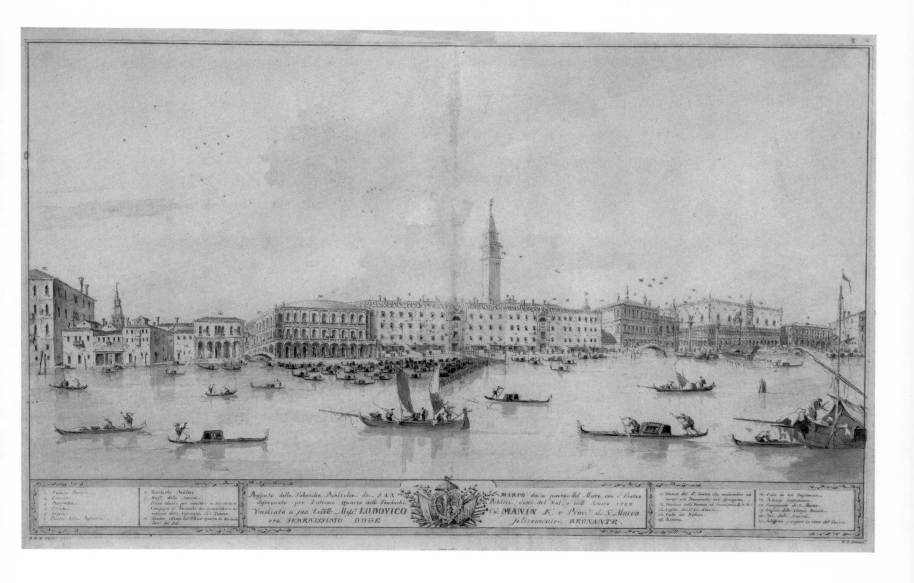

62 Panorama from the Bacino di San Marco

Pen and bister with wash on two sheets joined in the center, 351 x 677 mm.

Provenance: *Lady Catherine Ashburnham, Battle, Sussex.*

Bibliography: *Byam Shaw, 1951, no. 27; Orangerie Cat., 1957, no. 104; Cincinnati Cat., 1959, no. 230; Bean-Stampfle, 1971, no. 193; Morassi, 1975, Cat. no. 294; Kultzen, 1976, pp. 219–22; Szabo, 1981, no. 34.*

This is a preparatory drawing for a painting representing the regatta on the Giudecca Canal that reappeared only recently and was acquired by the Alte Pinakothek in Munich (Kultzen, 1976, p. 219). The painting and several drawings that are studies for it, including this one, were made between 1784 and 1789. Byam Shaw remarked that the present sheet "is among the most beautiful and ambitious drawings in Guardi's developed style" (Byam Shaw, 1951, p. 27). The panoramic view is especially breathtaking and extraordinary and is "certainly wider than the eye could include in a single focus" (Byam Shaw, 1951, p. 64). It is the conclusion of many scholars that Guardi must have composed this view from three separate drawings and from several different viewpoints, probably taken from a boat positioned in various places in front of San Giorgio Maggiore.

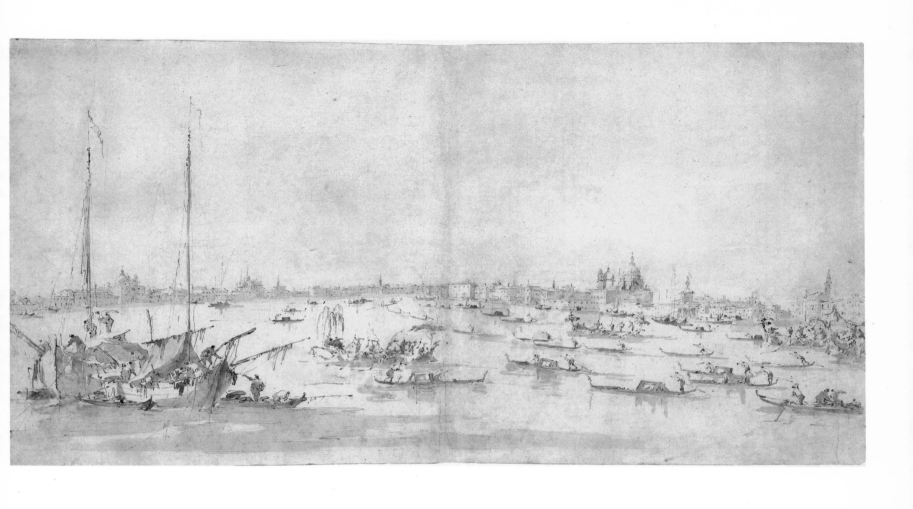

JACOPO DI PAOLO MARIESCHI

Painter; born in 1711 in Venice; died there in 1794. Marieschi was the pupil of Gaspare Diziani but was also influenced by Sebastiano Ricci and Pittoni. He was a prolific and dependable painter of frescoes and large altarpieces, many of which are still in the churches for which they were painted. Many of his drawings are preliminary designs or presentation sheets for these works.

63 The Transfer of the Relics of Saint John to Venice

Pen and ink with gray wash on paper, 227 x 415 mm.

Provenance: *Paul Wallraf, London.*

Bibliography: *Morassi, 1959, no. 43; Szabo, 1981, no. 59.*

This large drawing is a preliminary study for a fresco painted in 1743 in the second chapel on the right in the Church of San Giovanni in Brágora, Venice. The scene is the transfer of the relics of Saint John the Almsgiver to Venice in 1247.
Saint John the Almsgiver (c. 560—619), a native of Cyprus, became bishop of Alexandria while still a layman. He helped the poor and the needy and, according to his testament, "found the treasury of this church full and left it empty." Saint John's relics were kept in Alexandria until 1247 when they were transferred with great ceremony to Venice.
This study depicts the solemn procession in which the relics, on the left, were carried under a canopy, accompanied by the doge, who is disembarking on the right. The fresco, set in a semicircular field, was one of the more important commissions given the prolific Marieschi. Its importance is underlined by the fact that there is another design for it, somewhat different and embellished with color, now in the Museo Correr, Venice (cf. Morassi, 1959, p. 36).

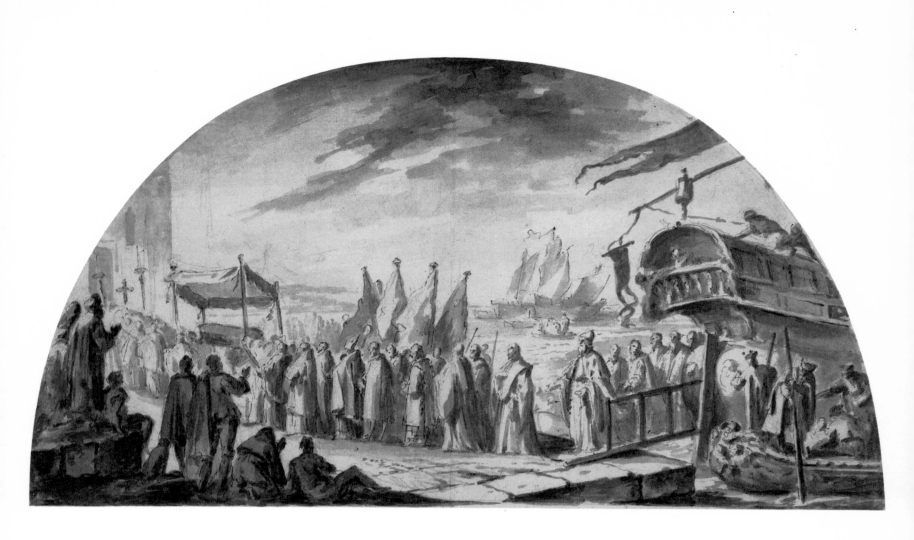

PIETRO ANTONIO NOVELLI

Painter, engraver, and poet; born in Venice in 1729; died there in 1804. A prolific painter of religious composi-
tions, portraits, and family groups, Novelli was active in Venice, Udine, Padua, and other North Italian cities.
He was active as an engraver and many of his drawings are related to graphic works. Novelli absorbed the
same stylistic influences as his contemporaries but never attained the individual style, nor the prominence, of
artists such as the Tiepolos or Guardi.

64 Study for a Family Portrait

*Pen and brown ink with sepia wash and white highlights on
brown paper, 297 x 375 mm. Inscribed on verso in an early-
nineteenth-century hand,* 10.

Provenance: *Vallardi, Milan; Paul Wallraf, London.*

Bibliography: *Morassi, 1959, no. 46; Szabo, 1980, no.
18; Szabo, 1981, no. 61.*

Morassi remarks that this study is very much in the
manner of the eighteenth-century English conversa-
tion pieces. These genre paintings and compositions
often represent group portraits of whole families in
elaborate indoor or outdoor settings (see Praz, *Con-
versation Pieces,* 1971, passim). Here a prominent Ve-
netian family is shown in the loggia of their palazzo
or villa. The father, possibly a senator judging from
his costume, explains to his sons the beauty and
goodness of the classical heritage which, in this draw-
ing, is personified by the statue of Minerva and the
round *tempietto* on the hill in the background. At the
left, the mother listens to her oldest daughter read-
ing. It is not known whether Novelli used this study
for a painting, but from the style of the costume
it may be dated to the 1780s.

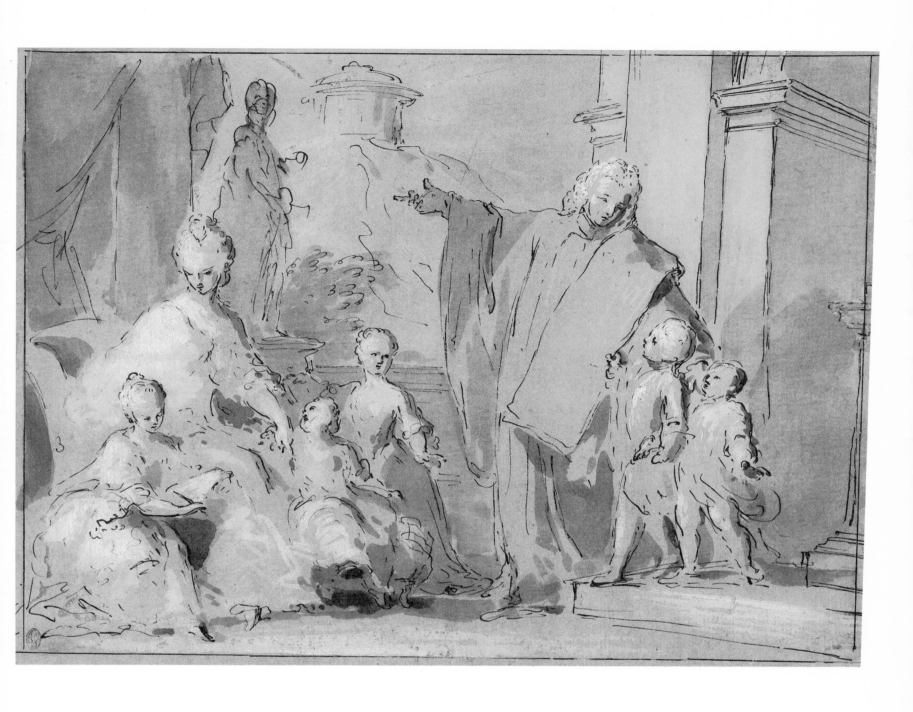

65 A Monk Displaying a Madonna Shrine to an Old Woman and Child

Pen and brown ink with sepia wash on paper, 266 x 200 mm.

Provenance: *Prince of Savoy, Aosta; Janos Scholz, New York; Paul Wallraf, London.*

Bibliography: *Morassi, 1959, no. 47; Szabo, 1980, no. 21; Szabo, 1981, no. 62.*

This inventive and dramatic drawing is also an inter-esting document of Venetian religious life and piety. Little tabernacles resembling the one represented here can still be seen affixed to houses and walls in Venice.

The dramatic contrast of dark and light areas, the bold pen strokes, and the sympathetic representation of the old people recall the drawings and graphic works of Rembrandt. Apparently Novelli, like Giovanni Domenico Tiepolo, was influenced by the Dutch master's oeuvre.

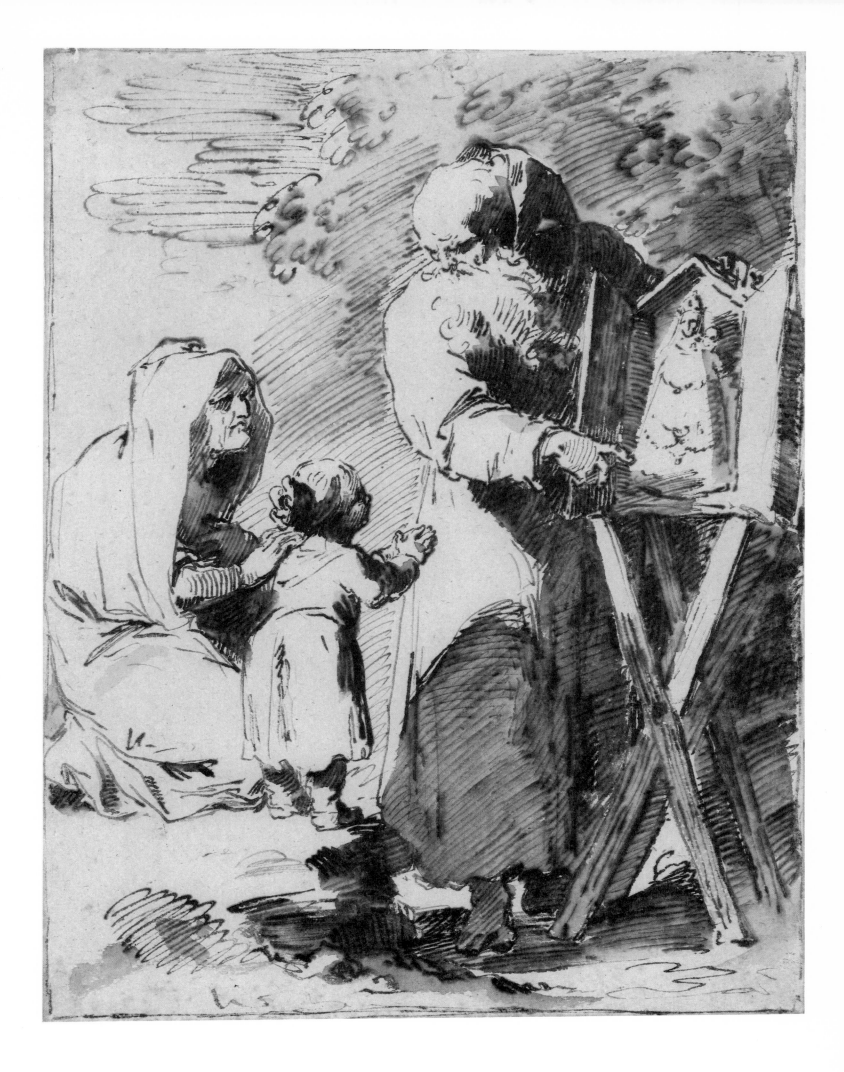

GIAN PAOLO PANINI

Born in Piacenza in 1691; died in Rome in 1765. Panini's artistic formation is based on the influence of Ferdinando Galli Bibbiena, Giuseppe Natale, and Giovanni Ghisolfi. As a painter of architecture, prospects, ruins, and views, Panini went to Rome in 1711 and there he followed the school of Benedetto Luti, a painter of historical subjects, in order to excel in the art of figure painting as well. In Rome he was also interested in realistic costume painting, the genre painting of Pier Leone Ghezzi, and the landscapes of painters such as Locatelli and Vanvitelli (Gaspar van Wittel) and other masters belonging to the Roman-Dutch school, such as Franz and Pieter van Bloemen. In order to enrich his style he added the romantic-arcadian elements found in Salvator Rosa's compositions, which emerge in his own views and ruins.

Through this kind of painting, in which he ingeniously fused poetry and truth, he established himself as one of the most interesting interpreters of this type of art. Notable echoes of his manner can be found in Piranesi, Canaletto, Natoire, Hubert Robert, Fragonard, and in many other painters all over Europe. The lively, delightful little figures which he inserts like a gentle breeze of contemporary reality into the fantasy of classical ruins created a school of their own and were to animate his own religious work.

In his first Roman period Panini also did fresco paintings on walls and ceilings. He was *principale* of the Accademia di San Luca in 1754, and a member of the French Academy in the Villa Medici, where he also taught.

66 Landscape with Statue and Ruins

Pen and brush with tinted ink washes and watercolor on paper, 184 x 262 mm. Verso: A sketch of ruins with a statue in tondo form in pen and brush with tinted washes (reproduced in Szabo, 1981, no. 66b).

Provenance: *Edward Fatio, Geneva.*

Bibliography: *Szabo, 1981, no. 66a.*

Like Panini's many similar compositions of ruins, sculptures, and landscapes, this one also fuses classical monuments and reminiscences with the poetry of nature. In this respect he transmits to later artists the Roman landscape tradition enriched with the deft application of tinted ink washes and watercolors. In contrast to many of his drawings, there is a notable absence of human figures in this work, which contributes to the romantic-melancholic atmosphere of the whole and ties it to the works of his contemporaries Piranesi and Canaletto.

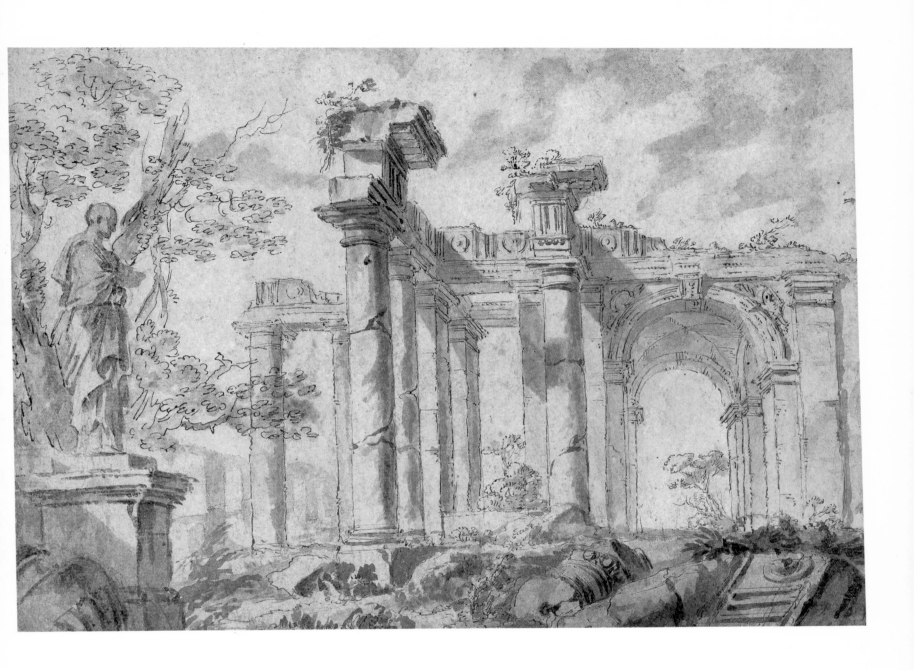

GIOVANNI BATTISTA PIRANESI

Born in Mogliano Veneto in 1720; died in Rome 1778. Piranesi was one of the protagonists of the complex cultural phenomenon which has been named Neoclassicism. But although the major part of his work was dedicated to the illustration of those monuments of antiquity exalted by the theorists of this classical movement, Piranesi cannot be limited to Neoclassicism. He was actually a transitional figure, with all the contradictions of one who participates equally in two contrasting worlds. In him were already to be seen the Romantic taste for archaeological fragments, calculated recompositions of heterogeneous elements, and the picturesque play of delicate light on pale surfaces, all important elements in the transition to the new vision of the late eighteenth century.

In architecture, as demonstrated by his work in Santa Maria del Priorato, the church of the Knights of Malta in Rome, he favored a highly picturesque style. The same conceptions and sentiments also animate his graphic work, which constituted his principal activity. In the *Opere di architettura*, published in Rome in 1750, he collected all his earlier plates, including the *Carceri* and the *Capricci*. In 1756 he published the *Antichità romane*, and in 1760 the second edition of the *Carceri*. To be cited finally are the *Vedute di Roma*, published between 1747 and 1778.

Piranesi's development as an etcher must have begun in his early youth, when he surely studied the etchings of Ricci and Tiepolo, from whom he derived a luminosity that is typically Venetian. In his prints he expressed his overriding love of ancient Rome, which he even polemically opposed to the Greek ideal of the German theorists. His grand, emotive vision of ruins, rendered still more evocative by the widened perspective, the almost necromantic atmosphere of his underground chambers populated with phantasmagoric figures, and the extraordinary construction of a lost world that still lives in memory create Piranesi's vast visual poem.

In many ways Piranesi may be compared with Francesco Guardi. These two artists seem to express the final lament of the two great civilizations of Rome and Venice, the former barely rediscovered, the latter already consigned to the past.

67 View of Pompeii

Pen and ink over faint traces of pencil gridwork on paper, 276 x 419 mm. Inscribed with numbers in various places.

Provenance: *Unknown. Acquired in 1961 from Stephen Spector, New York.*

Bibliography: *Szabo, 1981, no. 68.*

The fleeting manner, the gridwork, and the numbers all indicate that the drawing is a preparatory study for an engraving. As a matter of fact, it was engraved and published as Plate VI in the volume *Antiquités de la grande Grèce dessiné par G. B. Piranesi, Gravé par F. Piranesi; l'An 12* (1804). The strict perspective and the barren ruins are enlivened by six figures in various poses. These little vignettes betray the artist's Venetian origins, especially the standing man in the center who, with his tricorn and walking stick, recalls the caricatures of the Tiepolos.

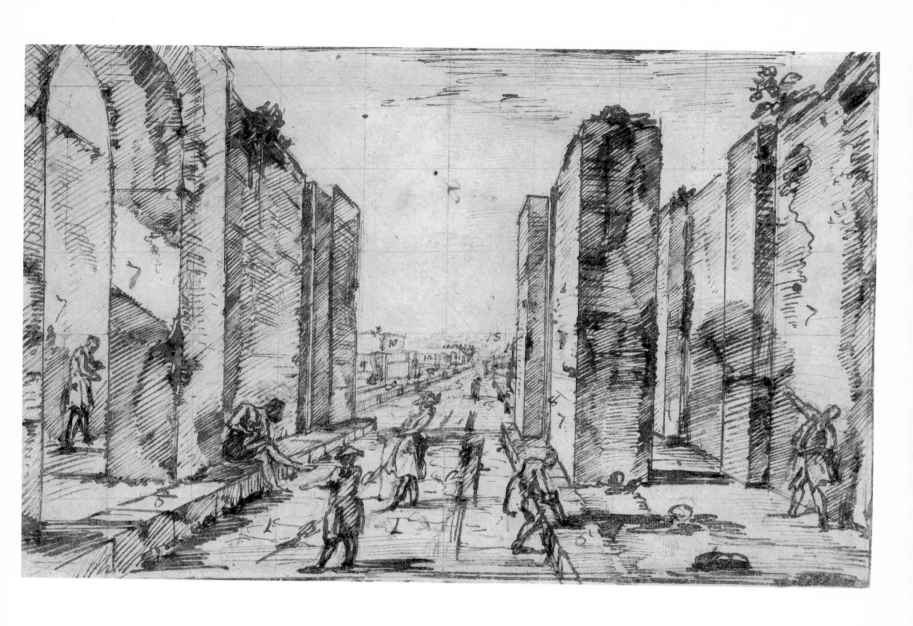

GIAMBATTISTA TIEPOLO

Born in Venice in 1696; died in Madrid in 1770. A pupil of Gregorio Lazzarini, in his earliest years Tiepolo was influenced by the chiaroscuro realism of Piazzetta and Bencovich, which was to appear at times even in his mature work. But he soon turned to the light-filled manner of Sebastiano Ricci and Pellegrini, which was more congenial to his sensibility. While developing Ricci's fantasy and charming ease of manner in bolder terms, he also submitted to the fascination of Veronese's decorative richness and sumptuous solemnity.

In 1719 Tiepolo married a sister of the painters Gian Antonio and Francesco Guardi. Enormously active, he has left frescoes in Venice, Udine, Milan, Bergamo, Vicenza, and other Venetian cities. Between 1750 und 1753 he was in Würzburg where he executed the frescoes in the Residenz. In 1762 Charles III summoned him to Madrid and there the aged painter continued to create canvases and frescoes for the rooms of the Royal Palace. Tiepolo's highly versatile production reaches its summit in his frescoes, which are unsurpassed for their expressive vigor, radiant luminosity, and fantasy of interpretation. A brilliant and tireless inventor and narrator, he is often seen at his best in the numerous existing oil sketches for his larger works. A fantastic and grotesque vein is manifested in his etchings, the *Capricci* and *Scherzi,* where his manner comes close to Castiglione.

The extant Tiepolo drawings number some thousand and are often preserved in groups that correspond to the artist's original albums, as in the Victoria and Albert Museum, London; the Heinemann Collection, Morgan Library, and Metropolitan Museum, New York; Princeton University; the museums of Trieste, Stuttgart, and Würzburg; and the Correr Museum in Venice. They constitute the greatest monuments of eighteenth-century graphic art and are an inexhaustible source for the study of Tiepolo's work.

68 Allegory with Figures beside a Pyramid

Pen and ink with brown wash heightened with white over black chalk preliminary drawing on paper, 421 x 275 mm.

Provenance: *Paul Wallraf, London.*

Bibliography: *Morassi, 1959, no. 52; Bean-Stampfle, 1965, no. 59;* The Tiepolos, *1978, no. 30; Szabo, 1981, no. 71.*

Morassi regards this dramatic drawing as an early work by Giambattista and dates it around 1725. Pyramids are often represented in Tiepolo's later works, especially in the so-called *scherzi di fantasia.* In some cases, they signify Africa, but here it is probably intended as a symbol of rulers and power (see Santifaller, 1975, pp. 193–207).

This sheet is of an extraordinary richness in color, tone, and texture despite the simple brown ink and wash. The masterful variations and manipulation and the highlighting in white imbue the drawing with the qualities of a painting.

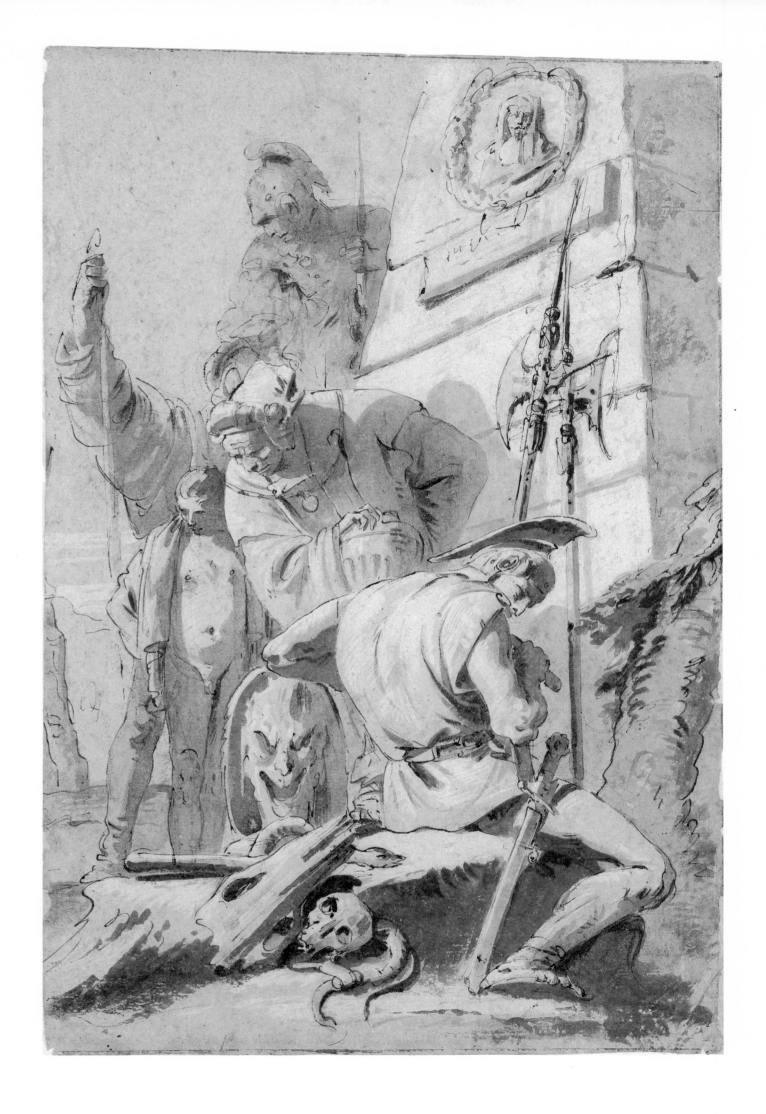

69 Bacchus and Ariadne

Pen and brown ink with brown wash over black chalk on paper, 311 x 241 mm.

Provenance: *William Bateson (Lugt Supplement 2604a); Philip Hofer, Cambridge, Mass.*

Bibliography: *Sack, 1910, p. 237, fig. 230; Hadeln, 1928, no. 73; Buffalo Cat., 1934, no. 64; Chicago Cat., 1938, no. 71; Orangerie Cat., 1957, no. 128; Cincinnati Cat., 1959, no. 226; Bean-Stampfle, 1971, no. 112; Szabo, 1981, no. 74.*

This justly celebrated drawing exhibits the whole range of Giambattista Tiepolo's mastery. The spirited group evidently was planned for a fresco and therefore it is not surprising that Knox associates it with Giambattista's ceiling frescoes in the Palazzo Labia, dated circa 1744 (Knox, 1970, no. 36). Similar compositions with Bacchus and Ariadne are in the Metropolitan Museum of Art and in private collections in New York and Paris (cf. Bean-Stampfle, 1971, p. 55).

However, the swift lines and the virtuoso use of the wash to suggest light and shade, the shapes of the bodies, and the receding planes all suggest a somewhat earlier dating. Bean and Stampfle point out that the drawing seems to be closer to those associated with the frescoes of the Palazzo Clerici in Milan that were painted by Giambattista in 1740.

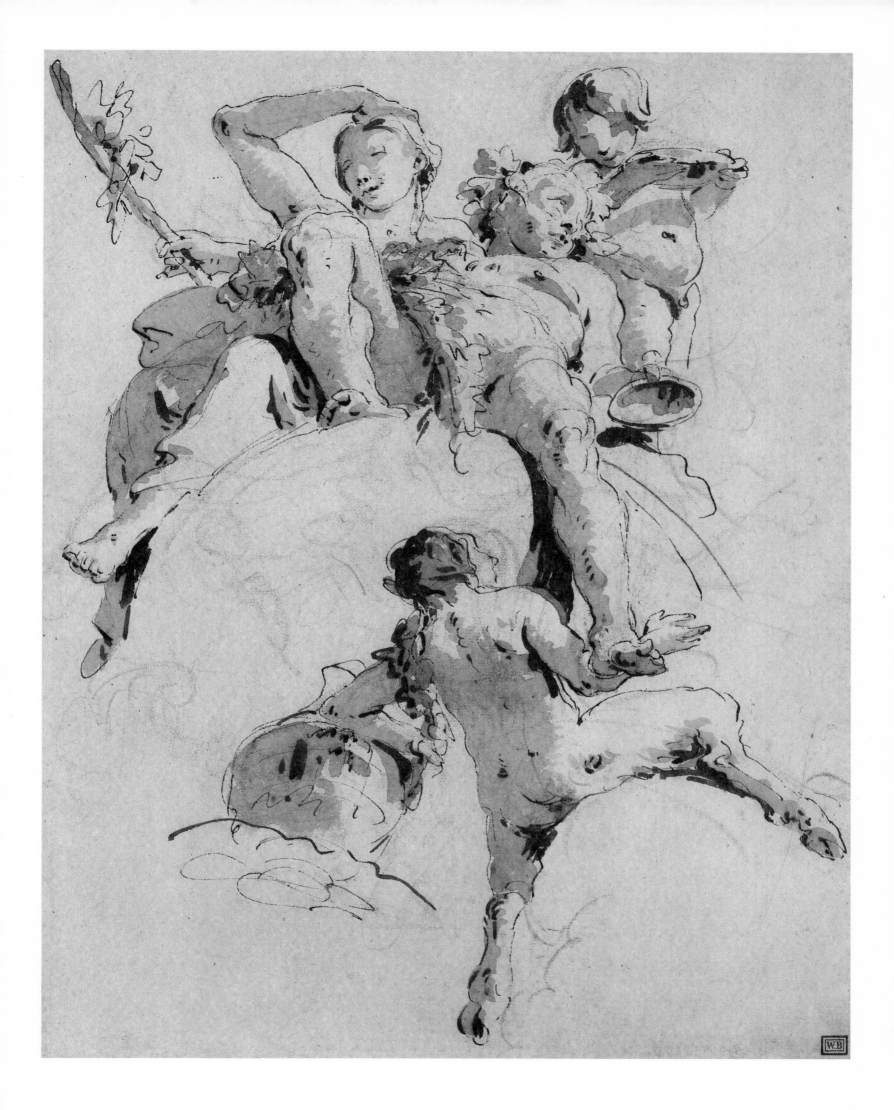

70 Group of Seated Punchinellos

Pen and ink with sepia wash over preliminary pencil drawing on paper, 194 x 285 mm.

Provenance: *Unidentified collection (stamp in lower right corner); Paul Wallraf, London.*

Bibliography: *Froelich-Bum, 1957, p. 56; Kozloff, 1961, p. 29, fig. 6; Morassi, 1959, no. 71; The Tiepolos, 1978, no. 64; Punchinello Drawings, 1979, p. 29, fig. 4; Szabo, 1981, no. 75.*

Giambattista's first drawings representing punchinellos are from the 1740s (cf. Vigni, 1942, pls. 223, 224). Morassi dates this and other drawings in private collections between 1755 and 1760 (see *The Tiepolos*, 1978, nos. 68, 69) and considers their "scratchy" penwork typical of Tiepolo's manner in this period. It is generally accepted that Giambattista's punchinello compositions were freely utilized by his son Giandomenico for the 103 scenes of his famed series, nine of which are in the Robert Lehman Collection, four of them reproduced here (cf. plates 77–80).

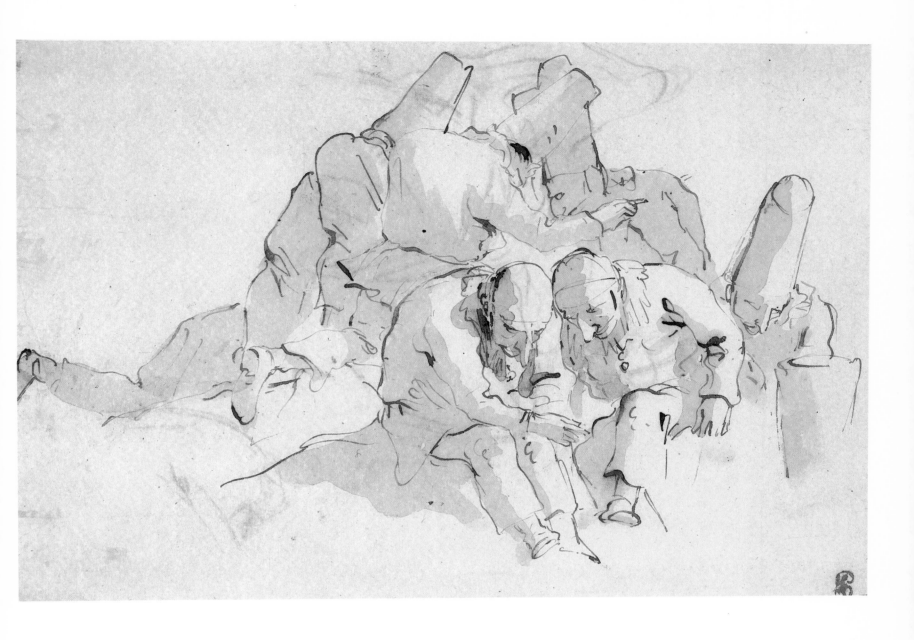

71 Virgin and Child Enthroned with Saints Sebastian, Francis, and Anthony

Pen and ink with brown wash over black chalk on paper, 456 x 300 mm.

Provenance: *Prince Alexis Orloff, Paris; Paul Wallraf, London.*

Bibliography: *Hadeln, 1928, no. 43; Morassi, 1959, no. 56; Knox, 1961, pp. 273—274, no. 741; Bean-Stampfle, 1971, no. 70; The Tiepolos, 1978, no. 44; Szabo, 1981, no. 76.*

This is another fine drawing of rich texture and vir-

tuoso technique, unfortunately without any relationship to known paintings by the artist. Paul J. Sachs and Agnes Mongan, however, have pointed out close similarities between it and a sheet in the Fogg Museum (Knox, 1970, no. 15). They called attention to the parallel arrangement of the saints and the similarity of the Virgin's throne in the Fogg drawing. Because of the close relationship, this sheet, too, may be dated around 1735 or somewhat later and possibly just before Giambattista's drawings associated with the Palazzo Clerici of 1740 (Bean-Stampfle, 1971, p. 44).

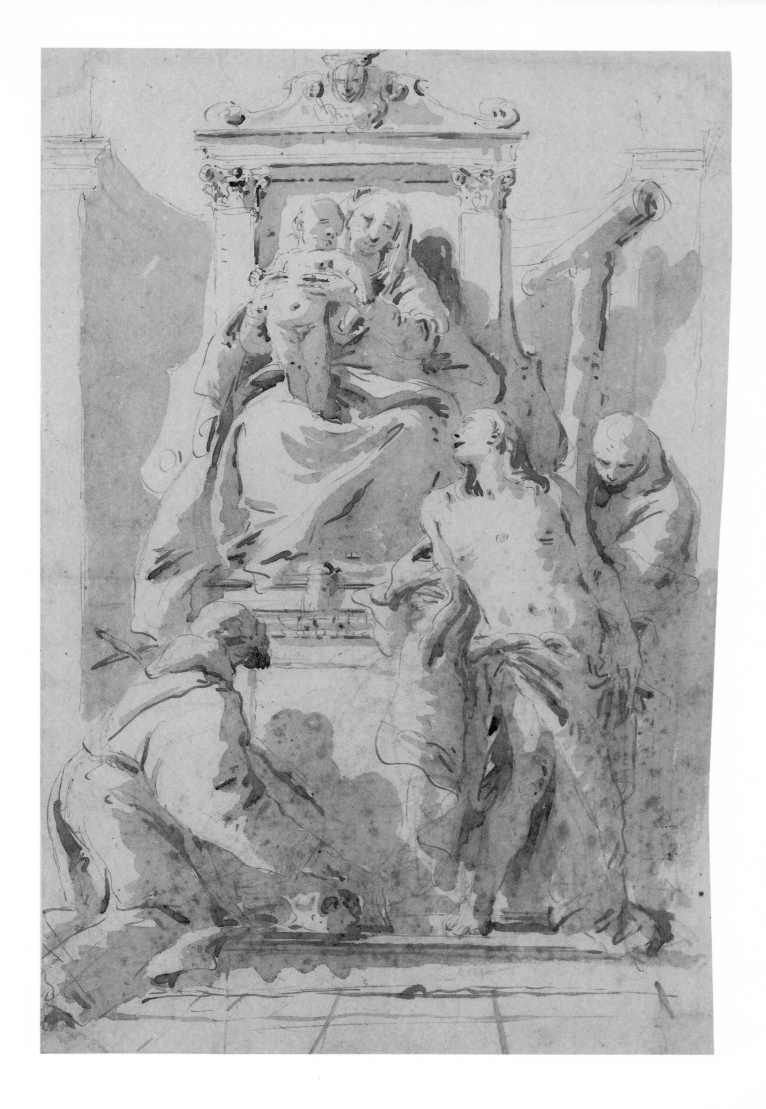

72 Man Leaning on a Horse

Pen and ink with gray wash over preliminary pencil drawing on paper, 195 x 165 mm. Verso: A sketch of a man's head and the inscription, No. 2808.2.f.G.M. (reproduced in Szabo, 1981, no. 82b).

Provenance: *Sir Robert Adby, London; Paul Wallraf, London.*

Bibliography: *Froelich-Bum, 1957, pp. 56–57, no. 391; Morassi, 1959, no. 62; Pignatti, 1974, no. 76; Szabo, 1980, no. 24; Szabo, 1981, no. 82a.*

According to Morassi, this is probably the first study for a fresco in the Villa Valmarana in Vicenza. Since the painting of this villa was begun in 1757 by the two Tiepolos, the drawing may be dated to the same year or shortly before (see Morassi, 1944, pl. 9). This figure appears in the scene called "Angelica Helps Medoro" in the so-called Gerusalemme Liberata room of the villa, which received its name from the subjects taken from Torquato Tasso's famous work (Pallucchini, 1945, pl. 30).

More recently, however, Pignatti has discussed the many differences between the drawing and the fresco and suggested a date in the mid-1740s for the former. He pointed out that similar figures can be found in the frescoes of the Palazzo Labia and in the large canvases at Varolanuova which are even earlier (Pignatti, 1974, no. 31).

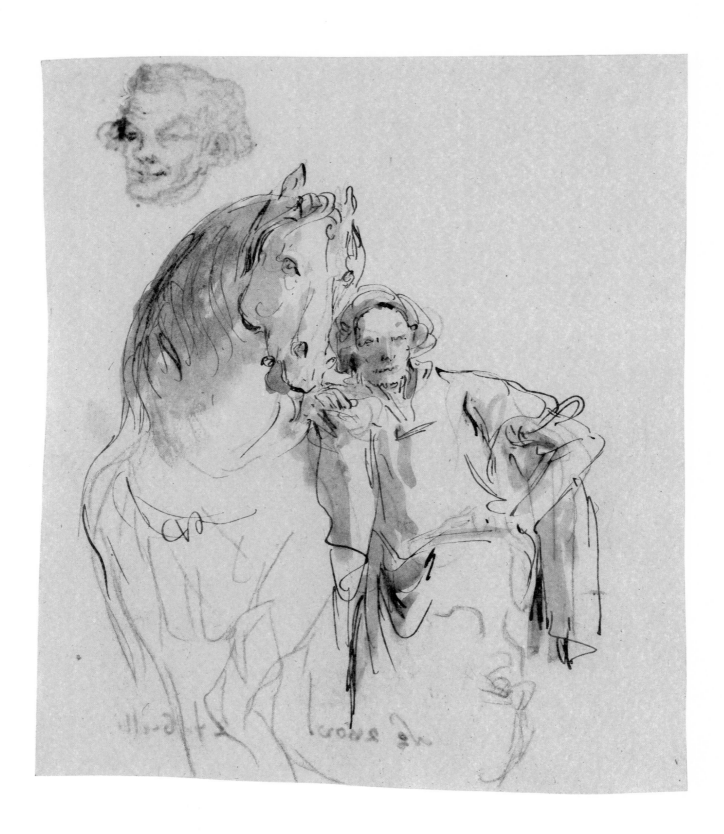

73 Zephyr and a Horse

Pen and ink with brown wash over preliminary pencil drawing on paper, 315 x 201 mm.

Provenance: *Paul Wallraf, London.*

Bibliography: *Morassi, 1959, no. 88; Pignatti, 1974, no. 77; Szabo, 1981, no. 95.*

This sheet is full of vigor, creative talent, and great inventive power. According to Morassi, it is one of Tiepolo's "highest fantasies." He also remarks that there are very few sheets as beautiful among the artist's drawings from the 1740s. Pignatti praises "this brilliant sketch" and associates it with the frescoes in the Palazzo Clerici and in the Palazzo Labia. He then continues, "Its overwhelming power derives from the contrast between the spaces left blank and dark areas of wash. Its expressiveness is reminiscent of Rembrandt" (Pignatti, 1974, p. 40).

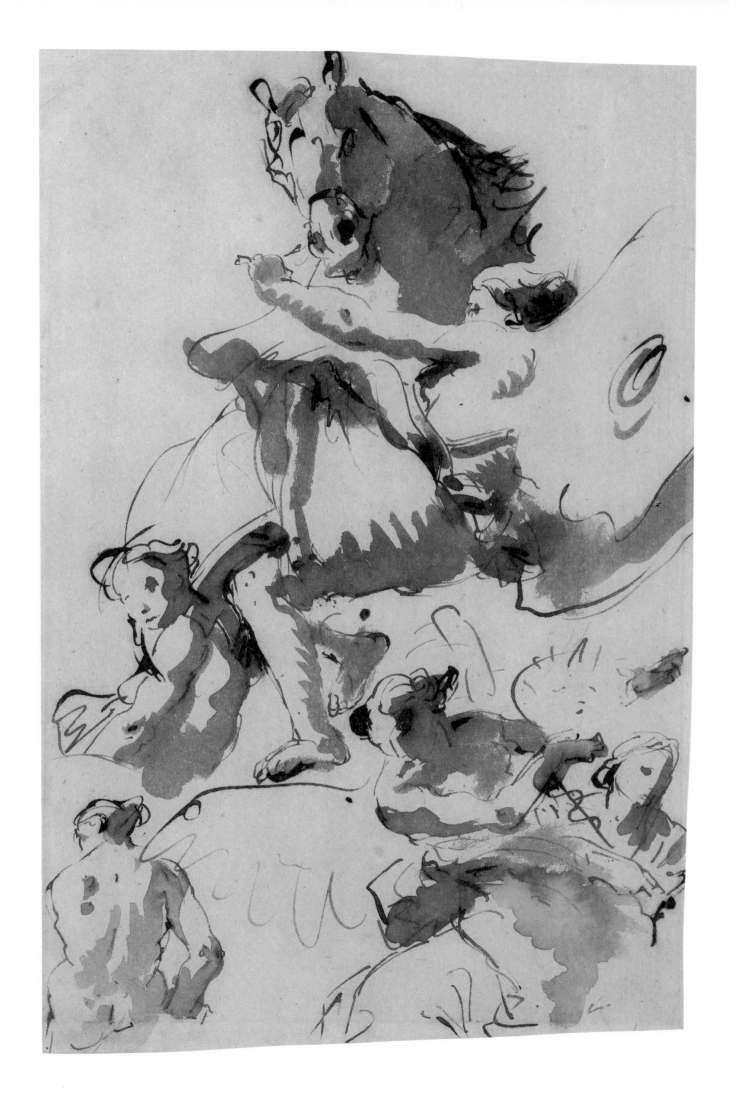

74 Caricature of a Man in a Mask and Tricorn

Pen and ink with wash on paper, 185 x 102 mm.

Provenance: *The Family Collection of the Counts of Valmarana, Vicenza; Count Sacchetto, Padua; Paul Wallraf, London.*

Bibliography: *Morassi, 1959, no. 77; Pignatti, 1974, no. 83; Szabo, 1980, no. 29; Szabo, 1981, no. 108.*

Pignatti remarks that this and other caricatures in the Lehman Collection "are among the most spirited ones that Tiepolo ever drew" (Pignatti, 1974, p. 41). He dates them around 1760. The mask is probably one of the white, ghostly type called *bautta*. This and the other caricatures by Tiepolo seem to reflect his amusement at his fellow-men, in particular the Venetians, rather than any social criticism or biting satire. A lighthearted attitude seems to guide his pen and brush in fleeting drawings that nevertheless belong to the masterpieces of the genre.

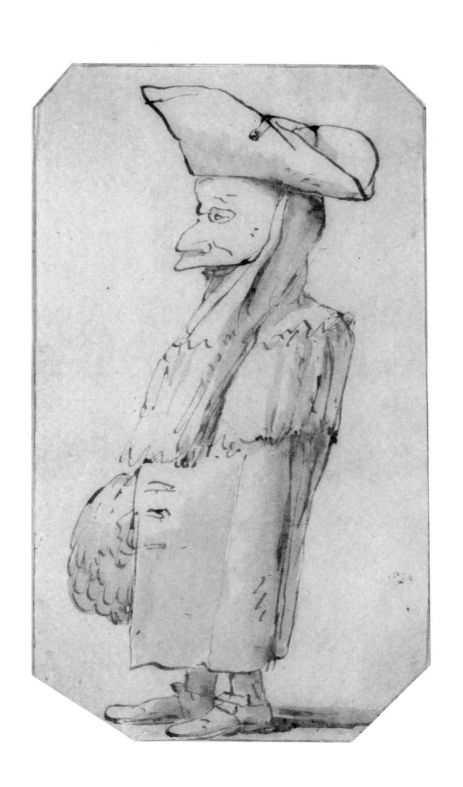

GIANDOMENICO TIEPOLO

Son and pupil of the great Giambattista and older brother of Lorenzo; born in Venice in 1727; died there in 1804. Giandomenico accompanied his father and brother to Würzburg in 1750–53 and to Madrid in 1762. Giandomenico's collaboration in the formidable activity of the Tiepolo workshop was above all on frescoes, where his own work corresponds so closely to that of the master, it is hard to distinguish between them. After his father's death in Madrid, he returned to Venice, where he remained except for a brief interval in Genoa in the years 1783–85. Giandomenico found a personal style and expression in the painting of popular genre scenes, animals, bucolic-mythological subjects, and landscapes, as can be seen, for example, in his frescoes of 1757 in the guest house of the Villa Valmarana in Vicenza. He showed particular originality in his drawings and etchings (*Via Crucis*, 1748; *Flight into Egypt*, 1753).

His vast production of prints and drawings is inspired entirely by themes of a basically realistic content, regardless of the actual subjects, which include everything from biblical stories to satyrs and animals, as well as punchinello scenes, a genre especially congenial to him. In these works he used ideas gathered from Callot, Rembrandt, Magnasco, and Marco Ricci, but so completely assimilated that they appear to be the fruit of his own imagination.

In the scenes of popular life in the Villa Valmarana and in the frescoes from the small Villa of Zianigo, now in Cà Rezzonico, Giandomenico shows himself to be the contemporary of the bitter and bizarre satire of Parini and Hogarth, and at times even a precursor of Goya.

75 The Baptism of Christ

Pen and ink with wash on paper, 254 x 172 mm.

Provenance: *The Hellenic Society, London; T. Grange, London.*

Bibliography: *Byam Shaw, 1962, p. 34, no. 1; Szabo, 1981, no. 125.*

The artist made a considerable number of drawings representing the Baptism of Christ. All are highly charged, dramatic compositions with a large variety of figures in the groups surrounding Christ and Saint John the Baptist. At some later time in Giandomenico's life, these drawings were gathered in an album which, according to Byam Shaw, contained more than eighty-four pages of these compositions. The Robert Lehman Collection possesses five more, each emphasizing a different aspect of the scene, one stressing the role of the crowd, others concentrating on the figures of Christ and Saint John (cf. Szabo, 1981, nos. 120–124).

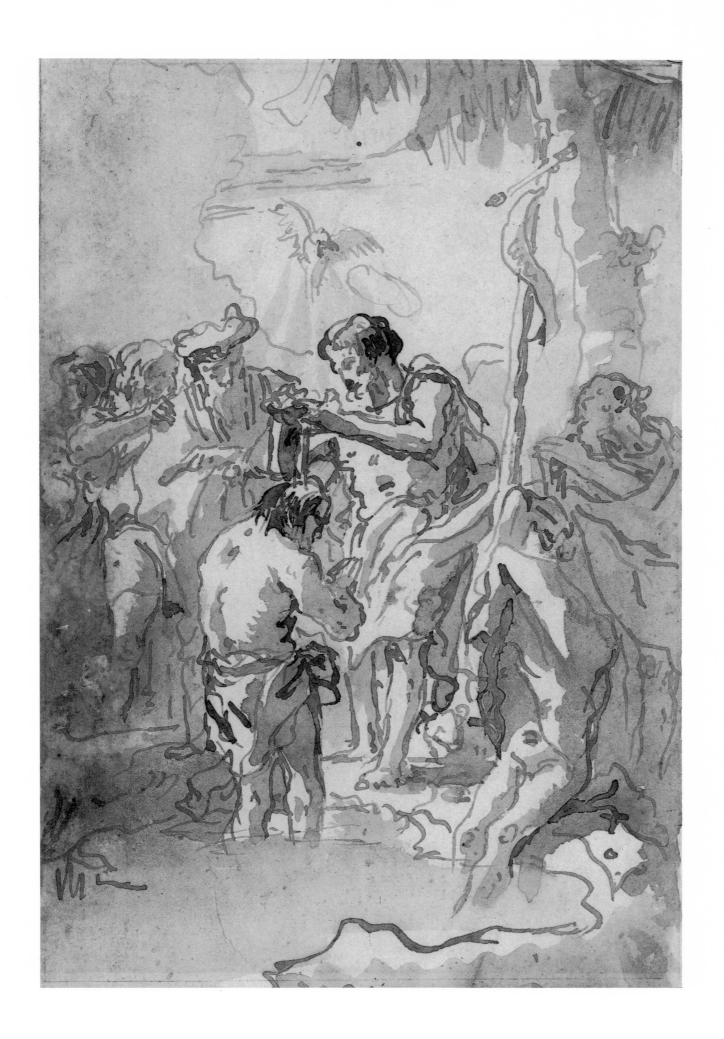

76 Rest on the Flight into Egypt

Pen and brown ink with wash over black chalk on paper, 470 x 379 mm. Signed in lower left corner, Dom° Tiepolo f.

Provenance: *Luzarches, Tours; Robert Cormier, Tours.*

Bibliography: *Bean-Stampfle, 1971, no. 257;* The Tiepolos, *1978, no. 129; Szabo, 1981, no. 127.*

According to a contemporary story, Giandomenico etched twenty-four variations on the theme of the Flight into Egypt to demonstrate his inventive and technical skill to a doubtful patron. Apparently the same subject inspired a large number of drawings by his pen, including ten sheets in the Louvre (Recueil Fayet), three in the Pierpont Morgan Library, and a few more in private collections (cf. Bean-Stampfle, 1971, p. 103). In this fresh and exceedingly fine sheet the artist introduced such exotic elements as the pyramid and the tree on the left. The little mule adds a touch of genre to an otherwise solemn scene. These elements date the drawing between 1750 and 1753.

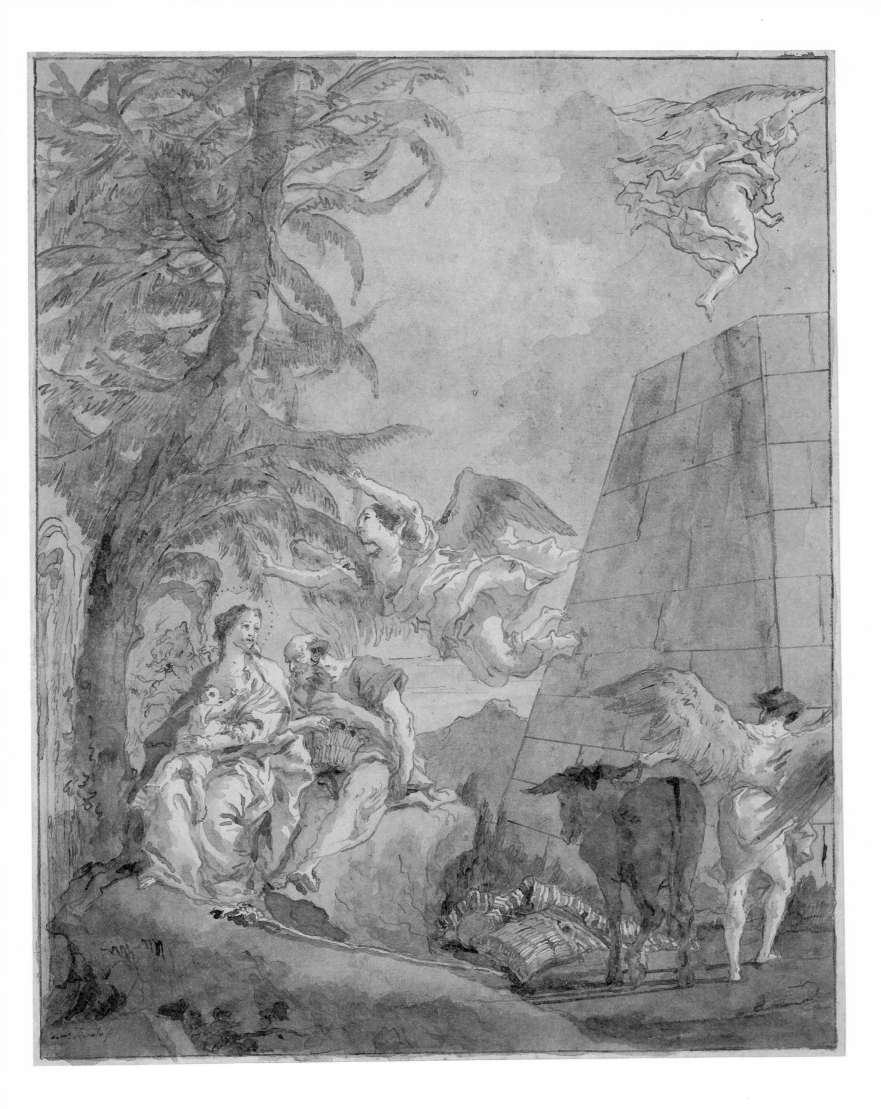

77 The Family Life of Punchinello's Parents

Pen and brown ink with brown wash over preliminary black chalk drawing on paper, 351 x 467 mm.

Provenance: *Anonymous collector; Richard Owen, Paris; Lady Elliott, London.*

Bibliography: *Byam Shaw, 1962, pp. 55—56; Bean-Stampfle, 1971, no. 271;* Punchinello Drawings, *1979, no. S2; Szabo, 1980, no. 41; Szabo, 1981, no. 130.*

This drawing is one of the first in Giandomenico's series of drawings entitled *Divertimento per li regazzi* (Entertainment for Children). Despite the title, it is intended for grown-ups, affectionately called *regazzi* (the children of Venice) by the aging artist who made the series around 1800. By featuring Punchinello, the leading character of the Italian *commedia dell'arte,* he satirized and poked fun at Venetian life and society in the guise of episodes from the life of Punchinello. He can be cruel or mild, but he is always understanding and affectionate of the human comedy that unfolds in the course of the 103 pages of the album. The subject was not new to the artist. His father, Giambattista, had made sketches of groups of punchinellos, such as the one reproduced in this volume (Plate 70). Around 1793 Giandomenico himself had painted frescoes of punchinellos for the Camera dei Pagliacci in the Tiepolo family's villa in Zianigo, some of which are now in the Palazzo Rezzonico in Venice (Lorenzetti, 1940, figs. 75, 79—85). The album was dispersed through auctions and sales, but fortunately nine of the 103 drawings are now gathered in the Robert Lehman Collection. The four reproduced here reveal the richness of this extraordinary creation by an exceptionally gifted artist who retained his creative power, imagination, and humanity until the very end of his life. (For the history of the album and a detailed description of its contents, see *Punchinello Drawings,* 1979, pp. 11—36).

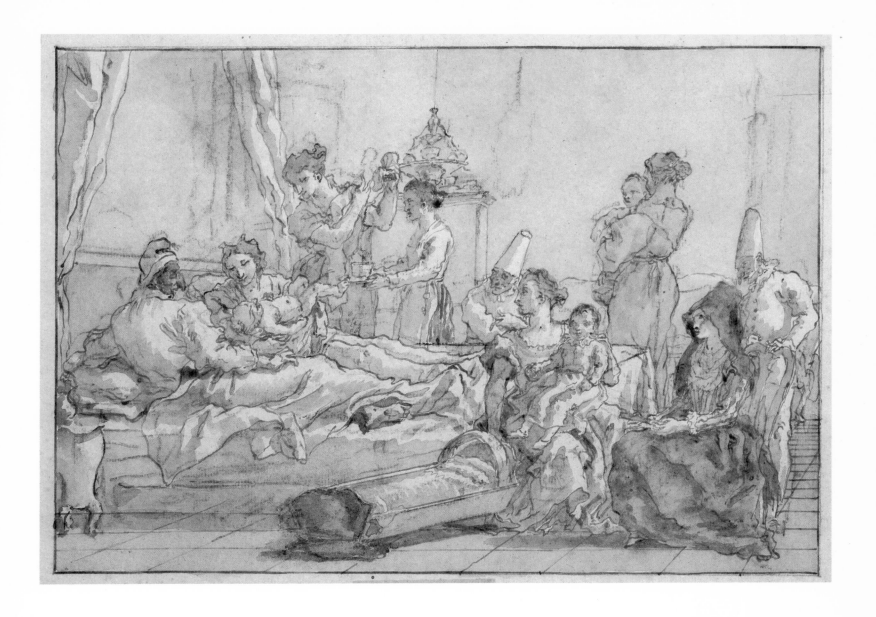

78 The Dressmaker's Visit

Pen and brown ink with brown wash over preliminary black chalk drawing on paper, 352 x 468 mm. Numbered in upper left corner of margin, 12.

Provenance: *Anonymous collector; Richard Owen, Paris.*

Bibliography: *Byam Shaw, 1962, p. 56; Bean-Stampfle, 1971, no. 278;* The Tiepolos, *1978, no. 121;* Punchinello Drawings, *1979, no. S17; Szabo, 1981, no. 133.*

This spirited drawing belongs to the group that rep-resents scenes from domestic life. In this case, the dressmaker fits his client with the help of Punchinello as his assistant. The interior is typically Venetian rococo, with elaborate furniture and a mirror with a richly carved frame. The other figures are all very lively, such as the servant carrying a tray or the boy with a lap dog under his arm, and are represented in motion with just a dash of wash and a few pen strokes. However, the dressmaker overseeing the fitting dominates the whole composition: "the effetely nonchalant couturier is one of Domenico's sharpest characterizations" (*The Tiepolos*, 1978, p. 144).

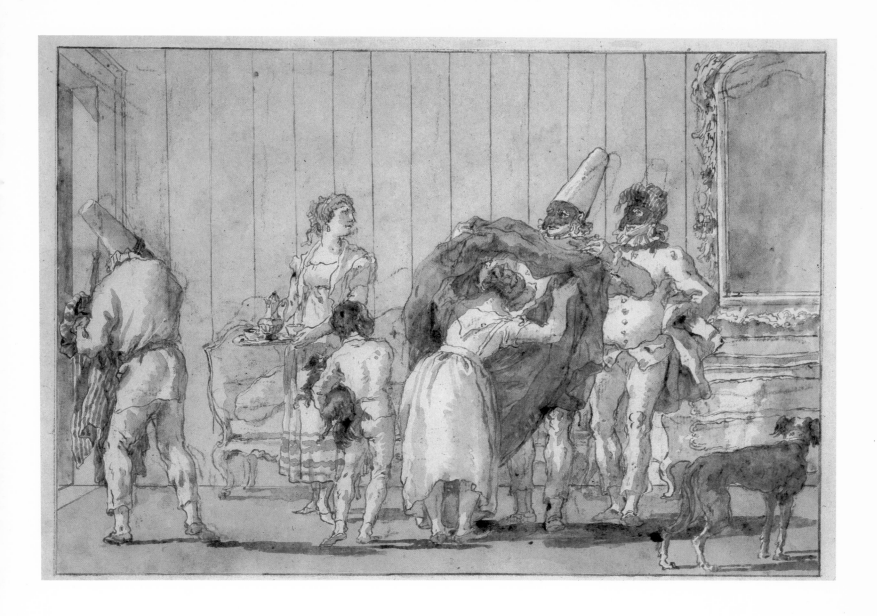

79 Punchinellos Resting outside the Circus

Pen and brown ink with wash over preliminary black chalk drawing on paper, 349 x 464 mm. Signed on the fence, Dom°. Tiepolo f. *Numbered in upper left corner of margin,* 50.

Provenance: *Anonymous collector, London; Richard Owen, Paris; Paul Suzor, Paris.*

Bibliography: *Byam Shaw, 1962, p. 56; Bean-Stampfle, 1971, no. 275;* Punchinello Drawings, *1979, no. S54; Szabo, 1981, no. 137.*

The crowd outside the wooden walls of the circus is a curious gathering of Venetians, and some are figures culled from Giandomenico's various earlier works, as has been pointed out in the catalogue of the recent exhibition of punchinello drawings. The elephant on the placard is depicted in a full-scale drawing in the Pierpont Morgan Library (Bean-Stampfle, 1971, no. 276); the hatless gentleman in profile also appears in one of the frescoes from the Villa Tiepolo in Zianigo, now in the Museo Correr. The lantern bearer in Eastern costume also appears in several drawings that represent scenes from contemporary life (*Punchinello Drawings,* 1979, p. 159).

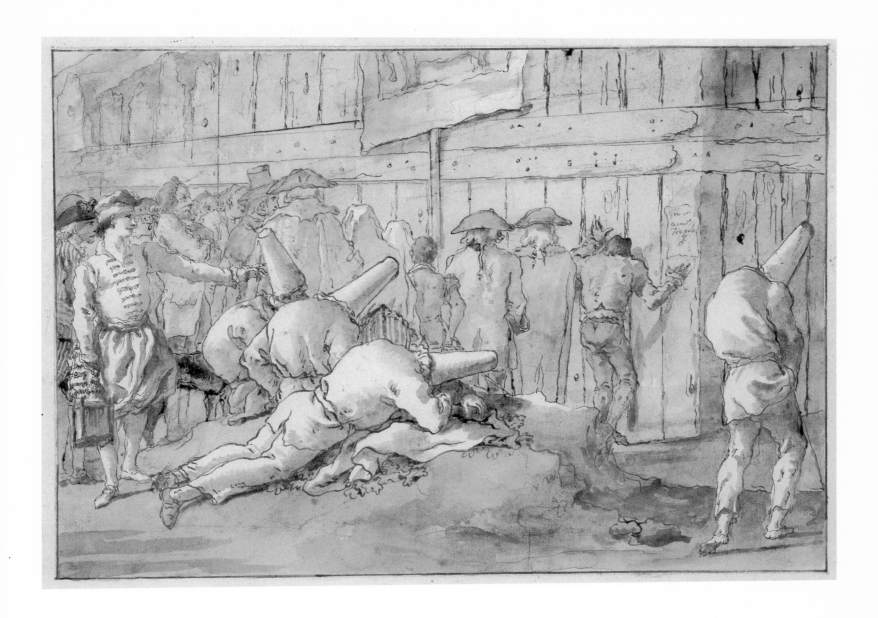

80 Punchinello as a Tailor's Assistant

Pen and brown ink with wash over preliminary black chalk drawing on paper, 352 x 472 mm. Signed in lower left corner, Dom° Tiepolo f. *Numbered in upper left corner of margin,* 55.

Provenance: *Anonymous collector, London; Richard Owen, Paris.*

Bibliography: *Byam Shaw, 1962, p. 92, pl. 88; Bean-Stampfle, 1971, no. 277;* Punchinello Drawings, *1979, no. S50; Szabo, 1980, no. 42; Szabo, 1981, no. 136.*

This drawing belongs to a group that Byam Shaw calls "Punchinello's Various Trades and Occupations." Other equally spirited drawings in the album represent him as a peddler, a barber, a carpenter, and a tavern keeper (see *Punchinello Drawings,* 1979, nos. S48—S51). These drawings are not only genre scenes but present a colorful and historically accurate panorama of Venetian crafts, many of which still flourish.

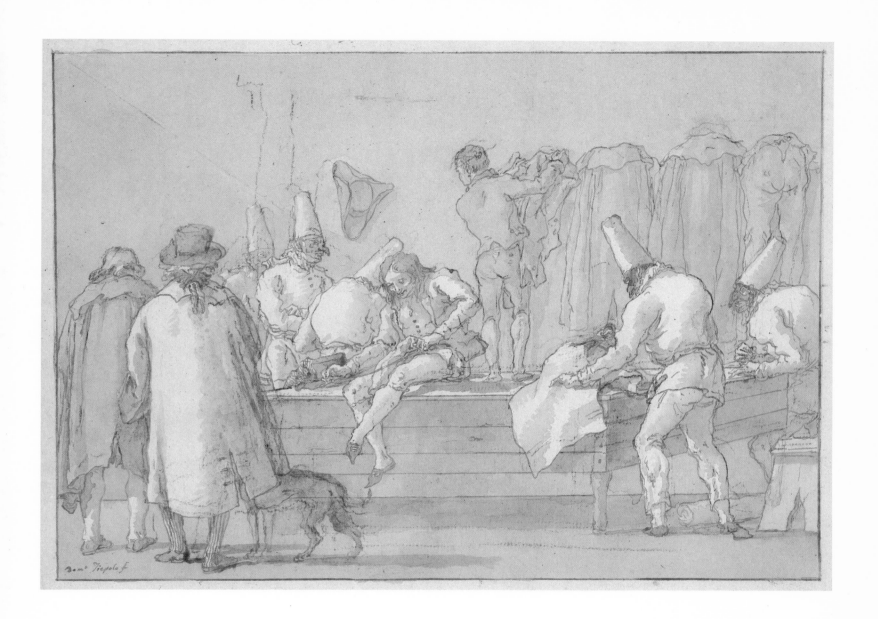

Bibliography

Adhémar, *Supp*.

ADHÉMAR, JEAN. *Bibliothèque nationale, Inventaire du fonds français. Les Graveurs du XVI* siècle*. II, *Supplément, Léon Davent*. Paris, n.d.

Baccheschi, 1973.

BACCHESCHI, EDI. *L'Opera completa del Bronzino*. Milan, 1973.

Barolsky, 1979.

BAROLSKY, PAUL. *Daniele da Volterra: A Catalogue Raisonné*. New York, 1979.

Bean, 1960.

BAYONNE, MUSÉE BONNAT. *Les Dessins italiens de la collection Bonnat*. Catalogue by Jacob Bean. Paris, 1960.

Bean, 1966.

PRINCETON UNIVERSITY, ART MUSEUM. *Italian Drawings in the Art Museum, Princeton University*. New York, 1966.

Bean-Stampfle, 1965.

NEW YORK, METROPOLITAN MUSEUM OF ART. *Drawings from New York Collections*. I, *The Italian Renaissance*. Catalogue by Jacob Bean and Felice Stampfle. New York, 1965.

Bean-Stampfle, 1971.

NEW YORK, METROPOLITAN MUSEUM OF ART. *Drawings from New York Collections*. III, *The Eighteenth Century in Italy*. Catalogue by Jacob Bean and Felice Stampfle. New York, 1971.

Berenson, 1903.

BERENSON, BERNARD. *The Drawings of the Florentine Painters*. 2 vols. London, 1903.

Berenson, 1938.

BERENSON, BERNARD. *The Drawings of the Florentine Painters*. Amplified ed. 3 vols. Chicago, 1938.

Berenson, 1961.

BERENSON, BERNARD. *I disegni dei pittori fiorentini*. Rev. ed. 3 vols. Milan, 1961.

Binion, 1980.

BINION, A. "Three Drawings by Canaletto," *Master Drawings*, XVIII (1980), pp. 374–75.

Blum, 1950.

BLUM, ANDRÉ. *Les Nielles du quattrocento. Musée du Louvre, Cabinet d'estampes Edmond Rothschild*. Paris, 1950.

Blunt-Cooke, 1960.

BLUNT, A. and COOKE, H. L. *The Roman Drawings of the XVII and XVIII Centuries . . . at Windsor Castle*. London, 1960.

Brink, 1977.

BRINK, JOEL. "Simone Martini, Francesco Petrarca and the Humanistic Program of the Virgil Frontispiece," *Mediaevalia*, III (1977), pp. 83–117.

Buffalo Cat., 1934.

BUFFALO FINE ARTS ACAMEDY, ALBRIGHT ART GALLERY. *Master Drawings, Selected from the Museum and Private Collections of America*. Buffalo,1934.

Bush, 1978.

BUSH, VIRGINIA. "Leonardo's Sforza Monument and Cinquecento Sculpture," *Arte Lombarda* (1978), pp. 47–68.

Byam Shaw, 1935.

BYAM SHAW, J. "Francesco Botticini," *Old Master Drawings*, IX (1935), pp. 58–60.

Byam Shaw, 1951.

BYAM SHAW, J. *The Drawings of Francesco Guardi*. London, 1951.

Byam Shaw, 1952.

BYAM SHAW, J. "A Giovanni Bellini at Bristol," *Burlington Magazine*, XCIV (1952), pp. 157–59; "A Further Note on the Bristol Bellini," *loc. cit.*, p. 237.

Byam Shaw, 1953.

LONDON, ROYAL ACADEMY. *Drawings by Old Masters*. Catalogue by J. Byam Shaw. London, 1953.

Byam Shaw, 1954.

BYAM SHAW, J. "The Drawings of Francesco Fontebasso," *Arte Veneta*, VIII (1954), pp. 317–25.

Byam Shaw, 1962.

BYAM SHAW, J. *The Drawings of Domenico Tiepolo*. London, 1962.

Camesasca, 1959.

CAMESASCA, ETTORE. *Tutta la pittura del Perugino*. Milan, 1959.

Causa, 1964.

CAUSA, RAFFAELLO. *Antonello da Messina*. Milan, 1964.

Cetto, 1950.

CETTO, ANNA MARIA. *Animal Drawings of Eight Centuries*. New York, 1950.

Chastel, 1969. CHASTEL, ANDRÉ. *The Myth of the Renaissance*. Geneva, 1969.

Chicago Cat., 1938. ART INSTITUTE OF CHICAGO. *Paintings, Drawings and Prints by the Two Tiepolos: Giambattista and Giandomenico*. Chicago, 1938.

Cincinnati Cat., 1959. CINCINNATI ART MUSEUM. *The Lehman Collection*. Cincinnati, 1959.

Clark, 1930. CLARK, KENNETH. "Italian Drawings at Burlington House," *Burlington Magazine*, LVI (1930), pp. 176–79.

Clark, 1937. CLARK, KENNETH. "Leonardo da Vinci, Study of a Bear Walking," *Old Master Drawings*, XI (1937), pp. 66–67.

Colacicchi, 1945. COLACICCHI, GIORGIO. *Antonio del Pollaiuolo*. Florence, 1945.

Columbia Exh., 1959. NEW YORK, M. KNOEDLER. *Great Master Drawings of Seven Centuries*. A Benefit Exhibition of Columbia University. New York, 1959.

Constable, 1962. CONSTABLE, W. G. *Canaletto*. Oxford, 1962.

Constable-Links, 1976. CONSTABLE, W. G. *Canaletto, Giovanni Antonio Canal*. 2d ed. Revised by J. G. Links. 2 vols. Oxford, 1976.

Couterier, 1954. COUTERIER, MARCEL. *L'Ours brun*. Grenoble, 1954.

Dacos, 1969. DACOS, NICOLE. *La Découverte de la Domus Aurea et la formation des grotesques à la renaissance*. London, 1969.

Dacos, 1977. DACOS, NICOLE. *Le Logge di Rafaello. Maestro i bottega de fronte all'antico*. Rome, 1977.

Dalai Emiliani, 1971. DALAI EMILIANI, MARISA. "Per la prospettiva 'padana': Foppa revisitato," *Arte Lombarda*, XVI (1971), pp. 117–36.

Degenhart, 1937. DEGENHART, BERNHARD. "Stefano di Giovanni da Verona," in Thieme-Becker, *Allgemeines Lexikon der Bildenden Künstler*. Leipzig, 1937.

Degenhart, 1941. DEGENHART, BERNHARD. *Pisanello*. Vienna-Turin, 1941.

Degenhart, 1954. DEGENHART, BERNHARD. "Di una pubblicazione su Pisanello e di altri fatti. II," *Arte Veneta*, VIII (1954), pp. 96–118.

Degenhart-Schmitt, 1964. DEGENHART, BERNHARD and SCHMITT, ANNEGRIT. "Methoden Vasaris bei der Gestaltung seines *Libro*," in *Studien zur toskanischen Kunst. Festschrift für Ludwig Heinrich Heydenreich*, pp. 45–64. Munich, 1964.

Degenhart-Schmitt, 1968. DEGENHART, BERNHARD and SCHMITT, ANNEGRIT. *Corpus der italienischen Zeichnungen, 1300–1450*. vol. I. Berlin, 1968.

Delogu, *Tintoretto*. DELOGU, GIUSEPPE. *I Grandi Maestri del disegno. Tintoretto*. Milan, n.d.

Dimier, 1900. DIMIER, LOUIS. *Le Primatice*. Paris, 1900.

Early Italian Engravings. LEVENSON, JAY A., OBERHUBER, KONRAD, and SHEEHAN, JACQUELYN L. *Early Italian Engravings from the National Gallery of Art*. Washington, D.C., 1973.

L'Ecole de Fontainebleau, Cat., 1972. *L'Ecole de Fontainebleau*. Paris, 1972.

Egan, 1959. EGAN, PATRICIA, "*Poesia* and the *Fête Champêtre*," *Art Bulletin*, XLI (1959), pp. 303–313.

Emiliani, 1960. EMILIANI, ANDREA. *Il Bronzino*. Busto Arsizio, 1960.

Ettlinger, 1953. ETTLINGER, L. D. "Pollaiuolo's Tomb of Pope Sixtus IV," *Journal of the Warburg and Courtauld Institutes*, XVI (1953), pp. 239–274.

Ettlinger, 1978. ETTLINGER, L. D. *Antonio and Piero Pollaiuolo*. London, 1978.

Fehl, 1957. FEHL, PHILLIP. "The Hidden Genre: A Study of the *Concert Champêtre* in the Louvre," *Journal of Aesthetics and Art Criticism*, XVI (1957), pp. 153–68.

Ferrari, 1961. FERRARI, MARIA LUISA. *Il Romanino*. Milan, 1961.

Finberg, 1920−21. FINBERG, H. F. "Canaletto in England," *Walpole Society*, IX (1920−21), pp. 68 ff.

Fiocco, 1928. FIOCCO, GIUSEPPE. *Paolo Veronese 1528−1588*. Bologna, 1928.

Fiocco, 1933. FIOCCO, GIUSEPPE. "Francesco Guardi, Pittore de teatro," *Dedalo*, XIII (1933), pp. 360−67.

Fiocco, 1950. FIOCCO, GIUSEPPE. "Disegni di Stefano da Verona. Proporzioni," *Studi di Storia dell'arte*, III (1950), pp. 56−64.

Fiocco, 1951. FIOCCO, GIUSEPPE. "I disegni di Antonello," *Arte Veneta*, V (1951), pp. 49−54.

Fischel, 1917. FISCHEL, OTTO. *Zeichnungen der Umbrer*. Rome, 1917.

Fleming, 1958. FLEMING, JOHN. "Mr. Kent, Art Dealer and the Fra Bartolommeo Drawings," *Connoisseur*, LXLI (1958), p. 227.

Fossi Todorow, 1966. FOSSI TODOROW, MARIA. *I disegni del Pisanello e della sua cerchia*. Florence, 1966.

Fossi Todorow, 1970. FOSSI TODOROW, MARIA. *I Disegni degli maestri. L'Italia dalle origini a Pisanello*. Rome, 1970.

Franco Fiorio, 1971. FRANCO FIORIO, MARIA TERESA. *Giovan Francesco Caroto*. Verona, 1971.

Frankfurter, 1939. FRANKFURTER, A. M. "Master Drawings of the Renaissance—Notable and New Items in American Collections," *Art News*, XXXVII (1939), pp. 128−29.

Froelich-Bum, 1957. FROELICH-BUM, L. "Four Unpublished Drawings by G. B. Tiepolo," *Apollo*, LXVI (1957), pp. 56−57.

Fry, 1906. FRY, ROGER. *Vasari Society . . . Drawings*. 1st series, II, no. 14. London, 1906−7.

Gabelentz, 1922. GABELENTZ, H. VON. *Fra Bartolommeo und die Florentiner Renaissance*. 2 vols. Leipzig, 1922.

Gere, 1969. GERE, J. A. *Taddeo Zuccaro. His Development Studied in His Drawings*. Chicago, 1969.

Grassi Sale Cat., 1924. London, Sotheby & Co. *Catalogue of Important Drawings by Old Masters Mainly of the Italian School . . . Sold 13 May 1924*. London, 1924.

Hadeln, 1928. HADELN, DETLEV VON. *The Drawings of G. B. Tiepolo*. 2 vols. Paris, 1928.

Hadeln, 1929. HADELN, DETLEV VON. *The Drawings of Antonio Canal*. London, 1929.

Halm-Degenhart-Wegner, 1958. HALM, PETER, DEGENHART, BERNHARD, and WEGNER, WOLFGANG. *Hundert Meisterzeichnungen aus der Staatlichen Graphischen Sammlung, München*. Munich, 1958.

Haraszti-Takács, 1967. HARASZTI-TAKÁCS, MARIANNE. "Compositions de nus et leurs modèles. Études sur la conception de la nature et sur la représentation de la figure humaine dans le peinture des maniéristes nordiques," *Bulletin de Musée Hongrois des Beaux Arts*, no. 30 (1967), pp. 49−75. .

Härth, 1959. HÄRTH, ISOLDE. "Zu Landschaftszeichnungen Fra Bartolommeos und seines Kreises," *Mitteilungen des Kunsthistorischen Institutes in Florenz*, IX (1959), pp. 125−30.

Hayum, 1976. HAYUM, ANDRÉE. *Giovanni Antonio Bazzi—"Il Sodoma."* New York, 1976.

Heinemann, 1962. HEINEMANN, FRITZ. *Giovanni Bellini e I Belliniani*. Venice, 1962.

Herbet, 1896−1902. "Les Graveurs de l'école de Fontainebleau," *Annales de la Société historique archéologique du Gâtinais*, 1896−1902, pp. 23 ff.

Herbet, 1937. HERBET, F. *Le Château de Fontainebleau*. Paris, 1937.

Heseltine, 1913. HESELTINE, J. B. *Italian Drawings*. London, 1913.

Hibbard, 1980. HIBBARD, HOWARD. *The Metropolitan Museum of Art*. New York, 1980.

Hoffmann, 1971. HOFFMANN, KONRAD. "Dürers Darstellungen der Höllenfart Christi," *Zeitschrift des deutschen Vereins für Kunstwissenschaft*, XXV (1971), pp. 75−106.

Horses of San Marco, 1979. NEW YORK, METROPOLITAN MUSEUM OF ART. *The Horses of San Marco, Venice.* Milan and New York, 1979.

Images of Love and Death, 1979. UNIVERSITY OF MICHIGAN MUSEUM OF ART. *Images of Love and Death in Late Medieval and Renaissance Art.* Catalogue by William Levin. Ann Arbor, 1975.

Italian Drawings, Royal Academy, 1931 LONDON, ROYAL ACADEMY OF ARTS. *Italian Drawings Exhibited at the Royal Academy, Burlington House, London 1930.* London, 1931.

Kennedy, 1938. KENNEDY, RUTH WEDGWOOD. *Alesso Baldovinetti. A Critical and Historical Study.* New Haven, 1938.

Kennedy, 1959. KENNEDY, RUTH WEDGWOOD. "A Landscape Drawing by Fra Bartolommeo," *Smith College Museum of Art, Bulletin.* no. 39 (1959), pp. 1–12.

Knapp, 1903. KNAPP, F. *Fra Bartolommeo della Porta und die Schule von San Marco.* Halle, 1903.

Knox, 1961. KNOX, G. "The Orloff Album of Tiepolo Drawings," *Burlington Magazine,* CIII (1961), pp. 269–75.

Knox, 1970. HARVARD UNIVERSITY, FOGG ART MUSEUM. *Tiepolo, A Bicentenary Exhibition.* Catalogue by G. Knox. Cambridge, Mass., 1970.

Koschatzky-Oberhuber-Knab, 1971. KOSCHATZKY, W., OBERHUBER, K., and KNAB, E. *I grandi Disegni italiani dell'Albertina.* Milan, 1971.

Kozloff, 1961. KOZLOFF, MAX. "The Caricatures of Giambattista Tiepolo," *Marsyas,* X (1961), pp. 12–29.

Kultzen, 1961. KULTZEN, R. "Bemerkungen zu einer Fassadenmalerei Polidoros da Caravaggio an der Piazza Madama in Rom," *Miscellaneae Bibliotheca Hertzianae,* Munich (1961), pp. 207–12.

Kultzen, 1976. KULTZEN, R. "Ein Spätwerk von Francesco Guardi in der Alten Pinakothek," *Pantheon,* XXXIV (1976), pp. 219–20.

Kurz, 1937. KURZ, OTTO. "Giorgio Vasari's 'Libro de' Disegni,'" *Old Master Drawings,* XI (1937), pp. 3–15.

Ladner, 1961. LADNER, GERHARD B. "Vegetation Symbolism and the Concept of the Renaissance," in *Essays in Honor of Erwin Panofsky,* pp. 303–22. New York, 1961.

Langton Douglas, 1946. LANGTON DOUGLAS, R. *Piero di Cosimo.* Chicago, 1946.

Longhi, 1953. LONGHI, ROBERTO. "Frammento siciliano," *Paragone,* IV (1953), pp. 26–30.

Lorenzetti, 1940. LORENZETTI, G. *Rezzonico.* 3d ed. Venice, 1940.

Lugt, 1956. LUGT, FRITS. *Les Marques de collections de dessins et d'estampes. Supplément.* The Hague, 1956.

Maggini, 1977. MAGGINI, ENRICHETTA. *Disegni di Fra Bartolomeo.* Florence, 1977.

Marabottini, 1969. MARABOTTINI, ALESSANDRO. *Polidoro da Caravaggio.* Rome, 1969.

Martin, 1910. MARTIN, F. R. "New Originals and Oriental Copies of Gentile Bellini Found in the East," *Burlington Magazine,* XVII (1910), pp. 5–6.

Meller, 1934. MELLER, SIMON. "Antonio Pollaiuolo tervajzai Francesco Sforza lovasszobrához. I progetti di Antonio Pollaiuolo per la statua equestre di Francesco Sforza," *Petrovics Elek Emlékkönyv,* Budapest (1934), pp. 76–79, 204–5.

Metz, 1789. METZ, C. M. *Imitations of Ancient and Modern Drawings.* London, 1789.

Milkovich, 1964. MILKOVICH, M. *Luca Cambiaso.* Exhibition catalogue. Memphis, Tenn., 1964.

Mireur, 1910. MIREUR, H. *Dictionnaire des ventes d'art.* vol. II. Paris, 1910.

Montini-Averini, 1957. MONTINI, RENZO U. and AVERINI, RICCARDO. *Palazzo Baldassini e l'arte di Giovanni da Udine.* Rome, 1957.

Morassi, 1944. MORASSI, ANTONIO. *La Villa Valmarana.* Milan, 1944.

Morassi, 1959.　　　　　　　MORASSI, ANTONIO. *Venezianische Handzeichnungen des achtzehnten Jahrhundert aus der Sammlung Paul Wallraf*. Venice, 1959.

Morassi, 1975.　　　　　　　MORASSI, ANTONIO. *Guardi, Tutti i Disegni*. Venice, 1975.

Moskowitz, 1962.　　　　　　MOSKOWITZ, IRA. *Great Drawings of All Time*. 4 vols. New York, 1962.

Mostra de strumenti musicali, 1952.　　　　*Mostra de strumenti musicali in disegni degli Uffizi*. Florence, 1952.

Muraro, 1957.　　　　　　　MURARO, M. *Catalogue of the Exhibition of Venetian Drawings from the Collection of Janos Scholz*. Venice, 1957.

Murray, 1966.　　　　　　　MURRAY, PETER. *Antonello da Messina*. London, 1966.

Oberhuber-Walker, 1973.　　OBERHUBER, KONRAD and WALKER, DEAN. *Sixteenth Century Italian Drawings from the Collection of Janos Scholz*. Washington, D.C., 1973.

Oppenheimer Sale Cat., 1936.　　*Catalogue of the Famous Collection of Old Master Drawings Formed by the Late Henry Oppenheimer, Esq., F.S.A.* London, 1936.

Orangerie Cat., 1957.　　　PARIS, MUSÉE DE L'ORANGERIE. *Exposition de la collection Lehman de New York*. 2d ed. Paris, 1957.

Ortolani, 1948.　　　　　　ORTOLANI, SERGIO. *Il Pollaiuolo*. Milan, 1948.

Pallucchini, 1945.　　　　　PALLUCCHINI, R. *Gli Affreschi di G. B. e D. Tiepolo alla Villa Valmarana di Vicenza*. Bergamo, 1945.

Paolini, 1979.　　　　　　　PAOLINI, MARIA GRAZIA. "Antonello e la sua scuola," in *Storia della Sicilia,* vol. V, pp. 3–61. Naples, 1979.

Paolini, 1980.　　　　　　　PAOLINI, MARIA GRAZIA. "Problemi antonelliani — I rapporti con la pittura fiamminga," *Storia dell'Arte,* XXXVIII–XL (1980), pp. 151–66.

Parker, 1927.　　　　　　　PARKER, K. T. *North Italian Drawings of the Quattrocento*. London, 1927.

Parker, 1948.　　　　　　　PARKER, K. T. *Canaletto Drawings . . . at Windsor Castle*. London, 1948.

Pignatti, 1974.　　　　　　PIGNATTI, TERISIO. *Venetian Drawings from American Collections*. Catalogue of a Loan Exhibition, Organized and Circulated by the International Exhibitions Foundation. Washington, D.C., National Gallery of Art, 1974.

Pope-Hennessy, 1971.　　　POPE-HENNESSY, JOHN. *Italian Renaissance Sculpture*. London and New York, 1971.

Popham, 1937.　　　　　　POPHAM, A. E. "The Drawings at the Burlington Fine Arts Club," *Burlington Magazine,* LIX (1937), pp. 85–87.

Popham-Pouncey, 1950.　　POPHAM, A. E. and POUNCEY, PHILIP. *Italian Drawings in the Department of Prints and Drawings in the British Museum. The Fourteenth and Fifteenth Centuries*. London, 1950.

Popham-Wilde, 1949.　　　POPHAM, A. E. and WILDE, JOHANNES. *The Italian Drawings of the XV and XVI Centuries . . . at Windsor Castle*. London, 1949.

Praz, 1971.　　　　　　　　PRAZ, M. *Conversation Pieces. A Survey of the Informal Group Portrait in Europe and America*. University Park, Penn., 1971.

Punchinello Drawings, 1979.　　INDIANA UNIVERSITY, ART MUSEUM. *Domenico Tiepolo's Punchinello Drawings*. Exhibition catalogue. Bloomington, 1979.

Puppi, 1962.　　　　　　　PUPPI, LIONELLO. *Bartolomeo Montagna*. Venice, 1962.

Ragghianti, 1972.　　　　　RAGGHIANTI, CARLO LODOVICO. "Bonnatiana, I," *Critica d'Arte,* XLII (1972), pp. 116–34.

Ragghianti Collobi, 1974.　　RAGGHIANTI COLLOBI, LUCIA. *Il Libro de' Disegni del Vasari*. 2 vols. Florence, 1974.

Ricci, 1912.　　　　　　　RICCI, CORRADO. *Il Pintoricchio*. Perugia, 1912.

Richter, 1939.　　　　　　RICHTER, J. P. *The Literary Works of Leonardo da Vinci*. 2 vols. Oxford, 1939.

Rouillard, 1973.

ROUILLARD, C. D. "A Reconsideration of 'La Réception de l'ambassadeur Domenico Trevisano au Caire. Ecole de Gentile Bellini' at the Louvre, As an Audience de Vénitiens a Damas," *Gazette des Beaux-Arts,* 6th ser., LXXXII (1973), pp. 297–304.

Ruhmer, 1958.

RUHMER, EBERHARD. "Bernardo Parentino und der Stecher PP," *Arte Veneta,* XII (1958), pp. 38–42.

Ruhmer, 1962.

RUHMER, EBERHARD. "Ergänzendes zur Zeichenkunst des Ercole de' Roberti," *Pantheon,* XX (1962), pp. 241–47.

Sack, 1910.

SACK, E. *Giambattista und Domenico Tiepolo.* Hamburg, 1910.

Salmi, 1953.

SALMI, MARIO. *Luca Signorelli.* Novara, 1953.

Salmi, 1954.

SALMI, MARIO. "Aspetti della cultura figurativa di Padova e di Ferrara nella miniatura del primo Rinascimento," *Arte Veneta,* VIII (1954), pp. 131–41.

Santifaller, 1975.

SANTIFALLER, M. "Die Gruppe mit der Pyramide in Giambattista Tiepolos Treppenhausfresko der Residenz zu Würzburg," *Münchner Jahrbuch der Bildenden Kunst,* XXVI (1975), pp. 193–207.

Schaack, 1962.

SCHAACK, E. VAN. *Master Drawings in Private Collections.* New York, 1962.

Schiller, 1971.

SCHILLER, GERTRUDE. *Ikonographie der christlichen Kunst.* vol. III. Gütersloh, 1971.

Scholz, 1967.

SCHOLZ, JANOS. "Italian Drawings in the Art Museum of Princeton University," *Burlington Magazine,* CIX (1967), pp. 226–27.

Sciascia-Mandel, 1967.

SCIASCIA, LEONARDO and MANDEL, GABRIELE. *L'Opera completa di Antonello da Messina.* Milan, 1967.

Shapley, 1945.

SHAPLEY, FERN RUSK. "Giovanni Bellini and Cornaro's Gazelle," *Gazette des Beaux-Arts,* 6th ser., XXVIII (1945), pp. 27–30.

Shapley, 1970.

SHAPLEY, FERN RUSK. *Paintings from the Samuel H. Kress Collection. Italian Schools XIII-XV Century.* London, 1966.

Skippe Sale Cat., 1958.

LONDON, CHRISTIE, MANSON & WOODS. *Catalogue of the Well-Known Collection of Old Master Drawings . . . Formed in the 18th Century by John Skippe.* London, 1958.

Smyth, 1971.

SMYTH, CRAIG H. *Bronzino as Draughtsman. An Introduction.* Locust Valley, N.Y., 1971.

Spencer, 1972.

SPENCER, JOHN R. "Sources of Leonardo da Vinci's Sforza Monument," in *Actes du XXIIe congrès international d'histoire de l'art.* II, *Evolution générale et développements régionaux en histoire de l'art,* pp. 735–42. Budapest, 1972.

Spencer, 1973.

SPENCER, JOHN. "Il progetto per il cavallo di bronzo per Francesco Sforza," *Arte Lombarda,* XVIII (1973), pp. 23–35.

Stauch, 1937.

STAUCH, LISELOTTE. "Bar," in *Reallexikon zur deutschen Kunstgeschichte,* I, cols. 1442–49. Stuttgart, 1937.

Steenbock, 1966.

STEENBOCK, FRAUKE. "Zu einer neuerworbenen Zeichnung von Stefano da Verona," in *Studien aus dem Berliner Kupferstichkabinett Hans Möhle zugeeignet,* pp. 9–15. Berlin, 1966.

Szabo, 1975.

NEW YORK, METROPOLITAN MUSEUM OF ART. *The Robert Lehman Collection. A Guide.* Text by George Szabo. New York, 1975.

Szabo, Cat., 1977.

TOKYO, NATIONAL MUSEUM OF WESTERN ART. *Renaissance Decorative Arts from the Robert Lehman Collection of the Metropolitan Museum of Art, New York.* Text by George Szabo, in Japanese with English titles. Exhibition catalogue. Tokyo, 1977.

Szabo, 1978.

NEW YORK, METROPOLITAN MUSEUM OF ART. *XV Century Italian Drawings from the Robert Lehman Collection.* Catalogue by George Szabo. New York, 1978.

Szabo, 1980.

SZABO, GEORGE. *From the Pens of the Masters; Eighteenth Century Venetian Drawings from the Robert Lehman Collection of the Metropolitan Museum of Art.* Huntington, N.Y., 1980.

Szabo, 1981. NEW YORK, METROPOLITAN MUSEUM OF ART. *Eighteenth Century Venetian Drawings from the Robert Lehman Collection.* Catalogue by George Szabo. New York. 1981.

Szabo, Notes, 1981. SZABO, GEORGE. "Notes on XV Century Italian Drawings of Equestrian Figures: Giambono, Pollaiuolo and the Horses of San Marco," *Drawing,* III (1981), pp. 34–37.

Tempesti-Tofani, 1974. TEMPESTI, A. F. and TOFANI, A. M. P. *I grandi Disegni italiani degli Uffizi di Firenze.* Milan, 1974.

The Tiepolos, 1978. ALABAMA, BIRMINGHAM MUSEUM OF ART. *The Tiepolos: Painters to Princes and Prelates.* Exhibition catalogue. Birmingham, 1978.

Tietze, 1947. TIETZE, H. *European Master Drawings.* New York, 1947.

Tietze-Conrat, 1943. TIETZE-CONRAT, ERICKA. "Francesco Morone in America," *Art in America,* XXXI (1943), pp. 83–87.

Tietze-Conrat, 1946. TIETZE-CONRAT, ERICKA. "Again: Giovanni Bellini and Cornaro's Gazelle," *Gazette des Beaux-Arts,* 6th ser., XXIX (1946), pp. 187–90.

Tietze-Tietze-Conrat, 1944. TIETZE, HANS and TIETZE-CONRAT, ERICKA. *The Drawings of the Venetian Painters in the 15th and 16th Centuries.* New York, 1944.

Tolnay, 1943. DE TOLNAY, CHARLES. *History and Technique of Old Master Drawings.* New York, 1943.

Treasures, Cat., 1979. *Treasures from the Metropolitan Museum of Art, New York. Memories and Revivals of the Classical Spirit.* Exhibition catalogue. Athens, 1979.

van Marle, 1923–38. VAN MARLE, RAIMOND. *The Development of the Italian Schools of Painting.* 19 vols. The Hague, 1923–38.

Vasari, *Lives.* VASARI, GIORGIO. *Lives of the Most Eminent Painters, Sculptors & Architects.* Trans. by Gaston Du C. DeVere. 10 vols. London, 1912–15.

Viale, 1954. VIALE, VITTORIO. *Sedici Opere di Defendente Ferrari.* Turin, 1954.

Vigni, 1942. VIGNI, G. *Disegni del Tiepolo.* Padua, 1942.

Vivant-Denon-Amaury-Duval, DENON, DOMINIQUE VIVANT and DUVAL, AMAURY. *Monuments des arts du dessin chez les*
1829. *peuples tant anciens que modernes.* 2 vols. Paris, 1829.

Ward, 1968. WARD, JOHN L. "A New Look at the *Friedsam Annunciation,*" *Art Bulletin,* L (1968), pp. 184–87.

Wazbinski, 1968. WAZBINSKI, ZYGMUNT. " 'Vir Melancholicus.' Z dziejow renesansowego obrazowania geniusza," *Folia historiae artium,* V (1968), pp. 5–17.

Wehle-Salinger, 1947. NEW YORK, METROPOLITAN MUSEUM OF ART. *A Catalogue of Early Flemish, Dutch and German Paintings.* By Harry B. Wehle and Margaretta Salinger. New York, 1947.

Weisbach, 1942. WEISBACH, WERNER. " 'Ein Fuss beschuht, der andere nackt.' Bemerkungen zu einigen Handzeichnungen des Urs Graf," *Zeitschrift für schweizerische Archaeologie und Kunstgeschichte,* IV (1942), pp. 108–22.

Weller, 1943. WELLER, ALLEN STUART. *Francesco di Giorgio, 1439–1501.* Chicago, 1943.

Wittkower, 1927. WITTKOWER, R. "Studien zur Geschichte der Malerei in Verona, III," *Jahrbuch für Kunstwissenschaft,* IV (1927), pp. 199–212.

Wright, 1919. WRIGHT, WILLIAM. "Leonardo as an Anatomist," *Burlington Magazine,* XXXIV (1919), pp. 194–203.

Zava Boccazzi, 1966. ZAVA BOCCAZZI, FRANCA. *La Pittura tardogotica veneta.* Milan, 1966.

Zerner, 1969. ZERNER, H. *The School of Fontainebleau: Etchings and Engravings.* New York, 1969.